Creating Games with Unity and Maya

Creating Games with Unity and Maya

How to Develop Fun and Marketable 3D Games

Adam Watkins

Routledge
Taylor & Francis Group
New York London

First published 2011 by Focal Press

711 Third Avenue, New York, NY 10017, USA
2 Park Square, Milton Park, Abingdon, Oxon OX14 4RN

Routledge is an imprint of the Taylor & Francis Group, an informa business

First issued in hardback 2017

Library of Congress Cataloging-in-Publication Data
Watkins, Adam.
 Creating games with Unity and Maya : creating games with Unity and Maya : how to develop fun and marketable 3D games / Adam Watkins.
 p. cm.
 ISBN 978-0-240-81881-8
1. Computer games--Programming. 2. Video games--Design. 3. Unity (Electronic resource)
4. Maya (Computer file) 5. Three-dimensional display systems. I. Title.
 QA76.76.C672W322 2012
 794.8'1526--dc23

 2011017562

British Library Cataloguing-in-Publication Data
A catalogue record for this book is available from the British Library.

ISBN-13: 978-0-240-81881-8 (pbk)
ISBN-13: 978-1-138-42799-0 (hbk)

Dedication

As always, to my beautiful and exciting Kirsten, Anaya, and Isaiah.

Acknowledgments

Books like this are the results of a lot of work by a lot of people. It is important to point them out.

First, many thanks to Kelly Michel and the team at the Los Alamos National Laboratory that made working on this book possible. The opportunities to learn and grow have been exciting to me professionally, and I've personally very much enjoyed my time working with my teammates Brian Dickens, Elise Elfman, Jake Green, and Birch Hayes.

Also, thanks to the tireless efforts of my tech editor, Anson Call; the book is more accurate, and tighter conceptually than it would have been without his meticulous work.

Thanks also, of course, to the editors at Focal with whom I have worked on the project: Sara Scott, Laura Lewin, Katy Spencer, and Lauren Mattos.

Finally, working on books is always a bit of an exercise in patience by the family of the author. This round, the patience of my forever friend Kirsten and her care of the little peeps has been of unimaginable help.

Contents

Contents

Contents

Contents

Contents

Introduction

Why This Book?

The Unity Game Engine has been shaking things up. The engine is only a little over five years old now and in 2010 they have earned *Develop Magazine*'s Grand Prix Award and surpassed 170,000 developers. The user base of consuming Unity products has grown dynamically as well. There are over 30 million total Unity Web Player installations, and the base continues to expand at over 2 million installs per month.

Part of this success undoubtedly comes from their 2009 bold move to give away a free version of Unity Indie. Suddenly, everyone could get their hands on a game engine and anyone with the will to learn could start making games. Unity further empowered the masses by making Unity a viable development platform for iDevices (iPhone, iPod Touch, iPad), Mac, PC, Xbox 360, Wii, and now Android and PlayStation 3. Web deployment further democratized the 3D development and distribution process. At conferences and online Unity is generating quite the buzz. Since I have been using the software, conversations among faculty at training institutions and game developers alike have gone from, "Unity? No, I've never heard of that. Is it new?" to "Yeah, we're using Unity in three of our courses coming up this semester," and Skype tags that say, "I want Unity 3.0."

But with all this buzz, and the rapid development and deployment cycle that the Unity 3D team has undergone, there has been a distinct lack of introductory documentation, especially documentation aimed at the entire process of game development. In recent months there have been some new (and really nice) books released to get people into Unity and it is true that Unity provides some nice downloadable projects and some tutorials attached to those projects (which you should grab for free if you haven't yet), but often while my students (who are trained as 3D artists) have worked through these, although they have become familiar with Unity's interface and with what does what, they are simply unable to extrapolate this knowledge into a new "authored from scratch" game. Further, most of the Unity 3D provided tutorials are focused on Unity and provide prebuilt assets that the reader simply plugs into his or her Unity project. This misses some of the vital creative processes and tricks of getting these assets into Unity.

And so the impetus for this book emerged: create artist-driven, holistic training modules that provide the theory of game development and the methodology behind Unity that empower readers to create their own games.

Who's It For?

My professional background recently has been developing training games for inspectors in pursuit of nonproliferation efforts at the Los Alamos National Laboratory. But this is a temporary assignment and part of a one-year research sabbatical. I am on sabbatical from a position as head of 3D Animation at the University of the Incarnate Word in San Antonio, TX where I have taught 3D animation for over 10 years. With this background, as I use tools, I am always thinking of how this particular tool or technique can be taught, and how it can be taught differently to different demographics.

In the construction of this book, there are three main groups of learners in mind:

- **Game Enthusiasts:** The biggest group of students we have coming into our university are those with the idea, "I love to play video games, therefore, I'll be *great* at making them." Unfortunately this is often not the case—consuming is much different than creating—but, this sort of enthusiasm is important to maintain through the long learning arcs that are required for making 3D games. This book assumes that, at the very least, you love games. And that you are passionate enough about them that you want to create your own games.

 This volume is for you. Equipped with a free version of Unity and a copy of Maya, this book will provide you with the necessary steps and ideas to empower your own game creation. The book is organized into manageable tutorials coupled with theory discussions so you can see measurable progress quickly that you can bridge into your own development. In a few days, or weeks, you could have your first tutorial-driven game developed, and the scripts to begin your own.

- **Students:** Ten years ago, developing 3D animation programs was all the rage at colleges and universities. This enthusiasm has crept into high schools and even middle schools. With this 3D curriculum—of which you may be a part—has come the natural desire to expand into game development. This book has been specifically structured with you in mind.

 The tutorials are structured so that they can be tackled in class or as part of a homework assignment. The pacing has been carefully considered to allow for bite-sized chunks of knowledge that are still delivered at a brisk pace. Most importantly, each chapter builds on the next and allows for real progress really quickly.

- **Teachers:** I have done a lot of training for teachers at colleges, universities, and high schools. I have seen the panic in teachers' eyes—the teachers with little 3D or game training—but who have been tasked with developing a game development curriculum and then teaching that curriculum. To be sure, it is a daunting task, and one that is a little unfair to saddle on a teacher with their other tasks. Have no fear though, this book will help lighten the load.

Included in the appendices for this book (on the supporting website (http://www.Creating3DGames.com) are some suggested curricula for using this book in a classroom setting. It will help in being able to plug this book into your work flow and class plans. Although it will be critical that you follow the tutorials yourself to understand the questions that the students will undoubtedly have, this volume will provide some tutorials for in class or homework that will help to provide a lot of instruction in learning the 3D-to-game publication process.

Structure

Although presently I am also a game developer, my long-term passion is teaching. I know how people learn 3D and game engines. There is an unfortunate trend for many early learners to pick up a tutorial and immediately start working through the steps without any consideration to why that tutorial was written, and what the basic concepts are behind the steps they are following. At the end of the tutorial, readers have the sense of accomplishment that they have finished the tutorial, but suddenly come to the crushing reality that they can't create their own project, and they couldn't even replicate this project unless the tutorial was in front of them again. Essentially, they have become recipe followers—they can only cook if the book is open in front of them, and if someone else has figured out the steps. They certainly aren't chefs. The goal of this book is to make master game chefs. To do this, there are some specific conventions this book will follow.

First, every chapter and every tutorial will be prefaced with some theory—some explanations of the method behind the madness of what they are about to embark on. This theory will cover not only the reasoning of the tutorial and its goals but also the reasoning behind Maya or Unity and their particular implementation of 3D technique. Avoid the temptation to skip the theory and smash into the tutorial; you will be much more enriched by understanding the reason behind the steps.

Every chapter will also include tutorials, some longer than others, but each with a very specific learning objective in mind. Each tutorial will build upon the last and move us closer to completing the game that will be playable at the end of this book. However, this book is a novel, not a collection of short stories, and if you skip too far ahead too quickly, you will miss vital information that make later chapters seem logical. So even if you know the technique covered and you have no need to follow a given tutorial, be sure you skim through it to see what is being covered there.

Finally, each chapter will include some challenges—homework assignments if you will—that ask you to use the information you have gathered to create your own implementation of the techniques. Hobbyist rarely use these, but

they are an important self-assessment tool to check if you have really gotten the core concepts presented in the chapter. You will get the most out of this book if you tackle those challenges. They will cement ideas and strengthen technique before you move on.

Book Paradigm and Assumptions

Although *Creating Unity3D Games* is meant to be holistic, it is not comprehensive of *everything* involved in creating 3D games. It is assumed that you have the following things:

- **Unity and Maya:** At the publication of this book, the latest versions of this software will be Maya 2011 and Unity 3.2. The Unity 3.2 Indie license is free (downloadable at www.unity3d.com), and if you are a student, Maya 2011 can be had for free for one year at http://students.autodesk.com/ if you sign up at the Autodesk Education Community. For a registered student, your biggest expense of the process will be this book.
- **Basic Knowledge of Maya:** This knowledge can indeed be basic, but this book will not take a huge amount of time to work through Maya interface, or basic tools. You should know how to navigate the camera controls and how to conduct basic functions of moving, rotating, and scaling objects. This book will be focusing on very game-specific techniques to modelling, texturing, and animating, and so some general knowledge of Maya will be of great help, although not critical.
- **Love and Knowledge of Games:** No need to be a game geek. But, knowing the basics of how games work and what makes them fun will be important to making games. The game in this book will be a first-person and third-person hybrid with both first-person shooter and puzzle elements. These are carefully designed to help you grasp some important concepts. But always be referencing past knowledge and looking for ways to expand the ideas covered in these pages to your own blockbuster title.

Book Conventions

Throughout this volume, I will be making use of several conventions to assist you in understanding what I'm talking about, and where.

When we are tackling a tutorial, each step will be numbered:
 Step 1: Do this and then,
 Step 2: Do this. When you're finished,
 Step 3: Try this.

Usually, these instructions will be tied closely to screenshots to help illustrate the step, or the results of a step.

Because the goal of this book is not to simply recreate the game presented here, but to equip you with the skills and tools to create your own game after

finishing this tome, there will be frequent "breaks" in the tutorials to do some explaining. Watch for:

Tips and Tricks
Warnings and Pitfalls
Why?

These will be the important notes that get you beyond the confines of the tutorials, and on to your own million-dollar games.

Finally, navigating through the programs can be tricky (especially in Maya with its multiple nodes). Drop-down menus will be indicated with the following format:

Modeling>Mesh>Combine (Options)

This is shorthand for, "In Modeling mode, go to the Mesh drop-down menu and look for Combine, and choose the Options box."

In Unity, this will be a little simpler since there are no disappearing drop-down menus like there are in Maya. However, it will be important that we are aware of what things need to be typed—as in code. Any script we type will be listed and formatted like this:

```
function Update(){
     SetActiveRecursively(true);
}
```

Occasionally, there will be some salient information within the code that is important to notice. When this is needed, the text will be bolded (you, however, would not need to use bold text when writing the script):

```
function Update(){
     SetActiveRecursively(true);
}
```

Similarly, new ideas, concepts, or keywords will be bolded within the body of the text.

A Note about the Approach

I come from an art background. I have a BFA in Theatre Set Design and an MFA in Graphic Design with an emphasis in 3D animation. I think like a 3D artist and I teach 3D artists. Because of this, this book and its approach to learning Unity is constructed through the lens of a 3D artist. This does not mean that there won't be programming or scripting—in fact, scripting is a critical part of the game development process. Without it there is no game, and so it cannot be ignored, and will be covered heavily in this volume. Even for artists, it's best to surrender now and embrace the power of scripting within a game engine. However, the entire process will be covered from the viewpoint of a 3D artist.

This will be very effective for some readers, particularly those who are coming at the game development cycle from an art or 3D background. But it may

include some information that might be too basic for those approaching this from a programming background. Not to worry though, the first part of the book is 3D focused, and so there should be plenty of new material for those coming from the scripting world.

So there it is. Tear into it. Be sure to read the theory and do the homework. It will be fun to have a completed game when you finish this book, but not nearly as fun as utilizing the tools and techniques we explore to create your own 3D interactive and engaging gaming masterpiece!

Game Production Process

Describing the game production process is actually a bit tricky, partly because it is different for every team and different for every budget. But also, the reality is that a team might be, well, you. Indeed, sometimes games are produced by very small groups of people, and occasionally by a team of one.

However, whether you are a team of fifty working on the next AAA blockbuster or a team of one creating a student project that you hope will get you on that team of fifty, there are some specific steps that need to happen to create a playable game. How successful you or your team are at these steps, and completing the steps in a timely manner, will play a big role in how efficiently the project comes together and how successful the game ultimately appears and plays.

The specifics of team management and money management and even time management are really out of the scope of this book (along with marketing your game and getting funding). However, understanding what needs to happen in what order will help you as you assemble your team or build your project.

The Team

"The Team" refers to the Design and Production Team—the group of people that actually make the game. This doesn't include the important roles of publishers, financial teams, marketing teams, or even quality assurance teams. Although all

of these are important for a profitable game, the focus of this book is learning the technology, so the production of the game will be the focus.

Generally most game production teams (or development teams) contain people in the following roles:

Designer: The Game Designer is the head of the creative vision. He or she must be artistically able and technically proficient. He is able to straddle the aesthetic and programming ends of the spectrum. More importantly, he understands and often has authored the goals of the game, the genre of the game, the game play, the rules and structure of the game, and any other game mechanics. The game designer typically communicates these goals through a document called a Game Design Document.

The Game Design Document is often predicated by a Game Proposal Document before it can be created. Usually, a game designer has substantial writing skills to be able to communicate the vision of a game. This Game Design Document becomes the bible upon which the other designers reference as the game production goes on.

The structure of this document is out of the scope of what we are covering here, but there are multiple references and examples online of such documents. Further, Game Design Documents should be specific to an organization, financial structure, and even work culture. However, although we might not cover the details of what this document *is*, what it *does* is relevant.

Now a Game Design Document is rarely set in stone. The scope of a game and the features of a game often have to be adjusted due to time, talent, or budget reasons. However, as the production cycle grinds on, effective management and distribution of this document becomes important to keeping the team on task. I have personally witnessed many times where days and even weeks of labor were wasted because team members failed to reference—and managers failed to confirm—that they were referencing a Game Design Document.

Even if you are working as an expansive team of one, developing an internal Game Design Document (even if it is a bulleted list, or a flowchart sketch on your whiteboard, or a list on the back of a napkin) can help you keep an eye on the prize and avoid pitfalls like feature creep, where new options forever find their way into a game and keeps it from ever being released.

Mechanics Engineer: Games have mechanics. Mechanics are the rules by which the game functions, including things like balance in power, physics illustrations, interaction between player and game, and interplayer interactions. Game mechanics are part of every game from checkers to the most sophisticated of PC first-person shooters to training modules for nuclear inspectors. The mechanics engineer (or Game Mechanics Designer as he or she is sometimes called), works through the details of how the vision outlined by the lead Game Designer can be implemented best. Often this team member comes from a programming or scripting background.

A quick note on this: The academic community has been studying the issue of game play and game mechanics fairly rigorously in recent years. It is still a developing field of study, and is a bit of a moving target as the rules of engagement with your game continue to change. However, if you want to get serious about understanding what makes games fun and how game mechanics can help this, there is an ever-increasing library of research that explores this. In the long run, researching this literature will be worth your while if you want to be a successful game designer or mechanics engineer.

Level Designer: Justifiably, this position has become more and more prominent in the game production process. This designer creates the environment in which the gameplay takes place. He works carefully with the Game Designer and Mechanics Engineer to ensure that the space he is designing both remains true to the vision of the designer and allows the space for effective game mechanics. These designs are carefully considered and designed and almost always begin with conceptual sketches or paintings and detailed floor plans that lay out where puzzles, challenges, pitfalls, and enemies appear or are interacted with.

Character Designer: This is often one of the sexiest roles because this person designs the characters. These characters are based upon the goals defined in the Game Design Document, and almost always start on paper with drawings. Conceptual sketches provide quick communication devices before the considerable modeling time is undertaken. These sketches also can provide a visceral response to a concept that often a T-pose-modeled character lacks.

Animator or Motion Designer: Animation is incredibly important in games since it seems to be the thing that draws our attention. Ironically, even complex games have a fairly limited collection of animations that are cycled as the game is played. Some characters have as many as 100 different moves, but most have much, much less. The animator will create in-game animations that are cycled, but will also often be responsible for cut scenes and more "meaty" assignments where traditional noncycled animation is used. Very large studios often will have separate cinematic (cut scenes and intro animations) departments that are creating higher-rez, prerendered animations.

Writer: Due to strikes in recent years, there has been a migration (at least temporarily) of film and television writers to the game industry. Writing for games is certainly different than any other medium, and too often people who have no business writing for games do so—and the results are usually cliché at best or downright corny at worst. However, a good writer can certainly assist in making a game experience more immersive with believable and engaging dialog, narrative, on-screen elements (think character correspondence or journals), and even in-game verbiage that lets the player know what to do. Often the writer is used for only part of the process since there is usually insufficient work to keep one occupied through the entire production cycle.

Sound Designer: Playing a game with the sound off has its charms, but anyone who has played a game on a big screen TV, with the lights off, and the sound pumped way up (or on headphones) knows how an effective sound design creates perhaps more ambiance than any visual elements of a game. Too often in all aspects of 3D animation, students or beginners treat sound and music as an afterthought, but it never is in big-budget games.

Sometimes for students there are budget restrictions that prevent custom soundtracks from being used. However, thinking early of sound effects and music will allow for proper timing and can even influence visual choices.

The Tools and Unity

Now that we have generally looked at who is on a team, it is important to talk through what the tools of that team are, and specifically how Unity fits within that tool box.

Unity is classed as a game engine. What this means is that it is the technology that drives a game. The way to think about it in production terms though is as an "assembler." Unity itself is generally not used to create assets (although there are some things like particles that are created within Unity itself). Almost all the art assets are created outside of Unity itself—the 3D models are created in a 3D application (Maya, Cinema4D, Blender, modo, 3DS Max, Lightwave, etc.), the texture assets are made in Photoshop or BodyPaint, and even the scripts are actually written in some other application (UniSCTE on a PC, Unitron on the Mac, or some other scripting tool all together). All these assets are imported in Unity through a quite painless process where you are then able to combine these assets to create the game.

So, you *assemble* games in Unity, but most games—and all games with any level of visual complexity—make heavy use of lots of other applications in the process. Just as there are lots of different ways to create 3D assets (some will choose Maya, others 3DS Max, for instance), there are multiple game engines as well. Unity is particularly flexible and accessible; that is why it is the tool of choice in this book. But be aware that there are lots of other methods of creating games (Unreal Engine, CryEngine, Source, etc.).

Teams of Teams and Pipelines

Often, a production team will be broken into two teams, an art team (sometimes called "Creative") and a technology team. The work of both is critical for a successful game, and communication between the two teams better ensures a smooth process.

One of the benefits of working as part of a team—or a team of teams—is that assets need not be created sequentially. The technology team doesn't need to wait for creative to finish up their work before starting on scripts.

Often, technology is being developed and has been developed when the creative team delivers certain assets that are then plugged directly into the game.

However, if you are working alone (and the assumption is that most readers of this book are doing just that) creation of assets in an appropriate order will make the development process much more efficient. So to begin, let's look at the assets needed for the game produced in this book.

Assets

Once the Game Design Document is completed, the lead designer will need to start working out what assets need to be created and when they need to be done. Assets can be a lot of things: 2D elements like GUI and interface designs, texture files, 3D models, sound files, animation clips, as well as things like scripts and other mechanisms that drive the game. For this book, we will focus on two categories of assets: art assets and scripting assets.

Art Assets

For the tutorials covered in this game we will need three art-based assets: models, textures, and animations. The models and animations will be created in Maya while the textures will be created in Photoshop, but linked to the models within Maya. Other visual elements like lighting will take place in both Maya and Unity (depending on which version of Unity you are using).

Technology Assets (Scripts)

Unity allows for mechanics to be built with a variety of scripting mechanisms. Most reference or discussion you will find will be in either Unity's implementation of JavaScript or C#. These scripts are attached to an object or objects within your Unity scene and drive the interaction between the player and the game.

There are many approaches for tackling the scripting problem. My software engineer colleagues that I work with extensively here make heavy use of C# and drive nearly everything in the game (including creation and placement of assets) with these scripts. They understand the structure of the game when they can see the script that is doing it.

The scripts we will be creating will primarily use Unity's version of JavaScript, and we will (with a few instantiation exceptions) hang these scripts off of objects we manually place within the scene. We use JavaScript because historically, the documentation's examples are primarily in JavaScript, and referencing Unity's documentation in the future will be a necessity when moving beyond the scope of this book and it will be important to have an established vernacular with the provided documentation. Likewise, much of the discussion that takes place on

forums uses Unity's version of JavaScript as the vernacular. We will hang the scripts off of objects (rather than allowing the script to do this for us) because it is a more visual approach and often easier for artists to understand what's controlling what within the scene.

In either case, the technology assets are just little pieces of ASCII text that harness the power of Unity and allow interaction to be created and controlled.

Order of Operations

In this book, we will be creating all of our art assets first, importing them into Unity as we go, and then we spend the last part of the book creating the tech assets. However, it is important to note that this process of art first, script second is certainly not a rigid one. Unity is very good at allowing art assets to be updated and changed along the way. Sometimes it takes a little bit of reattaching scripts to new objects, but with careful naming, even this is minimized. I find in my own development process, the back and forth between my 3D application and Unity is frequent and important.

So in this way, the process outlined in this book is quite unlike a studio's workflow. In a studio, although the scripters will do most of the bug squashing and wrapping up, they will start on developing scripts and programming solutions long before the artists have finished their work. Further, in your own development process, you will find that spaces you thought would work well for a particular challenge or battle don't work quite as planned. Or that a character doesn't quite convey what you had planned. So you go back and rework in 3D in the middle of your scripting process.

So while our linear process here lends itself to learning Unity well, it likely will not be the way you work on your own projects.

Conclusion and Introduction to *Incursion*

But enough talking about making assets and games; let us get to it. For the game presented in the coming pages we will assume that the game designer (me) has already done the conceptual work and written a stunning Game Design Document that is so perfect that it needs no revision. With this fantasy in mind we can create the specific assets we need to create our game, and in a sure-footed manner write the scripts that enable the game to function.

The game will be called *Incursion*. The basic narrative is that you—Aegis Chung—are an American post-cold-war warrior sent on a mission to infiltrate an abandoned Soviet facility and retrieve a stolen classified device. The equipment was handed over to the Soviets by a traitorous scientist who is now living in Russia. The Soviets were unable to capitalize on the technology and left it in an abandoned submarine service base. Although abandoned for years, the old security systems are still running off and on. Several unmanned mechanisms like cameras and other security devices are left to monitor the

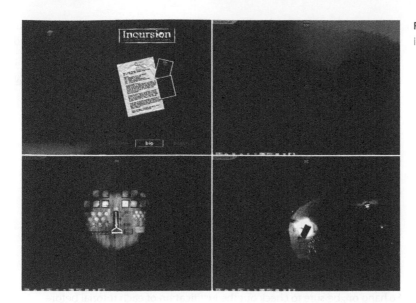

FIGURE 1.1 Screen shot of final in-game experience.

premises. You must bypass these security systems through whatever means necessary (espionage, alternate paths, hacking, explosives) to gain entry to the inner lab where the device is stored. Along the way, all your training (both physical and mental) will be tested (Figure 1.1).

For you as the game development team, this will provide opportunities to model a character, a level design, and various instrumentation. As the scripting team, this game will allow for extensive mini-games as you get a chance to build in the puzzles that are the security devices the player must bypass. All in all, there are a lot of learning opportunities with this game.

Note to teachers and students: To make sure that the game stays appropriate for larger audiences, although we will use a gun to defeat certain obstacles, there will be no shooting of people.

A Note on Research

Often people like to pretend that they can sit down and create beautiful environments or characters that flow beautifully out of their minds, through their pencils onto the paper. I suppose there are some character designers who can do exactly this, but only after years of study and observation of anatomy, people, animals, and other designer's work. For most of us mortals, before great work can emerge, we have to research similar locations, feelings, and styles.

The space on which we will be basing our game's style is really an abandoned Soviet nuclear submarine base. The base is in Balaklava, Ukraine and has some really fine reference photos online. Because I don't own the rights to these images, they can't be included in the book; however, before we get started, be

sure you do a quick Internet search for "balaklava ukraine submarine" and you will be led to a great collection of web sites with background information, and loads and loads of great photographs.

It will be worth your while to collect images of the space, as you'll recognize them coming together in the book, and these additional reference photos will be valuable. In any case, good research provides information about spaces that most people simply won't include if they are "building it from their head." There's no need to copy directly from your research, but let your research inform your choices as you build any space. Research, if followed, is *guaranteed* to bring an added level of sophistication and believability to any project. When you move on to create your own game from scratch, be sure you are providing some real visual meat to your project by doing appropriate research.

And on We Go...

So hang on, be sure to check out the justification of each tutorial before diving in, and let's get creating.

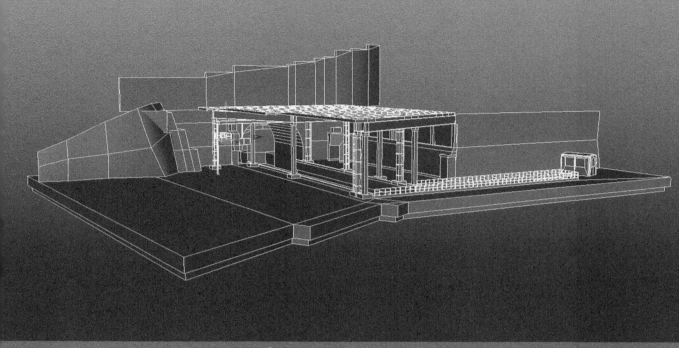

Asset Creation: Maya Scenography Modeling

Scenography Modeling within the Game Design Pipeline

The game pipeline—specifically, the Unity game development pipeline—can be a fairly flexible thing. There are not that many elements that must be done in a sequential order. Many can be done concurrently, and often the order of steps can be leapfrogged and rearranged. While the art team is developing models, textures, and animations, the tech team (i.e., scripters and programmers) can be developing the technology and mechanics that drive the game. So the things that happen in the following three scenography chapters do not need to be complete before the programmers do their thing (or before you do the programming thing).

In fact, in our studio, we almost always create quick mock-ups of the level design and even objects the player will interact with, and throw those over the fence to the programming team. This gives them a chance to work with scale, and have something to work with as they work out the technical wrinkles. Even if you are a one-man studio, this is a very effective strategy because you may find that the level you had planned

doesn't work quite as well as you had hoped when laying it out on paper. Once you walk a space, or try playing the mechanics, you may find that the space you had planned may not be the best. If you've just got quick mock-ups, you can quickly adjust before investing all the time into the scenography asset creation.

However, in a book setting we need to work largely in a linear progression. So for these tutorials we want to imagine that the prototypes have yielded results that have cemented the level and character design. And so, with the approval of the game designer, we are moving forward with our art asset creations.

Why Maya Tutorials?

Unity is the last step in the chain of technologies that creates the game. Without it, an effective game can't be made. But the success of the game will also rely heavily on the effectiveness of the assets that go into it. No matter how well the chef knows the tools and the oven when baking, if he or she uses poor quality ingredients, the cake is not edible.

I've had many students who, when working in Unity, are unable to create the game they envisioned because of poor choices or techniques in their 3D application of choice. General 3D techniques are not necessarily the same as 3D game techniques. Creating economic and correctly structured 3D assets and textures is an absolutely critical part of creating games in Unity.

Why Maya? Well, Maya isn't even my favorite 3D package. However, it does have an amazing market penetration and without a doubt is one of the most powerful 3D tools out there. Ironically, modeling is not one of its strongest points, but for our purposes its polygonal modeling tools will do just fine. Among other parallels, the default camera manipulation and object manipulation tools in Unity have identical keyboard shortcuts to Maya. Additionally, Maya has some very powerful character animation tools, which we will use, that import via FBX very easily into Unity. Ultimately, I chose to create our assets in Maya because the large base means there are lots of people who know how to use the software and you will have lots of options to further your skill set beyond this book once you are done reading it.

Even if you are not a Maya user and are capable in some other 3D app, take a quick look at these chapters to make sure you make note of topology and texture creation and how to extrapolate those techniques into your own application. It will make your game assets stronger, tighter, and better to work within Unity.

So here we go. In the following few chapters the art assets will come together, and these assets will be imported into Unity to allow for exploration and refinement. Although these are largely Maya-based

tutorials, the assumption is that you are familiar with the basic Maya tools (Move, Scale, Rotate) as well as how to select component parts (vertices, edges, faces). If you don't understand these concepts, it will be worth your while at least to watch the introductory videos that are included with your Maya installation.

A Bit of 3D Theory

Although we assume you know something about Maya's tools, it will be vital that the basic theory of 3D is understood. Without this baseline understanding of how digital 3D works, it will be impossible to appropriately construct assets to be used in a game framework.

Figure 2.1 shows the anatomy of the polygon—the building block of 3D. The main form that we think of as a polygon is referred to in Maya as a **face**. The face is what the video card (and thus we) "see." The face's shape is editable by the components that surround it. The face is surrounded by **edges** that are joined by **vertices** (singular form is **vertex**). Most of these sorts of concepts are covered in some form of junior high geometry; the one other important concept and part of a polygon is the **normal**. The normal defines the front of the polygon. In Figure 2.1, this is indicated by the green line coming right out of the middle of the face. Understanding that faces have normals is important since most game engines save processing power by only drawing the front of a polygon. If the camera is behind the polygons (if the normal is facing away from the camera), the polygon is invisible.

Three-dimensional forms in a 3D application are created when collections of polygons are put together. Think of polygons as unbending sheets of metal. Where the sheets of metal connect can hinge, but the polygon itself cannot. This means that the more polygons present, the more places the mesh can bend, and thus the more complex the form can be. Take a look at Figure 2.2 to see how a form goes from six polygons to 32 polygons to 100 polygons, and the resulting forms that are possible.

Forms that are seen in a 3D environment are drawn by the video card in your computer via a rendering engine of some sort. The rendering engines see shapes by recognizing polygons. To be more specific, most rendering engines actually see only triangular polygons (sometimes called **tris**). There are several ways to construct these tris; Maya's techniques include NURBS, Subdivs, and straight polygonal modeling. All of these are different methodologies of

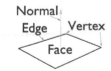

FIGURE 2.1 Anatomy of a polygon.

FIGURE 2.2 More polygons means more places to bend. This allows for more rounded forms, but it requires a bigger data set.

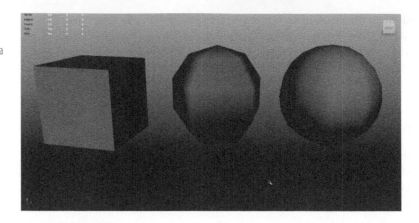

constructing forms of assembling polygons. Some methods are derived from curves; others work along the line of creating polygons directly. But at the end of the process, all the methods' results are turned into triangles by a process called **tessellation**, so that the engine can see them and the video card can draw them.

Rendering

This drawing of polygons and the textures and lighting associated with them is called **rendering**. There are two kinds of rendering: software and hardware rendering. Software rendering is what commonly is used in television and film projects. The scene is built within a 3D application including lights and textures, and then the CPU is engaged to draw the complex interaction of the objects, colors, and lights in the scene. Because the results are displayed later (not in real time), if it takes a second for a frame to be rendered, or a minute, or even an hour per frame, this is acceptable. The sequential stills that are the output of this process are put together via a video editing package, and watched as a moving image.

Hardware rendering is much different. Games are in this category because the video card renders the polygons within the digital space to represent 3D space. The hardware draws what is on the screen (including all the objects, textures, and light) and needs to do so at many times per second. Generally, if players are getting much below 30 frames per second, they notice the choppiness of the game.

So how does a computer draw 30 frames per second of one project, but one frame every 30 minutes of another? The answer is simply the size of the data set and the hardware dedicated to handle that set. For projects that will not be rendered in real time, the amount of data can be much higher. The number of polygons can be much more, the size and number of textures bigger, and the complex calculations of light more sophisticated. In real-time situations (hardware rendering, with dedicated hardware chugging away on this data set), the amount of data the video card deals with is much, much smaller.

Video Cards

Video cards are a big part of the "hardware" in "hardware rendering." Video cards come in lots of different configurations and power combinations. The intricacies of how a video card works are varied and cards that seem the same (share the same amount of video RAM) may not actually be identical in their ability to draw assets. However, for our purposes we will oversimplify and say that "bigger" cards (cards with more video RAM) are able to draw more information.

"More information" can include a lot of things: more polygons, more textures, or larger textures. It can also mean dynamic lighting visualization. In all cases, a video card being able to render more information means that the complexity of a scene can increase as the video card gets larger.

At this point it is worth noting that the cost of gamer's video cards have become a very manageable cost in most computers. And in fact, when students come to me complaining about slow working conditions on their home computer, the first suggestion I almost always make is to upgrade the video card. One GB video cards can easily be had for less than $100 and it's a quick and easy way to empower a computer to show more polygons more quickly.

The technology embedded in video cards evolves so quickly it would be foolish to try and explain it all in a book—as soon as it was published the specs would be outdated. However, generally, there's no need to buy a workstation card—the gamer's cards usually do quite reasonably and come with a substantially cheaper price tag.

In my 10-plus years of using Maya, I generally have had better experiences with NVidia cards. Either ATI or NVidia seem to get along well with Unity; but NVidia has provided the most predictable experience in authoring 3D elements when using Maya. This is based largely upon anecdotal evidence of my systems and the systems of a few hundred students, but when buying or upgrading a card to work with Maya, NVidia has worked better for me.

Limitations and Optimizations for Games

So what does this all mean? With video cards getting bigger and better by the day and their price tags continually dropping, we should be able to create shapes with reckless abandon with no concern for the data set we are creating. Right?

Well, unfortunately, no. For years, the implied promise of instantaneous output of trillions of polygons always seems to be just over the horizon. Computers get faster, video cards get bigger, and it seems like the process of drawing polygons would become a nonissue, one that just happened flawlessly behind the scenes. However, what has happened is that as computers got faster new things became possible. Suddenly, game engines could start using dynamic lighting (a light bulb swings around in the scene and the objects and walls reflect this change), reflections became the norm (which really means that everything in the scene gets

drawn twice, essentially doubling the number of polygons in the scene), and new visual effects like particles and complex shaders became used and expected by gamers. As the hardware got more powerful, we simply asked more of it.

Rules of 3D Game Modeling

So now that we've established that there are indeed limitations to what computers can show, it's easy to see that limits or rules need to be heeded when creating assets for unity. We will visit new rules with each step (there are specific considerations for texturing, for instance, that we won't cover until later). For this first tutorial, the two rules are:

1. Polycount matters.
2. Topology is critical (quads are best).

Polycount Matters

All the dynamic rise in hardware means that the visual sophistication of games continues to rise at an exciting pace. It also means that carefully creating our assets to allow for room to create these great effects remains the reality. Ultimately, effective use of the number of polygons in a scene (**polycount**) will be critical to both the immersive impact of the game and conversely, the performance in frame rate at which the game will play. Now, with most recent machines, polycount is much less of an issue than it once was. And frankly, usually if a game is dog-slow, it isn't a case of the sheer number of polys—it's usually related to other texture problems or other issues related to **draw calls** (more on this later). However, keeping an eye on the number of polys in your scene remains one of the pressures on a video card, and keeping a reasonable poly-budget is important (especially if ultimately developing for any mobile devices).

This can sometimes be a tricky balance. Figure 2.3 shows two sphere-like objects. The one on the right has 1000 polygons and the one on the left has 20. Sure enough, the 20-polygon model will require less video card power to draw, but it really doesn't appear to be a sphere anymore. Carefully dialing the details up to effectively communicate the shape while keeping the number of polygons low enough to draw quickly is part of the art that is game asset creation.

FIGURE 2.3 Varying polycounts can widely change the draw on a video card, but optimized too much moves away from the form.

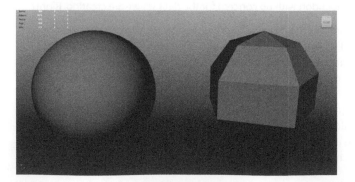

For our uses we will be focusing primarily on polygonal modeling techniques (the techniques using the tools in Maya's Polygons mode). The other methods of NURBS (non-uniform rational b-splines) and Subdivs are too indirect in their creation of polygons, and thus we lose control over polygon placement and count.

Topology

Topology refers to the structure or organization of polygons on a surface. Topology matters. Correctly structuring polygons makes a huge difference in how the mesh can be deformed later (with things like joints), how the form interprets collisions in Unity, and how easy it is to lay out UV maps. Much of topology concern centers around the tessellation process—the process of converting the form into three-sided polygons (tris) when it comes time to render.

Maya, like most 3D software, allows the user to create polygons of any number of sides (usually called n-gons). This is relatively new in the 3D production history. Not many years ago, 3D software would allow polygons to be constructed only as tris or quads (four-sided polygons). Tris are pretty hard to work with and manipulate quickly, so quads became the preferred method of organizing polygons. To allow artists to more fluidly create forms, most 3D apps began allowing the user to pay no attention to the number of sides of a polygon as the form was built. However, woe be the modeler who doesn't pay attention to the construction of his polygons. Five- (and more) sided polygons cause all sorts of problems down the road.

The issue is in the tessellation process. When the 3D software (or game engine, like Unity) converts a 3D form into all tris (which it must for the video cards to draw them), there are some shapes that are easier to tessellate. A quad is relatively easy, since it just splits it in half from vertex to vertex (Figure 2.4). However, the tessellation of the n-gon is often unpredictable, especially from a game asset creation standpoint. It does it for sure, but the resulting mesh is a mess (Figure 2.5).

This messy tessellation that can be seen in Figure 2.5 may not seem to be a big deal here, but when these polygons are subjected to distortion techniques (like bending a mesh with joints), suddenly the edges where things can actually bend end up being in unpredictable places and result in

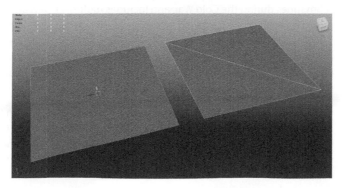

FIGURE 2.4 Tessellating a quad is pretty straightforward. Just split it corner to corner to create two tris.

FIGURE 2.5 Working with an n-gon makes for messy tessellation that can even be different from 3D application to application and from game engine to game engine.

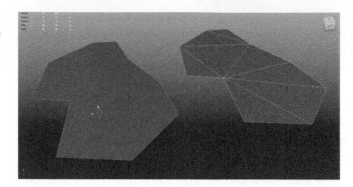

unpredictable distortion, and even worse pinching of the mesh. Additionally, when we get to creating UV maps, quads are much easier to work with than any other form.

So the first consideration we need to always keep in mind when modeling is to work with quads. Quadrangles will always make for easier modeling and for the most predictable results as we go. Don't succumb to Maya's temptation to allow for the creation of n-gons; they are nothing but trouble.

On to the Tools

Now that we've established the reason for our two rules of game modeling and discussed the importance of them, we can start to use them in action. In this chapter we will complete four tutorials that will culminate with a completed level (none of the mini-puzzles, just the architecture) in which our game will be set. At the end of this chapter, the player will be able to walk through the unlit halls of the Soviet facility. The tutorials will allow us to model, UV, and texture our asset. Finally, the last tutorial will bring the completed model into Unity.

Before we get started, make sure to set up a new Maya project called "Incursion–Maya." If you are unfamiliar with setting up projects (a vital part of creating assets with Maya, be sure to check out Appendix A, "Creating and Setting Maya Projects" that is housed on the supporting website (http://www. Creating3dGames.com).). Then move on to the tutorial.

The facility we are about to model is large. It was used to service nuclear submarines during the Cold War, and includes multiple levels and many, many hallways. In the following tutorials, we will not be modeling the entire complex or even the entire level that we will be using in the game. Instead, we will be targeting a few specific sections of the facility that are either indicative of the aesthetic style of the level, or that help illustrate a particular technique of modeling that is important to understand.

Do note that we will be using a much larger version of the facility in the construction of the game. We will be building parts of the game in these tutorials with challenges to create the rest included at the end of the chapter. If you're confident with your modeling skills, and don't want to have to create the

remaining parts of the level, you can simply use the versions that are included on the web site (http://www.Creating3dGames.com). However, if you're looking to make sure your game modeling skills are tight, be sure to attempt the challenges at the end of the chapter and complete the entire level by yourself.

Tutorial 2.1: Game Level Modeling: The Entryway

The entry of the Balaklava facility is a great place to start. First, the parts that make up the entry are largely rectilinear. Anything man-made and rectilinear is easily created in 3D applications. Second, all these rectilinear forms are a perfect trap for beginning modelers—a trap to create shapes that neither produce the appropriate sense of age or dirt. Over the course of the tutorials, we will look at taking a simple geometric space and making it look like it's been around for a while (Figure 2.6).

Step 1: Double-check you've got a project set up called "Incursion–Maya." If you don't, or don't know how, check out Appendix A.

Step 2: Choose File>Save Scene (Options).

Step 3: Check Incremental Save and click Save Scene.

Why?

Incremental Saves are insurance policies. What happens is that each time a scene is saved, Maya makes a copy of the scene from the last time it was saved and saves it to a folder called incrementalSaves. This does mean that there are lots of copies of your file, but it makes sure that in the catastrophic case of corrupted files you have a backup. Even if you run out of Undo's, an incrementalSaves folder means you can go back in time to what you wanted or needed. Every single semester I have taught, incremental saves have saved at least one student's project.

Step 4: In File Name: enter `EntryWay` and click the Save button. Note that if the project has been defined correctly, you are in the Incursion–Maya\ scenes folder.

Warnings and Pitfalls

I know it's tempting to skip this step since you're anxious to get started. Worse, I see lots of students who don't quite understand this step and skip it because it doesn't seem important. But keeping track of your assets is critical to success in projects as diverse as games. Create and Set your project in Maya. You must know that your texture files are in the sourceimages folder, and that your scene files are in your scenes folder.

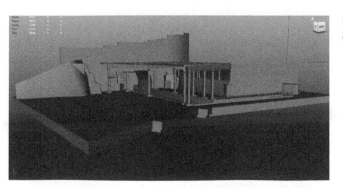

FIGURE 2.6 Completed model at the end of this tutorial.

Columns Base Shape

Step 5: Create the base shape of the cement columns with a polygonal cube (Create>Polygon Primitives>Cube). Using the Channel box, make the cube Width = 1, Height = 16, Depth = 1 units by adjusting the polyCube1 INPUTS (Figure 2.7). Make sure the Subdivision Width, Height, and Depth is set to 1. In the Outline (Window>Outliner), double-click this new pCube and rename it `EntryWayColumn`.

FIGURE 2.7 Creating a long tall cube as the basis of our pillar.

Why?

X = 1 Y = 16 and Z = 1? How come? Well, no reason actually, except that it's a nice round number. Scale between apps and Unity is always a little tough and something that we will tackle more specifically in Unity. In Maya, absolute sizes are frustratingly difficult to keep track of, so we will focus on relative sizes. However, it is clear from the research that the pillar's cross-sections are square, and so numerically ensuring that this is so is much more accurate than eyeballing the thing. The Subdivision settings are set to 1 because we only need one subdivision to describe the shape, and any more is a waste of polys.

Step 6: Create a base using the Extrude tool to widen the base and give it depth (Figure 2.8). As a review, right-click on the object and select Face. Select the bottom face, choose Polygons>Edit Mesh>Extrude, and use the manipulator handles to scale out the first extrusion. Repeat the process and use the manipulator handles to add depth.

FIGURE 2.8 Creating column base.

Why?

The shape here is really a long cube on top of a short squatty one, so why not just create two cubes? There are several reasons for this. First, when we create textures for this object, it will be much easier if we have one solid mesh (more on this later). Second, and more importantly, if we have one object that defines the base and shaft of the column, we have half as many objects to define the same shape. Less objects mean less Draw Calls and thus a faster game (more on this later too).

Step 7: Delete the bottom face.

Why?

We will never see that bottom polygon. But, this polygon will take up texture space (which is at a premium in games) and add to the overall polycount. Yes, it's only one quad (two tris), and doesn't seem like it would be a big deal in the scheme of a big game, but if there are going to be many duplicates of any object, cleaning up faces that absolutely won't be seen can pay dividends for over 100 duplicates. Taking time to keep it clean now will save optimization time later.

Step 8: Repeat similar process to create column capital (Figure 2.9).

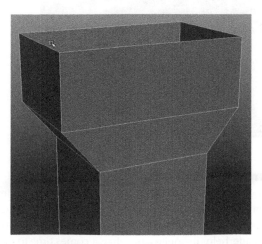

FIGURE 2.9 Capital created by extruding faces.

Dock Creation

Step 9: Begin creation of the cement dock area in similar fashion. Start with a cube (renamed in the Outliner to `EntryWayDock`) that is X = 20, Y = 4, Z = 60 (this can be adjusted later as we build), and extrude the faces as shown in Figure 2.10.

FIGURE 2.10 Beginning to lay out dock.

Step 10: Continue working around the dock making sure to make extrusions at locations that will allow new extrusions that will allow for holes (Figure 2.11).

FIGURE 2.11 Continuing dock layout.

Tips and Tricks

Deciding when to make extrusions is a skill you build up over time and with experience. I find that sketching out the shape I want to make on a sheet of paper, and then sketching out the places that extrusions would need to be made, helps me quite a bit when it comes time to do it digitally.

Step 11: Here's where things might get a bit tricky. What we want to do is make sure we have new locations to build outcroppings of the dock. Look carefully at how extrusions are made to allow for future extrusions that make the stepping out. Notice that this creates some pretty inefficient topology (geometry where there needn't be), but we will clean that up in a bit (Figure 2.12).

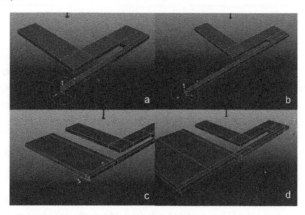

FIGURE 2.12 Dock continuation.

Tips and Tricks

This part of the process is really about roughing out the shape. It won't be perfect right away, so don't worry too much about being exact. When creating this tutorial, I ended up with lots and lots of Undo's to get back to a place that would allow me to more efficiently create the form. 3D creation is a process of stops and starts to be certain.

Step 12: Create a stepped section by deleting faces and filling them in with the Append to Polygon tool. Select the faces on the far corner (as shown in Figure 2.13) and delete them. This will leave a hole in the mesh that needs to be filled. One way to fill this is the **Append to Polygon** tool. To use this tool, be sure to be in Object Mode (right-click the object and select Polygons>Edit Mesh>Append to Polygon Tool) and then click an edge of the hole. Purple arrows will appear that show the path of the new polygon that will be created. Click these arrows until the face is filled and press Enter. Repeat for the other plane that needs to be filled.

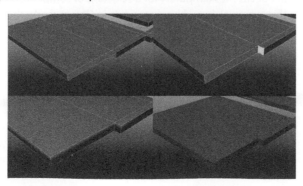

FIGURE 2.13 Deleting polygons and filling holes with the Append to Polygon tool to create stepped forms.

Tips and Tricks

When using the Append to Polygon tool, usually there is no need to go all around the outside of the shape that is being filled. It is faster to click one edge, and then click the edge opposite that edge and press Enter. This fills the hole quickly as it figures out the other edges are included in the function.

Tips and Tricks

Notice that after filling the hole, there will be some black chunks across the new planes that have been made. This is happening because the new polygon has **soft normals**, which are great for organic shapes, but not so great with rigid forms like this dock. To get rid of these, select the object and choose Polygons>Normals>Harden Edge.

Step 13: Rotate the front of the dock. Right-click the dock and choose Vertex from the hotbox menu. Marquee select the vertices across the front of the docs as shown in Figure 2.14. Choose the Rotate tool (keyboard shortcut is the E key), and then (to move the axis of rotation) press and hold the D key on the keyboard. Move the manipulator handles back to the back corner of the collection of vertices that have been selected. Release the D key and rotate the vertices from this new axis just defined.

FIGURE 2.14 Rotating a collection of points from a new axis of rotation.

Tips and Tricks

This rotation trick or moving the axis of rotation (via holding down the D key or by pressing the Insert key) works in Object mode too. The axis of rotation can be moved to wherever it needs to be for a given object. In our case, it's temporary for a selection of components (vertices in this example), but when done while in Object mode, the object will "remember" this new axis location.

Dock Optimization

Step 14: Optimize the mesh. In the process of outlining this shape, we have quickly made some shapes that could be optimized. As pointed out earlier, polycount is rarely *the* problem with slow games, but it is certainly one of them. Especially if you are developing for iOS (iPad, iPhone, iPod Touch) or Android, keeping a tight grasp on polycount will be critical.

To optimize what we've created, we will be deleting edges that aren't needed and rearranging some of the edges that exist. Figure 2.15 shows one such edge that we should delete. Double-click the edge that will attempt to select an edge loop and then either press Delete on the keyboard (and then select and delete the vertices it leaves behind), or Ctrl-right-click and choose Edge Loop Utilities > To Edge Loop and Delete (which will automatically delete the left-behind points).

Step 15: Adjust topology to ensure four-sided polygons. Look carefully at Figure 2.16. Note that this top polygon is actually a five-sided polygon. It's deceptive as sides 4 and 5 at first blush appear to be one edge, but there is a vertex in the middle where that other edge comes out. In a case like this, where all the polygons on the top of the deck are on the same plane, this five-sided poly would likely not cause any trouble; to be sure we will use another new tool, the **Split Polygon tool**.

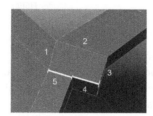

FIGURE 2.15 Edge that isn't needed and should be deleted. Make sure you delete the points it leaves behind.

FIGURE 2.16 Deceptive five-sided polygon.

In Object Mode, choose Polygons>Edit Mesh>Split Polygons Tool. This tool works by clicking and dragging on an edge to establish where to split the polygon. Usually click an edge and drag along that edge to a point (Figure 2.17). Click again on the opposite edge and drag to the point opposite the first. This will create two polygons (a four-sided one and a three-sided one) where there was once one five-sided polygon.

Step 16: Clean corners. Now that we've used the Split Polygon tool, we can further optimize our polycount in places that make right corners. Figure 2.18 shows the result of using the Split Polygon tool to make a new cut from corner to corner. After this diagonal cut is made, the two straight edges that used to make the corner can be deleted.

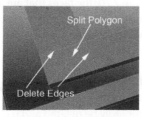

FIGURE 2.17 Using the Split Polygon tool.

FIGURE 2.18 Optimizing a corner. Split Polygon tool creates the diagonal which then makes two edges unneeded.

Tips and Tricks

Be sure that when getting rid of the edges that are no longer needed that those edges as they continue down the size and bottom of the shape are deleted as well. Additionally, watch for left-over vertices that should be selected and deleted as well.

Step 17: Repeat and optimize throughout right corners (Figure 2.19).

FIGURE 2.19 Optimized corners.

Why?

Looking at Figure 2.19, you can count four four-sided polygons that were involved in the three right angle turns the shape made. This makes for eight tris. Compare that with the seven four-sided polys that were there before (14 tris), and you can see how this sort of optimization can whittle down a polycount in a hurry. Ultimately there are some tradeoffs you have to make. It takes a bit of time to optimize, and if you're taking too much time out to optimize you're eating into your creation time. However, I find that if I do a bit of obvious optimizing as I go, it saves me from hours of painful optimization later.

Step 18: Delete the polygons along the bottom. We don't see them, we don't need them, get rid of them.

There is certainly some other optimization that can be done here, but we have looked at the basic techniques that are used to make a lean, mean mesh. Feel free to further optimize, but for now we'll move on.

Step 19: Add the lip to inside of the channel. Select the faces as shown in Figure 2.20 (the faces that are along the inside of the channel into the mountain), and use the Extrude tool to extrude them out just a small bit. This will create a new collection of faces along the dock top. Select these and extrude up to create the lip.

Step 20: Duplicate and place the column roughly as shown in Figure 2.21. Yes, I realize it would be better to UV map the column first before duplicating it. And in fact, these columns we are placing now will undoubtedly be deleted and replaced by duplicates that are UV mapped. However, placing these here allow for some important placement of items in the upcoming steps.

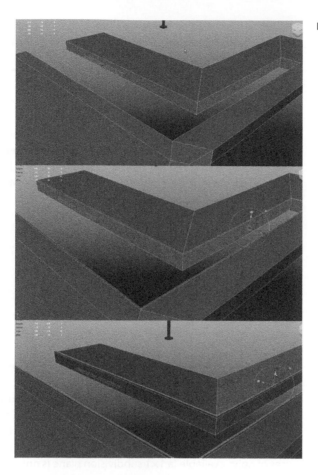

FIGURE 2.20 Creating the lip.

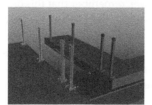

FIGURE 2.21 Placing columns.

Backface Culling

Step 21: Turn on Backface Culling in the Persp view panel. In the Persp view panel go to Shading>Backface Culling and click it on.

Why?

Backface Culling is not drawing the backs of polygons—it culls (excludes) the backfaces. By default this is turned off in Maya, which can be a problem because it is always on in Unity. Without it turned on, you could build a beautiful form that you'd only see the inside of

in Unity. Or, create a plane for a wall that was completely invisible in Unity. Turning this on will give you a better idea of how things will appear in Unity.

Roof Creation

Step 22: Create a roof. Figure 2.22 shows a collection of cubes with one big plane across the top. The exact shape of this is unimportant, so don't worry about that (although it's safe to assume that the long vertical beams are paired 2×6s and the shorter horizontal ones are 2×4s). The importance of this is how we are going to optimize this form.

FIGURE 2.22 Created, but nonoptimized roof.

Tips and Tricks

The roof shown in Figure 2.22 has a few additional extrusions (extruding edges instead of faces to get the outcropping bits), but to start with it was a single 1 Subdivision × 1 Subdivision plane. Working with planes (like the top of this roof unit) can be among the most efficient uses of polys available (a 1×1 subdivision plane is one—yes one—four-sided poly). However, remember that this one polygon has a front and a back. Since Backface Culling is turned on, quickly it will become apparent that the plane disappears if being viewed from the "wrong" side. Remember that we will be below this roof looking up, so make sure and either rotate the roof so its face is facing down, or use Polygons>Normals>Reverse to make sure the plane can be seen when the player is beneath it and looking up.

Tips and Tricks

When working with something with regular repetitions like this roof has, use Maya's Duplicate (Edit>Duplicate) and Duplicate With Transform (Edit>Duplicate With Transform). Create one cube. Ctrl-D will duplicate it, and if you move immediately in one move (with one click and drag) and press Shift-D, Maya will duplicate again, offsetting the new duplicate by the same amount as the last copy was moved. It's a quick way to create lots of equally spaced copies.

Step 23: Optimize by combining. Select all of the roof (cubes and plane) and select Polygons>Mesh>Combine. Then select Modify>Center Pivot. Finally name it `EntryWayRoof`.

Why?
In my example, I have 29 rafters and one plane for the roof. This is 30 objects (and thus at least 30 draw calls on the video card). If each of these rafters had a material on them, we would need at least 60 draw calls just to draw the roof. By combining the meshes into one, and assigning one material to it, we will go from over 60 draw calls to two (well actually a bit more than that, but it's easiest to round off at this point in the process). From 60 to two is a significant savings.

Why?
When meshes are combined, Maya automatically puts the axis of that new mesh at 0,0,0 in world space, which is absolutely useless when trying to organize and place an item. By using the Center Pivot command, we get this pivot back into a place where the manipulator handles will be in a useful location.

Cleaning or Deleting History

Step 24: Delete history; all of it. Choose Edit>Delete All by Type>History.

Why?
Maya keeps a history of the steps taken in construction. This history is stored in series of nodes. This history can allow for an amazing amount of flexibility because it allows you to go back to one step in the creation process and make a change to that node, and all the nodes downstream of that will be calculated based upon this tweak. However, keeping track of this history increases the size of the data set by quite a bit, and can yield some really funky results when things are taken out of Maya (like into Unity). So cleaning the history (by deleting it) occasionally as you go along will help you keep a clean Outliner and avoid hidden and unexpected items showing up in Unity.

Tips and Tricks
For even more optimizing, delete the faces on the tops of those rafters. This pays dividends in a couple of ways. First, it cuts down on the polycount of the roof, but second, it frees up that UV space for textures later.

Handrails

Step 25: Create handrails, optimize them into one mesh (Figure 2.23). Center the pivot, and name it `EntryWayHandrails`. Delete the history.

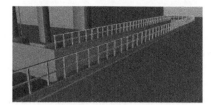

FIGURE 2.23 Completed handrails.

Tips and Tricks

If an element is optimized before duplicating (for instance deleting the top and bottom planes of the vertical posts of the handrails), it'll save the step later of selecting a big bunch of them later.

Archway and Booleans

Step 26: Create the start of the entry arch with a modified cube. Create a cube (Create>Polygons>Cube), then scale and position it similar to Figure 2.24. Select the top face, and using the Extrude tool, extrude and scale the top of the box (Figure 2.24).

FIGURE 2.24 Beginning of entry arch.

Why?

The idea for this next group of steps will be to use Maya's Boolean functions to create a form. Booleans work on the idea of subtracting (or adding or intersecting) two shapes. To make this work we have to have this block to subtract from. In the next step we will form the shape we wish to subtract from this block.

Tips and Tricks

Notice that in Figure 2.24 the scaling that occurs after the plane is extruded only happens along the X axis. This makes sure that the front two polygons line up and makes the Boolean to come a bit cleaner.

Step 27: Create a cylinder with 60 (yes, 60) Axis Divisions. Do this one of two ways. Either create the cylinder (Create>Polygon Primitives>Cylinder), then in the Channel Box, select the polyCylinder node in the INPUTS section and change the Subdivision Axis entry there. Or, select Create>Polygon Primitives>Cylinder (Options) and in the Polygon Cylinder Options box, change the Axis Division entry to 60.
Rotate and translate the cylinder to match Figure 2.25.

FIGURE 2.25 Placed elements ready for Boolean function.

Why?

"60 axis division?!" you cry incredulously, "all this talk of being efficient with our polycount and you make such a heavy primitive! What gives?" Yes, yes, 60 subdivisions is a lot, and it's important to be very careful where to use such a heavy (high polycount) object. This is one of those places. The reason is that the curve across that archway is very large, and in fact at times in the game it may indeed cover the entire screen. When a curve spans such a large visual space, this is a good place to blow some of the polygon budget. When elements are small on screen—or never get much scrutiny in the course of game play—this is where to stay super stingy with polys. Note that although we started out with a 60-subdivision shape, we actually only used half of them, so there are only 30 subdivisions across the top of that arch.

Warnings and Pitfalls
Although it is a bit difficult to see in the screenshot, that cylinder completely penetrates the altered cube and comes out the other side. For this Boolean function to work, the hole object (the cylinder) must be longer than the object it is being subtracted from.

Step 28: Tweak the cylinder to make an arched entry (rather than a round tube). Press the space bar (to move into four-panel mode), then move the mouse over the front View panel, and press the space bar again. This will make the front View panel full screen. Switch to vertex mode (right-click the cylinder and select Vertex from the hotbox) and Marquee-select the vertices that make up the bottom half of the sphere. Use the Translate tool to move them down below the bottom of the modified box (Figure 2.26).
Step 29: Subtract the cylinder from the modified box. In Object Mode, select the box, then Shift-select the cylinder (the order of selection is important here). Choose Polygons>Mesh>Booleans>Difference. The result should be similar to Figure 2.27.

FIGURE 2.26 Adjusted cylinder.

FIGURE 2.27 Results of Boolean function.

Completing Geometry

Step 30: Finish. Alright, this is a big step, but it is where you get a chance to use the modeling skills and optimization that we've learned so far to create some good-looking models. Keep your polycount low. Model things to look close to Figure 2.28.

FIGURE 2.28 Finished entry.

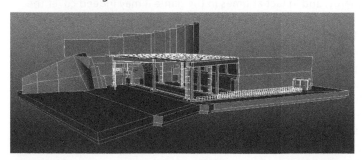

Why?

Everything that remains in the scene thus far (as can be seen in the files contained on the web site, http://www.Creating3dGames.com), use the same methods we have just described. Since the focus of this book is on techniques and Unity, we won't cover every single step of the creation process. However, take a look at any research you can get your hands on online, and make some choices in how you would like to have the space constructed. The important thing is that you are being efficient with your polygons; the techniques we have covered thus far will assist you in doing this.

Why?

There is lots of latitude in the construction of this space. The only critical part will be the entryway shown in Figure 2.29. This is how we will enter the base. Otherwise, populate the docks with old guns, trash, or anything else you think adds to the ambiance of the space.

FIGURE 2.29 Needed entryway.

Step 31: Delete all history (Edit>Delete All by Type>History).

Step 32: Take stock of your polycount. Choose Display>Heads Up Display>Polycount. Pull way out so you can see all the geometry on your screen, and take a look at your Tris: number. For me it is 8358.

Why?

This will turn on some numbers and words in the top left of your View panel—this is your **Heads Up Display** (HUD). There should be three columns (Figure 2.30). The first represents the Verts, Edges, Faces, Tris, and UVs that are visible on your screen. The second column shows the information for the selected object(s). The third column shows the information on a component level (so you could have 56 verts selected out of an object that contains 267 for instance).

Verts:	5718	267	180
Edges:	9956	398	0
Faces:	4245	162	0
Tris:	8358	329	0
UVs:	8280	455	0

FIGURE 2.30 Heads Up Display showing polycount.

Knowing your polycount is important information. With a quick glance you can see if you need to be concerned about further optimization. Or, you can quickly see that your polycount is indeed quite manageable, and you have some room to spice things up.

8358 tris is a relative number. If the plan for this level is to have 200 characters on the screen, 8000 polygons might be too many and we'd need to cut it

Warnings and Pitfalls

Although useful, this particular function within Maya is fairly buggy. In Maya 2011, this seems to work sometimes and sometimes it doesn't. If you are not getting values, or getting strange nonsensical values, save and restart. Maya usually fixes itself.

way down. However, if there is not going to be a lot more on the screen (i.e., characters), 8000 polys is really a low number for an entire scene. Most characters in current generation games have more polys than this. This means that we can do some refining, or add a lot more visual elements to this level.

Visual elements can include additional polygons (like trash on the sidewalk, or the big gun shown in the extra challenges). Alternately, it can include "up-rezing" elements that are already created. Up-rezing is slang for adding additional polygons (higher resolution) to make surfaces smoother or more complex. This should be used carefully because a very efficient scene can suddenly get out of hand with someone who is up-rezing their work.

Deciding what to up-rez can be tricky. Generally, if you are in the lucky situation of finding you have a nice low polycount, the first thing to do is generally to add additional elements. In our case, we will be using the up-rez process to add a bit of visual complexity to the columns. The reason we're doing this to the columns is that the player will be able to get up close to these things, and perfect corners and edges (like they presently have) can really quickly rip the player out of the experience as the artificiality and "computerness" of the game is suddenly revealed.

Beveling

Step 33: Select the edges highlighted in Figure 2.31.

FIGURE 2.31 Beveling edges of a column.

Tips and Tricks
You can probably do this by double-clicking on an edge. Maya will attempt to find **Contiguous Edges,** which essentially are edges that are within a particular angle of each other. It's a quick way to select rings of edges.

Step 34: Select Polygons>Edit Mesh>Bevel (Options). Match the settings in Figure 2.31.

Why?
Beveling is the process of taking an edge (or all the edges of an object) and splitting it into a defined number of **segments**. It then offsets each of those segments over a given **width** and softens these new edges to give the corner a rounded look. It's a sort of corner-softener tool. The default

setting of 1 segment creates a hard edge bevel. Generally, I find that three segments rounds the edges with a noticeable result, but keeps the number of polys manageable.

Applying a bevel to edges helps get rid of that exactness that computers are so good at creating. It helps the surface feel like it's been standing there for a while when the edges of the form aren't razor sharp. When doing high-rez (as in not games) 3D, I bevel most edges. In games, that luxury would kill the polycount; however, some careful choices in bevel can add some sophistication to scenes.

Tips and Tricks
Bevel only one column. We are going to delete all the columns, but we delete one later, after the form is UVed.

Tips and Tricks
Remember that you need to fine-tune the bevel settings depending on the edges and size of the objects you are beveling. Also remember that some objects may be far enough away from the camera that a setting of 2 or even 1 for the number of segments might just do the trick without the polygonal overhead.

Step 35: Bevel other surfaces that need it (and that you can afford).

Tips and Tricks
As you bevel you may find some strange visual artifacts popping up in the corners of newly beveled surfaces. Sometimes this occurs because of problems in the edge normals. Usually, these artifacts can be fixed by selecting the edges in the affected area and using Polygons>Normals>Soften Edge. Sometimes, selecting the edges on the outside edge of the bevel and doing the opposite (Polygons>Normals>Harden Edge) will fix the issue. It depends on the situation; tweak for best results.

Wrapping Up

And with that we will leave our discussion of level modeling. There is still a lot of level modeling to do for our game. The additional areas of the model can be seen in the Challenges section of this chapter. Feel free to take up the challenges, or use your research to create hallways and corridors of your own. Be sure to remember the tools discussed here to create efficient meshes that stay light on the polycount, but high on the visual impact.

If you are comfortable with your modeling skills and know that you can model with efficiency and speed, all the results of the challenges are included on the web site (http://www.Creating3dGames.com). These assets can be used quickly in the tutorials once inside of Unity. However, if you are still finding your modeling legs, try building them from scratch.

Warnings and Pitfalls
Once you start beveling, the temptation will be to bevel everything. "If it looks good here, it'll look good everywhere! Right?" Well, that may be true, but be aware that beveling carries other costs besides in the polycount. UV layout isn't nearly as clean and speedy when you are dealing with beveled edges. Every surface you bevel will add some considerable time to your UV layout efforts. So while applying a bevel is a nice touch, be aware it does exact a toll later. Bevel is good, but bevel with care.

Homework and Challenges

Challenge 1: There will actually be two levels to this game. The first is the entryway we are building here. But the second will be a long hallway in which cameras, steam, and locked doors conspire against our hero. Using the techniques covered in this chapter, model a hallway that includes lots of doors, some great arches, and stairs. My solution (should you wish to copy it) is on the supporting web site (http://www.Creating3dGames.com; Figures 2.32–2.36).

FIGURE 2.32 Entire level.

FIGURE 2.33 View from long hall.

FIGURE 2.34 Main loading hall.

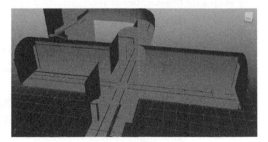
FIGURE 2.35 Junction hall.

FIGURE 2.36 The Pit.

Challenge 2: Props. There are lots of objects that "dress" the scene. Some will be functional to the game, and others will not. Try modeling some (or all) of the following objects that will be placed in the scene (Figures 2.37–2.44).

FIGURE 2.37 CCTV camera.

FIGURE 2.38 The device Aegis is after.

FIGURE 2.39 EMP mine.

FIGURE 2.40 Keypad.

FIGURE 2.41 Attached light.

FIGURE 2.42 Hanging light.

FIGURE 2.43 Lockbox.

FIGURE 2.44 Trolley.

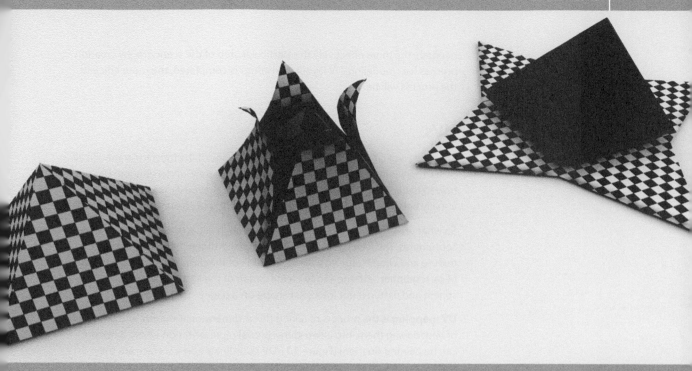

Asset Creation: Maya Scenography UV Mapping

Scenography UV Layout within the Game Design Pipeline

In the previous chapter we discussed how flexible the pipeline was when using Unity, and how it is often preferable to not tear through all the art assets before starting on game mechanics and scripting. However, in the 3D art asset pipeline, there are some fairly clearly delineated steps that need to be followed.

UV layout is the second step of these strict guidelines. Generally, it is important to make sure the geometry (model) is just as it should be before starting your UV layout. If a UV layout is created, and then the geometry is changed, the UV layouts have to be redone.

Similarly, the UVs need to be complete before extensive work is done on texture creation. Since UVs define how a texture is "attached" to a geometric form, if UVs are changed (or the form), the texture will no longer lay appropriately across it.

So, although there is almost always some adjustments as the UV is laid out (stray polygons that aren't needed are found or additional geometry is

needed), the more effectively this particular step of the scenography creation process (i.e., modeling, UV layout, texturing) is completed, the more efficient the process will be.

UVs

The process of creating and editing UVs can be one of the most frustrating in all of 3D. There is little intuitive about them. Unfortunately, understanding UVs and how to manipulate and utilize UV space is one of the most important aspects to visually believable projects—and absolutely critical to effective games.

So what are UVs? Well, they really aren't so much of a *what* as a *where*. UVs are coordinates. They are involved in the complex problem of how to take a 2D texture and wrap it around a 3D form. Think of the problem as much like that of cartographers attempting to create a map of the earth. How do you take a sphere and flatten it out into a flat shape on a page?

UV mapping is the process of taking three-dimensional shapes, and *unfolding* or *unwrapping* them into a two-dimensional representation where a texture can be painted on them (Figure 3.1). UV coordinates on a surface are the locations at which to "pin" the textures. Once these locations are pinned down, even if the surface flexes or distorts, the texture will flex and distort with it.

At the end of the day, UV mapping is what helps a texture look "right" on a surface. A poorly laid out UV map yields unsightly stretching and pinching of the texture that is applied to it. A well-executed UV map produces believable surfaces with textures that belie the usually simple geometry beneath it. In games especially, where textures do much of the visual work, a good UV map is critical to visual success.

In the following tutorial, we will be looking at three ways to create UV maps. Through this process, it will be important that we understand texture space and how it relates to 3D space. We will look at the UV Texture Editor within Maya and how it allows for the manipulation of UVs. We will look at Maya's automatic mapping options, its unfolding capabilities, and manual mapping and manipulation of UVs.

FIGURE 3.1 An illustration of UV unwrapping.

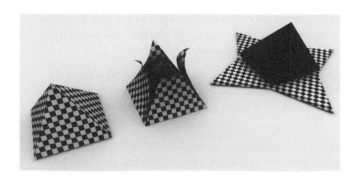

Exploring the UV Texture Editor

When any of Maya's primitives are created, these primitives include a default UV layout. For instance, go to Create>Polygon Primitives>Cube. With this cube selected, choose Window>UV Texture Editor (Figure 3.2). In the UV Texture Editor, the six-sided cube will appear unfolded. All the faces are laid out flat in the top (1,1) quadrant of the UV Texture Editor space. By default, the background here will be a medium gray color; this is actually the texture that is applied to the cube. Within the UV Texture Editor, right-click and hold, and a hotbox will be presented that allows for choosing which type of component to select. The regular Edge, Vertex, and Face are presented, as well as UV.

After choosing a component type from the hotbox, these components are now selectable within the UV Texture Editor. At first blush it seems that the only difference between Vertex and UV is the color of the component when it is selected (vertices highlight yellow and UVs always highlight green). This is because Maya's primitives have their UVs located at the vertices of the form. However, don't confuse the two. Vertices and UVs are one-dimensional—they have no geometry of their own—but they serve much different functions.

In fact, once faces or edges are extruded new vertices will always be created along with the faces created (there cannot be faces without the vertices); however, these new vertices will not necessarily have new UVs attached to them. Further, although UVs are visible in 3D space (i.e., the View panels), they can only be altered—moved, rotated or scaled—in 2D space, within the UV Texture Editor.

This transition from 2D texture space to 3D space is often a hard thing to visualize and even harder to explain. However, it becomes much easier to comprehend once it is seen in action. Because of this we won't spend too much time pounding on the theory further. Let's start seeing it in action.

FIGURE 3.2 UV Texture Editor and the UV layout of a cube primitive.

Tutorial 3.1: Game Level UV Layout, Tools, and Techniques

In this tutorial, we will continue working on the EntryWay we began earlier. Although we won't explicitly map every object, the techniques covered here are extensible to all the objects in this scene, and indeed into all the scenes in the rest of the game.

Step 1: Create a checkered pattern. In Photoshop, create an image that is 32×32 pixels. Create guides horizontally and vertically in the middle of the canvas. Fill the top left and right with black. Select all, choose Edit>Define Pattern. Name the pattern.

Step 2: Create a checkered base texture. Create a new image that is 1024×1024. Choose Edit>Fill. In the Fill dialog box, choose Use:Pattern and pick the previously created checkered pattern and click OK. The results should look like Figure 3.3. Pretty exciting, eh?

FIGURE 3.3 Base checkered texture.

Why?

Why a checkered pattern? Why not just use the checkered texture that's canned in Maya? Why 1024×1024? All good questions. As we attempt to lay out the UV map, it will be important to know that the mapping we have created does not cause stretched or pinched textures. Further, sometimes we want to know how much texture is actually on any one part of the mesh. By using a checkered texture, we can have a quick reference of how the texture is mapped across the surface, and how we are distributing the texture in 3D space. The reason to build your own instead of using Maya is that the Maya checkerboard is set at the number of checks across and down. By creating our own, we can create a more densely populated collection of checks. The file is 1024×1024 because we want to get in the habit of building by **power of two** when working with texture (much more about this later).

Step 3: Save as Checkerboard.psd in the **sourceimages** folder of the project file.

Why?

The sourceimages folder is where Maya goes to look for textures when a new material is created. There are lots of other seductively logical folders (images, textures, etc.), but don't succumb. The only folder that matters for saving textures within Maya is sourceimages.

Creating and Applying New Material

Step 4: Create and apply a new material on a column. Right-click and hold on the column that we previously beveled. Choose Assign New Material. In the Assign New Material window, click Lambert. This *should* open a new lambert material in the Attributes Editor. If it does not, press Ctrl-A, and the Attribute Editor will show the attributes of this new material.

Why?

Why a lambert? Lamberts are matte materials that Maya draws really quickly and well. More importantly for us, when Unity initially brings in the Maya-created objects, everything looks like a lambert. Any other attributes present in other materials (specular in Phong, etc.) has to be redefined in Unity anyway. So spending a lot of time tweaking settings in Maya is wasted since it has to be redone. For this reason, lamberts are quick, easy, and predictable ways to get textures applied and to see the general look of the scene.

Step 5: Name the material. Name the material. Name the material. Did I mention to name the material? Name the material `EntryWay_Column_Mat`.

Why?

Beginning modelers or beginning game builders often skip effective naming and pay the horrible price later. When moving assets between applications (like from Maya to Unity), assets will be tied together differently, and sometimes in the production process materials will become disconnected from objects. If there are 100 materials named lambertx, you will be immensely slowed in your work. Take just a little time to name materials what they are, and you will save many hours later. Especially if you ever hope to work with others as part of a team—effective naming is critical to smooth work flows and keeping your job.

Step 6: Create a Render Node for the Color attribute. In the Attribute Editor, at the far right of the Color channel is a little button that (ironically) looks like a checkerboard. Click this to bring up the Create Render Node window. Tell Maya to import a file to define the color attribute of the material by clicking the File button.

Step 7: Choose Checkerboard.psd to define the color attribute. After following the previous step, the Attribute Editor will change to display a file1 node with an **Image Name** input field. Click the folder icon next to that input field, and you *should* be taken to the sourceimages folder of the project. Double-click Checkerboard.psd.

Step 8: View the scene in *Textured* mode. Do this by pressing **6** on the keyboard. This will show the scene with any applied textures and should yield a strange result as seen in Figure 3.4.

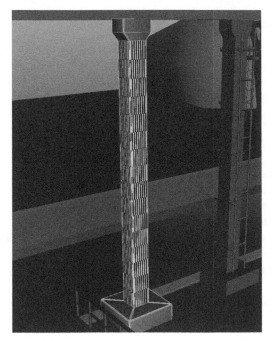

FIGURE 3.4 Base checkerboard texture applied and the strange current default UV map.

Why?

So what are we seeing here? Think way back to when we first began building this column; the shape we began with was a cube. The parts of the column that have texture are the original faces of that cube. The polygons we extruded off of that shape are gray; they have no UV coordinates, and thus have no location for the texture to be "pinned" to. Further, the texture that is applied to the main shaft of the column is stretched and not efficiently organized.

Mapping Beginning with Automatic Mapping

Why?

The first way we are going to look at UV mapping is to start with **Automatic Mapping**. Generally, anytime software does something "automatically" be a little wary—this is no exception. However, Automatic

Mapping does create UVs for all the geometry we have, and once we have those UVs we can fix the map into what we need.

Step 9: Use Automatic Mapping on the column. With the column selected, choose Polygons>Create UVs>Automatic Mapping (Figure 3.5). In the UV Texture Editor window, choose Image>Display Image (to turn off the checkerboard), and see the shapes that represent the column.

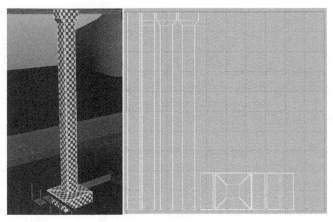

FIGURE 3.5 Results of Automatic Mapping.

Why?

At first glance all is well—that was amazingly easy. But take a look at the UV Texture Editor (Window>UV Texture Editor) and you'll notice a couple of important things. In the UV Texture Editor window choose Image>Display Image (to turn the background checkerboard off), and see the shapes that represent the faces of the column. First, notice that there is a lot of the texture space that we are not making use of. In the game, we are paying for that space whether we use it or not, and it's very inefficient to leave so much of that texture space unused. Second, notice that each of the sides of the column are separate. This means that the texture won't crawl around the corners or the column—there will be a seam across every corner of our form.

Seams are inevitable. If a form is to be unwrapped, there has to be a seam somewhere, but we want to minimize those. To do this, we will be cutting up some of this map and reassembling (via sewing) other parts.

Step 10: Cut the heads off the columns. In the UV Texture Editor, right-click and choose Edge from the hotbox. Select the edges (there are really three there, although they are all in a line) shown in Figure 3.6. In the Editor window choose Polygons>Cut UV Edges.

43

FIGURE 3.6 Cutting the heads off the column.

Why?

We are cutting the heads off so we can sew up the side edges of the shaft. In the game, we will see much more of the shaft than the capital of the columns. So making sure there is only one seam on the shaft makes for a better experience for the game player.

Step 11: Move the head away via UVs. Right-click again and choose UV from the hotbox. Marquee select a few UVs (that are part of the column capital - maybe the top right corner of UVs) and then Ctrl-right-click-hold (I know it's a lot) and choose To Shell (Figure 3.7). This will select the *shell* of UVs that make up the top of the column. Move them aside. Moving a UV shell can be done with the regular Move tool (press W to activate it) or in the Editor window choose Tool>Move UV Shell Tool and then move them aside (anywhere really).

FIGURE 3.7 Selecting a shell of UVs.

Why?

What is a shell? Shells of UVs are shared UVs that share UVs, or edges. Because we cut the edges at the bottom of the column capital, the edges there were no longer shared, so when we selected a shell, it stopped there.

FIGURE 3.8 Separated column capitals.

Step 12: Repeat steps 10 and 11 for the other sides of the column. Keep in mind that this all takes place in the UV Texture Editor. Figure 3.8 shows the capital chunks all separated.

Sewing Shells

Step 13: Sew the edges of the shaft. In the UV Texture Editor, right-click and choose Edge from the hotbox. Click (don't marquee select), on any one of the outside edges of the shaft sections of the column. Notice that although an edge was clicked, a second edge will highlight somewhere in the UV Texture Editor. This is because it is the same edge but is split (which is why we'd have a seam).

With this single edge selected twice, choose Polygons>Move and Sew UV Edges. One shell will slide over to the other and the split edge will become one (Figure 3.9).

FIGURE 3.9 Sewing edges.

Why?

Sewing these edges up mean that the texture will be seamless as it crawls around that corner. For a better understanding of what this does, select the shell that is the newly sewn together shaft segment and use the Move tool to move this shell in the UV Texture Editor (we're moving the UVs through texture space here), and look at what happens in the View panel. See that along the edge that was just sewed up, the texture crawls across the corner without a problem, but on the other three corners there is a visual disconnect.

Step 14: Repeat for all the outside vertical edges of the column shaft. The final shell should appear like Figure 3.10.

FIGURE 3.10 Sewed-up shaft.

Why?

Notice that there will still be one seam on either outside edge of the shell. This is OK and inevitable. As we finally position the columns we may look at ways to rotate this away from where the player will see it.

Step 15: Repeat the process for the column base. However, this time, instead of sewing up the vertical edges, we will sew up the horizontal edges that run across the top of the base. The completed shell will look something like Figure 3.11.

FIGURE 3.11 Sewn column base.

Why?

We are looking to reduce seams in places where the player will most likely notice them. For the shaft, it would be easy to see the vertical seams, so we take care to get rid of those. For the base, where we would be standing above it and looking down, the player would most likely notice seams as the form moved from the top to the side, so we get rid of those seams and leave the vertical seams by the ground.

Step 16: Repeat the process for column capital shells (Figure 3.12).

FIGURE 3.12 Column capital shell.

Why?

Why Move and Sew UV Edges and not just Sew UV Edges? Part of what the Automatic Mapping did for us was to evenly distribute our UVs so the checkers were indeed square. When Move and Sew UV Edges is used, Maya moves the entire shell and thus keeps the relative position of the UVs constant. This means the texture is not distorted in the process. Sew UV Edges moves just the edge, and in the process distorts the texture across the surface.

Tips and Tricks

Often, when working with objects that have had things like bevel applied to them, they will end up with little shards of polys floating around in the texture space. Keep your eye open for these, and look at where they could be resewn (via Move and Sew UV Edges) back onto larger chunks.

Step 17: Arrange the shells to better take advantage of the space (Figure 3.13).

FIGURE 3.13 Arranged shells.

Why?

"Hey, wait a minute!" you may be saying, "that doesn't look like you're using very much of the texture space. I see a whole lot of empty space." And you're right. There is a whole lot of empty space left in this UV map. There are two things we could do with that space. One, we could resize our UV shells to better take advantage of that space—but if we did that we would need to construct our texture equally distorted to match the distortion in texture space. This can be harder than it sounds.

The second alternative is to simply use that space to hold the UVs of another object. This is the idea of **atlasing**, meaning that a **texture atlas** can be created that holds the texture information of multiple objects. A texture atlas is really just like any texture—only there are multiple objects' texture information crammed into one file. This is actually a very useful optimization technique because the video card then simply draws the same texture on the same shader multiple times to represent a lot of

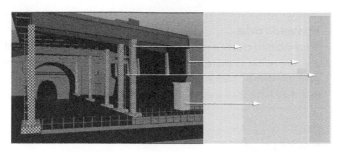

FIGURE 3.14 Final UV layout of the object EntryWay_Columns with the EntryWay_Columns_Mat material assigned. Don't worry about making this happen just yet—but be aware that this is the final goal of a texture atlas.

different objects on the screen. It takes much less of the video memory, and dramatically reduces the draw calls. Since in my scene I have other things that are attached to the columns (ladders and frames), I am going to place the UVs for those objects in the spaces of the quadrant that are empty, and then assign the same texture to all these objects. The idea of Texture Atlases are so powerful that we will be visiting them again.

Finally, when the UV was done for this level, the UV map for the single mesh EntryWay_Columns (which was actually the result of lots of combines) looked like Figure 3.14.

Further Optimization

Step 18: Duplicate, place, and combine this UVed column. Delete the old duplicates of the column and replace them with this one. When they are all placed, select all of them and combine them (Polygons>Mesh>Combine). Name this new polygon shape EntryWay_Columns. Finally, to make sure the manipulator handle for this new group makes sense, select Modify>Center Pivot.
Step 19: Repeat this process for other squarish shapes. Using the objects in my scene this included the beams above the columns, the roof, and various other obviously square structures. Those shapes that were UV mapped using this technique are shown checkered in Figure 3.15.

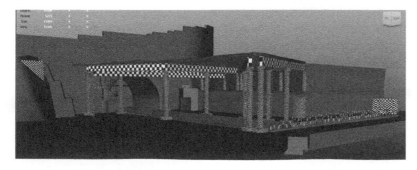

FIGURE 3.15 Objects UV mapped using the Automatic Mapping as a start.

Tips and Tricks

Remember to create a new material for each object or groups of objects (that are going to share the same material). Although all of them will share the same Checkerboard.psd file as their color texture, we want to be sure they have their own unique material assigned to them.

Tips and Tricks

A nice thing about using the same checkerboard for all the UV mapping is that it gives a quick look at how much texture space each object will have. Knowing this helps show how high fidelity the texture will likely appear in a game. Notice in Figure 3.15 that objects that are close to the ground or on the ground have small checkers. This means they have a lot of texture space, which means there will be a lot of pixels used to describe this surface. Things that are far away from the player in the game (like the beams overhead) have larger checks because they won't need quite as much texture since they won't be subject to quite so close a scrutiny.

Maya's Unfold UV via Smooth UV Tool

Why?

Automatic mapping works great if working with cubes or objects that are largely cubic in shape. But a scene full of crates makes for a pretty boring scene, and ultimately more organic shapes become important to most scenes that have any variation. Maya's Unfold UV tool is a relative newcomer to the Maya toolset (at least in the configuration it currently uses). This kind of technique is available with other tools (see the free and powerful Roadkill http://www.pullin-shapes.co.uk/page8.htm), but is nice to have available in Maya. In the next few steps we will be looking at how Unfold works within Maya in a simple shape. However, this tool is especially powerful for things like faces and other complex organic shapes, so we will be visiting it again.

Step 20: Assign new material (with checkerboard as the color texture) to the EntryWay_Earthwall object (if you are building off of the version of the map downloaded from the site; if you are using your own version assign the new material to whatever you are using for the big retaining wall). For a refresher on how to do this, be sure to view steps 4 through 7. Name the new material `EntryWay_EarthWall_Mat`.

Step 21: Use Planar Mapping to ensure the entire object has UVs. With the object selected, choose Polygons>Create UVs>Planar Mapping (Options). Change the Fit projection to: setting to **Best Plane**, and press Project (Figure 3.16).

FIGURE 3.16 Results of Planar Mapping (showing parts that didn't work so well).

Why?

Unfold works great; however, it only unfolds UVs that exist. As we have seen before, when faces or edges are extruded, often the new faces that are created lack UVs. Using Planar Mapping does a few important things for us. First, it ensures every part of a particular mesh has UVs. Second, it ensures all these are part of one shell. Third, by choosing Best Plane in the options, we give Unfold its best chance at providing a distortion-free UV map.

Step 22: Unfold (interactively) the UVs via the Smooth UV tool. In the UV Texture Editor (Window>UV Texture Editor), right-click the mesh and choose UV from the hotbox. Marquee select all the UVs. Select the Smooth UV tool either from the iconography in the top left of the UV Texture Editor or from Tool>Smooth UV Tool.

Step 23: Drag the new Unfold button to unfold the mesh. Look for the new pop-up tools that are surrounded in yellow boxes. Drag the word Unfold and watch as the UVs unfold and reveal a much better distributed checker pattern in the View panel (Figure 3.17).

Step 24: Resize (and rotate if needed) the UV Shell to get it to fit into the top-right quadrant.

Why?

Although UVs do not need to always remain in that top-right quadrant (and in fact in the next setup steps we will be moving out of that space), if the situation calls for a nonrepeating texture, it needs to have it remain within this quadrant. For this earth wall, since we will be seeing all of it at once within the game, we will want to avoid a repeating pattern if we can. Plus, by rotating and scaling these UVs, it allows us further texture space to create another mini-atlas.

Warnings and Pitfalls

At first blush, all looks well—the entire surface is covered with checks. However, if you look carefully at the checkers you will see that there are some really distorted checkers (especially in the upper-right corner of Figure 3.16). This is happening because Planar Mapping shoots a texture across a surface like a slide projector. As the image is projected against faces that are perpendicular to the projection plane it looks great; but as the form begins to wrap around so that the planes are parallel to the projection, we get stretching. If this is left this way, the rock texture that will be applied will also be deformed as it wraps around the form. Thus, the next steps are important and powerful.

51

FIGURE 3.17 Unfolding the EarthWall.

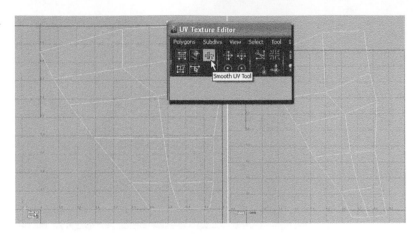

Manual Mapping

Why?

With all the "auto-magic" techniques that are available in Maya, sometimes some manual mapping with some good ol' fashioned edge sewing is the only way to get a good UV map. If you're familiar with manual mapping, skip the next few steps, but if you haven't made UV maps before, the following steps will be of value.

Step 25: Isolate the main archway (EntryWayArch). Select the arch and choose Display>Hide>Hide Unselected Objects.

Step 26: Assign a new material (`EntryWay_Arch_Mat`) to the arch. As usual, be sure that Checkerboard.psd is the color texture.

Step 27: Select all the faces that make up the front of the arch, and use a Planar Mapping to map these faces. To do this, right-click the archway and choose Face from the hotbox. Select all the faces that are not inside the arch. Select Polygons>Create UVs>Planar Mapping (Options). In the Planar Mapping Options window, check **Bounding Box** and **Z Axis** (unless your arch is facing a different direction than mine). Click Project (Figure 3.18).

FIGURE 3.18 Planar Mapping front face.

Tips and Tricks

Selecting faces can be a tricky thing. Remember that sometimes it's easier to select all the faces and deselect the faces not wanted. Sometimes the Paint Selection tool is the best way to go.

Tips and Tricks

Notice that after the Planar Projection was created, the checks might not be perfectly square. Also notice that immediately after the Planar Projection, there are some manipulator handles that surround the area just mapped and that these handles allow for the projection to be adjusted so it can be scaled narrower if needed.

Why?

Yes, you're right. A flat projection creates some mean distortion as the faces turn the corner to create the relief of the archway. To fix this, use the trick of using the Unfold section of the Smooth UV tool (not Polygons>Unfold).

Step 28: Map the UVs of the inner curve of the arch. In Face mode, select the faces that make the curved part of the arch (Figure 3.19).

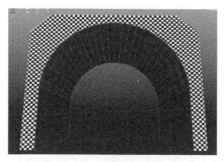

FIGURE 3.19 Selected faces for cylindrical mapping.

Step 29: Select Polygons>Create UVs>Cylindrical Mapping. Rotate the projection by –90 degrees in X. Press Ctrl-A to bring up the Attributes Editor. There should be a polyCylProj1 tab active. Make sure Projection Attributes is expanded. In the first Rotate input field (the X), enter –90 (Figure 3.20).

Why?

Cylindrical projections are like wrapping an object with a tortilla—or more accurately, by default, wrapping half the object with half a tortilla. This half tortilla by default is standing up. In this case, the polygons we are attempting to map would be best wrapped with a tortilla wrapping from the top. By rotating the projection by –90 degrees, the projection (as can be seen by the manipulator) is much closer to the shape of the polygons they are projecting upon. Getting closer.

FIGURE 3.20 Rotating cylindrical projection.

Step 30: Adjust the manipulator to get the checkers square. It's a little hard to see this in the screenshots as the manipulator handles are so small, but there will be green handles on the top and bottom edge of the manipulator. Pull one out to lengthen the projection to get the checkers closer to square (Figure 3.21).

FIGURE 3.21 Adjusting manipulators to get closer to square checkers (and thus a well-distributed UV map).

Step 31: Adjust the projection center to match the curve of polygons. Figure 3.21 also highlights a little tool on the corner of the manipulator that looks like a little red T. Click this, and the manipulator will change and show a new manipulator handle in the middle of the projection that looks like the Extrude tool's (it has Translate, Scale, and Manipulator handles). Use the Translate tools to slide the projection down so that the

projection matches more closely the arch. It is right when the checkers at the top of the arch are without distortion (Figure 3.22).

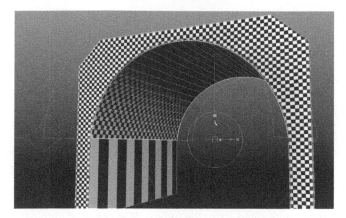

FIGURE 3.22 Adjusting the center of the projection.

Step 32: Project the bottom polygons of the arch. Select the two faces on either side of the bottom of the arch. Choose Polygons>Create UVs>Planar Mapping (Options). In the Planar Mapping Options window, check the Bounding Box and X axis radio buttons and press Project.

Step 33: Adjust the manipulator handles to get the checkers to match those in the curved part of the arch (Figure 3.23).

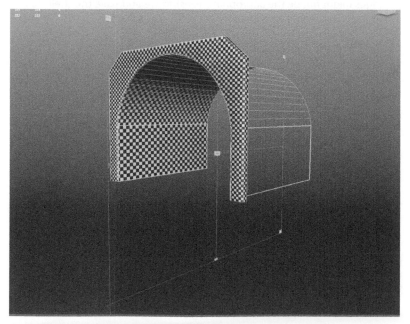

FIGURE 3.23 Adjusting the Planar Projection manipulator handles to get the checkers the correct size and proportions.

Step 34: Arrange the shells so they can all be seen separately in the UV Texture Editor. In the UV Texture Editor, click (not marquee select) any one UV. Ctrl-right-click-hold and choose To Shell from the hotbox. Use the Move tool to move the shell away to a place where it can be worked with. Repeat for each of the shells until all the shells can be seen in distinct shapes (Figure 3.24).

55

FIGURE 3.24 Arranging shells.

Why?

We are going to sew some of these shells together so that the texture can move uninhibited across the surface. When we used Automatic Mapping the shells were all laid out well for us; but not so when we manually map.

Step 35: Resize shells to appropriate sizes. Earlier we learned that when an edge is selected, if that edge is shared in another shell it will highlight as well. As this happens, it may become clear that earlier estimates of matching checkers in the View panel doesn't quite hold up here (the edges might not be the appropriate sizes). Move and scale the shells to be appropriately matched (Figure 3.25).

FIGURE 3.25 Adjusted shells. Shells were moved and scaled.

Step 36: Sew arch edges up. Select an edge at the bottom of the arch, which should select the top of one of the bottom polygons and use Polygons>Move and Sew UV Edges. Do this on both ends of the arch (Figure 3.26).

FIGURE 3.26 Finished arch manually mapped. The edges that were sewn are highlighted.

Tips and Tricks

Since we projected both sides at once (with a Planar Projection), one face is going to have UVs that are backward—mirrored of what they should be. When edges start to get sewn together, one side will yield a really strange result. Figure 3.27 hows the result with the Toggle UV Shaded display activated. The lavender area shows overlapping UVs. If this happens, Undo back so that the backward shell is disconnected. Select the shell and flip it using the Flip Selected UVs in V Direction button. Then resew and things will behave more predictably.

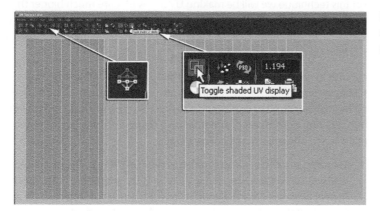

FIGURE 3.27 Problems with sewing due to planar mapping two facing faces, and the tools to fix it.

Tips and Tricks

That Toggle UV Shaded display tool is very handy. Notice that with it checked you can see if any shell is backward. Generally, all the shells should appear blue; they show up pink if the back of the shell is being shown. In this case, it doesn't matter if the entire inner arch shell is backward, but if you wish to flip it, use the Flip Selected UVs in V (or U) to get it facing the right way.

Step 37: Move and scale the shells to fill (but not overflow) the quadrant.

Why?

This is a very large object in the scene, and an area where the player may indeed be walking up close. Because of this, we are going to leave this object as one UV map, and not try and force it into one of our texture atlases.

Step 38: Make everything visible. Back in Maya's main interface, select Display>Show>All.

Floor UV Strategies

Floors are actually deceptively tricky. It seems like a flat plane would be a really easy thing to texture. However, in most games, the player ends up seeing an awful lot of floor at any one time. It's not unusual for players to have two-thirds of

their visual space taken up with a floor plane with wide open spaces. So having a floor with a texture that holds up to this scrutiny ends up being very important.

To make this successful, we are going to work with tiling textures. For most of the UV maps we have set up so far, the texture is meant to have a 1:1 ratio. The UVs are all contained within the top-right quadrant of the UV space. This means the column texture is painted and wrapped around the column once. Each pixel is represented once on the surface of the column. But on large surfaces like the dock deck, this technique would yield a very pixely surface and one that would look very poor if the character looked down.

For this technique we will be making UV maps that are much bigger than the top-right quadrant. This means the texture will repeat, or tile across the surface. This also means that the texture can be much higher resolution and will hold up much better in the game.

Warnings and Pitfalls
Don't be fooled by the gray thumbnails. This is sometimes the drawback of using the very flexible .psd format, but sometimes the previews of the textures are not accurate in the Hypershade. Rest assured (and you can see), these materials indeed have the checkerboard assigned within them.

In order to do this, we can't be dealing with texture atlases—the entire texture needs to replicated multiple times across a surface—and if there are multiple textures, all of that would show up. So we can either split the dock up into separate objects, each with their own material, or we can apply multiple materials to one object on a per-face basis.

Step 39: Create three new materials in the Hypershade. The Hypsershade is available via Window>Rendering Editors>Hypershade (the exact layout of the Hypershade may differ depending on which version of Maya you are using). Figure 3.28 shows Maya 2011's Hypershade layout. To create a new material here, click the Lambert button in the Create tab. The new material can be worked in the Hypershade, or continue working with it in the Attributes Editor (Ctrl-A). For each, import the same Checkerboard.psd file into the Color channel. Name the first `EntryWay_DockTile_Mat`, the second `EntryWay_DockWhiteCement_Mat`, and the third `EntryWay_DockCement_Mat`.

FIGURE 3.28 Hypershade in Maya 2011.

Why?

Why are we suddenly building a bunch of materials in the Hypershade, when in the past we have built them as we went? Well, creating a material as we assign it works great for situations when one material is all that will be on a given object. However, when assigning multiple materials to one object, it works best if the materials are already constructed.

Step 40: Assign EntryWay_DockTile_Mat to the polygons shown in Figure 3.29. To do this first swap to Face mode in the View panel (right-click-hold and select Face from the hotbox). Select the polys shown in Figure 3.29. Open the Hypershade, and right-click and hold on EntryWay_DockTile_Mat and select Assign Material to Selection from the hotbox.

FIGURE 3.29 Picking the faces to assign EntryWay_DockTile_Mat.

Tips and Tricks

When the material names get long, while in the Hypershade, it can be difficult to know which is which depending on the size of your thumbnails. However, as the mouse hovers over any material swatch, a yellow hint box will pop up with the full name.

Step 41: Assign EntryWay_DockWhiteCement_Mat to the polygons shown in Figure 3.30. The polygons selected are essentially all the polygons along the inside of the canal, and the polys of the lip. The process of assigning the material to just these polys is the same as in the previous step.

FIGURE 3.30 Polygons for EntryWay_DockWhiteCement_Mat.

Step 42: Finally select all the remaining polygons (and deselect those that we have already assigned materials to) and assign EntryWay_DockCement_Mat to them.

Why?

Pretty strange results, no? If you are working with the version of your set that you built from the previous chapters, you are finding that there are lots of polygons that are still gray, and those polygons that have texture are all sorts of screwy. Of course, this is because we have not UV mapped this form, so the only polys that will have any textures are the original faces of the cube we began this form with. In the next few steps we will take control of the UVs again, and give recognizable texture to this form.

Step 43: Planar map the tiled part of the dock. Select the two polys that we previously assigned EntryWay_DockTile_Mat to. Choose Polygons>Create UVs>Planar Map (Options). Tick the Bounding Box and Y axis radio buttons and press Project. Use the manipulators to adjust the projection to yield square checkers (Figure 3.31).

FIGURE 3.31 Mapped white cement parts of the dock via Automatic Mapping.

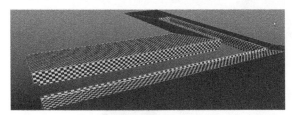

Why?

Don't worry too much about the exact size of these checkers. The UVs that are being edited at this point can be way out of the top-right quadrant of the UV Texture Editor, and in fact once we start building textures, this will undoubtedly change. What we're interested in is undistorted UV mapping at this point. So as long as the checkers are square, you're good.

Step 44: UV the white cement parts with automatic mapping. Select the polygons that have previously been assigned EntryWay_DockWhiteCement_Mat to, and UV map these polys with Automatic Mapping (Polygons>Create UVs>Automatic Mapping). Use the projection manipulators (visible in the View panel immediately after Automatic Mapping is chosen) to scale the UVs to ensure square checkers (Figure 3.31).

Tips and Tricks

Be sure you are looking at all sides of this projection. The manipulators for Automatic Mapping look different than those for Planar Mapping, and it will be important to take a close look at all the polygons to get things adjusted appropriately. Remember that sometimes that manipulator is good for gross adjustments, but for any sort of fine adjustment use the UV Texture Editor.

Tips and Tricks

The UV Texture Editor can be very powerful, but a little picky. One trick I like to use goes like this: Immediately after using Automatic Mapping, use the Manipulator in the View panel to get a very rough cut of square checkers. Then, without selecting any other object or component, bring up the UV Texture Editor (Window>UV Texture Editor). There notice that only the polygons (faces) just mapped are selected and highlighted. Right-click and select UV from the hotbox, and marquee select around everything visible. As soon as this is done, notice that all the UVs of the form appear (it'll look a mess), but only the UVs that you just mapped will be selected. Use the Move tool to move these UVs off to the side somewhere you can work with them. Here, you can scale UV shells into submission. Move and Sew UVs if there are easy places to eliminate seams.

Step 45: UV map the remaining polygons (those assigned to EntryWay_ DockCement_Mat) by either automatic mapping, manually mapping chunks and sewing them together, or some combination of both (Figure 3.32).

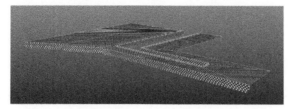

FIGURE 3.32 Finished dock UV Mapped.

Tips and Tricks

Again, don't worry about the absolute size of the checkers. Figure 3.33 shows how my UV map looks at this point. There are three clusters of UV shells (the left is cement, the middle is white cement, and the far right is tile), but they aren't concerned with living inside the top-right quadrant. Since we will be repeating the texture, we want the shells to be larger than the texture. Remember that although we see all the shells together here, there are actually three materials involved. When we texture (next chapter) we will spend some good time again here understanding how to work with multiple materials on one object.

Step 46: Finish UV mapping the scene. At this point there won't be too much left, but using the techniques covered thus far, you should be able to finish UV mapping the scene so you are ready to texture in the coming chapters.

Conclusion

So there you have it. We have looked at all the core ideas to UV mapping. Hopefully this is largely a review of techniques you have worked with previously, but placed within a game design framework. At this point, the

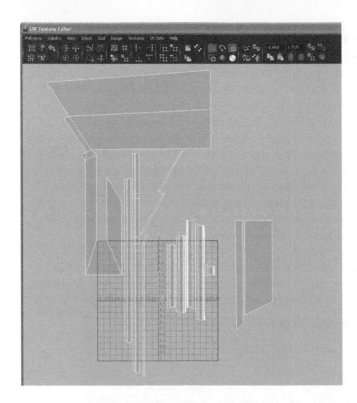

FIGURE 3.33 Current layout of UVs for dock.

scene will look like a jumble of checkers. Working with this checkerboard texture helps to know what objects have yet to UV, and how the textures are distributing across the objects.

Knowing how to use texture atlases and assigning multiple materials to a single combined object will assist in keeping the draw calls low(er) and keep the scene running smoothly. In the next chapter we will be creating several texture atlases to see how this works; but texture atlases (textures) are only as effective as the UVs that are laid out to take advantage of them. Having control of how to distribute UVs, and how to cut, sew, and position UV edges means you have absolute control over what parts of the texture appears on what parts of the polygons.

To me, UV mapping is work. It has to be done, and it has to be done well. Don't take shortcuts because good textures are a critical part of the visual impact of games (at least as important as the geometry beneath it), and a good UV map is the way to effectively place and control textures.

The good news is that texturing the scene—the sexy visual part of the process—comes next. And once your UVs are well laid out, the texturing process really does become an immensely fun and rewarding process.

Homework and Challenges

Challenge 1: UV Map the Hallway challenge built in the last chapter.
Challenge 2: UV Map all the props built in the Homework and Challenges of the last chapter.

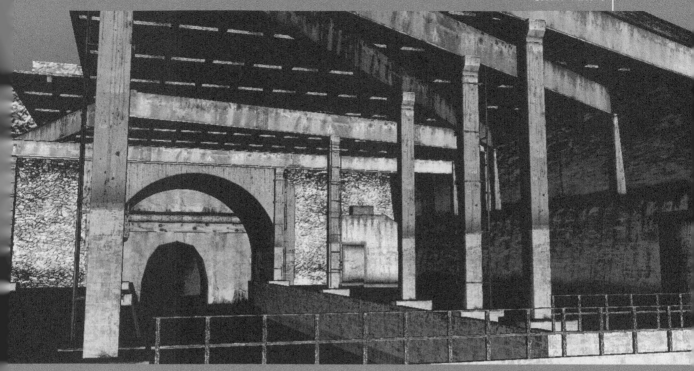

Asset Creation: Maya Scenography Texturing

Textures, Materials, and Shaders

Now that you've paid the price of UV mapping you're ready to dive into the fun part of creating the visual impact of a scenography element—the color and visual tactile elements called "texturing."

There are a lot of terms that sometimes get thrown around when talking about adding visual information to your gray (or in our case, checkered) set. But technically there are some very real meanings to these terms that shouldn't get confused.

Textures are really images; they can be photos or painted images. Textures are 2D elements that define a particular attribute of a **material**. Textures can be used to define a material's color or visual tactile elements like bump. When a material is applied to an object, a **shader** is used to show how this material will react to light and the viewer's angle of view. When someone says they are "texturing" a scene, they usually mean they are creating materials by assembling textures that will be applied to geometry that when lit will reveal what can be visually sophisticated forms.

Nature of Effective Textures

Not all textures are created equal. Some textures (image files) are simply easier to envision in a 3D and texture space. Further, and importantly, some textures draw faster, which in game design is a critical consideration.

Be Square

When we were working on the UV layouts, we were working in the top-right quadrant of the UV texture space. Notice that this quadrant is square. If any textures are imported into a material in Maya, it will still show up square within this space. Because of this, it is generally easier to visualize textures by working with square images. Although materials can be deformed (squash them for instance), we went through great effort to create perfectly squared checks when doing the UV layout. This means that we are assuming the texture is not deformed and the results will be much more predictable.

It is important to notice, however, that texture within Maya (or within Unity) do not *have* to be square. And there may be times when an oblong texture makes the most sense (a long wall for example); however, Maya will still show it as a square image within the UV Texture Editor. So in most cases it just makes the creation process easier for beginners if they see the texture undistorted.

Power of Two

Video cards draw certain assets quicker than other. Part of this has to do with how computer hardware is able to package information. Start with 1 and multiply it by 2 and in turn multiply each result by 2 and a sequence of numbers will emerge like this: 1, 2, 4, 8, 16, 32, 64, 128, 256, 512, 1024, 2048, 4096, and so on. These values are referred to as **power of two (POT)**. Textures work most efficiently if their pixel measurements are one of these packaged values. So if we are working with square textures, think 256×256, 512×512, 1024×1024, 2048×2048, or even 4096×4096.

There was a time not long ago when video cards could not display textures that were not a power of two texture. Most video cards today have some strategy to deal with this; however, this almost always includes some sort of resampling the texture into a power of two texture. This means valuable horsepower is being wasted converting a 300×300 texture down to a 256×256. This waste of processing power usually results in lower frame rates and slower game play.

Maya will happily take any size texture thrown at it with nary a complaint, which can lead to a false sense of security. Additionally, new to Unity 3, Unity will take non-power-of-two textures without griping, either—in fact it won't even alert you (unless you look in the Inspector for each texture) that it's taken in non-power-of-two textures and what it's doing

with them. However, behind the curtain, Unity is quietly converting the non-power-of-two textures into power of two versions. In Unity 2.x and earlier, Unity had to be told to do this, but now Unity assumes you mean to and chugs away on import bending the files into the size that they will work fastest with.

However, resampling an image that is just off of power of two (say 520×520) down to 512×512 can lead to muddy images. It can be tough for software to know exactly which pixels to leave out as they resize down, or which pixels to double when resizing up.

Ultimately, creating textures as power-of-two texture will yield time-saving results on import and create crisper images that MIP Map (more on this later) better and play quicker on all video cards.

Seamless Textures

Some of the UV Mapping we have completed works on the idea that each pixel of the texture is shown once, and only once on the surface it is applied to. This can yield really intricate textures, but is sometimes hard to maintain good resolution without monstrously large files (and thus lower frame rates). For other maps (like the floor, for example) we built a UV map with the assumption that we were going to repeat, or tile a texture. This means that instead of seeing one 1024×1024 texture spread across our entire dock (which would mean a very few muddy pixels being visible when we look down at our feet), we could repeat that texture many times so that we could (in theory) see the entire 1024×1024 texture right at our feet. This allows for a texture that holds up much better upon close inspection.

However, when a texture is going to be repeated like this it becomes critical that there are no seams as the texture tiles. If the top of the texture doesn't line up perfectly with the bottom, the tiling will be seen and the illusion of an unbroken surface will be destroyed.

Maya and Unity

Luckily, the Unity paradigm for describing Textures/Materials/Shaders is virtually the same as Maya's. It is part of why Maya and Unity make such a good pairing. If you understand the creation of materials in Maya, moving into Material and Shader creation in Unity will be much smoother.

However, having said this, some data is lost in the .fbx conversion process when moving assets from Maya to Unity. Unity deals with .fbx files. What it does with most any model that it imports is convert that model from Blender or Maya or C4D or whatever into an .fbx file. Unfortunately, complex shader networks created in Maya do not transfer as is into Unity. There almost always is some rebuilding when the assets move from Maya (or whatever 3D application you're using) into Unity.

Because of this reality and restriction, we aren't going to create really terribly complex shader networks in Maya. Generally, we will create very simple materials that may have a color and bump channel (sometimes a transparent channel), so we can get the feel for the efficacy of our textures; however, we will likely need to reassemble some of this within Unity.

Tutorials

Creating effective textures is truly an art form and many of the most successful texture artists I have worked with had a serious painting background. There is much to effective texture design that is beyond the scope of this volume, but there are some techniques that are useful to most all 3D artists when creating interesting texture maps.

In this chapter we will cover two tutorials. The first two will focus on essentially Photoshop techniques with a smaller section within Maya that allows for the creation of seamless textures and dirty textures. Creating textures that really feel grimy and that tile well can give a scene an entirely new sense of history—as if people and the weather have actually been there before—and hold up under scrutiny.

In our game, we are largely working with photorealistic or photo-inspired textures. To accomplish this best, good resource material is critical. Generally, when working on a commercial game it's a good idea to go and take your own photographs of the surfaces you wish to use in your game. However, taking good photos and working out the lens distortion issues is nontrivial and beyond the scope of this book.

Luckily, for our purposes, there are quite a few places for surface resource on the web. My favorite is at http://www.cgtextures.com. Loads of great textures there, most of which have had some work done on them to compensate for lens distortion issues, and many that have had the issues of seamless edges worked out for you. However, even with these great textures as base, you will likely find that some manipulation of the images is required to make it match your research, or just to make the textures visually yours.

So, as per the official licensing agreements of CG Textures: *One or more textures on this 3D-model have been created with images from CGTextures.com. These images may not be redistributed by default. Please visit www.cgtextures.com for more information*. (Note that CGTextures requires a quick registration and has a bandwidth limit per 24 hours. Still it's a great resource and worth the hassle.)

Tutorial 4.1: Seamless Tiled Textures

So before we get into the "hows" of creating seamless textures, we should chat a bit about the "whens." In the UV layouts we did in the previous chapters, there were times when all the UVs for a shape fit within the top-right quadrant. In this case none of the UVs were sharing any texture space. This means that the texture that is applied to that surface is very linear; each

pixel in the texture will be shown once on the surface. In situations like this, there is no need for seamless texture. We can paint a custom texture that wraps around the form and add or include any specific crack, stain, or bullet hole. There are times when this works great and in some ways is preferable. It allows for very interesting and accurate textures and texture placement.

However, there are other areas of the model, like the ground surface, where we did not make sure that the UVs were set within the top-right quadrant. Although having all the UVs not sharing any texture space allows for intricately painted textures, these textures can fall apart upon close-up inspection (unless HUGE texture files are used that slow your game to a crawl) because suddenly more and more of the screen is being filled with a smaller and smaller chunk of the texture file. Although a crate may be able to use a 512×512 texture since the crate takes up only a small section of the screen, if a 512×512 texture is stretched out over the entire floor surface of our dock, when the player looks at his feet and the floor takes up the whole screen, he'd see only one or two pixels of the texture file; it'd look terrible (Figure 4.1).

This is where seamless textures become powerful. If a seamless texture is created at 512×512, but repeated many times over the same dock surface, when the player looks at his feet, he may be seeing all 512×512 or even more if the texture has tiles small enough. It means that as the player looks out on the scene and the floor takes up a lot of screen space, the fidelity of the texture holds up much better (Figure 4.1).

There are inherent problems with tiling a texture over a large surface. The first is that it can become pretty obvious that a texture is being tiled as it is easy to visually pick out the repeating pattern. This problem can sometimes be mitigated through picking a texture that doesn't have too many large defining visual elements (Figure 4.2). This can also be mitigated by developing a good lightmap (much more on this later).

The second problem with tiling textures is when the tiles don't match up. If a texture is not seamless, it is easy to see where one copy of the texture ends and the next begins. This tutorial is out to fix this problem. Interestingly, solving the seamless problem is not a 3D issue at all, and thus not solved in Maya. We'll solve it in Photoshop.

FIGURE 4.1 The image on the left is a huge (4096×4096) texture stretched across the entire ground plane. The image on the right uses only a 512×512 image, but tiles.

FIGURE 4.2 Textures (even if seamless) that have a big easily identifiable element will produce output that the tiling is revealed too overtly.

Select and Prepare a Raw Texture Image

Step 1: Find a raw texture file that would work well as the base of the dock concrete surface. I'm using ConcreteBare0312_S (see the support web site, http://cgtextures.com/texview.php?id=44665).

Why?

There are actually a few parts of the dock surface. One part is tiled, another is a sort of worn painted cement, and then there is a raw cement section. This is going to be for the raw cement section. My research photo shows a sort of brownish cement, but the exact choice is up to you.

Tips and Tricks

Warnings and Pitfalls
Generally it's not a good idea to resize an image; it can create some mushy stuff on resampling (Photoshop can't always decide which pixels to leave out as it reduces the total amount of information). In this case though we will be adjusting the UVs anyway to make the texture look right once it's applied to the dock, so we have a bit more tolerance.

CGTextures allows for huge-sized textures. In a TV or film situation, using huge resource and piecing together a huge collection of big textures to create a massive texture that holds up on the big screen might be needed, but for a tileable texture, it hardly ever is. So download the smallest version of whatever texture you choose.

Step 2: In Photoshop, resize the image to 512×512. Select Image>Image Size. Click off the Constrain Proportions option, and enter 512 into both the Width and Height (pixels) input fields.

Why?

512×512 is a power-of-two size and thus will create an image that will render quickly and import cleanly into Unity.

Offset and Clone Stamp

Step 3: Offset the image by 256 pixels in both horizontal and vertical. Choose Filter>Other>Offset. Change the Horizontal and Vertical to both read 256. Be sure the Wrap Around radio box is checked. The results can be seen in Figure 4.3.

FIGURE 4.3 Offset and the results.

Why?

The problem with any image and trying to make it seamless is getting to the seams. The seams are the edges of the image. The Offset with the Wrap Around option activated does some important things for us. First, it offsets or slides all the pixels over (and/or down) and then wraps the pixels that it slides off the edge of the canvas around to the other side of the image. This means two important things. First, after the Offset filter has been applied, the right edge of the image matches seamlessly to the left edge of the image and the top and the bottom match as well. Second, it takes the old edges (the old seams) and puts them right in the middle of the scene where we can deal with them.

Step 4: Clone Stamp out the seams. The Clone Stamp is an incredibly powerful tool that allows for interactively painting the pixels from one part of an image to another. To use it, select it from the Photoshop tool bar, then hold the Alt (Option on a Mac) and click the area where the pixels are to be pulled from. Release the Alt and mouse, and then go and paint where the pixels are to be painted (in this case the seams in the middle of the image). The results are seen in Figure 4.4.

FIGURE 4.4 Clone Stamped image.

Tips and Tricks

The [and] keys will change the size of the brush (bigger and smaller). Often this is an important step in effective seam working. Make sure to have control of the brush size.

Tips and Tricks

The Clone Stamp tool has several options that (in CS5) show up at the top of the Photoshop interface. NEVER paint with Opacity and Flow both at 100 percent. The texture will become a blotchy mess very quickly, and will begin to show features too frequently, in effect reducing the visual information available in the texture. I like to paint with a Flow value of around 10 percent, which allows me to gently layer pixels onto a seam and through the combination with the pixels beneath, make an area that doesn't exist anywhere else on the texture. Think of the process as massaging the seam out, not painting it out.

Step 5: Save. File>Save and name the file `EntryWay_DockColor`. Be sure to save it in the **sourceimages** folder of the project file.

Tips and Tricks

The file format is not terribly important. Maya reads most image formats, although it can get pretty persnickety about .psd files if using Mental Ray. Unity, on the other hand, reads most anything. Since my original was a .jpg, I am saving it as a .jpg as well. But if there is a lot of layer action going on, don't shy away from .psd. Unity will keep the original multilayered .psd file, and import it as a flattened image.

Unify the Color Balance

Step 6: Run a High Pass filter on the image. Filter>Other>High Pass will open a dialog box. Within this dialog box, drag the Radius slider to the far right (250 pixels). This will make the image look quite gray (Figure 4.5).

Why?

Often, when sampling an image or cropping, the image looks fine until it is offset. Then the gentle gradients that are often visible in textures becomes apparent. Suddenly, when the left side of the image lines up with the right side of the image, the colors there can be totally different. This process allows for the unification of the color fields. The High Pass filter desaturates much of the colors, but leaves a data set that will work well with the coming steps.

FIGURE 4.5 Results of the High Pass filter.

Step 7: With EntryWay_DockColor still open, choose File>Open and open the original file used as the base texture (in my case ConcreteBare0312_S). This will become our source image.

Step 8: Go back to EntryWay_DockColor (Window> EntryWay_DockColor).

Step 9: Match color. Choose Image>Adjustments>Match Color. At the bottom of the Match Color dialog box, choose ConcreteBare0312_S (or your image) in the Source drop-down menu. Press OK (Figure 4.6).

FIGURE 4.6 Matching color to unify texture's color fields.

Step 10: Test the texture in Photoshop. Do this by again selecting Filter>Other>Offset and moving the sliders around to all sorts of different values. The result should remain seamless; the seams that once were there should never be seen.

Step 11: When satisfied, save.

Apply the Texture

Step 12: Open Maya (make sure the project is appropriately set) and open EntryWay.mb

Step 13: Open the Hypershade and graph the EntryWay_DockCement_Mat material. Open the Hypershade with Window>Rendering Editors>Hypershade. In the Hypershader choose the Materials tab, and then select the EntryWay_DockCement_Mat swatch. Select Graph>Input and Output Connections. This should appear like Figure 4.7.

FIGURE 4.7 Graphing the EntryWay_DockCement_Mat material.

Why?

What you're seeing here is how the nodes are connecting to create the material. The far left node indicates how the texture is placed within the UV space (by default 1:1), the second is actually the checkerboard texture, the third is the material, and the far right is the shading group. Once the material is graphed like this, it's easy to see how the material is assembled and how to make the desired changes.

Step 14: Rename the texture node. Still in the Hypershade, double-click the texture node (the one with pink at the bottom). This will open the node in the Attributes Editor. There in the file: input field enter `EntryWay_DockCement_Color`.

Why?

This is a bit of housecleaning that could have been done earlier. When a file node is created while creating a material, Maya automatically names it file##. In my case it was at file12. The problem is that this makes it hard to keep track of what nodes are where. Especially when there are so many checkerboards, it can become very difficult to see them visually. By taking a moment to rename, it becomes clear (especially to any other artists who may access this file later) what is going on.

Step 15: Replace the checkerboard with the new EntryWay_DockColor. Still in the Attributes Editor, look at the Image Name input field. It should read: sourceimages\Checkboard.psd. To change out the cement texture, click the folder icon to the right of the input field. Then, in the Open dialog box that comes up, choose EntryWay_DockColor.jpg. Click Open (Figure 4.8).

FIGURE 4.8 Results of swapping out checkers for new cement texture.

Why?

So what just happened? Notice that the entire dock didn't change; this is by design. In the previous chapter we assigned different materials to different parts of the dock. When we swapped out the checkerboard and defined a different image to describe the color attributes of the material, only the polygons with the EntryWay_DockCement material changed. Now we can adjust the UV sizes to make this texture the right size.

Step 16: Adjust the UVs to taste. Select the dock and choose Window>UV Texture Editor. Select the UVs that define the part of the dock that is our cement and scale (in all directions by dragging on the yellow square in the middle) the UVs up so that they become larger (meanwhile, your texture will begin to tile in the View panel). Watch the View panel as the handles are dragged in the UV Texture Editor to see how the size of the texture changes on the surface (Figure 4.9).

Tips and Tricks

Within the UV Texture Editor notice that multiple textures can be displayed in the Textures drop-down menu. This is because (in this case) we have multiple materials assigned to a single mesh. Sometimes when working with UVs it will be important to see how the UVs align with a particular texture, so toggle through them here.

Warnings and Pitfalls

If you press the folder button and are not taken directly to the sourceimages folder of the project, or if EntryWay_DockColor isn't sitting there waiting, stop. It means you are either in the wrong project or you've saved the texture file to the wrong location. Take a moment and either reset your project or track down where you've errantly saved the file and get things in order.

FIGURE 4.9 Scaled UVs to allow multiple repeating texture.

Conclusion

And there you have it. This same technique will work for most any texture that needs to be tiled. Admittedly, it can get trickier for surfaces like (ironically) tile, where getting the ends to line up can take some deft handling. But, the work will pay off. As large surfaces become visible, the effective texture will pay visual dividends down the road.

Notice that there are some good things happening here. Zoom down and place the camera about where a player would be in the game; the texture should hold up pretty well. However, when the camera is way up (as in Figure 4.9), the repeating pattern will be pretty clear. Some of this will become a nonissue once the scene is baked, and since we are never very high in relation to this dock, it's unlikely we'll notice the repeating pattern. If, in the game, we do have a distracting repeating pattern, we can go back and scale the texture a bit, or work with a larger sampling of texture, or both.

Tutorial 4.2. Nontiled Textures and Their Dirt

One of the biggest errors of young 3D students is that they are too clean. Yes, I agree it's hard to believe that 18- and 19-year-olds can ever be accused of that, but in 3D this is almost always the case.

This is what happens: The student goes out and does some good research, tracks down some great resource textures, creates the appropriate paintings of the surface from copying and pasting the necessary textures together, and then slaps that onto the surface.

The problem emerges once everything is put together. In reality, the region where two surfaces meet is a really interesting area. It collects all sorts of dirt, grime, and visually interesting things if it's an inside corner (think of where the floor meets the wall), and collects all sorts of drips on outside corners. When the texture artist fails to take this into account, the scene loses much of the visual information that clues the eye in on these all-important corners.

For the first part of this tutorial, we will look at how to put together a texture-for-texture space without overlapping UVs. For the second part, we will take this texture and dirty it down.

> **Step 1:** Select an object with nonoverlapping UVs and open the UV Texture Editor (Figure 4.10). For this tutorial, I will be texturing the small portico (downloadable at www.Creating3dGames.com) of the main door that lets Aegis Chung into the facility.

<div style="float:right; width:30%;">

Warnings and Pitfalls
Make sure that the object is selected in Object Mode. If in any component mode, the next step won't work. Outputting a UV Snapshot only works when the whole object is selected, not just its parts.

</div>

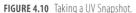

FIGURE 4.10 Taking a UV Snapshot.

UV Snapshots

> **Step 2:** Output a UV Snapshot. When the UV Map is displayed in the UV Texture Editor, choose Polygons>UV Snapshot (all within the UV Texture Editor). Within the UV Snapshot window, make sure Size X and Size Y both read 2048 and that the Image format is set to TIFF. Change the name to EntryWay_PorticoUV.

Tips and Tricks

Notice that the File Name input field includes a path. Notice that this path is (or should be) the project file and the images folder within the project file. The images folder is one of the default output locations for Maya. Once again, having the project set correctly raises its head.

Why?

Why 2048×2048? First it's a power-of-two value texture. But why not 1024×1024 or even 4096×4096 or even 512×512? This is a good question; what size to make a texture is dictated largely by experience and the situation.

In this case, we will be spending some time within this portico, and so we want to have a reasonable resolution so that the walls that surround the player holdup to visual scrutiny. Now, we may discover that we don't need 2048×2048 (that is in fact a big texture). I suspect a 1024×1024 might do the job just fine. But because Unity allows for some really easy adjustments in the size that it imports files to, there is little penalty from creating the texture a little larger for now, and then optimizing if need be or the situation allows. It's better to have the resolution and not need it than the other way around.

Step 3: Open the UV map in Photoshop (Figure 4.11).

FIGURE 4.11 UV Snapshot.

Preparing the UV Snapshot for Painting in Photoshop

Step 4: Copy the UV guidelines to another layer. The easiest way to do this is to open the Channels palette (Window>Channels). Ctrl-click the Alpha 1 channel (this will select the white lines), choose Edit>Copy, and then Edit>Paste. Open the Layers palette and rename this new layer UV Guidelines.

Why?

The UV Snapshot in Photoshop is the image that will serve as the guide to know what texture is being applied where. If a red line is painted through the middle of a wall on this map, bring this map into the color channel of the material, and the red line will appear in the scene (on the wall). This is tremendously powerful since texture is placed right where it should be on the mesh.

However, painting on top of the default image is a problem because it covers up the guides that help to know where on the surface is being manipulated. By duplicating the UV lines onto another layer, new layers can be created between this new UV Guidelines layer and the Background layer. So as the texture map is created it remains clear where on the object you are applying texture.

Tips and Tricks

Depending on the texture being built, this new UV Guidelines may be more effective with black lines. Remember a layer can have a stroke applied (Edit>Stroke) or inverse the white lines to black (Image>Adjustments>Invert).

Painting the Texture

Step 5: Lay down an initial color pass using photo reference. Figure 4.12 shows the results of my first pass. It is made with many copies of BunkerPainted0010 (http://cgtextures.com/texview.php?id=47345) for the white painted parts, and ConcreteBare0314 (http://cgtextures.com/texview.php?id=44689) for the cement floorboards. If you'd like to use these same textures the links are on the supporting web site (http://www.Creating3dGames.com), although feel free to use whatever you feel is most effective here.

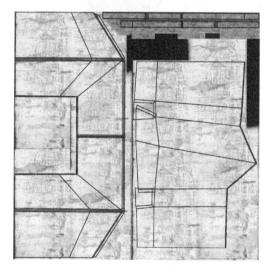

FIGURE 4.12 Initial color pass.

Tips and Tricks

As much as possible, try and use nondestructive methods to cobble together swatches of texture. My favorite way to do this is by applying layer masks to each layer, and then paint out sections by painting black on the mask. Then if I need some of that texture back later, I can just paint it back in with white on the layer mask.

Step 6: Find and download an image that provide some good grime for corners. Figure 4.13 shows ConcreteDirty0271 from CGTextures (http://cgtextures.com/texview.php?id=51950). We're looking for a straight edge (at the bottom of the image) and then an organic color shape next to that. Don't worry about the stuff at the top of the image (we'll mask it out).
Step 7: Import or cut and paste the image into the UV Snapshot. Scale it and rotate it so the "grime" sits at the base of the wall (Figure 4.14).

FIGURE 4.13 Base texture of our corner grime.

FIGURE 4.14 Placed grime layer.

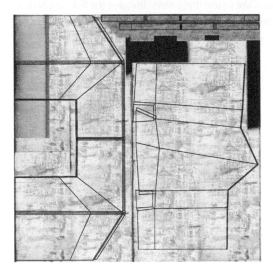

Tips and Tricks

Be sure that as these new layers are created or copy and pasted that they are named. As discussed earlier, naming is important both for the efficacy of the artist creating the asset, and for the artists who inherit assets later.

Layer Mixing

Step 8: In the Layers palette (and on this newly created grime layer), change the Layer Mixing setting from Normal to Multiply (Figure 4.15).

Why?

The Layer Mix option of the Layers palette is incredibly powerful. It allows the layers to interact in important ways beyond just "put this layer atop the one beneath it." Multiply is one of my favorites because its

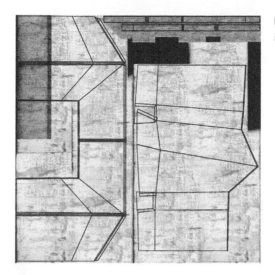

FIGURE 4.15 Results of using Multiply for Layer Mix setting.

result allows both the top layer and layers beneath it to be seen. Notice that once this is done, the painted cement beneath it is visible, but this layer has certainly changed its appearance.

Layer Masks

Step 9: Apply a Layer Mask. Make sure your grime layer is selected. At the bottom of the Layers Palette, click the Add Mask button. Paint the mask to paint out the parts not desired (Figure 4.16) and allow this grime layer to blend better with the texture beneath it.

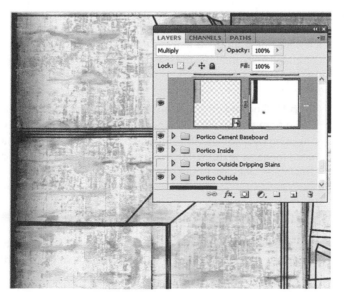

FIGURE 4.16 Applied and painted Layer Mask.

Tips and Tricks

The easiest way to apply the Layer Mask is still within the Layers palette. Remember that the Layer Mask works by painting black or white to hide or show various parts of the image. Also note that the keyboard shortcut X will swap the foreground and background colors to allow for quick addition and subtraction of the mask.

Step 10: Duplicate the layer and apply to all inside corners. Scale, rotate, copy, and paste as needed (Figure 4.17).

FIGURE 4.17 Inside corners dirtied up with masked layer.

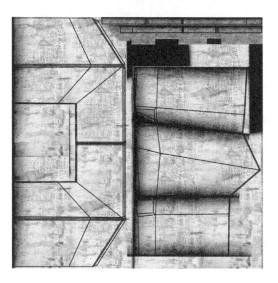

Tips and Tricks

A few keyboard shortcuts that make this quicker include Ctrl-J (or Command-J) to duplicate the selected layer and Ctrl-T or (Command-T) to free transform a layer.

Step 11: Find and download an image to provide dripping that comes down from a top seam. Check out the Decal/Stains section of CGTextures. I'm using DecalsStains0061_1 (using the smallest size since that's all we need for game textures (http://cgtextures.com/texview.php?id=53349)). The image looks like Figure 4.18.

Why?

This texture again has the important qualities of a flat edge, and has the added benefit of the nonstained part already being taken out. However, the same techniques we looked at in the previous steps could be employed if you find a texture that you prefer elsewhere.

FIGURE 4.18 Dripping texture from CGTextures.

Step 12: Import or copy and paste the drip texture to spots along the top of the form (Figure 4.19).

FIGURE 4.19 Dripping texture applied.

Tips and Tricks

Notice that in this case there are flat areas where placing this dripping texture would be simple, and other areas that are diagonal where it's a bit trickier. The easiest way to do this is still with the Free Transform tool (Ctrl-T). When in the Free Tranform mode, if Ctrl is held down, you can deform the image to alter the perspective and allow those drips to run straight down the wall starting from a diagonal top.

Warnings and Pitfalls
Notice that this collection of layers is also using Multiply as the Layer Mixing setting.

Step 13: Continue to layer additional texture images as needed in the texture. Remember that layered textures add a real sense of visual depth to any scene and ensure that the scene is yours with your original touch. My finished texture can be seen in Figure 4.20.

FIGURE 4.20 Finished layered texture.

Tips and Tricks

When working with many, many layers of textures, it is always worth the time to spend a bit of time organizing and labeling. I like to use the ability to make folders in the Layers Palette to organize my layers.

Saving Multiple Files

Step 14: Save the file back to the images folder as `EntryWay_PorticoUV-Raw.psd`.

Why?

It is always a good idea to have a copy of the construction file in case an edit to the texture is needed once it has been placed in the scene. However, my file is clocking in at 156 MB and it is usually not a good idea to force Maya or Unity to chew on a file that size (if nothing else it just takes too long to do so). By keeping a copy of the construction file in the images folder, this version is always available to come back to, but you can also save another version (in the sourceimages folder) that will actually be used in the Maya/Unity scene.

Step 15: Hide the UV Guidelines layer and save the file to the sourceimages folder at `EntryWay_Portico_Color.psd`. In the Save As window be sure to turn off Alpha Channels and Layers.

Application in Maya

Step 16: Apply the texture to the portico in Maya. Back in Maya, open the Hypershade (Window>Rendering Editors>Hypershade), track down the material that is applied to the EntryWayPortico (do this in the Hypershade by choosing Edit>Select Materials from Objects), and graph the material (Graph>Input and Output Connections). Double-click the node that contains

the checkerboard (probably named file16 or something like that). In the Attributes Editor rename the node to EntryWayPortico_Color and click the folder next to the Image Name input field. The directory should be the sourceimages folder where EntryWay_Portico_Color.psd can be chosen as the image to define the color of the material. The results are shown in Figure 4.21.

FIGURE 4.21 Applied texture in Maya.

Step 17: Finish texturing the EntryWay scene. I know again, lots to do, but you've got the tools to do it (Figure 4.22).

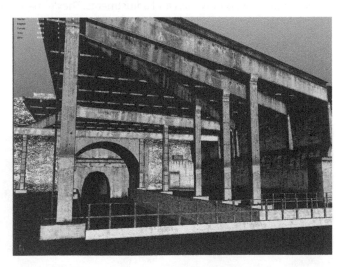

FIGURE 4.22 Textured scene.

Conclusion

There's the process. The rest of the scene can be textured using one of the two methods looked at in this chapter. Which technique to use will be dictated by how big the UVs ended up being in the UV Texture Editor. If all the UVs of a shape are within the top-right quadrant, create carefully custom-painted textures like those shown in Figure 4.21 and explained

in Tutorial 4.2. If working with a very large space (like the dock) where the situation calls for a smaller texture tiled, then the first tutorial is the process to use.

The "Homework and Challenges" section includes renders of other assets in our game. Look at how these different shapes might call for different methods. My choices can be found on the accompanying web site (http://www.Creating3dGames.com). Pick them apart and see if our choices matched.

Additionally, if you've got the idea of texturing and don't want to spend time reworking, just download my version to continue on to the next chapter, where we get to start taking the hard work we've done in Maya and place it within Unity, where the fun really begins.

Tips and Tricks

One of the myths that tutorials sometimes propagate is the one that creation is a linear process. In the tutorial, the author creates something, then creates the next object, textures it, and never goes back. The reality (at least for me) is that the creation process is full of "oops" and "shoot, didn't notice that, I need to fix it." As you work, be on the lookout for mistakes that you've made in the past—a stray poly here or there, UV layouts that just aren't as efficient as you'd like them to be, and so on. As you look through the example files from these tutorials you'll find loads of these sorts of tweaks and adjustments. They're part of the fun of creating.

Homework and Challenges

Challenge 1: Texture the hallway (Figures 4.23–4.27).

FIGURE 4.23 Textured entrance to hallway.

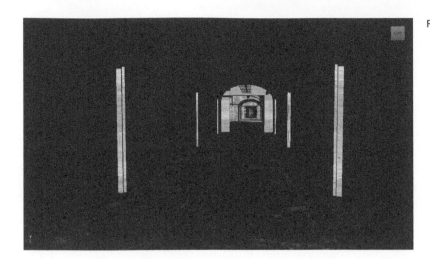

FIGURE 4.24 Long hallway textured.

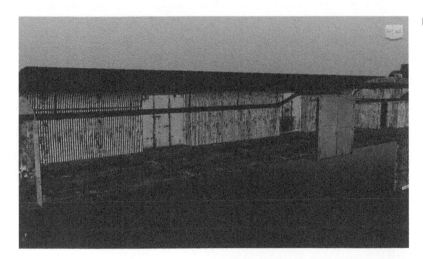

FIGURE 4.25 Textured dock.

FIGURE 4.26 Textured junction.

FIGURE 4.27 Textured pit.

Challenge 2: Texture props (Figures 4.28–4.33).

FIGURE 4.28 Textured CCTV camera.

FIGURE 4.29 Textured device.

FIGURE 4.30 Textured EMP.

FIGURE 4.31 Textured keypad.

FIGURE 4.32 Textured lock box.

FIGURE 4.33 Textured trolley.

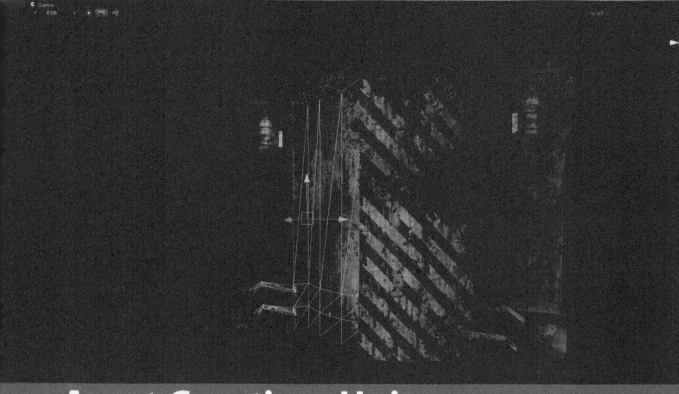

Asset Creation: Unity Scenography Importing

Unity

The fun can begin. The assets of the level design are designed and produced. Now we can get to the fun where we actually get to walk around and explore the level within Unity.

Remember that it is always a good idea to actually import assets into Unity well before this point. What looks good as the scene is tumbled around in Maya may not when the player is walking through the space in Unity. The textures that seem to be a great move in Maya just may not hold up as planned inside Unity. The process of prototyping a space is an important one, and dropping a prototyped space into Unity will provide very instructive time for the space's feel and mood.

However, in the linear medium that books are, we are working in the classic "finish this step and then do this one." So, here we are with a completed model that we will be bringing into Unity.

The Plan

Here's the plan for this chapter. First, out of necessity, we will very quickly look at the Unity interface. Because this is covered fairly well in the free Unity documentation we won't spend a lot of time covering all the details of what is what, but we will spend just a bit of time understanding what these parts are and how best to use them.

After a quick run through the interface, we will jump back into Maya to explore how best to prepare the file for export. There is always a bit of cleaning that can be done to make the process smoother. Here we will also discuss how best to transfer the files into Unity, and why I argue to always do the .fbx export manually (and not simply drag the .mb into the Unity assets folder).

Finally, back in Unity we will import our completed scene and do a bit of optimizing to make sure the game can run smoothly. We will optimize our textures, and dig down to find the resolution we need to give the visual effect we want while keeping the amount of resources required to run the game low.

Unity Projects

One of the reasons Maya and Unity make so much sense as sister technologies is that Unity's working structure is much like Maya's. Among the equivalencies is the importance of the project file. In the Maya chapters we worked very hard to establish a project and to make sure all relevant assets were stored in the appropriate locations within this project file. Unity is the same way—in fact, Unity will not even open unless there is a project defined.

Before we get to defining projects, we need to talk a bit about how Unity creates and deals with projects.

Like Maya, when a project is created in Unity, a new folder is created on the hard drive. This folder will include several subfolders that we will get into later. This folder is important in several ways, and treating this folder right will be important to an uninterrupted creation process.

Tutorial 5.1: Creating a Unity Project

If you have not downloaded and installed Unity at this point, please do so now. Remember the standard Unity license is free and available at http://www.unity3d.com. Just go to the Download section. There are some very nice features in Unity Pro (real-time shadows, deferred rendering, occlusion culling), but to learn Unity, there is plenty that can be done with the standard (and free) Unity.

To set up a new Unity project and to set up Unity to effectively allow for the management of projects, do the following.

> **Step 1:** After installing Unity, when run, Unity will present a Unity-Project Wizard window (Figure 5.1). This Wizard has two tabs: the Open Project and Create New Project.

FIGURE 5.1 The Unity-Project Wizard.

Tips and Tricks

If you've already been using Unity, there will be a slew of projects listed in the Open Project tab. In fact, if you've already been using Unity, the wizard may not be presented at all. Unity automatically defaults and opens to the last opened project and thus skips the Project Wizard. I'm not a big fan of this method because it opens up a lot of possible mistakes of saving files to the wrong project. Luckily Unity has a setting (Edit>Preferences) called Show Project Wizard at Startup. Activate this so that when Unity is launched you always know that you are working in the correct project.

Step 2: Select the Create New Project tab.
Step 3: Click the Browse… button. Choose a location to save the Project file. Create a new folder (Unity requires that the location of a new project be within an empty folder). In our case, it's easiest to find where you have your Incursion–Maya folder and (not within that folder but) at the same place create a folder named `Incursion-Unity`. Click Select Folder.

Why?

In the development of a game, there will be a lot of assets created and manipulated. If you've been doing 3D production for a while, you know how easily you can wind up in a mess if you don't keep a good eye on where you're storing your textures. In a game there not only are models and textures but a slew of other assets. By keeping the Maya file and the Unity projects in close proximity to each other it's not only easier to get assets from one place to another, but it keeps all the relevant data near.

Step 4: Back in the Create New Project tab, look in the "Import the following packages:" section and choose "Character Controller. unityPackage". Click Create.

Why?

There are a huge number of packages made available in this tab. **Packages** are just what they sound like: they are a little parcel of assets that include information on how these assets may (or may not) be tied together. Packages are a great way of moving certain types of assets (especially objects that have scripts draped on them) from project to project.

Beginning Unity users often simply click all the packages. "I might need them sometime," they say. And this could be true, they might be needed sometime, but until they are used, there is a tremendous performance price that is paid. Whenever a new script is made or changed, Unity recompiles all the scripts that are within the Assets folder. So if there are 50 or 100 scripts that were imported as part of these other packages that aren't used, Unity will have to take a look at them every time script editor is touched. Popping in and out of the script editor is a very common occurrence, and these slow compile times can really start to add up. Additionally, by keeping the project clean you ensure that you don't have some rogue script floating around your project that is affecting your project in ways you don't know about.

Having said all that, we do know that we will be using the Character Controllers that come shipped with Unity (custom controllers can be built, but the included ones are sophisticated and powerful so we will restrain ourselves from reinventing the wheel and roll with the ones provided). So, now is a perfect time to include them.

If later we decide that we need the contents of other packages (which we will), we can always import them at a later time (which we also will do in the process of the tutorials).

About the New Project File

So what's happening now? Unity will chug along for a minute before presenting the Unity assembly interface. What Unity is doing is unpackaging the packages you've selected, as well as a few other packages of data, and putting them in some folders it will create on the hard drive. In the OS, look at the newly created Incursion–Unity folder, and find that it contains three folders: Assets, Library, and Temp. Generally, don't mess with the Library or Temp folders. The Assets folder though is where we will be doing much of our work.

Importing Items Paradigm

Don't actually import anything right this minute, because it's important to understand how we will interact with this new project file. The way to import assets into Unity is to (in the OS, *not* in Unity) find the **Assets** folder within the project folder. Then, using the OS, just drag the things Unity should access into the Assets folder. When a new model, texture, sound, or movie is placed there, Unity recognizes something new and acts on it—it attempts to understand the file and always attempts to import it. What this means is the

Assets folder should be treated with a bit of reverence, and not filled with garbage or files that won't be part of the game.

I've seen developers and students just throw their entire Maya project folder inside of this Assets folder. This is really a poor work flow as it forces Unity to analyze all the files (including all the raw texture construction files, swatches, incremental saves, etc.) and indeed to then chug away to convert all that stuff into forms Unity likes to work with. There really isn't a "please stop importing" button or a "ignore this stuff" option, so it becomes important that only the assets that are going to be used in the game end up in that Assets folder. Otherwise, there will be much waiting done as Unity chews on mounds of stuff that will never be used.

Exactly which items to actually place in the Assets folder is actually a little trickier than it might sound. Some developers like placing their Maya file (.mb or .ma) there and then sorting through their sourceimages folder to pull out the textures they know they finally used in their project and including those in the Assets folder. I'm not a fan of this approach because it quickly becomes an unmanageable collection of files if there are multiple Maya files and keeping track of what textures are used where can be a chore.

Instead (and much more on this later), I prefer to export my files manually from Maya as a .fbx file and simply have that file embed the media it uses for the material creation. A streamlined collection of files into the Assets folder means a streamlined import process and a much more streamlined production cycle.

Deleting or Rearranging Items

While placing assets into the Unity project happens in the OS, deleting files from the project shouldn't be done in this way. When assets are dropped into the Assets folder, and Unity imports them, it creates a series of metadata files that help Unity keep track of where files are at and how they are tied to other files. The problem is that if files are deleted or moved around in the OS, the metadata doesn't go with it—or update to represent these changes. This can really mess Unity up as it loses track of where assets are.

Instead, whenever an already imported asset needs to be deleted or reorganized, do it within Unity. This will happen within the Inspector window and we will look at how to do this in the tutorials to come. However, just keep in mind, from the project's inception, to bring in assets to be used in the game outside of Unity (in the OS), but once the assets are in Unity do all organizing and deletion within Unity—it will save much frustration. The details of Unity's import process will be covered in the coming pages.

Warnings and Pitfalls
I know I just said it, but it bears repeating. Reorganize or delete the asset files only within Unity. Do not do so in the OS's file browser.

Unity Interface

Figure 5.2 shows the Unity interface and what the parts of the interface are. We aren't going to spend a huge amount of time picking through this since, by this time, I'm sure you're anxious to get into it, but a quick overview will help in understanding how Unity "thinks."

Toolbar

Across the top of the interface are some navigation and organizational tools. The first four tools are navigation tools. However, if these are used to navigate, a monumental amount of time is lost. If you're familiar with Maya's camera navigation tools, this will be an easy transition. Alt-left-mouse-button-drag orbits (or spins) the camera, Alt-middle-mouse-button-drag tracks (or slides up and down or back and forth) the camera, and Alt-right-mouse-button-drag dollys (or moves closer or further) the camera. Stay away from the interface navigation buttons. Use the keyboard/mouse shortcuts to move the camera about in the Scene view.

On a side note, to make Unity further like Maya, W activates the Move tool, E activates the Rotate tool, and R activates the Scale.

Next in line are the Pivot/Center and Local/Global toggle buttons. These have to do with where Unity places the handles for a selected object. They allow an object to be rotated around a pivot point that has been defined in Maya, or around the geometric center, and choose to move an object relative to its local orientation or relative to its local rotation. More on these later.

The VCR-looking buttons are about moving from the authoring environment to the game environment. Pressing the Play button plays the game. Pressing it again stops the game and returns to the authoring environment. The Pause button pauses the game play, which allows any physics simulations to stop or for the developer to take a close look at what's happening. The last button of the batch is the Step button, which allows for movement through the game or simulation one frame at a time.

On the far right are two drop-down menus that allow for hiding (or making visible) various layers. Or choose various preset layouts. Objects can be assigned to layers. The layers can become very powerful because a layer can be hidden within the Scene view, and certain cameras can be told to see only certain layers (and this can be used with things like Raycasting). The Layout tab can be very handy if you are the kind of software user who tends to set up custom layouts for various tasks.

Scene

The Scene area is where the game is actually constructed. In this window objects can be placed or manipulated in space. This is most like Maya's View panels and even has that handy **Scene Gizmo** (in the top right corner), which helps understand where the editor camera is in global space and allows for quick movement to the various Top, Bottom, Right, and Left othrographic views.

Note that there are several buttons at the top of the Scene area including the ability to show how the scene is presented. The scene can be shown as Wireframe, with Alpha, with or without Lights, Grid, and/or sound.

The other thing that is important to notice about the Scene area is that it's hiding the Game area.

Game

The Game view is actually what the game will look like. When you Play the game (Play with a capital P meaning you press the Play button), the Game window will come to the foreground where you actually see what happens in the game.

This actually seems to me to be a really unintuitive way to work. Having either the Scene *or* the Game view visible can sometimes cause real problems when trying to understand what is happening in the game or when troubleshooting. If you have a big enough monitor to support it, you will find it worth your while to rearrange the default workspace to be able to see both the Scene and Game at the same time.

Tips and Tricks

To rearrange your workspace within Unity, just click and drag any of the tabs where the name of the area appears. So Game tab can be grabbed and remounted below the Scene area, or move the Hierarchy and Project views to your second monitor. It's really an important update to Unity 3, and makes Unity a much more configurable tool. Figure 5.3 shows how I have my workspace set up with my dual monitor setup.

FIGURE 5.3 The WatkinsCustomLayout, made to utilize dual monitors by dragging areas of the interface around. Note the Console visible (an important tool not visible in the default layout).

Inspector Panel

This does exactly what it sounds like—it allows assets to be inspected. If an asset is selected in any view or panel (Scene, Hierarchy, or Project), the attributes of that object will be visible in the Inspector panel (think the

Attribute Editor in Maya). Not only does this allow for the inspection of the asset, it also allows for changes to be made to the attributes of the object. Lots of attributes and connections can be seen here. Which scripts are attached to which GameObjects can be seen. Which texture is assigned to a mesh can be seen. Further, even important details like which scripts are talking to which other objects in the scene are laid out here.

Hierarchy Panel

This and the Project panel work in close concert. The Hierarchy panel shows what objects are in the scene. Here the organization of the objects can be changed (which objects are children of which) and, when the game is playing, can show what additional objects have been instantiated (which means "created during game play"). To get assets to the Hierarchy (and thus in the game), either put them there programmatically (via script) or drag them from the Project panel.

Notice that the Hierarchy panel has a Create drop-down menu that allows for the addition of all sorts of Unity-generated assets to the scene. This can also be done via the GameObject>Create Other drop-down menu.

Note too, that there is a search input field to find an asset that you know is in the scene but you can't quite find by perusing the list.

Project Panel

Think of this panel as the library or storage bin. This is where all the assets that are available for the game live until they are dropped into the Hierarchy (or pulled over via script). Remember that when assets are represented in the Hierarchy panel, they are in the game as well.

The Project panel is essentially the Assets folder. In the OS's file browser, when things are dragged into the Assets folder—and after they have been imported and understood by Unity—they will be presented in the Project panel. It is here that reorganizing and deleting of assets should be done (as discussed earlier in the chapter).

Notice that here too is a Create drop-down menu with a different collection of Unity-generated assets. Also, here new Folders for organizational purposes can (and should) be created to organize the assets into logical bins for easy access. Lastly, notice that here too is a search input field to find a particular asset if it's not immediately visible.

Using It All

So there's the crammed interface overview. The best way to learn an interface is to use it. The pieces and method to the madness begins to become clear. So let's do that.

Tutorial 5.2: Exporting from Maya

Optimizing in Maya

"What?!" you cry, "I thought we were about to get into Unity…finally!" Agreed, it's time to walk around the space we've made. However, as is the case with much of 3D, effective preparation of assets in earlier stages yield superior results later. Cleaning up the file in Maya will ensure a smoother transition into Unity, and exporting manually from Maya will ensure only the needed assets get transferred.

Step 1: Open the scene in Maya. In this case, it will be the EntryWay.mb file that we have been building in earlier tutorials.

Step 2: Delete All History. Choose Edit>Delete All by Type>History.

Why?

Hopefully you've been cleaning your history as you were working in Maya, but here's the chance to make sure there are no lingering unwanted data nodes floating around your file.

Step 3: Remove unused Materials. Open the Hypershade (Window>Rendering Editors>Hypershade). Within the Hypershade choose Edit>Delete Unused Nodes.

Why?

If it's not used, why include it in the data being passed around?

Step 4: Check for orphaned nodes. Open the Outliner (Window>Outliner) and make sure that all the elements listed there are accounted for in the scene. Occasionally, even after cleaning history, there can be some leftover remnants of modeling process in the past (groups without anything in them, or other null objects). If any of these are present, delete them.

Step 5: Double-check all the naming. In the Outliner and the Hypershade make sure there are no pCube25 objects or lambert26 materials. Every object should have a descriptive name that makes sense not only to you, but would make sense to someone else inheriting the file.

Warnings and Pitfalls
Remember that there are some default materials here that can't be deleted (lambert1 and particlecloud1). Don't worry about those, they can be left as is. It's part of the beauty of manually exporting the Maya file that none of these default nodes will be included.

Why?

Taking time in the middle of the creation process to name objects and materials is not a favorite of beginning artists or students. The students think they can select the object and know what it is, so who cares what the thing is actually named? The problem is twofold. First, when working in Unity and working with scripts, sometimes objects will be called by name, not by the Unity user selecting them. If there are 50 spheres in the scene, it really slows the process trying to track down exactly which sphere is what. Second, game production is very often a team activity. Even a project that a solo developer began can often end up being a team project before it sees release. Team members that inherit a poorly named file with poorly named assets within do not remain happy for long. Name your stuff.

Export Options

Unity has attempted to make the Export/Import process very painless by doing a lot of the conversion process behind the scenes. Technically, this .mb file could just be dropped into the Assets folder of the Incursion–Unity file. Then in the background, Unity opens a version of Maya (the Render application actually) and converts the .mb into a .fbx, which it can then read. Unity actually does this with any of the file formats it supports (i.e., opens C4D and exports the C4D file into an .fbx). On the surface this seems like a really amazing and painless process as Unity "automagically" converts bunches of things into the formats it uses.

However, I have found through many projects that I prefer to manually export files from their respective applications. Here are my reasons:

- When Unity does the conversion (via the 3D software), there is no way of knowing what version of FBX the 3D software is attempting to use and if that particular version is compatible with the version of Unity being used. For instance, there were some significant differences between FBX2010 and FBX2011, and FBX2011 stuff was not coming into Unity at all until Unity had a chance to catch up with the new file format.
- While Unity is doing the converting, you are powerless to intervene in the process. If it crashes, is it crashing on export from the 3D application or crashing on import into Unity? Very tough to troubleshoot without knowing which is the problem.
- When Unity does the conversion, it is up to the user to include all the relevant texture files that are used in the scene. If the user misses a file, Unity forgets that the material is ever tied to it, which means the materials all have to be relinked manually. It's quick to do this but can add up quickly.
- By manually exporting you are creating another backup of your model and work in another file format. As a professor, I have seen at least one student each semester with a .mb file that suddenly shows up at 0 kb—it's gone. While using Incremental Saves in Maya can help prevent some tears, it is certainly nice to have the asset in another format in case something goes bad with your Maya install, or some other catastrophe happens mid-production cycle.
- In a team situation, manually exporting from Maya means that other members of the team do not have to have Maya installed on their machines to access the files that are output. This means that a team could have artists using a wide variety of 3D applications, and they could all be assembled on a machine without any licenses of the 3D applications (perhaps used by a scripter or programmer).
- By manually exporting the file from Maya, all the necessary textures can be embedded into the .fbx exported. This means one file is moved into the Assets folder for each Maya scene built. When Unity unpacks the .fbx it will create a sister folder where it includes all the relevant textures. This means that automatically, all the textures involved in a particular Maya scene are organized. It makes it easier to find assets when in the midst of heated Unity development.

So, if you buy my reasoning, here are the simple steps to manually control the export/import process in Unity.

Step 6: In Maya, choose File>Export All.

Step 7: In the Export All dialog box, change the Files of type: drop-down menu to **FBX export**.

Step 8: In the Options… section of the Export All dialog box expand the File Type Specific Options, then the Include section, and finally the Embed Media. Check the Embed Media option.

Why?

Embed Media means that all the textures used in the scene will be included in the .fbx file that is exported. It essentially packages all the used textures and keeps them with the geometry file.

Step 9: Still in the Export All dialog box, expand the Advanced Options and the FBX File Format options within. In the Version drop-down menu choose FBX 2010.

Why?

FBX2011 is a new format that has had some problems with early versions of Unity 3. By using FBX 2010, all the important characteristics are carried through to Unity, but with a much more reliable flow. Unity has a good habit of catching up with hotfixes, and hopefully the FBX2011 wrinkles will all be ironed out. Knowing and controlling the export format, however, is still an important part of the troubleshooting process.

Step 10: Enter EntryWay into the File name: input field and navigate to the Assets folder of Incursion–Unity. Press Export All (Figure 5.4).

Warnings and Pitfalls
These steps are very specific to Maya 2011. If you are using any earlier version of Maya be aware that the step details may be a bit different.

Tips and Tricks

Next time a file is exported from Maya, these settings will be remembered. So it takes just a moment to set up a reliable workflow, but things go much smoother when it ends up in Unity. Do remember that these settings have been changed. Maya works hard to remember what settings were changed last time, and if you're dealing in other situations, you may not want these same settings.

The Import Process

Interestingly enough, by saving the EntryWay.fbx file into the Assets folder, a big chunk of the importing has been done. When Unity is swapped to or launched (and make sure it's pointed at the Incursion–Unity project file), Unity will look at this new .fbx file and start chewing on it.

FIGURE 5.4 The Export All dialog box with the two important settings to change before exporting.

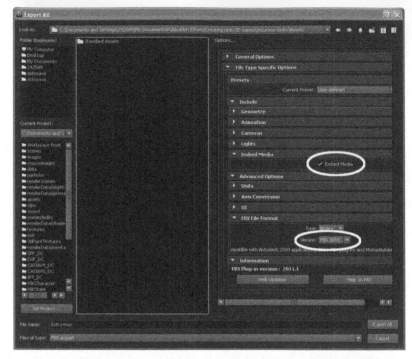

On a PC, disconcertingly the Unity interface will not be visible except for an Importing Assets: progress bar (although Windows 7 will show some nice detail of progress in the Taskbar). On a Mac, usually there is a bit more of the Unity interface visible. But either way, watch for this progress bar to know that Unity is working on understanding the new assets it has been presented with (Figure 5.5).

Once Unity has indeed chewed on all the assets, the project file should look something like Figure 5.6.

There are several things worth noting in Figure 5.6. Let's start from the bottom up.

The **Standard Assets** folder is actually the result of setting up the project and importing the Character Controller package. Any of the default packages that ship with Unity will be placed within this Standard Assets folder. It's a handy way to separate which scripts are yours and which came from Unity. It's wise to not place any non-Unity provided assets within this folder to keep track of what assets came from where.

FIGURE 5.5 The Importing Assets progress bar may be the only indication that Unity is indeed importing the assets it's been given.

FIGURE 5.6 Results of the export/import process.

The **Materials** folder is new since the EntryWay.fbx was imported. When Unity imported the .fbx and understood what it was, it created this folder and in it are all the materials that Unity has applied to the polygon meshes you built in Maya. We will be adjusting the attributes of these materials as time goes on. Generally, there is little need to mess with this folder or its organization.

The **EntryWay.fbm** folder is the result (and benefit) of manually exporting the .fbx file from Maya. In this folder are all the texture files created for use in Maya. These specifically are the texture files that are used on the geometry contained in EntryWay.fbx.

EntryWay with its unique icon is the **Prefab** of the imported Maya .fbx. This is the model created in Maya with the materials attached to the meshes. To understand what this is, we need to talk nomenclature for a minute.

Unity Nomenclature

GameObject

GameObjects are essentially things in your scene—anything that is in the scene is a GameObject. GameObjects can be thought of as containers; they can contain all sorts of components including cameras, lights, geometry, audio sources, audio listeners, and so on. GameObjects can hold lots of components at once. For instance, look at the Hierarchy panel of the scene and there is a Main Camera object there. This is a GameObject with a Camera component on it. If the Main Camera is selected in the Hierarchy panel, the Inspector will show all the components that are actually attached to this GameObject (including an Audio Listener).

Sometimes, certain GameObjects include other important items like geometry. Looking at the Project panel, the prefab EntryWay is a type of GameObject that includes meshes with attached materials.

Prefabs

Prefabs are GameObjects that can be reused. Sometimes these prefabs contain meshes, as EntryWay does, but they can also contain other types of components (audio, texture, text, particles, etc.). When prefabs are dragged into the Hierarchy panel (or into the Scene view, which also then populates the Hierarchy panel), an instance or copy is made in the scene. Multiple instances can be placed in the scene, and if the original prefab is ever altered the changes inherit down to all the instances placed within the scene.

Scenes

Unity thinks of **Scenes** in the same way that Maya does. A Unity scene file will contain lots of different assembled assets. Any particular game may contain several scenes that the player passes through over the course of the game. A scene can contain a single prefab, or many. Often multiple scenes can make for

a quicker startup to a game (since the starting scene does not contain the entire game), but means that there are loads as the player moves through the game. Currently in our tutorial, we do not have a Unity scene saved yet but we soon will.

Now that we know a bit about what is in the Unity project, we can start assembling and tweaking a Unity scene.

Tutorial 5.3: Importing, Tweaking, and Placing Scenography Assets into Unity

Step 1: Save a Unity scene. Choose File>Save Scene. In the Save Scene dialog box, name the scene `Scene-EntryWay` and Save.

Why?

Before we start creating or assembling things, saving the scene where things are going will speed up the process. Saving often is always a good idea, and being able to quickly press Ctrl-S or Command-S to save allows for a minimal amount of work to be lost.

Tips and Tricks

Notice that by default Unity points to the Assets folder within the project file. At this point, saving the Unity scene right to the Assets folder will be fine, and leaving EntryWay and EntryWay.fbm at the Assets folder level is no problem. However later it will be important to start organizing assets.

Why?

Notice that once a scene is saved to the Assets folder, a new asset will appear in the Project panel. This will have the Unity logo as its icon to indicate that indeed this is a Unity Scene file.

Step 2: Delete the Main Camera. In the Hierarchy panel, select Main Camera and press Delete on the keyboard.

Why?

Main Camera in this case is a pretty useless GameObject. Yes, it would allow us to see the model in the game, but it gives us no information on scale and it can't even be moved in its present state in the game. Deleting it will make room for the kinds of camera and control that is needed.

Step 3: Place a First Person Controller into the scene. In the Project panel, expand the Standard Assets Folder and then the Character Controllers folder. Drag the First Person Controller prefab from the Project panel into the Hierarchy panel.

Why?

By moving the asset from the Project panel (our library) to the Hierarchy panel, the prefab First Person Controller has been placed into the game. Alternatively, this could have been done by dragging the First Person Controller prefab into the Scene window.

Why?

So why place the First Person Controller now when there is nothing for it to do? This is a good question and an important part of the scaling process. The First Person Controller prefab has some important information such as size. If the First Person Controller instance is selected in the Hierarchy panel, the Inspector panel will show the attributes of the instance. Note that the height of the Character Controller is 2 (meters).

This is important because now there is a guideline object to help us understand how big the later-placed objects should be. As other assets are placed in the Unity scene, they will be scaled around the First Person Controller. Although this may seem counterintuitive—it seems like it would be easier to scale the controller to fit the scene—this ensures that the scale of the objects is appropriate for the world scale. This is particularly critical for functions like physics. If the objects in the scene are very large or very small, the physics simulations will always appear off.

Step 4: Move the First Person Controller instance to 0,1,0. Select the First Person Controller instance in the Hierarchy panel. Then in the Inspector, look to the Transform component and change the Position X=0, Y=1, Z=0.

Why?

By placing the First Person Controller at 0,1,0 we are placing it at the world center with the bottom of the controller on the ground (it's 2 units high with its center at the geometric center so Y=1 puts its bottom on the "ground").

Step 5: Center the First Person Controller in the Scene window. Still with the First Person Controller selected in the Hierarchy panel, press F on the keyboard. This will center the selected element (First Person Controller) in the Scene window.
Step 6: Place the EntryWay prefab into the scene. This time, drag the prefab EntryWay from the Project panel into the Scene window.
Step 7: Place the EntryWay instance at 0,0,0 in the world space. In the Hierarchy panel, select the EntryWay instance and in the Inspector set the Position X,Y,Z to 0 (Figure 5.7).

FIGURE 5.7 Imported and placed First Person Controller and EntryWay (your results may be a bit different). Not quite right yet, eh?

Why?

When there is little in the scene, moving prefabs into the scene can be a strange experience. It is very tough to understand where an object is in world space or even how big the object is within that space. By moving both the First Person Controller and EntryWay to world center, we can get a good view of what the size is of the imported elements.

Step 8: Scale EntryWay to fit appropriately in the scene. To do this, tweak the EntryWay prefab's import settings. In the Project panel, click once on EntryWay. This will open the EntryWay's characteristics in the Inspector. Specifically, in the FBXImporter section, the Inspector will show the settings Unity used when importing EntryWay.fbx into the Unity project. Change the Scale Factor to .5 and press the Apply button. Now adjust the Scale Factor as needed (Figure 5.8).

FIGURE 5.8 Scaled EntryWay. For this example the setting of 0.5 was the best. This may be different in your scene.

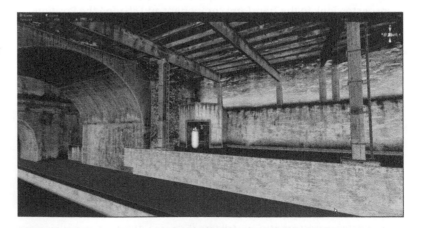

Why?

Why not simply scale the object in the Scene view? In many cases, that would be perfectly acceptable, and actually in this case that would work since the EntryWay prefab is likely to be used only once. However, when a prefab is going to be used a lot of times, it is best to adjust the Scale Factor

of the FBXImporter so that every time that prefab is placed in a scene it is already at the right size. Additionally, by making sure this is the right size on import, it keeps the work flow smooth and the size of everything constant if the project ends up inherited by another artist or scripter.

Tips and Tricks

Scaling of objects is often a battle when working between 3D applications. Generally, 1 unit in Maya is 1 unit in Unity. So if your tool of choice is exclusively Maya, making a 2-unit-tall stand-in guy in the Maya scene will allow for good scaling in Maya as the scene is built. Still, the FBXImporter's Scale Factor will need to be changed from its default 0.01 setting to 1.

However, when working with a team, especially a team working with various 3D applications, scale gets all funky, and getting used to adjusting the Scale Factor is just a part of the process.

Tips and Tricks

When adjusting the scaling, it can be tough to find the right size. Look for areas that allow for good comparisons, like doorways. If the First Person Controller is moved over to a spot like a doorway, it can be easier to figure out the appropriate size.

Step 9: Fall through the floor. In the Toolbar, press the Play button. There will be one glorious moment of seeing the scene and then "you" (the First Person Controller) will start falling, and falling, and falling until the Play button is pressed again. This is because by default the EntryWay prefab has no **colliders** so it doesn't stop things passing through it.

Why?

Colliders are important components of GameObjects in Unity. They do just what their name implies—they register collisions. A collider may be the exact shape of a polygon mesh (called a **Mesh Collider**) but they can also be more basic shapes like cubes, spheres, and capsules that approximate a shape.

Calculating collisions is a nontrivial function and if allowed to get out of hand can drag a game to a standstill. We recently were developing a bomb-defusing tool and had used Mesh Colliders on a complex bomb mesh. In the game, whenever the First Person Controller got anywhere close to the bomb, the frame rate would drop to 2 or 3 frames a second. All the hundreds of little components in the bomb with Mesh Colliders was just too much for Unity and our machines to calculate. The solution for us was to remove the Mesh Colliders and place Box Colliders on just the elements the player was to interact with. Suddenly, the frame rate was back up to where it should be.

Because of problems like this, Unity does not assume that the meshes that are imported are all using the accurate but intensive Mesh Colliders. In fact, it doesn't assume any collider at all. Unity has to be told to add them.

Step 10: Add colliders to EntryWay. Select the EntryWay prefab in the Project panel. In the Inspector, under the FBXImporter check the Generate Colliders option. Click Apply.

Tips and Tricks

Clicking Generate Colliders is a quick and dirty way to make sure that a mesh is "solid," meaning the player can't pass through it. However, it isn't the most efficient method in terms of optimizing for game play. By clicking this option, every single mesh in the scene has a Mesh Collider, including the parts of the scene that the player can't even get to. For instance, are colliders on the beams overhead really necessary if the game play never calls for getting up to them?

For a PC-based game like this, using Mesh Colliders is acceptable since there just won't be that much happening at this point in the game. However, if this were being developed for iOS or Android or even for distribution on machines that may not be very tough, it would be more efficient to leave off the Generate Colliders option and instead create some manual Box Colliders around just the areas that the player would actually touch.

Step 11: Play the game. Press the Play button in the Toolbar. Using the standard WASD or Arrow keys, move around the scene using the mouse to look around (Figure 5.9). Press the Play button again to stop playing the game.

FIGURE 5.9 Moving around the scene.

Tips and Tricks

Make sure that the First Person Controller is not halfway through the floor, or that it is hovering over empty air. Select the First Person Controller in the Hierarchy panel, and then in the Scene window make sure that it is just slightly above the ground, so that when the game is played, the controller will actually be in contact with the floor.

Why?

It's fun to actually walk around the space. However, notice that everything is looking really flat. This is mostly because the scene has yet to be lit, which will add all sorts of important dimension to the scene. However, this can provide a quick "feel" for the scene, and help track down any problem areas.

Step 12: Adjust the Ambient Light. Because the scene is too dark to see, temporarily make everything brighter. Select Edit>Render Settings. Click the long gray color swatch next to Ambient Light. In the Color Picker that comes up next, choose a much lighter gray and watch as the scene lights up (Figure 5.10).

FIGURE 5.10 Increasing the Ambient Light to better view the scene.

Why?

Ambient light generally is a bad idea in 3D. It is light that comes from everywhere and nowhere. Ironically, it will make the scene look as flat as it did before it was turned up, but the textures will be visible, and that's what is important at this point. Later, the Ambient Light settings will be adjusted again when the scene is appropriately lit.

Step 13: Inspect the scene again. Press the Play button again and walk around the scene. After having fun moving through the scene, take some time to look carefully at the textures and the geometry and look for problems. Figure 5.11 shows an area of the level that is indeed problematic—the texture on that stone wall is such low resolution that it simply does not hold up.

Why?

The textures seemed to look fine in Maya—what gives? Well, in Maya remember that most of the textures were built at 2048×2048. Unity attempts to help its users streamline their games by automatically downsampling imported textures to no bigger than 1024×1024. Sometimes this works great and it is difficult to tell the difference between the textures in Maya and Unity. However, sometimes, this downsampling causes some problems and the textures need to be upsampled again.

107

Step 14: In the Scene window, select the rock wall by clicking it and then clicking it again.

Why?

The first time a mesh is clicked, the parent-most object in its prefab is what is selected. But if the mesh is clicked again, Unity will drill down and actually select the object that is being clicked.

Step 15: Look in the Inspector to understand how Unity sees the mesh.

Inspector Breakdown

Figure 5.12 shows what the Inspector shows when the EntryWayWallsInner mesh is selected. There is actually loads of important information here, so please excuse this brief tangent while it's broken down.

This inspector is broken down into six areas. It is worthwhile to discuss what is seen here.

Immediately under the Inspector tab is the name of the object next to a checkmark and a symbol (looks like a blue cube) that indicates that this is indeed a GameObject. Here the GameObject can be renamed or turned off (with the checkbox). Notice that this section also has areas to assign the GameObject a Tag or assign it to a Layer (more on this later). The Model section there allows for prefabs to be updated (more on this later as well).

The Transform section is just like the Channels Box in Maya, and has been looked at before. Here the GameObject can be moved, scaled, or rotated numerically.

The Mesh Filter section actually defines which mesh the GameObject contains (this can be changed although usually it is not).

The Mesh Render is an important area because it simply decides if a mesh is to be drawn on the screen. This can be turned off so that the object remains

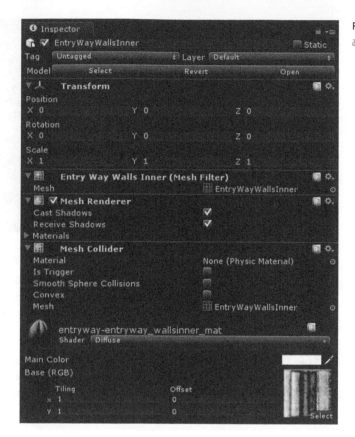

FIGURE 5.12 Inspector for a selected mesh.

in the scene and still blocks the player from walking through it, but cannot be seen.

The Mesh Collider is the component that was added when Generate Colliders was checked in the FBXImporter settings in previous steps. This is what prevents the player from running through the wall.

Finally, the last section is the Material applied to this GameObject. Notice that there are actually several sections here. Immediately underneath the name of the material is a drop-down menu allowing for the changing of the Shader. Much, much more on this later. But for now, just note that the default shader is "Diffuse." A diffuse shader uses a color texture file to define the color of the material. It has no specular highlight or bump to it. This will be changed later, but is a nice way to get started checking out materials.

Below that section is the Main Color section that shows the texture file that is being used to define the color of the material. This texture file is what we are interested in.

Step 16: Select the color texture file. In the Inspector, in the Main Color section, click the Main Color texture swatch (Figure 5.13).

109

FIGURE 5.13 Selecting the texture file used in a material. Notice that when the swatch is clicked, the file it represents highlights in the Project panel.

Warnings and Pitfalls

Truth be told, 2048×2048 is a big texture—too big in fact. A 2048×2048 texture isn't twice as big as a 1024×1024, it's four times as big. So choosing to use such a big texture is not a choice to be taken lightly. In fact, using multiple UV sets is a technique that can allow for small tileable textures to be overlaid by larger, rougher textures. Using multiple UVs can actually create much more efficient games than what we are currently building. However, it's a fairly obtuse process and a bit beyond the scope of this book. So the compromise we are making is by making larger textures that are not tileable but easy to understand how they apply to a surface. To compensate for this compromise though, be careful choosing which textures **must** be of larger sizes. If the texture looks acceptable at a lower resolution, leave it there.

Why?

A number of things happen temporarily when this swatch is clicked. The Project panel will expand and the file that this swatch represents will be temporarily highlighted (as can be seen in Figure 5.13). The actual file can then be selected within the Project panel.

Step 17: In the Project panel, select the highlighted file. If using your own file, choose the inner wall (or any object really). If using the files provided on the web site (http://www.Creating3dGames.com), this will be EntryWay_WallsInner_Color.

Why?

Immediately, the Inspector will show the attributes of the EntryWay_WallsInner_Color file. This is important since now we can see what the settings were when this asset was imported, and more importantly, these settings can be changed.

Step 18: In the Inspector, change the Max Size to 2048. Press Apply.

Why?

The Inspector will be showing a preview of the texture (Figure 5.14). Notice on the very bottom, Unity will indicate that the texture is 1024×1024 RGB Compressed DXT1 0.7 MB. The part that is important to us is the 1024×1024. It means that Unity thinks of the texture as 1024×1024. This is because the Max Size setting (seen a little further up in the Inspector) is set to 1024. With that setting, no matter how big the image, Unity reduces it to 1024×1024. By changing it the Max Size to 2048, Unity will then see if there is 2048×2048 worth of information in the file and if there is, will reimport it at this newer higher resolution. There will be an immediate change in quality in the Scene view.

FIGURE 5.14 Inspector for a texture file (note this is after doing step 18).

Step 19: Examine the scene closely, and change the Max Size for any textures that need it.

Step 20: Examine the scene for any abnormal geometry. In my version of EntryWay that was completed in Chapter 4, there is an error (that I'd like to say was left there on purpose, but it was just an error) that can be seen in Figure 5.15. See how only one side of the door is visible, although we can see the inside of the left side door? What this means is that the normals are reversed on that left side door. This is a common problem during the building process if a mesh was duplicated and scaled by −1 to get a mirror version. To fix it, we need to get back into Maya.

Step 21: In Unity, choose File>Save Scene.

Why?
Saving often is always a good idea. When bouncing between Unity and a 3D application, always save the Scene file to avoid losing work in case of import problems.

FIGURE 5.15 Problem area found in a scene once placed in Unity.

Warnings and Pitfalls
In this case the problem was in my construction technique. As I was creating the doors, I duplicated a door and then scaled it using X = −1. The tricky thing about this is that in Maya, the normals look correct but in Unity they do not. The problem here is that by using the Scale X = −1 method, that mesh ends up with an Opposite tag that can be tough to track down. A better method is to use Mesh>Mirror Geometry when needing this sort of duplication.
To fix this problem, either reconstruct using the Mirror Geometry method (and then separating the duplicate from the original (Polygons>Mesh> Separate)) or, take the errant copy and combine it with the original. Then the normals will appear as they will in Unity. Reverse the normals that are reversed (Polygons >Normals> Reverse), and separate the two doors. Be sure to rename the newly separated meshes appropriately.

Step 22: In Maya, open the Maya file EntryWay.mb (**not** the .fbx we exported). Fix any geometry or normals problems.

Step 23: Export manually from Maya again (File>Export All), although this time turn off Embed Media in the File Type Specific Options section of the Export All dialog box. Be sure to overwrite the old EntryWay.fbx in the Assets folder of your Unity project file.

Why?

Because all the textures have already been imported into Unity, there is no need to include them in this new version of the .fbx. It will save loads of time in exporting and even more importing. By overwriting the old EntryWay.fbx, the changes made here will automatically fix themselves in the instances placed in the scene.

Conclusion

So there it is—exporting manually from Maya and importing to Unity. I haven't had a project yet where I didn't have to do a little bit of tweaking to a level once it was imported. But because the process is so quick, it really is quite painless to make the necessary adjustments.

Now the game is playable enough to walk around the scene. It still has a lot of problems (no lighting, the sky is that strange flat blue, etc.), but not to fear; in the next chapters, we will use some of Unity's built-in asset creation tools to give some more life to the scene.

Homework and Challenges

Challenge 1: If you've been building the hallway (along with UV and texture), export the hallway from Maya and create a new scene within Unity to place it in (save the file as Scene-Hallway). Walk through the level to test.

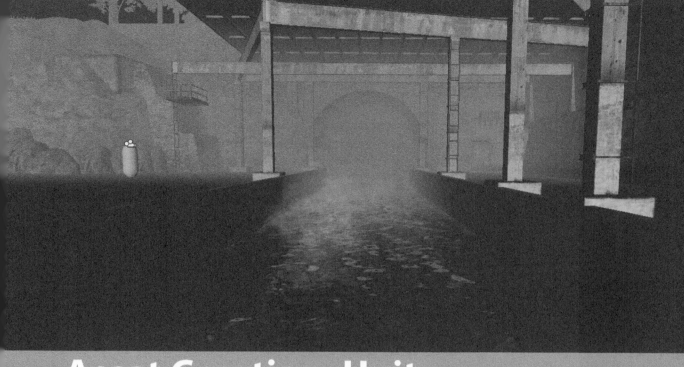

Asset Creation: Unity Scenography Creation Tools

Asset Creation in Unity

In the previous chapters we have looked at using Maya as the primary asset creation tool. Indeed through the course of those tutorials we molded polygons and textured them using a tool completely outside of Unity.

Generally, this is how games are created; the assets are assembled in a package built for 3D object manipulation. Unity is just not a modeler (although it has been becoming an increasingly robust animator), and so to get complex forms and textures to bring those forms alive the game artist needs another package.

However, despite these limitations, Unity does have some asset *creation* capabilities. It can do more than simply bring assets in from outside. In this chapter, the EntryWay scene that has been created thus far will be further augmented with some of Unity's asset creation tools: built-in prefabs like water, terrains, trees, and particles.

Tutorial 6.1: Adding and Manipulating Unity Water, Sky, and Fog

Before getting to the business at hand, it's worthwhile to revisit the idea of Packages. In Unity, we have seen how to import meshes that become GameObjects that have attached to them materials (and other components). These GameObjects can also have scripts and other functionality hung on them as additional components. When a GameObject has scripts attached to it, or special shaders to define the visual appearance, it can be a fairly robust asset.

To move these robust assets from project to project, Unity has developed this idea of packages that contain decorated and configured GameObjects. When the project was created, we imported the Character Controller packages that included the prefab GameObjects of First Person Controller (which has already been used in the scene). At the time the project was created we refrained from adding other packages to keep the project lean and mean.

At this point, however, there are some very sophisticated and beautiful-looking prefabs that Unity has created that would be useful to us here ... specifically the water. In this tutorial we will look at importing these additional assets via packages and place them in our scene.

Importing Packages

Step 1: Open Unity. Make sure to set the project to Incursion–Unity.
Step 2: Import Water packages. Choose Assets>Import Package>Water (Basic or Pro depending on which license you have). If you have Unity Pro, import the **Water (Pro Only)** package. If you are using the free Unity, use **Water (Basic)**.

Why?
What's the difference? Unity Pro includes some render to texture effects that allow for some more visually sophisticated water. Although you can import both packages (which I do for screen shot purposes here), if you do not have a Pro license, the functionality of the Pro water will not be seen.

Step 3: After Unity decompresses the package, press Import in the Importing Package window that will pop up. Unity will then bring up an Importing Assets progress bar. When done, a new Water (Pro Only) folder or Water (Basic) folder will appear as a child of the Standard Assets folder within the Project panel.

Water

Step 4: Explore the water prefabs this process has brought in. In the Project panel, expand the Water folder and click once on one of the prefabs that has been imported (either Daylight Water/Nighttime Water or Daylight Simple Water/Nighttime Simple Water).

The Inspector will explode with information. Notice that the GameObject will have some familiar components (Transform, Mesh Filter, Mesh Renderer) but will also contain a Water (Script) component and a very complex shader with lots and lots of inputs (especially if using the Pro version). This is the benefit of bringing in a package—all the appropriate textures that make the water look and move like water have been attached to the shader where they belong, and the script that further helps the effect has been attached and configured (Figure 6.1).

FIGURE 6.1 The settings of the Daylight Water prefab as brought in via the Water package.

Step 5: Place the water in the scene. From the Project panel, drag one of the Daylight waters into the scene view (Figure 6.2).

Why?
Yes, the water could have been placed by dragging from the Project panel to the Hierarchy panel. However, by dragging directly into the scene, the water can be roughly positioned within the space. The results, however, are the same as dragging to the Hierarchy panel.

Step 6: Move and scale the water to approximate Figure 6.3. The idea here is to make the water big enough so the edge cannot be seen inside the tunnel, and expands out past the edges of the dock enough so the edge is not too pronounced (we will hide it later with fog).

115

FIGURE 6.2 Placing a water prefab by dragging from Project panel to the Scene view. Note that this is using the Pro version of water (real-time reflection).

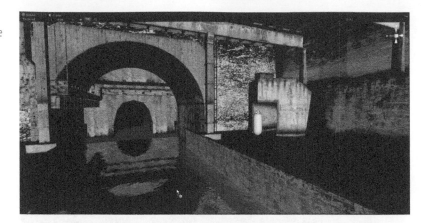

FIGURE 6.3 Placed water.

Step 7: Play the game to check out the new water. Press the Play button (or press Ctrl-P on the PC or Command-P on the Mac) and walk around the scene to see how the water looks.

Why?

Don't worry too much about how this looks quite yet. It's very likely that in the game view the water looks way too blue (even if you are using a Pro license). This is because the water is reflecting the sky, which at this point is just a flat blue. It will be prettier as we define the environment further.

Skyboxes

Skyboxes are interesting things. In effect they paint a sky behind everything in your scene. The sky behaves visually as the real sky does (although generally not animated). There are a few things that are a little unintuitive about them though. First, a skybox is not a GameObject—it can't be seen in the Hierarchy panel. Skybox materials are chosen in the Render Settings (of all places), and then Cameras have the option of whether to draw them or not. Second, skyboxes don't affect any sort of lighting or baking. They are images that looks

like the sky (and this sky shows up in reflections if you have Unity Pro), but don't really do anything *to* the scene.

Still, even though it's a bit unintuitive to track down where a skybox is, it really does help take a scene out of that flat look that the solid blue background gives it. In the next few steps we will set up a skybox to see how it works and what it does for the scene. However, this is an exploration of the tool—and in steps soon after that we will eliminate the skybox to give the scene a much more ambient effect.

Step 8: Import Unity's skybox package. Unity, as part of the standard packages that it ships, includes some fairly nice skyboxes. While custom skyboxes can be created, for now choose Assets>Import Package>Skyboxes. Again, after importing, the Project panel will show a new folder called Skyboxes within the Standard Assets folder.

Step 9: Examine any of the skyboxes. In the Project panel, expand the Standard Packages folder, and then expand the Skyboxes folder. Notice that the skyboxes contained there are not prefabs or GameObjects at all. That circle icon represents a material. If any of these materials are selected, the Inspector will show that the skybox material actually consists of six images for each side of the box (Figure 6.4).

FIGURE 6.4 Skyboxes are constructed with materials made of six texture images. No GameObjects are involved.

Step 10: Apply a skybox material in the Render Settings. Select Edit>Render Settings. The render settings will appear in the Inspector panel. There, notice the **Skybox Material** area. To apply a material here, either (1) drag a skybox material from the Project panel into the area where it says None (Material) or (2) click the little target icon at the far right of the Skybox Material line and pick a skybox material from the displayed swatches.

Tips and Tricks

Either of these methods work. Sometimes, deciding which material to use is much easier to do by seeing a visual preview of it and other times, if the name is known, it's faster just to drag it from the Project panel. It's part of the power of Unity that either way will work.

Step 11: Try throwing a few different skybox materials in there to see the dramatic difference it makes in the scene. Especially if your copy of Unity is Pro and the water is reflective, the entire color balance of a scene changes with a skybox (Figure 6.5).

FIGURE 6.5 Quick dramatic changes with various skyboxes.

Tips and Tricks

The built-in skyboxes are nice, but custom is always better. One of my favorite tools is to use C4D (which has some really great sky creation tools) and using the custom rig found here (http://forum.unity3d.com/threads/9030-Unlimited-SkyBoxes-from-Cinema4D) to create and output the images needed to construct a custom skybox.

Step 12: Remove all skybox materials. Access the Render Settings again (Edit>Render Settings) and click the target icon at the end of the Skybox Material line. Double-click the **None** swatch in the Select Material window.

Why?

Yes, I know—the skies were so pretty. Agreed—but they really are a bit too pretty and don't give the scene quite the ominous feeling this game requires. The other problem with a sky like that is the horizon must be taken care of in a reasonable way and this current model simply wasn't designed to do this. In the following steps, we will be making use of Unity's fog capabilities to help hide the end of the water and make the scene more ominous and interesting and (most importantly) appropriate for this genre of game.

Fog

In Unity, fog is handy and easy to use. Think of it as more than just the gray fog that is seen in the real world (although Unity's fog can be used to do that as well). Fog in Unity can be used to make dark scenes darker as the player gazes into the faraway corners of a space. Fog in Unity can be used to provide a soft haze on the horizon line to soften the sky/ground plane line. Fog can be used to make underwater feel like a murky mess, or just allow the water to "blue-out" as it gets further from the player. In short, fog—with a bit of tweaking—can be used for all sorts of interesting effects that can bring depth and polish to the scene.

In the case of *Incursion*, fog will be used to hide the edge of the water, and to give the scene a damp and murky feel. It will provide a sense of ambiance of a truly abandoned location, but one in which the player is never quite sure if he is alone.

> **Step 13:** Change the background color of the Main Camera to gray. The background color is an attribute of the Camera component. In the Hierarchy panel, expand the First Person Controller and select the Main Camera GameObject. Its attributes will appear in the Inspector. Under the Camera component, click the long blue swatch next to Background. Choose a new color that is rather gray-blue (this can be changed easily later; Figure 6.6). Jot down the RGBA values (mine were 89,101,120,255).

FIGURE 6.6 Changing the background color.

Why?

When there is no skybox present, cameras paint a solid color behind all visible geometry (or actually more accurately, it draws a solid color field and then draws the geometry on top of it). Unfortunately, fog doesn't affect this background quite as we would expect. Regardless of the density of the fog, that color field will still be visible. For that matter, a skybox is also still visible even if the fog is so thick the player can't see any other geometry. This, of course is not how fog really works, so to fix this, match the background color to the fog color to begin with so the fog really appears to thicken the further it gets away from the player even if there is no geometry out there.

Tips and Tricks

It's important to note that the background color is an attribute of a camera. This means that changes to the background color can only be seen through the camera. If Main Camera is selected in the Hierarchy, a little Camera Preview window will be set within the Scene window (Unity 3 or later only). Or, by bringing the Game window forward by clicking its tab, the background color changes will also become apparent. But, the background change will not be shown in the Scene window.

Note that this also means different cameras can have different background colors. So if another camera is providing a map view or a night-vision view, that camera can have its own black (or whatever) color. Background color affects cameras, not the actual environment.

Step 14: Activate fog. Choose Edit>Render Settings (which will open in the Inspector). Click the Fog check box.

Step 15: Change the Fog Color to match background. Still in the Render Settings, the Fog Color has a long color swatch similar to the Background Color setting. Click this swatch and change the color to match the background (in my case 89, 101, 120, 255).

Step 16: Adjust the Fog Density. The higher the Fog Density value is, the closer the fog obscures objects. This value can be adjusted in a couple of ways, either by clicking the numerical value and entering a new one or by moving the mouse up to the Fog Density word and click-dragging left or right (the cursor will have a double-tipped arrow appear (Figure 6.7). Adjust to about 0.04 (although change this to your taste).

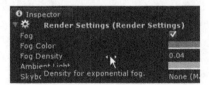

FIGURE 6.7 Adjusting value by dragging left and right on the variable's word.

Tips and Tricks

Generally, I find that dragging values can sometimes be a little tricky (it either slides way too high too quickly or never seems to move at all). A lot depends on the situation, but a quick way to work is to drag the value higher or lower to get in the general neighborhood of the value (and thus the look) that you are after. Then, for the fine-tuning, numerically tweak the value to taste.

Wrapping Up

The screenshot in Figure 6.8 shows the current results of water, fog, and background color adjustments made in this tutorial. Notice that the water may be a different color than yours. This comes from some tweaking made to the scene after all the previous steps were complete. You should do this too to make the water look as you'd like.

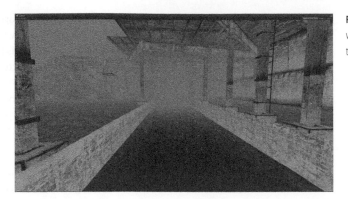

FIGURE 6.8 Results of this tutorial with a few additional minor tweaks to water parameters.

Tweak the background color to various hues to see which matches your vision of the scene. Be sure to match the fog to that value. The water has all sorts of parameters that can be tweaked. To tweak them, select the Daylight Water in the Hierarchy panel and make the adjustments in the Inspector panel. Figure 6.8 shows water that had the Refraction Color adjusted to a dark green and the Wave Speed settings cut in half. These adjustments are fairly painless and can quickly help establish a different scale to the water, and an entirely different hue and style.

So there are still some issues here. The lighting—or lack of lighting—combined with a high ambient color setting still makes the scene look flat. However, a bit of reflective water and a splash of fog can go a long way to give a scene just a bit of depth.

Some other benefits of the approach here is that what was once a very small space (just the dock) suddenly *feels* like a much bigger space. The player can feel the large space of the sea out beyond the dock even if he cannot see it. Although in the next few tutorials the hill this base is built into will be built, not much of it will be seen, although it will be implied. Very often, the most expansive-feeling levels may not be that large at all.

Tutorial 6.2: Terrain Creation

Terrains are a relatively new addition to Unity (Unity 2.x). Terrains can be really cool in the right situation. A Terrain is a GameObject that is created in Unity that can contain texture maps and "smart" objects like trees and grass. By "smart" I mean they do some really fancy things like change their level of detail as the player moves closer or further away from them. The classic example is trees. Trees that are a mile from the player shouldn't contain 2000 polygons; the player would just never see this sort of detail. So the trees that are a long way away are billboards—a two-triangle plane that has an image of the tree on it. Then as the player gets closer, the tree morphs to high resolution until, when the player is right up to it, the tree is in its high-resolution splendor that holds up much better to inspection.

121

Additionally, terrains allow for some basic sculpting of the landscape. It's a bit like the Sculpt Geometry tool in Maya where virtual brushes allow the user to push or pull soft clumps of the geometry. Once this geometry is painted, Unity provides for a similar experience to MAXON's BodyPaint texturing scheme, where the user can layer texture in various opacities and size over the terrain. So you want a beach that gently transitions into a rocky shoreline that transitions into grassy plains and then to rocky mountains? It will probably be easier and quicker to do it with terrains in Unity than to model that sort of thing in Maya.

To further empower the user, custom trees can be brought in or built within Unity itself. These trees will blow in the breeze (along with the grass beneath them) and will adjust their level of detail as well. There is not much that restricts getting a custom look in a scene and getting very expansive scenes. In fact, there are many games where the vast majority of the actual level was created exclusively within the Unity Terrain system.

Restrictions of Terrains

Terrains can definitely do some great stuff but not everything. For instance, the tools to sculpt terrains will allow for meshes to be moved essentially in the Y direction only. This works great for hills or mountains or even canyons, but this means no caves (unless the cave is going down into the ground as opposed to straight into a mountain).

Terrains are great for broad strokes of organic surfaces. It's quick and easy to make forms gently rise from the surface. However, it can be tricky to be very accurate in the painting of forms or textures. For instance, recently I was modeling some custom homes for a builder and attempting to put grass around the home but not have it poke up through the sidewalk that I had modeled in Cinema 4D. Alas, getting that grass to neatly edge the sidewalk was nearly impossible and I ended up spending more time on trying to get that look right than I did modeling the outside of the house.

Still, even with the accuracy issues and restrictions on forms, terrains can be a powerful tool to make some beautiful game assets. As is the case with all tools, making believable terrains is an art and takes some study. True, with Unity's tools, anyone can make a terrain with hills, mountains, grass, and textures, but to get a terrain that looks believable or stylistically appealing takes some study of good research and careful refinement. So be sure to surround yourself with the look you're after.

In this tutorial we will be building the mountain that the submarine base was carved out of. This mountain will do a few things for the scene. First, it will provide a visual masking of the edge of the scene so the player can't see where the model stops. And second, it will provide a physical barrier to the player so he doesn't go traipsing off into parts of the level where there is no geometry—it keeps him from falling off the end of the world.

Step 1: Turn off the fog. Do this in Edit>Render Settings and flip off the Fog checkbox.

Why?

Although in the game the fog will be a great thing, it really makes it hard to work in the scene. While building the terrain, turning off the fog will give us a clear view of the shape and textures being formed.

Step 2: Create a terrain. Use Terrain>Create Terrain. This will create a huge terrain object with the corner at 0,0,0 in world space (Figure 6.9).

FIGURE 6.9 Newly created terrain.

Tips and Tricks

Note that when a terrain is added, new things appear all over the place. First, there is the physical placement of the terrain in the scene visible in the Scene window, but a terrain object also appears in the Hierarchy panel. Additionally, there is now a new terrain object in the Project panel. All of these are interacted with in different ways, but be aware that they are all present now.

Step 3: Resize the terrain. Select the terrain instance in either the Scene window or the Hierarchy panel. Choose Terrain>Set Resolution. Change the Terrain Width and Terrain Length to 150. Change the Terrain Height to 35 (Figure 6.10). Press Set Resolution.

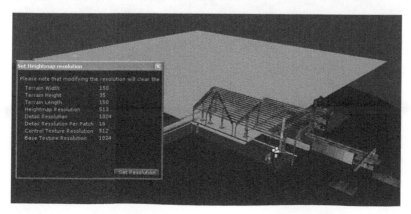

FIGURE 6.10 Setting terrain size via the Set Resolution drop-down menu. Note that the results of the changes made do not appear until after the Set Resolution button was pressed.

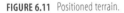

Tips and Tricks

Note that the screenshot in Figure 6.10 shows the already resized terrain; however, Unity draws the newly sized terrain only after the Set Resolution button is pressed.

Why?

Why not just use the Scale tool? It doesn't work on terrains. Probably because of the parametric and procedural basis of terrains, the Scale and Rotate tools won't affect them. The Move tool will, but the only way to change the size of a terrain is via the Set Resolution drop-down menu.

Why?

Why so small? Remember that with the fog the player won't be able to see much beyond a few feet off the end of the dock. If a sunny bright scene was called for in the game, a big terrain could be great to show the other side of a river or bay and the land that emerges there, but in this case we are only building small chunks of stuff right around the existing geometry of the EntryWay. Keeping the terrain a reasonable size keeps all the relevant assets in a size and placement that makes moving around the scene easier.

A size of 150×150 is just an approximation of the size of the scene, and was found through trial and error. The height setting of 35 indicates the highest the mountains will rise off the surface of the terrain. This too can and might be edited later, but a reasonable height setting allows for easier fine-tuning as the terrain is painted.

Step 4: Move the terrain so that it sits beneath the water and extends beyond the edges of the dock, and also that the EntryWay is situated roughly in the middle of the terrain (Figure 6.11).

FIGURE 6.11 Positioned terrain.

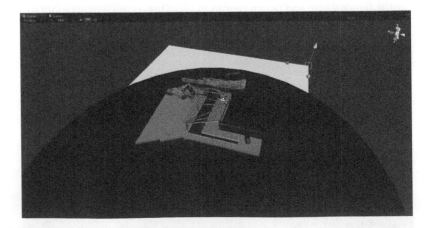

Why?

Although terrains can be painted by raising parts up or pushing them down, I find it easiest to simply pull stuff up for the rough cut. And since the player should look down and see the water and not the mountain, sticking it below the water to begin with makes for a quick solution.

Tips and Tricks

Remember the keyboard shortcuts for Move, Rotate, and Scale are the same in Unity as they are in Maya (W-Move, E-Rotate, R-Scale). Additionally, remember that the movement can be constrained with the cone handles on the manipulator once the Move tool is active.

Step 5: Examine the Inspector for the terrain:

Terrain Editing Tools

Figure 6.12 shows the Inspector when the terrain is selected. At the top, there is the usual Transform component (although the Rotation and Scale settings here have no effect). On the bottom is the Terrain Collider component that allows the player to walk across the terrain. Right in the middle under the Terrain (Script) section are the tools that allow for the manipulation of the actual terrain.

These tools (Raise/ Lower Terrain, Paint Height, Smooth Height, Paint Texture, Place Trees, Paint Details, Terrain Settings) allow for various modification of the terrain. If the mouse hovers over any of the tool buttons a screen hint will pop up to indicate what the tool does. If a tool is selected, the options beneath it will change to allow for the specifics of how the tool works to be tweaked. Following is a brief description of what these tools do.

FIGURE 6.12 The Inspector for a terrain instance.

Raise/Lower Terrain: This works much like the Airbrush tool in Photoshop. A brush is defined by size and opacity (the rate the brush actually changes the area it is painting). Note that there are a bunch of different types of brushes (why anyone would use a Star brush is a mystery to me), but they can quickly allow for organic forms as the brush is left in one spot or dragged across the surface. Clicking and holding or clicking and dragging raises the terrain surface until it reaches the Terrain Height setting defined in the Terrain Resolution from step 3, at which point the terrain will plateau. Holding the Shift button down while clicking and holding or clicking and dragging pushes the surface back down until it reaches its default starting height.

Paint Height: In many ways this is similar to the Raise/Lower Terrain; however, it also allows for areas of the terrain to paint up to a specific height and stop (think tiered plateaus). To use it, either set the height with the slider, or Shift-click the terrain to define a target height, and then paint on the terrain to raise (or lower) the terrain to plateau at the target height.

Smooth Height: Think of this as erosion. It smoothes areas of the terrain and softens the area.

Paint Texture: This tool allows the user to define textures and then apply them to the terrain. Note that this tool is useless until the tool has been told which textures can be used in the scene. This happens with the Edit Textures… button contained in the tool nested within the Inspector panel (much more on how to use this later). The power of this tool becomes apparent when there are several textures defined, and these textures are layered using various opacities upon the terrain.

Place Trees: Much like the Paint Texture this allows for trees (as in geometry) to be placed on the terrain using a painting paradigm (or Paint Effects if you're familiar with Maya). This tool does not include a wide variety of brushes, but the size of the default round brush can be changed as well as other variables including the density of trees as they are placed; the color, height, and width of the trees; and the variation of these attributes. Again, this tool is useless until tree meshes have been defined; this tool is done via the Edit Trees… button within the tool (nested in the Inspector panel). This tool can also be used to remove trees by Shift-painting over the terrain to remove all types of trees and Ctrl-painting to remove only the active types of trees.

Paint Details: "Details" is kind of a funny word here. It actually means grass or detail meshes. Grass is an appealing part of Terrain as it is low poly but moves in the wind in believable ways and can really bring a scene to life. Detail meshes are things like rocks—things that when spread about on the scene and slightly adjusted in size or rotation can suddenly change the profile of the scene. Detail meshes can be anything really, including low vegetation. As expected, the tool only works after Grass or Detail Meshes have been defined. They are defined with the Edit Details… button in the Inspector when the Paint Details tool is active.

Terrain Settings: This area includes a lot of settings that define how the terrain will react with the player. How far away from the player with a tree swap from a billboard to a high-poly tree? How hard and fast will the wind blow? How much will the wind bend elements? This and more await the user within the Terrain Settings. If there is a setting that should be adjusted for how the terrain looks or plays, chances are it's within this panel of sliders.

But enough of the grocery list of descriptions. Let's build something with it.

Creating the Ground Topography

Step 6: Using the Raise/Lower Terrain tool, make a first rough pass similar to Figure 6.13. Don't worry about poking in too far into the dock, just use as big a brush as you can; just make sure it has a soft edge, and give the terrain a rough outline to mask out the edges of the dock and come up to the walls of the dock.

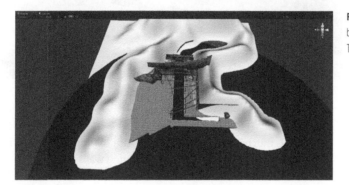

FIGURE 6.13 First draft with a big brush using the Raise/Lower Terrain tool.

Tips and Tricks

Notice that generally the first pass here is simply a ridge of mountains around the outer ring of the shape of the EntryWay object. Big strokes like this are made to just give a little bit of structure to deciding what is needed. The key to effective terrain creation is multiple passes. Don't worry about getting any one area just right on the first pass.

Step 7: Add some mass to the terrain with further raising of the terrain (Figure 6.14). Again, use a large brush to quickly rough it out.

FIGURE 6.14 Added mass.

Step 8: Carve back the mountain for walls. Pick one of the round brushes with a hard edge. Reduce its size to 10. Find areas where the terrain is poking through the walls that are supposed to be holding it back (Figure 6.15) and hold down the Shift key and paint right in front of the walls. This will allow for carving into the mountain and pulling it away from the wall.

FIGURE 6.15 The process of carving back terrain behind retaining walls.

Why?

Often it is much easier to carve chunks out of mountainous terrain than it is to add it up in delicate areas like retaining walls.

Warnings and Pitfalls

When carving out areas, be sure to take a close look at all parts of your models. An easy place to forget would be the tunnel. There shouldn't be any parts of the mountain poking through there. Part of the challenge with terrains is moving from the very big to the very small, but it is very important to get close and personal with all parts of the level when the terrain interacts with imported meshes as closely as these do.

Tips and Tricks

Although the mountain and its retaining walls should generally match up, do not worry about getting them perfectly aligned. Remember that there is no reason for the player to be running up the mountains; in fact later we will add some colliders to ensure that he cannot. The only place the player will ever see these mountains is from the dock. Looking up from below it is difficult to see if the top of the retaining walls match up with the mountainside.

Step 9: When the mountains appear correct be sure to Play the game and walk around carefully inspecting whether the new terrain does what it should. What looks good way up in God's view as the terrain is created might not be nearly so perfect where the boots hit the ground.

Adding Texture to the Topography

Although the snowy-looking marshmallows that have just been painted might look yummy, they aren't really in sync with the style of the game or the style of the model created in Maya. It's time to start adding some dirt and rocks to this form.

Step 10: Find a rocky base texture and make it seamless. Figure 6.17 shows Cliffs0168_1_S from CGTextures (http://cgtextures.com/texview .php?id=55487) as the Terrain Texture applied to the terrain created in earlier steps. Other textures could certainly work as well. Use the seamless texture techniques used in the previous chapter.

Why?

The terrain created so far includes a sort of UV map and the textures we are going to apply will be tiled. Since they are tiled, they need to be seamless.

Step 11: Add this new seamless texture to your available assets. In the Unity Project Panel, click the Create drop-down menu and choose Folder. Rename the folder `Terrain Textures`. In Photoshop save the seamless texture to this Terrain Textures folder (or simply drag it to this folder in the OS if the texture has already been saved somewhere).

Why?

The project is beginning to have a larger collection of assets. A few effective folders keep your workspace clean and the assets easy to find.

Step 12: In the Hierarchy panel, select Terrain. In the Inspector, click the Paint Texture tool. Click the Edit Textures… button and choose Add Texture… from the drop-down menu.

Step 13: In the Add Terrain Texture window that will pop up click the target icon. The Select Texture2D window will appear. From this window find the seamless texture you just made and double-click it. The window will close and the texture will be added next to Splat in the Add Terrain Texture window. Click the Add button (Figure 6.16), which will close the window and add the texture to the terrain (Figure 6.17).

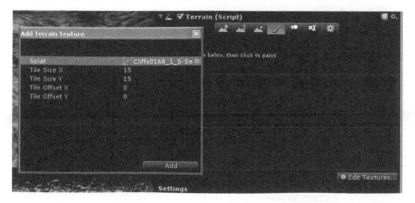

FIGURE 6.16 Adding a terrain texture.

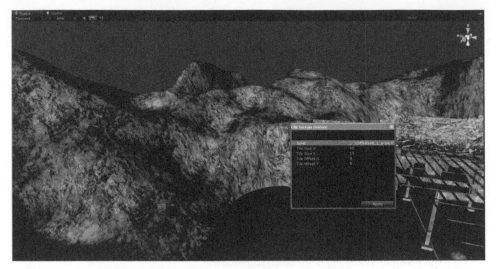

FIGURE 6.17 Result of adding the first terrain texture.

Why?

When a first Terrain Texture is added to the available textures, that texture is automatically plastered over the entire terrain. This seems awfully forward of Unity, but since there will be lots of other textures painted over this one, it's not a bad strategy and can save a lot of time in the long run to have a base texture applied.

However, the size of the texture as plastered across the terrain may not be quite right.

Step 14: Adjust the Terrain Texture size. Still with the Terrain selected in the Hierarchy, click the Terrain Texture in the Inspector. Click the Edit Textures… button and the Edit Texture… option. In the Edit Terrain Texture window, change the Tile Size X and Tile Size Y settings from the default 15 to 5 (or whatever looks best in the scene (Figure 6.18)).

Tips and Tricks

Remember that there are two ways of looking at the scene. The first is via the Scene view, but the second is the more important—the Game view. Be sure to check out changes in terrain textures in the Game window as well. That's the only way the player will see the scene and sometimes things that look good in Scene don't look as good in Game.

Step 15: Find a cliff-side texture, make it seamless, and import it as a Terrain Texture (note this is a repeat of steps 10–14). I am using http://cgtextures.com/texview.php?id=49431.

FIGURE 6.18 Resized Terrain Texture.

Tips and Tricks

Most all Terrain Textures are going to be repeated and tiled. Because of this, there is usually no need for a very large original file. When going through CGTextures and accumulating textures, the smallest size is usually sufficient.

Step 16: Paint with the texture. With the terrain selected, choose the Paint Texture tool in the Inspector panel. Click the newly imported cliff-side texture (it will highlight with a blue bar beneath the swatch). Use a soft-edged brush (one of the first two in the Brushes section) and paint areas of the terrain that would be cliff side (Figure 6.19).

FIGURE 6.19 Painting with additional Terrain Texture.

Tips and Tricks

Note that in order to paint with any Terrain Texture, that texture must first be selected in the Terrain section of the Inspector. It's a powerful function to be able to swap back and forth between multiple Terrain Textures.

Tips and Tricks

Layering textures is a very powerful way to add nice variation to any terrain. However, if the layered textures are too different, no matter how much Opacity adjustments and Target Strength tweaks are made, the results can appear ham-fisted. By using textures that share a common hue balance, the transition between the textures can appear much gentler.

Step 17: Import and paint with additional textures to taste.

Tips and Tricks

Be sure to spend time only on areas that will be seen. Remember that most of this terrain will never be seen by the player because of the fog. A quick pass or two with additional textures helps to make the terrain look better for sure, but if it isn't going to be seen, don't sweat it.

To check the progress, try turning on the fog (Edit>Render Settings) and walk around the scene to see what holds up and what needs more refining.

Adding Trees and Rocks (Trees and Detail Meshes)

Once the Terrain's workflow is understood (as just outlined for painted textures), the rest of the tools fall easily into an artist's toolbelt. Within the Terrain paradigm, trees actually follow a similar workflow as textures. A tree is defined within the Inspector, and then painted onto the surface of the terrain. Shift-painting removes all trees and Ctrl-painting removes the trees of the selected type.

For a quick rundown of the technique and a few tricks, the next few steps will make use of Unity's Terrain Assets package. We will paint in a few variety of trees, and look at placement and editing strategies.

Step 18: Import Unity's Terrain Assets package. Among the resources Unity includes on its site is a collection of prebuilt Terrain Assets. They are available at http://unity3d.com/support/resources/assets/terrain-assets and are a pretty nice collection of ready-to-use textures, trees, bushes, and so on. Just go to the URL, download the package, and then import the package (Assets>Import Packages>Custom Package…). This will create a new Terrain Assets folder within the Assets folder of the project file.

Why?

True, using prebuilt, ready-everywhere-on-the-web assets is generally a bad idea. If it looks good in your scene, it will look good (and exactly the same) in everyone's scene. For a commercially created game, generally it is preferable to make your own trees—and in fact, Unity now comes with a really fun Tree generator (GameObject>Create Other>Tree…). But for the learning process here, downloading and using prebuilt assets will speed the overarching learning process.

Step 19: Add a ScotsPineTypeA tree to your tree types. With the Terrain selected in the Hierarchy view, go to the Inspector and click the Place Trees button. Click the Edit Trees… button and choose Add Tree from the drop-down options. In the Add Tree dialog box, click the target icon, which will pull up a (now well-populated) Select GameObject window. Double-click the ScotsPineTypeA icon. Lastly, click the Add button in the Add Tree dialog box. This will add a new tree in the Place Trees section of the Inspector.
Step 20: With the default settings, paint on the Terrain. Insta-forest.
Step 21: Undo (Edit>Undo or Ctrl-Z or Command-Z).

Why?
The default settings of placing trees make for a very dense placement of trees. This actually can be a hint at how Unity plans for trees to be placed (lots and all over), but in our stark scene, there really isn't need for that many trees, especially since there will be very few visible through the fog. So the settings need to be tweaked.

Step 22: In the Settings area adjust Brush Size to 10 and the Tree Density to 75. Now paint these new trees across the highest parts of the scene (Figure 6.20).

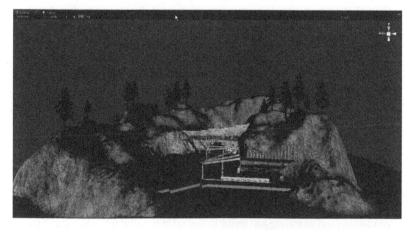

FIGURE 6.20 Painted Scots Pines.

Tips and Tricks
Having a smaller Brush Size allows for slightly more accurate tree placement. In this case, where there are not going to be many of these large trees down close to the entrance, an accurate placement helps. However, remember that often it is much easier to remove trees where they shouldn't be than to try and get any one tree exactly where it needs to be.

By throwing up a lot of trees, and then Shift-painting to remove the excess, the random placement of the trees holds up and saves the frustration of painting on an area with a low Tree Density setting and never getting the stinkin' tree you're after.

Step 23: Repeat for a few other trees or bushes. Add other trees to the tree library (including bushes) and experiment with various Brush Sizes, Tree Densities, Tree Height, and Color Variation. Place trees and bushes and remove them in places where they would not make sense (Figure 6.21).

FIGURE 6.21 Several tree types and bush types placed throughout the scene.

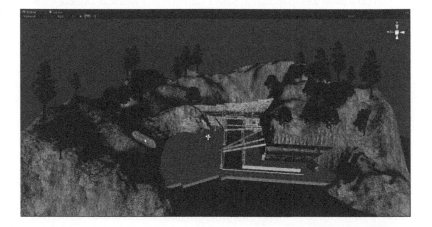

Why?
Figure 6.21 seems to show a pretty sparse placement of trees and bushes. And it is. The point of the trees is to help shake up the profile of the land a bit, but since this game calls for a foggy outside, we only want to catch a hint of those trees. No need to have trees in areas of the Terrain that will never be seen, so careful placement will continue to keep the data set small and the game snappy.

Tips and Tricks
Remember that in this game, the scene will never be seen from way up in the God-mode that the trees are painted in. When painting in God-mode, the trees will be continually popping in and out of billboards and sometimes look really strange on the Terrain. Be sure to get down close to see how the trees really lie across the terrain. Further, be sure to Play the game and see which of the trees you can see and which are just invisible. Get rid of the stuff not needed and be sure to understand really how those trees look and feel in the game.

Step 24: Add rocks as Detail Meshes. Still with the Terrain selected, click the Paint Details button in the Inspector. Here, click the Edit Details… button and Add Detail Mesh… from the drop-down menu. As before, click the target, and then choose RockMesh. Change the options to match Figure 6.22. Click the Add button.

Why?
The Random Width and Height are settings that mean the painted rocks can be up to five times the size of the original mesh. For some objects, this should be very low (houses for instance), but for rocks, a wide variation will work much better.

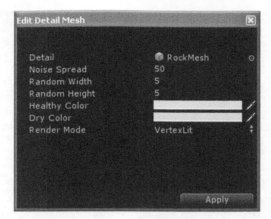

FIGURE 6.22 Options for importing the rock mesh.

The Healthy Color and Dry Color seem like really strange settings for a rock, and they are. They are the basis of the other half of the Paint Details tool—grass. When not using grass, these color values still need to be defined. If they are left green, Unity will paint some very green-looking rocks. These can be adjusted after the rocks are painted (and usually need to be changed), so give them your best gray guess.

Finally, the Render Mode settings should be changed to Vertex Lit for any detail meshes (like our rocks). When painting grass, Grass should be the render setting selected.

Step 25: Change the brush size to 2, the Opacity to 0.05, and the Target Strength to 0.06.

Why?
Just for fun, don't do step 25 and try painting with this new RockMesh detail mesh. The results are some very strange mounds of indistinguishable forms. The detail meshes are being painted too densely. Using a very small brush size with low Opacities and Target Strengths will take a little longer to place a bunch of rocks, but will allow some semblance of control.

Step 26: Paint in rocks along the seam of where the dock meets the mountain, and along the shoreline where the mountains drop into the sea (Figure 6.23).

Why?
Rocks are a very organic way of helping imported meshes transition into terrains. As discussed in earlier chapters, transitions and corners are where 3D models often fall into the computery-looking valley of death. By breaking these transition spots up, the too-clean line of assets meeting can be made more organic.

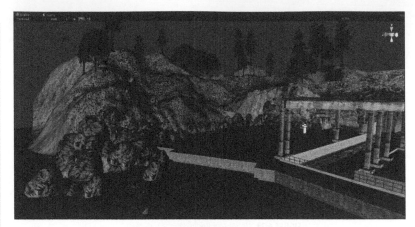

FIGURE 6.23 Placed rocks.

Warnings and Pitfalls

RockMesh does some things well and some things not so well. If it were to be opened in Maya, it would reveal it has no bottom. It is a mesh designed to be jutting out of the ground and specifically out of a flat ground. This means that if the RockMesh detail is painted on a mountainside, the orientation of the hole in the bottom of the mesh points straight down. This means that looking up you can see the missing bottom. The RockMesh doesn't hold up well on a steep hillside.

To fix this, the rock could have the bottom added back in (or a new rock could be modeled and textured from scratch), or just be very careful in the placement. Be sure to run around in the game and take a look at these rocks once they are placed.

Further, note that detail meshes (by default) have no colliders attached to them. This means that the player will walk through the rocks (which could be awkward if the rock is a huge boulder). Not really much of a problem in this case since the rocks are up on the mountainside that the player won't be allowed to travel to, but an important detail to remember.

Tips and Tricks

The absolute size of any detail mesh can be changed by changing the prefab. For instance, to change the size of the RockMesh, find it in the Project panel (Terrain Assets>Rocks>RockMesh) and select it. Like any other imported mesh, change the FBXImporter setting's Scale Factor and click Apply. The change won't show up immediately, but by selecting the Terrain again (in the Hierarchy) and double-clicking on the RockMesh (in the Place Detail button), Unity will go out and look at the RockMesh again—see its new size and update.

Conclusion

As is the case with most any organic elements, multiple passes and careful refining will help in the final product. Now that Terrain editing is within your toolbelt, keep adjusting and make the scene appear as Aegis Chung should happen upon it.

Continuing on in the next tutorial, we will look at a few more Unity-created assets to give the scene a few last finishing touches.

Tutorial 6.3: Primitives and Particles

Earlier, when talking about the union of Maya and Unity, we spoke of how Unity was not a polygonal-generating machine; rather it presented polygons made by other applications and made them interactive. Well, that's not entirely true. Turns out Unity can make a few shapes itself: cube, sphere, capsule, cylinder, and plane. Yes, this list is a bit underwhelming and further problematic when these polygons are presented and nothing can really be done with them except for move, scale, and rotate the entire shape (well this isn't entirely true, I've got a colleague busy having Unity make shapes with holes cut in them—he's got all sorts of control over Unity-created meshes, but he does it all programmatically and is doing some pretty heavy under-the-hood work to make this happen) and it is why most forms are still built in other applications.

This small collection of primitives can be useful for a few things though. For roughing out ideas or a temporary placeholder, using GameObject>Create Other> to drop in a spare cube or sphere can be a real time saver and allow for an idea to very quickly be explored. Additionally, there are times when a polygonal object can be used to control other capabilities of Unity, like particle emitters.

In this tutorial, we will briefly create a few polygonal primitive GameObjects and then use them to define the attributes of a particle system. The particle system we are going to create is a low-lying steam rising off the water surface in this cold and uninviting scene. It will help provide some further movement to the scene and give it further ambiance.

A quick bit of theory about what particles are. Essentially, particles in Unity are little tiny billboards or planes (although the mesh can be more complex) that emit into the scene and always face the camera. This gives the illusion of volume for things like smoke when these planes are textured with semitransparent textures. Because the default emission object is a place, the polycount remains low but great effects are added.

Particles can be effectively used for smoke, fire, sparks, steam, and so on.

> **Step 1:** Create a new Plane. GameObject>Create Other>Plane. This will create a new Plane object in the scene in the middle of the screen space. Note this could be in all sorts of weird places, so swap to the Move tool and move the Plane up to where it can be seen in the Scene view.

Tips and Tricks

Note that when creating one of Unity's polygonal primitives, it only shows up in the Hierarchy and Scene window (it does not become a prefab automatically and thus does not show up in the Project panel). It can be made into a prefab if the object needs to be used again and again after it has been created, but we'll get to that in a minute.

> **Step 2:** In the Hierarchy panel, name the Plane `WaterSteamEmitter`. Rename objects in the Hierarchy by either right-clicking and choosing Rename, or clicking once, waiting, and then clicking again, or by selecting it in the Hierarchy and renaming it in the Inspector.
>
> **Step 3:** Remove the material. Select WaterSteamEmitter in the Hierarchy panel, and in the Inspector look for the Mesh Renderer section. Expand the Materials part, and click the target icon next on the Element 0 line. Double-click None in the Select Material window. The mesh should turn pink.

Why?

There really isn't a hard and fast rule or need to get rid of the material. In later steps we will be turning off the Mesh Renderer for this GameObject completely so it won't be seen in the scene; so the current material doesn't matter much. The reason we are turning it off is the scene is awfully gray, and when a polygonal GameObject has no material it turns it bright pink, which makes it very easy to see.

Step 4: Scale and Move the WaterSteamEmitter to match Figure 6.24.

FIGURE 6.24 Placed WaterSteamEmitter.

Why?

This plane is going to be the source of the water steam (as the name implies). Although we could create a particle system (GameObject>Create Other>Particle System) that is really independent of polygons or any mesh, when working with particles that need to come from a very specific area, making a polygonal object that matches this area is a quick and easy way to take control of this.

It is a little smaller than the channel because the steam particles will be expanding, and when particles cut through polygons (like the side of the dock) they can make strange artifacts appear. So having the emitter a bit smaller will give the same steaming-water effect but avoid the artifacts.

Step 5: Add the three key components to a Particle System: Particle Emitter, Particle Animator, and Particle Renderer. All three of these are in the Component drop-down menu. Make sure the WaterSteamEmitter is selected and then choose Component>Particles>Mesh Particle Emitter, Component>Particles>Particle Animator, and then Component>Particles>Particle Renderer.

Why?

What each of these components do is pretty obvious from their names; but it is clumsy to have to add each individually. However, it's worth noting that usually when a straight Particle System is created, all of these components are already added to the system as it is created.

Step 6: Create a new material. This can be done in one of three ways. Either (1) Choose Asset>Create>Material, (2) in the Project panel, choose Create>Material, or (3) in the Project panel, right-click and choose Create>Material. Rename the new material WaterSteam Material.

Tips and Tricks

When creating a new asset (like a material), Unity will create and place that asset within the Project field within whatever folder is active. So, if for some reason, the folder Standard Assets is highlighted in the Project panel, that is where the new material would stick itself. To make sure to create it outside all the folders (where it can be seen and then placed later), just click any of the empty-space in the Project panel first.

Step 7: Change the WaterStream Material's shader type to use Particles/Additive (Soft). To do this, select the material in the Project panel. The Inspector panel will then show you the attributes of this material. Immediately under the name of the material is the Shader-type drop-down menu. Change this to Particles>Additive (Soft).

Why?

Shaders are tricky things and although they can be written from scratch, the authoring of such things is way beyond the scope of this book. So generally we will be using the built-in shaders. Not to worry though—many a great looking game has been created without making custom shaders. The built-in shaders are a powerful collection of tools to manipulate and exploit.

Anyway, emitters don't need to emit objects that have particle shaders on them. However, for smoke, fire, and steam, these particle shaders are just the ticket, and they produce some engaging visual effects. Additive (Soft) provides a gentle very transparent effect that makes the start of one particle and the end of another very hard to visually detect.

Step 8: Find a smoke puff that would work as a steam puff. This can be done manually by rendering something manually in Photoshop, or our good friend CGTextures can provide a good resource. http://cgtextures .com/texview.php?id=43653 is the texture used for the next few steps and are shown in Figure 6.25.

Step 9: In Photoshop, use the Crop tool (and hold Shift down to crop to a square (future power of two) image) to get the core parts of the image (Figure 6.26).

Step 10: Use the Clone Stamp tool to soften out any hard edges (Figure 6.27).

Why?

Although this image will have a heavy alpha and thus be largely transparent, making sure there are not hard edges to highlight where the end of a particle is will help hide individual puffs of steam. The image should be seamless due to black around the entire edge of the image.

Step 11: Run a Gaussian Blur filter to soften the image. Filter>Blur>Gaussian Blur… with a setting of around 2 will provide a nice soft image (very smoky; Figure 6.28).

FIGURE 6.26 Cropping to create square image.

FIGURE 6.25 Smoke puff used as basis of steam (Smoke0170 (Texture: #43653) at CGTextures).

FIGURE 6.27 Cloning in soft edges everywhere.

FIGURE 6.28 Softened image due to Gaussian blur.

Step 12: Resize the image to 512×512. Do this with Image>Image Size.

Why?
512×512 is of course a power of two size and thus a quick renderer.

Step 13: Save the file to the Incursion–Unity project's Assets folder as `WaterSteam_Color`.

Step 14: Adjust the import settings to include alpha. Back in Unity, the WaterSteam_Color image should now appear in the Project panel. Select it and in the Inspector panel click the Generate Alpha from Grayscale checkbox. Click Apply.

Why?

Alpha channels—or the channels that define what parts of the image to render transparent—can be created in Photoshop and Unity will recognize them upon import. However, for black-and-white images like this one, Unity can generate an alpha automatically. It just looks at the grayscale image and the parts of the image that are white become opaque and black pixels are rendered as transparent.

Step 15: Apply this color texture to the WaterSteam_Material. In the Project panel, click once on the WaterSteam_Material (this will bring it up in the Inspector panel). In the Inspector panel, notice that the Particle Texture area swatch says None with a little Select subbutton. Click that Select and then double-click WaterSteam_Color in the Select Texture2D window (you may have to scroll down to find all of these options).

Step 16: Use WaterSteam_Material as the material for the WaterSteam Emitter's Particle Renderer component. In the Hierarchy view, Select Water SteamEmitter. In the Inspector, scroll down to see the Particle Renderer section. Expand the Materials area and make sure the Size input field reads 1. Then (either click the target icon on the next line and choose WaterSteam_ Material or) drag WaterSteam_Material from the Project panel into the Element 0 input field.

Step 17: Animate the Particle. Still with WaterSteamEmitter selected in the Hierarchy panel, move to the Particle Animator component. Ensure that Does Animate Color? is checked. Then in the Color Animation[x] section click each of the five color swatches. Look at Figure 6.29. Notice that there is a gray color at the top of each, and then a black-white bar at the bottom of the swatch. This swatch represents the alpha of that color. Each of these swatches show how the particle will be tinted over its lifetime with Color Animation[0] representing birth and Color Animation[4] representing the particle's death. The idea here is to have the alpha very low (mostly black) at birth and death so the particle fades into and out of existence.

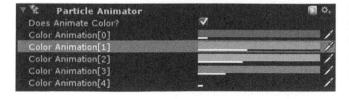

FIGURE 6.29 Particle Animator settings. Specific colors are not important, but be sure the Alpha settings are very transparent on both Color Animation[0] and Color Animation[4].

Tips and Tricks

The Alpha setting is changed in the Color Picker (when a color swatch is clicked) using the A slider.

Step 18: In Particle Animator component change the Size Grow to 0.4.

Why?

This will make sure that the particles also get smaller as they get older. It helps to keep the particles from popping out of existence.

Step 19: Finally, adjust the Mesh Particle Emitter settings to match Figure 6.30.

FIGURE 6.30 Mesh Particle Emitter settings.

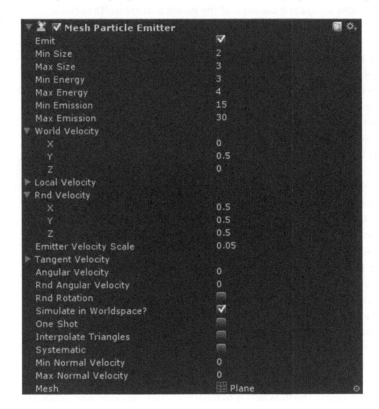

Why?

So many settings here it is just easiest to take a screenshot. Most of the entries are pretty self-explanatory, but here are a few that may not be. Min and Max Energy determine how long a particle is in existence (randomized). Min and Max Emission indicates how many particles are in existence at any one time. World Velocity indicates how fast and in what direction the particles leave the particle emitter. Rnd Velocity (Random Velocity) helps to provide a more organic movement to the particles as they emerge.

Tips and Tricks

Particle Emitter systems are fun since they happen in real time in both the Scene window and in the game. If the emitter is selected in the Hierarchy panel, when the attributes are changed, the Scene window will draw the effects of that change. However, remember that the particles that have already been emitted will not change with the new settings—only the

particles that are about to be emitted. So when changes are made, give Unity a second to really see how those changes affect the scene.

Step 20: Turn off the Mesh Renderer. In the Inspector (with WaterSteam Emitter still selected) check off the Mesh Renderer component.

Why?

No need to see the plane any longer, just the particles it emits.

Step 21: Play the game and test the effect (Figure 6.31).

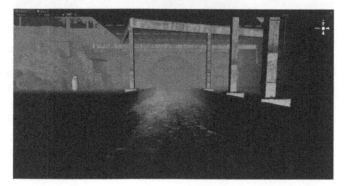

FIGURE 6.31 Effects of the Particle Emitter system.

Step 22: When pleased with the look, Copy/Paste the WaterSteamEmitter. Move, Scale, and Rotate the copy to approximate Figure 6.32 (to fill the other channel).

FIGURE 6.32 Second Particle Emitter system.

Step 23: Test the scene by Playing through. Be sure to turn on Fog in the render settings to make sure all the effects created thus far are compatible (Figure 6.33).

Tweaking Terrain Settings

Step 24: Adjust Terrain settings. With Terrain selected, check the Inspector. The far right button within the Terrain(Script) section looks like a little gear; this is where the Terrain Settings are stored. If, when walking through the game, the trees were all billboards (Billboard Start) or the detail meshes were

FIGURE 6.33 Finished Particle Emitter systems.

upsampling at the wrong time (Detail Distance), take a look at this section where all these attributes can be tweaked for a more seamless experience.

Remember that it is important for performance to have trees that are indeed far away to be billboards and detail meshes to be very low poly when they are far from the player. The quick solution a lot of students employ is to just crank these settings up (or down) so that all the trees are never billboard (for instance), but this starts to defeat the whole point of allowing Unity to generate these dynamic terrains. It takes a little tweaking to get the settings just right, but it's worth it when the game looks beautiful *and* plays smoothly.

Conclusion

In the course of this one chapter, we have created a great deal of assets solely within Unity. Largely these have not been objects to interact with (although theoretically they could be), but rather objects to add style or atmospheric effects.

The scene has some great things happening. The scale feels good, the previously modeled level is now surrounded by mountains with trees and rocks to hide the transitions. The atmosphere of steaming water and thick fog give the scene both movement and a cold feel. However despite all this, the scene still feels very flat at times because of the evenly lit scene. This is a result of that shortcut of adding ambient light to the scene. Everything is lit, but everything is lit the same.

In the next chapter we will continue in Unity and look at lighting the scene so that it has a sense of light and shadow and visual depth. Lighting is one of the most important parts of getting a scene to look "right." Taking time to get the lighting right and then baking that lighting in will start to make the scene feel complete and ready to play.

Asset Creation: Advanced Shading, Lighting, and Baking

You're a baker baking a cake. You fly to South America to personally select the very best chocolate, travel to Wisconsin to personally massage the cows so they produce the very best milk, assemble pure wheat from Nebraska after ensuring that every stalk is untouched by anything that would mar the precious kernels it held, sing to the chickens every night in the barn to make sure they lay the most perfect eggs, and then after putting all these ingredients in a bowl, you go out and grab the water needed from the gutter outside. This is how beginning game artists far too often go about approaching their shading/lighting/baking design in their levels.

Much, much too often students spend huge amounts of time planning, modeling, and texturing a level or set design. They spend many sleepless nights refining a normal map to get the bump just right on a character's costume. They go without food and drink to get the form just right on a piece of architectural detail. Then, when all the models and textures are complete—often after weeks or even months of effort—they try and slap together a lighting scheme in 15 minutes.

Models and textures are only as good as the lights that illuminate them. Many a beautiful asset has been completely muddied and ruined by poor

lighting. Similarly, sometimes mediocre work or simplistic design reads very sophisticated due to some especially effective lighting schemes.

When teaching Maya by itself, I spend several weeks in class working through lighting techniques as well as rendering technologies (Maya Software vs Mental Ray vs VRay, etc.). In reality effective lighting is worthy of its own book and thus beyond the scope of this one.

However, it is important to see how Unity's lighting tools work—specifically, how these lighting tools can be used to "bake" a lighting scheme onto the textures that cover an object.

Baking

Baking can refer to a lot of things in 3D. Animation can be baked. Physics simulation can be baked. Cloth can be baked. And of course, lighting can be baked. At its core, baking is the process of taking something that is calculated dynamically (balls falling and colliding with objects in a physics simulation, or cloth bending and deforming, or shadows being rendered on a surface) and transferring that information into a static file that is inflexible (cannot be changed without appending or rebaking) but very quick. So in Maya, a complex cloth simulation that takes several seconds a frame to figure out, can be baked down into something that plays in realtime.

In the case of lighting, baking is the process of taking the illumination a light gives off (and more importantly), the shadows that objects cast on other objects, and painting those adjusted color values on objects. Think of painting cast shadows across a surface, and painting a tint on a surface that shows the yellowish light of the dirty lamp post.

This is important because rendering lighting in realtime is an expensive process. Video cards (even dedicated cards) have to expend a lot of cycles and memory to make this happen. By baking the lighting in, the video card is simply drawing a texture (or layered textures) and not having to draw illumination and shadow passes.

Baking in Unity (aka Unity Lightmapping)

So why not Maya? Why not cover Maya's lighting tools and how to bake in Maya? Good questions with some good answers. It can be a tough call deciding what to do in Maya and what to complete in Unity, especially as Unity increases its flexibility in level organization and movement. Previous to Unity 3, Maya undeniably would have been the place to bake, but with the new technologies in Unity 3, baking in Unity has some distinct advantages.

The first reason we won't be covering baking in Maya in this book is because there's a really nice Maya baking tutorial at http://unity3d.com/support/resources/tutorials/lightmapping-in-maya; no need to replicate it here. Second, lighting a scene and baking it in Maya usually means a whole lot of material reconstruction once the asset is imported into Unity. Unity essentially brings in

all the materials as flat Diffuse shaders. If the shadows and lighting are baked into the color texture in Maya then this import goes well and quickly. But if the scene has some tiled textures applied to a UV set that is bigger than the 1,1 quadrant in the UV Texture editor, then this isn't possible. In Maya, the way around this is to make a separate UV set that tells a separate texture (a lightmap) how to apply to a surface without any overlapping UVs. This then generates another problem when the scene is brought into Maya because all the materials then have to be rebuilt to include this new lightmap. This remapping and rebuilding is not a trivial task and can suck up a lot of time.

Alternatively, Unity 3 includes some new, really amazing technology (Beast) that allows for lighting solutions to be baked within Unity. Essentially this does the same thing as baking in Maya but with much added flexibility. Unity will generate its own lightmap UV set (more on this later), and after baking automatically builds the materials appropriately to show the lightmap. Plus, if the scene suddenly needs to be at night, or in different weather, the lighting can be rebaked in Unity without having to go back to Maya, relight, rebake, and then reimport (including all the material rebuilds).

To further empower this new system, Unity's lightmapping process creates texture atlases to ease the hardware requirements. To really make things exciting, this baked lightmap can be swapped out for dynamic lighting based upon the player's distance from an object. So if a door opens and changes the lighting in the scene, this lighting can update in game rather than stay painted on as it would with a Maya lightmapped scene. Talk to most scenic game artists who work in Unity—the new lightmapping capabilities are among the new features of Unity they are most excited about.

Limitations to Unity Lightmapping

Before we all get too euphoric there are some restrictions and problems with Unity's new lightmapping. First, the demo videos seem to show that Unity's lightmapping is quick and easy and that users can continue to work while their scenes bake. It is true that clicking the Bake button is easy, but getting the settings right to provide for the best quality in the least time can take a bit of practice and patience. In the demo videos on Unity's site, the baking time is indeed phenomenal, but the scenes are also not particularly complex either. It's one thing to bake a four-sided room or a collection of buildings without any overhanging areas—it's an entirely different issue to bake a complex scene with real spaces and corners. It means that baking can take a while. A big scene with a complex lighting scheme can take several hours to bake and it almost always takes multiple sessions of baking to get the look just right. Here at our studio, with some particularly complex scenes, baking has taken over 5 hours on very well-equipped machines. Additionally, it is true that other things can be done on the machine doing the baking (e-mail, web browsing, even some basic Maya work), but you'll find that trying to work in Unity while it is baking is a jerky, losing process. Press the Bake button as you leave for the day; it'll save lots of frustration.

Plan of Attack

As implied in this chapter, the main focus will be on baking the lighting of the scene. This will actually take a few steps that build upon each other. First, before we start doing much lighting, we will look at some advanced shader construction—the use of Normal Maps, which will help to provide surfaces that appear bumpy (or not) and not just like flat objects with color on them. This advanced shader construction will come in handy as we look at Unity's lighting scheme and how to control Unity's lighting instruments.

Finally, once some real-time lighting has been established we will look at baking strategies and settings to get a nicely baked lightmap that will look good in the game. Along the way, we will light the scene for a couple of different scenarios—first for a bright sunny day (since it allows the effects of light maps to be seen most clearly), and then for the dark, damp, and dismal day that the game actually calls for.

Tutorial 7.1: Normal Maps

Normal maps are maps that help create more tactile-looking surfaces. Normal maps don't actually change the polygons of a surface—they don't really change the object they are attached to, but they present the visible representation of a more complex form. The grandfather of normal maps was bump maps, but normal maps are more powerful in some important ways.

Bump maps were largely grayscale (or at least that was the only value that mattered to the 3D software rendering them). When the texture map that was used to define bump had pixels closer to white, they were rendered as raised and pixels close to black were rendered as receding. The power of this was that a surface looked as though it had all sorts of bumps and valleys when the geometry did not.

Normal maps take this to the next level in that they use a similar idea, but instead of simply rendering the surface as raised or lowered in one direction, they describe the x, y, and z coordinates of a normal vector. The science and math here is well beyond what is relevant, but the net results are low-poly forms that are able to visually indicate much higher forms. The textures react to change in light and behave in believable and predictable ways as a player moves around them. In 3D arenas where polycount is important (like games), normal maps are tremendously powerful.

Historically, there are three ways that normal maps are usually created. The first is to actually model a very high-poly version of a surface (including characters) and then generate a normal map from that high-poly mesh that will be applied to a much lower-rez version of the form. In many ways this is most accurate, and frankly often produces the best normal maps. However,

this essentially means creating the form twice, which can take some serious time. Although for characters that will be seen throughout a game, this could well be a worthwhile technique.

The second method is to use some of the relatively new tools on the market (ZBrush or Mudbox) to paint normal maps. Essentially what these packages are doing is creating higher-resolution copies of a form that are sculpted (in some really fun ways) in these applications and then normal maps are generated and applied to their lower-resolution cousin. Especially for character work ZBrush and Mudbox are some really awesome tools. They have become ubiquitous in game character creation. If character design and creation are your thing, be sure to get your hands on one of these tools (I prefer Mudbox because it interfaces well into Maya, but there are fantastic results coming out of both packages).

The third method is the method we will be exploring—extracting a normal map from a color map. Up to this point we have been defining a surface by the color attributes alone. A rock wall is painted to look like a rock wall. However, this painted rock wall is flat without any of the real peaks and valleys that such a wall would have from one rock to the next. This means that the still image might work out, but as a player walks up to and past the wall, there is never any of the visual clues that there are actually rocks coming out of that mortar.

Because the color maps are complete, and because the raw versions of those color textures are carefully saved in the images folder of the Maya project file (Incursion–Maya), the core building blocks of this technique are at hand. A bit of time in Photoshop and a few additional tools will yield some reasonable normal maps.

The drawback to using Photoshop to develop normal maps is that the creation is a little more opaque. Figure 7.1 shows what a bump map would look like as opposed to a normal map.

FIGURE 7.1 Bump (top) vs normal (bottom).

It's easy to see how bump maps can be easily altered with a bit of contrast adjustment, and even by hand painting some white areas that needed to be rendered higher. Not so with the normal map. In fact, the red, green, and blue normal-vector values must equal exactly 1, and if the colors are painted by hand the values may not be what are needed and break the texture. So to ensure these values are correct and will function in the game we will need to use some other tools.

Additional Tools

There are some cheap and even free software packages that assist in creating normal maps. A very nice one (and one that is reasonably priced: $299 for Professional, $99 for Personal, $49 for Student) is CrazyBump (http://www.crazybump.com). CrazyBump allows for a 30-day trial, but anyone who tries this will quickly see how powerful and easy it is to refine a normal map from a color map. If it's in your budget, CrazyBump is a really great time-saving tool to add to your tool kit. Importantly, CrazyBump is available for Mac and PC whereas the plug-ins for the next step unfortunately appear to be PC only. So if you're Mac based, be sure to grab CrazyBump's free trial and skip this tutorial.

For those of you who use a PC and are interested in the free options, there are some free alternatives (which are what we will be using for this tutorial). NVidia has released a free set of plug-ins for Photoshop that assist in the creation of normal maps. They are available at http://developer.nvidia.com/object/photoshop_dds_plugins.html. We will only be using the Normal Map Filter part of the package, but just this part is quite powerful.

> **Step 1:** Download and install NVidia's Plug-ins for Photoshop (use the preceding URL). The install package is a .exe, so just launch it and follow the instructions to install.

Unfortunately, when using the default installer, the plug-ins will be installed in the 64-bit version of Photoshop. On install, you should be able to define which version of Photoshop the plug-ins are installed to, and if you are, just point the installer to the 32-bit version. However, if you were not able to define which version of Photoshop to install the plug-ins to, go to C:\Program Files\Adobe\Adobe Photoshop CS5\Plug-ins\Filters and copy the NormalMapFilter plug-in and paste it into C:\Program Files (x86)\Adobe\Adobe Photoshop CS5\Plug-ins\Filters. Then, of course, launch the 32-bit version of Photoshop when you wish to use these plug-ins.

> **Step 2:** Select a texture to work from. I am using the texture assigned to the EntryWayWallsInner. This texture is EntryWay_WallsInner_Color. Open the **unflattened** (all the layers intact) version in Photoshop (Figure 7.2). This version will probably be within the images folder of the Maya project file and may be labeled either EntryWay_WallsInner_Raw or EntryWay_WallsInner_UV if you just saved over the UV snapshot. Do not edit the version of this texture in the sourceimages folder. We need the layers. Finally, resave this file as `EntryWayWallsInnerNormalRaw`.

Warnings and Pitfalls

It has been a while since NVIDIA updated these plug-ins. Unfortunately this means they are apparently not compatible with 64-bit versions of Photoshop. So, if you are using a 64-bit operating system (Windows 7 or Windows XP 64-bit) you will need to use the version of Photoshop that was installed in the Program Files (x86) folder—this is the 32-bit version.

FIGURE 7.2 Raw version of the inner walls texture. Notice the complex collection of layers that will pay off here.

Tips and Tricks

Remember that in the texture creation chapter (Chapter 4), whenever we built a texture we kept a copy of the construction texture in the images folder and a flattened version in the sourceimages folder (both within the Maya project folder). Keeping that raw version pays dividends in situations like this. Because all the dirt and drips are on separate layers, those can just be hidden to reveal the base texture beneath.

If you are following exactly along with the tutorial and using the assets I use as provided on the web site (http://www.Creating3dGames.com), the file we are after, EntryWayWallsInnerUV, is in the images folder.

Cleaning up the Raw Texture

Step 3: Hide all the grime, dirt, and drips layers. Do this in the Layers palette by just turning off the eye icon on the layers that are not wanted (Figure 7.3).

FIGURE 7.3 Base texture without added dirt and grime.

Why?

The dirt and grime was very important for the effective color map. However, in the real world usually this dirt and grime is over the top of existing tactile attributes. This means, usually the grime is going over the peaks and settling into the valleys of a surface and not actually changing the rises and falls. Through this process we will be using the light and dark parts of the color texture to define (roughly) the high parts and low parts of the surface. If the drips (for instance) were left, the normal map would interpret them as actually recessed sections of the surface rather than grime atop a surface.

Step 4: Gray out areas without much bump (Figure 7.4). This can happen with an adjustment layer, or with a new layer with 50% gray filled or painted in over areas that are smooth.

FIGURE 7.4 Areas without bump grayed out.

Why?

The two areas that are grayed out in Figure 7.4 are the cement floorboards and the cement wall under the roof. Since this is cement, it may have a bit of bump (which is why the gray isn't a solid gray), but not a whole lot. If this is not grayed out, then every dark splotch on the color part would register at a pock mark. Graying it out keeps the surface visually smooth.

Step 5: Flatten the layers. Layer>Flatten Image.

Why?

Once we are down to the core color information, there is little need for all the other layers to be taking up all that memory space and slowing the work. Alternately, the dirt layers could just be deleted instead.

High Pass Filter

Step 6: Run a High Pass filter. Select Filter>Other>High Pass. Adjust the Radius to about 10 (although this is largely to taste (Figure 7.5).

FIGURE 7.5 Applying a High Pass filter.

Why?

The High Pass filter does some important things for us. First, it desaturates or removes the color information. Second it starts to remove some of the detail from the image. Ultimately, the goal of the normal map is to create some large undulations across the surface; but when building the normal map off a color map, there can end up being way too much information and the result being entirely too bumpy. By removing a bit of the variation on the surface of the rock, we can keep the focus on higher rocks with much lower grout and not on sandpapery-looking stones.

Step 7: Adjust the Levels to take advantage of the highs and lows of the image. Access the Levels via Image>Adjustments>Levels… and move the sliders beneath the histogram to where the input levels really start to rise (Figure 7.6).

NormalMapFilter

Step 8: Apply NVidia's NormalMapFilter. Assuming the NVidia package has been installed, choose Filter>NVidia Tools>Normal Map Filter…. Change the settings to match Figure 7.7, basically changing the Filter Type to 4 Sample, the Height Source to Average RGB, and the Scale to 10. Press OK. A sample of the newly created normal map is seen in Figure 7.8.

153

FIGURE 7.6 Adjusting the levels.

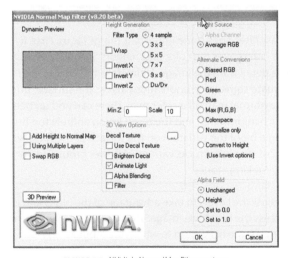

FIGURE 7.7 NVidia's NormalMapFilter settings.

Why?

These settings are not entirely intuitive. The parts we are more interested in allow for a fairly soft sampling (Filter Type) with a pretty high Scale (10).

Step 9: Gaussian blur the results. Select Filter>Blur>Gaussian Blur. For this size image, change the Radius to 1 pixel (Figure 7.9).

FIGURE 7.8 Sample of the newly created normal map.

FIGURE 7.9 Sample of first level of Gaussian blur.

Why?

Even with our High Pass, there is still quite a bit of "noise" in that initial pass. Giving a little blur helps soften the noise and keeps the information where it should be. This shouldn't be too high since too much of a blur will simply wipe out all the detail (including the desirable large detail).

Tips and Tricks

How much to blur this first pass is tricky. Much of it is relative to the file being affected. A Radius of 1 might be just the trick for a 2048×2048 image, but way too much for a 512×512. Further, if the image is tillable and much closer, it might need to be much higher (5 or more). So keep frequent saves to make sure you can go back to an earlier version if things aren't going as planned.

Layering to Increase Height

Step 10: Duplicate the Background layer. The quick keyboard shortcut for this is Ctrl-J (Command-J on a Mac). This will create a new layer (Layer 1) identical to the first that sits atop the original.

Step 11: Change the new Layer 1 Blending to Overlay. You can do this either within the Layers palette (immediately beneath the Layers tab) or by double-clicking the layer and in the Blending Options section of the Layer Style window changing the Blend Mode drop-down menu. The results can be seen in Figure 7.10.

FIGURE 7.10 Results of duplicate layer with an Overlay Blending Mode.

Warnings and Pitfalls
By using an additional layer and adding the value, this is no longer a valid normal map. Remember when we talked earlier about the normal vectors needing to equal exactly 1? Well, now they definitely do not. So be sure not to use the file in its current state or the results will be very unpredictable.

Why?

Often the results of the NormalMapFilter are too muted. The amount the surface will be raised is just too low. By duplicating the information and adding the color information to the original via the Overlay Blending Mode, the height of the normal map will increase.

Step 12: Gaussian blur Layer 1 with a Radius of 2 (Figure 7.11).

155

FIGURE 7.11 Blurring new layer.

Why?

By making the next level up blurred a bit more, we are creating a stepped increase in the new height being created. Each successive layer copy will be blurred a bit more, thus increasing the height and spreading the up ramp out a bit.

Step 13: Repeat the process of duplicating the level and then running a Gaussian Blur, but this time with a radius of 4.

Step 14: Repeat the duplication and Gaussian blur process five more times, each time increasing the radius of the blur by 2 (Figure 7.12).

FIGURE 7.12 Multiple layers of increasingly blurred normal maps.

Why?

Take a look at Figure 7.13, which shows the initial output by NormalMapFilter and compares it to the result of the multiple overlayed layers. Notice how much more information is there, and how much richer the normal map actually is.

FIGURE 7.13 Comparison between original output and layered approach.

Housekeeping

Step 15: Save again. Be sure you're saving as `EntryWayWallsInner NormalRaw`.

Why?

Since this strange bluish image makes it pretty tough to know what the result will look like, it will be important to have the raw version to come back to if the final result in Unity is not what was planned.

Step 16: Flatten the image (Layer>Flatten Image).

Why?

We will need to "normalize" the image to bring the normal vectors back into the needed value of 1, but this needs to be done to the total image and not just one layer.

Step 17: Normalize the image. Choose Filter>NVidia Tools>NormalMapFilter. In the Alternate Conversion area check Normalize Only. Press OK.

Why?

The other settings can all remain the same because none of them will be used. Normalize Only will ensure the red, green, and blue normal vectors are exactly 1 and thus ready to be a normal map.

Step 18: Save the image for use in Unity. Save the file as `EntryWay_ WallsInner_Normal` into the Incursion-Unity/Assets/EntryWay.fbm. The file format can be whatever you'd like (I saved it as a .psd).

Why?

Due to our deft use of manual exporting, all the texture files related to the EntryWay are in this EntryWay.fbm folder that Unity created. Adding any new texture assets that are meant for EntryWay keeps the Project panel clean.

Back in Unity

After all this work in Photoshop, we need to help Unity understand what this new asset is and where to use it.

Step 19: Help Unity understand that this is a Normal map. In Unity, in the Project panel, select EntryWay_WallsInner_Normal. In the Inspector look for the Texture Importer section and change the Texture Type to Normal map. Click off the Generate from grayscale setting. Click Apply.

Why?

Unity likes to know what it's dealing with. If this image is used to define the normal channel of a bumped shader, Unity will complain that the image is "not tagged as a normal map." By telling Unity to bring the image in as a normal map, this warning will be avoided. However, the Generate from grayscale option is not what we want here. What this option attempts to do is what CrazyBump does or what we just did in the past 17 steps—it attempts to create a normal map from a color texture image. However, in my experience, the result here is neither optimal nor easy to control. The most control comes from techniques outside of Unity.

Step 20: Select the EntryWayWallsInner GameObject. Do this by either clicking the object in the Scene window or finding it by name in the Hierarchy panel. The attributes of the GameObject will appear in the Inspector.

Step 21: Change EntryWayWallsInner's shader to be Bumped Specular. In the Inspector look down toward the bottom at the entryway-entryway_wallsinner_mat. In the Shader section there, choose Bumped Specular from the drop-down menu. There should appear a new Normalmap section.

Why?

Really, most any of the Bumped shader would work. However, to really get a look at what this normal map does, the specular flavor shows it off the quickest. This will probably be changed later as the specular shaders make things look shiny or wet, but for now, for illustration purposes it'll do just the trick.

Tips and Tricks

If there are no options below the Shader section in the Inspector, click once on the sphere swatch. It will expand or collapse the settings for that particular material.

Step 22: Use EntryWay_WallsInner_Normal as the Normalmap. Still in the Inspector, in the Normalmap section, click the Select button and choose our newly imported EntryWay_WallsInner_Normal image. The results should be immediately visible in the Scene window. Figure 7.14 shows the before and after.

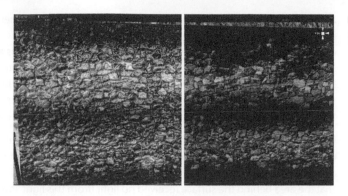

FIGURE 7.14 Before (right) and after (left) using the normal map.

Why?

Yes, it appears a bit hyper right now—it is too wet with too much specular. But because the scene has not been lit yet, we just needed a glimpse of the visual effect of the process. Later it'll be changed and made a bit dustier. Do note that normal maps show differently depending on the lighting that is illuminating it. Upon first applying the normal map, there may not be a huge difference in the appearance of the surface—this will come later when additional lights are placed in the scene. If you would like to experiment with some quick lighting (GameObject>Create Other>Point Light (or Spotlight or Directional Light)), you can get a quick feel for how lighting and shading are closely intertwined as the light is moved around. Don't sweat the lighting too much at this point though. We will be working much more with lighting in steps to come.

Step 23: Repeat this process for any surfaces that need a normal map. This could include the tiles and maybe even parts of the rusty beams. Don't worry about areas that are mostly smooth (well-worn cement for example), but areas that should be bumpy need normal maps.

Conclusion

Normal maps can add tremendous depth to a scene. If you are using a quick tool like CrazyBump, they won't even take very long to implement. We could have made these while working in Maya, and indeed it would have made the model look better in Maya. However, because Unity interprets some things (especially normal maps) differently than Maya does, it is usually not worth getting too caught up making extensive materials in Maya. Do that assemblage in Unity.

Tutorial 7.2: Lighting and Baking in Unity

Up to this point, the scene has made use of a very simple lighting scheme—it had none. OK, well, turning up the Ambient Light in the Render Settings *could* be considered a lighting scheme, but that's stretching it. Ambient light in

a 3D software sense is light that comes from everywhere and nowhere (for example, objects have no shading, and appear flat). In reality, what we think of as "ambient light" in the real world is really bounced light. There is a light source (the sun, a light bulb, etc.), and that light emits from the source and then bounces off surfaces to further illuminate other objects around it. This bounced light really isn't "ambient light" but light that has been dissipating as it continues to strike and ricochet through our reality until all its energy is absorbed.

Back in 3D world, the problem is that all this bouncing light is a nontrivial calculation. In fact for a long time, most rendering solutions did not calculate any bounced light at all; when a light ray hit a surface, it stopped. This meant that the area behind the surface received no light (from this light source) and thus rendered black, as a shadow. At first blush, this sounds fine. The problem is that real shadows in most situations are never black. There is enough bounced light shooting around the environment to still illuminate the objects in shadow, and thus the grass under a tree on a sunny day is simply less lit, not black.

As rendering technologies matured, radiosity-based solutions emerged that simulated bounced light. In Maya, MentalRay is typically the rendering engine to enable this. Through tools like Final Gather and Global Illumination, nice diffuse light appears to be bounced across surface and the light even picks up the color of the surface it has just bounced off of (actually the lit surface is really just sampling surfaces around it through stochastic samples, but let's not split hairs). The problem is that all this beautiful bounced light simulation is processer intensive. Rendering a complex scene with great sampling rates was a very time-intensive task. It just is not that unusual to have 12- or 15-hour renders for a single frame, which of course won't work in game situations.

Hence the need to bake the lighting. Previous to Unity 3, baking in Maya could yield some very nice results that could then be brought into Unity (with the time-intensive reconstruction of materials). Now though, via Beast (the technology for which Unity Technologies has a license), a built-in radiosity-like renderer will calculate a render that includes bounced light that yields much more believable shadows and even color bleed.

So baking in Unity is not only a possibility but preferred (for further convincing, just wait until we talk about Deferred Lighting—yeeha!). This means that learning Unity's light tools becomes more than just a placeholder or "rough-it-out" technique—it becomes critical to getting the scene to look right.

In this tutorial we will be looking for a bit at Unity's lighting instruments and the options they allow for. In the course of the tutorial we will light the scene for daytime on a sunny day and again for the dusk time on a foggy day, which the game calls for.

Unity's Lighting Instruments

Unity's lighting instruments are all available under the GameObject>Create Other drop-down menu. There you will see Point Light, Spotlight, and Directional Light. Here's a quick overview of each. Don't worry about placing

any lights in the scene quite yet, just take a look at the following explanations to see what the lights do before placing any in the scene.

Point Light

Think of point lights as a single light bulb suspended in space. Figure 7.15 shows a point light sitting in the scene (with ambient light turned off). There are really two types of handles that a selected point light presents in Unity 3. The first is the actual light source—the point from which the illumination emits. This light source can be moved, scaled, or rotated, although since the light is emanating from all sides, only moving it will yield any noticeable results. The second are the Range Handles. These handles are actually just the six little yellow dots at the intersection of the three yellow rings that surround the source. In any tool (move, rotate, or scale), selecting these handles will increase or decrease the falloff range of the light. The illumination from the point light will go no further than these handles.

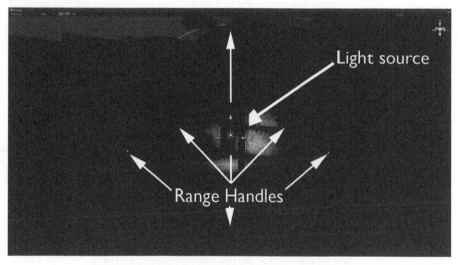

FIGURE 7.15 Point lights and its relevant handles available in the Scene window.

Tips and Tricks

These handles are really, really picky. The tip of the arrow of the cursor has to be exactly on that handle. Takes a little practice to grab those just right, but they are definitely more intuitive to use than the numerical range input field in the Inspector.

The Inspector shows the other options available for the point light. Because these are covered fairly well in the documentation, we will refrain from covering them all here except for a few tips.

Intensity and **range** have an interesting relationship. Intensity refers to the brightness of the illumination, but this illumination will still stay within the light's range.

Cookies are gobos from the theatre world. What they do is provide a textured light—a light with some shadow on it. Think of the shadow made as light streams through a tree without a dense canopy of leaves. Cookies can be handy to imply geometry that isn't there (think of plays that take place in a forest lit with a "cookie" so the audience can see the shadows of trees and leaves that are not actually present). For point lights, cookies must be Cube Maps with alpha channels.

Shadows are beautiful but expensive in terms of resources. It takes a good deal of horsepower to draw the shadows emitted by any light. Point lights are especially expensive because they are essentially six spotlights shooting out in each direction. This means drawing all these shadows and draw calls in realtime can very quickly drag your game to a crawl. Hard shadows are easier to draw than soft, but without some serious baking, multiple-point lights with shadows will kill a frame rate. Note that shadows drawn in realtime are available only with Unity Pro—although they will be present in baked scenes when using the free Unity.

Halos can be thought of as glows.

Render mode is used for determining how critical a light is when Unity is determining what to draw. For our level (and for most levels) Auto is a fine setting.

Culling mask determines what this light illuminates. By default it illuminates everything, but this can be restricted so a certain light only lights certain objects. This actually comes in handy more often than you'd think.

Lightmapping allows for the definition of whether this light is used in the lightmapping process or not. It can be used in both lightmapping and realtime of course, and in most situations a setting of Auto works fine.

Spotlight

Illumination emanates from a single point from a spotlight but emits out in a cone shape just like a real spotlight. Figure 7.16 shows a spotlight and its relevant handles. It still has a Range handle, but only one, and it indicates the linear throw the light has. The new handles available here are the Spot Angle Handles, which allow for the angle of the spot.

The Move and Rotate tools are very important for this tool. Rotating to find the right spot to spotlight is the key to this tool.

Most of the notes for point lights apply to spotlights as well. A couple of notable exceptions are (1) for a spotlight, **cookies** can be a single image with an alpha channel, but it must have a black edge all the way around the image; and (2) upon import, the Texture Import settings must have Border Mipmaps activated, and the wrapping mode selected to Clamp.

Directional Light

Directional lights can be a little goofy to understand. Figure 7.17 shows the scene with one directional light that is casting shadows. Remember that only Unity Pro will cast realtime shadows, but shadows help illustrate what this

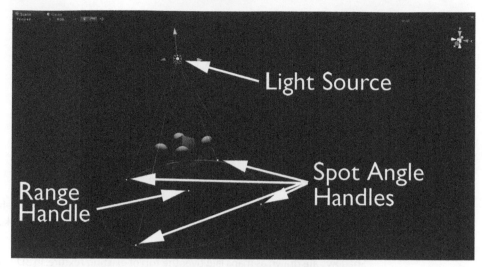

FIGURE 7.16 Spotlight with its handles.

FIGURE 7.17 Directional light casting shadows. Notice that the light is beneath the roof, but the shadows indicate the illumination coming from above it.

light is doing. Notice that the actual light source is *underneath* the roof, yet the shadows indicate that the light source is above the roof. What gives?

The core idea here is that directional lights (like directional lights in Maya) come from infinitely far away and throw an infinite distance (with parallel rays). This means that the angle of the light is more important than its physical location. It can sit anywhere in the world, but the light will still come from far away in the sky. This is why there are no Range Handles in the Scene window or Range settings in the Inspector.

The most obvious use for directional lights is as the sun. They quickly light everything in the scene. This also brings up other challenges though. If you're using Unity Pro, the shadows that a directional light casts (by default) can seem to be of really poor quality (Figure 7.18).

Shadows

Since understanding shadows is an important part of fine-tuning the visual quality of the game, it's worthwhile to take a bit of time out here and talk about how Unity deals with the shadows it draws. In Figure 7.18 it's easy to

FIGURE 7.18 Poor-quality shadows from the default directional light.

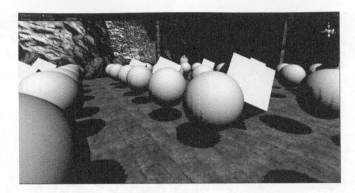

see the drawbacks to the default settings, but getting this to look and behave better is not hard. But before we look at how to fix the problem, let's look for a minute at why the problem exists.

Shadows are drawn as maps laid over the top of existing texture. In 3D-speak these are referred to as shadow maps. When using Maya or other 3D applications, drawing the shadow map can indeed be a slow process as the software figures out where to draw these dark blobs of pixels. A shadow map is essentially an image with a finite resolution (and, like any raster image, can look pixilated when viewed at a close range).

Choose Edit>Project Settings>Quality. This will bring up an image like Figure 7.19. First look at the top collections of settings (Default Standalone Quality, Default Web Player Quality, Editor Quality). By default these are all set to Good. The specifics of what Good means are contained in the following sections (Good and Fantastic are expanded in Figure 7.19).

FIGURE 7.19 Quality Settings from Edit>Project Settings>Quality.

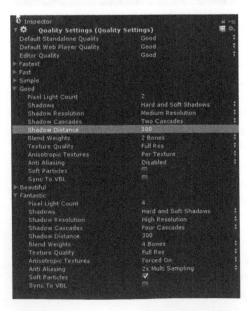

Standalone is a build that is its own executable on Windows or application on a Mac. **Web Player** is a build destined for the web and includes some partner html files. **Editor** is the space we are currently working in. Editor refers to both the Scene window and the Game window.

So with the Editor Quality set to Good, it is important to know what Good means. In Figure 7.19 the Good settings are expanded. Note that there are four sections focused on shadows: Shadows, Shadow Resolution, Shadow Cascades, and Shadow Distance.

Shadows: This actually has two meanings. First, here you can turn off all shadows (No Shadows) and choose what types of shadows will be rendered (Hard only or Hard and Soft Shadows). Hard Shadows are cheaper to render in realtime although Soft Shadows often have a more-refined look, especially in interiors.

Shadow Resolution: When it's understood that a shadow map is really a sort of image, a shadow resolution starts to make more sense. A higher-resolution shadow map means there are more pixels to define a shadow. Take a look at Figure 7.20 to see a quick illustration of this idea. At higher resolutions, there are more pixels available to describe any one shadow, which means the individual pixels are smaller, which means the shadow is cleaner.

Shadow Cascades: These are used only for Directional Lights. The idea is that Unity divides the viewing area into sections (cascades) that get larger as they get further from the camera. Yet each section uses the same-sized shadow map. So areas far from the camera are much lower resolution (larger area covered by a map), and areas closer are higher resolution (smaller area covered by a map). Four Cascades looks better than Two Cascades as the viewing area is split up into smaller sections with each section having the same amount of shadow information. More information in one cascade (the nearest) means higher-quality shadows (Figure 7.21). Remember though that the additional cascades means additional calculations, so there is a bit of a performance hit with higher cascades, although for well-equipped systems this hit may not be noticeable. It's just one more of the performance/quality balance considerations that are forever a part of game creation.

Shadow Distance: This refers to how far away from the cameras shadows are rendered. By decreasing the shadow distance, the surface area that the shadow map is covering becomes smaller and thus the quality of the visible shadows increases. But (and this is important), it means that shadows further than the Shadow Distance setting are simply not rendered. An illustration of this idea is seen in Figure 7.22. A Shadow Distance of 5 means the shadows right in front of the camera look great, but the spheres stop casting shadows further away. The shadows that used to define the area under the overhang are gone altogether. However, a Shadow Distance of 5000 means that all the shadows are there, but since the shadow map is being shared by such a long distance, the quality is horrible.

FIGURE 7.20 Shadow resolution differences.

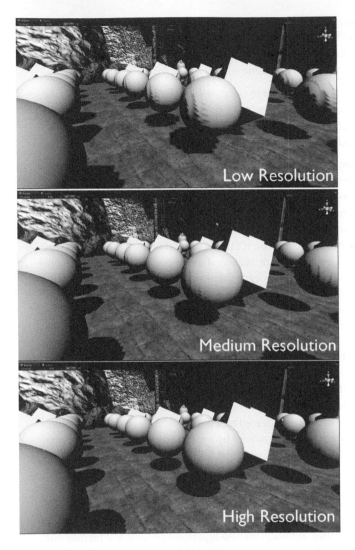

Finding the sweet spot for a game becomes an important piece of optimization. In many scenes, objects may be far away and casting shadows, but the shadows can hardly be seen even when visible. This is a perfect situation to decrease the Shadow Distance and allow more of that resolution to be used right up close to the camera.

Figure 7.23 shows the quality settings high and with a shadow depth that seems to be a good balance in quality and coverage.

Tips and Tricks

Note that Fantastic settings include High Resolution and Four Cascades. If, up in the Quality Settings, the Editor Quality was changed from Good to Fantastic, the shadows would instantly look better in the scene. However, it would still be important to optimize the Shadow Distance setting.

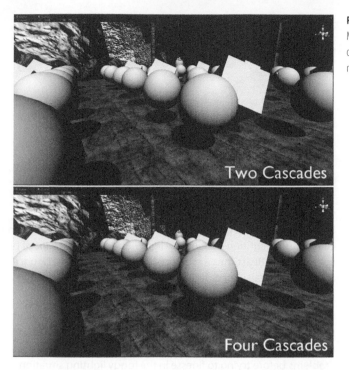

FIGURE 7.21 Cascade comparison. More cascades mean smaller chunks of viewing area getting a shadow map.

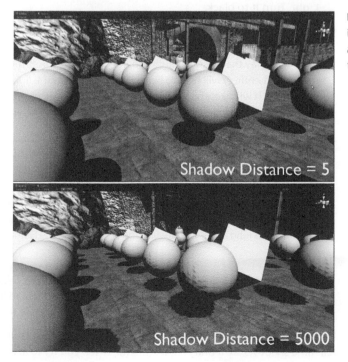

FIGURE 7.22 Shadow Distance illustration. Too low and shadows that are needed disappear. Too high and the shadow quality gets too low.

FIGURE 7.23 Settings that make the real-time shadows appropriate *for this scene* (they could all be different for a different scene with different lengths of visible distance.

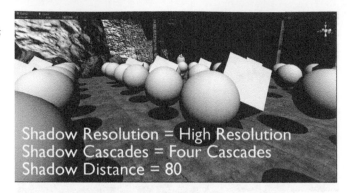

Shadow Resolution = High Resolution
Shadow Cascades = Four Cascades
Shadow Distance = 80

Clear Day Lighting

Exterior lighting can be some of the easiest to make happen in Unity. At its core, outdoor lighting has one key light—the sun—and a lot of bounced light. Because Beast uses a radiosity-like engine, the light bounce will be automatically calculated during baking. However, before baking we need to quickly light the scene and look for any holes.

Often with scenes like this, when the game calls for subdued lighting, getting the lighting right, and seeing flaws in the model and lighting design, can be tricky with a first pass. By lighting for a clear day, it can be easier to see any problems before trying to finesse in the foggy lighting situation.

> **Step 1:** Turn the Ambient Light off. Open Render Settings (Edit>Render Settings) and click the color swatch next to Ambient Light. Turn it to black.

Why?

In the same way that Ambient light provided a quick look at the set, turning it off entirely will help to illustrate exactly what the light is doing in the scene. It will likely be reactivated, though at a much lower intensity later, but we need to see what the light is doing to the scene without this everywhere and nowhere light always lighting surfaces.

> **Step 2:** Create and orient a Directional light. GameObject>Create Other>Directional Light will create a Directional light GameObject in the Hierarchy panel and in the Scene window. Its placement may be strange, so move it up into the sky (more as an intuitive place to go find it later) and rotate it so it is pointing down on the scene. The exact rotation and angle is not important, as long as it is illuminating the scene. Name the GameObject Sun.

Baking

> **Step 3:** Enable shadows for baked textures. If using Unity Pro, select Sun and in the Inspector turn the Shadow Type to Hard Shadows. Behind the scenes, this will make sure that when the scene is baked it will include the shadows.

If you are using Unity (Standard), Shadow Type may be grayed out since real-time shadows are a Unity Pro feature (or, when you try to activate

shadows, Unity will tell you this feature requires Unity Pro). However, it will be important that this light is casting shadows when the scene bakes. To make sure that the Sun is indeed casting shadows in the baking calculation select Window>Lightmapping. In the Lightmapping window, click the Object tag/button. The Sun(Light) object will appear here. Change the Baked Shadows setting to On (Realtime: Hard Shadows).

Step 4: Create custom Lightmap UVs. In the Project panel, select EntryWay. In the Inspector, in the (FBXImporter) section, check the Generate Lightmap UVs checkmark. Click Apply.

Why?

In some cases this doesn't need to be done. If the model imported has no overlapping UVs (and all the UVs are completely contained in the top-right quadrant of Maya's UV Texture Editor), the existing UVs will work fine. Unity will bake the shadows and know right where to paint those shadows on the surface. However, if you have used any overlapping UVs or worked with tiled textures your UVs won't work for lightmapping; with overlapping UVs a shadow would be painted across objects multiple times and be wrong. By clicking this Generate Lightmap UVs button, Unity knows that it needs to create a custom set of UVs (with no overlapping UVs) for the entire scene that it will use to map the lightmap it will render in the coming steps. This new lightmap is reasonably well laid out and tightly packed. So although a second UV set could be manually created in Maya before importing, usually it's not worth the effort since Unity's automatic version works quite well.

Step 5: Prepare geometry for baking. In the Hierarchy panel click the EntryWay GameObject. In the Inspector panel look for the Static checkbox (it will be in the upper-right-hand corner of the Inspector). Check this. A warning dialog will pop up (called Change is Static) that will ask, "Do you want to make the object and all its child objects static?" Click the Yes, change children button.

Why?

What's this static business? The Static check box is (among other things) Unity's way of knowing which objects to be included in the baking process. Generally, the thinking here is to bake in shadows and objects only of things that won't move. Since only the door in the EntryWay level will move, we can have everything in the EntryWay GameObject inherit the Static label. This means all these objects will be included.

Step 6: Ensure that the Terrain is also set to Static. Remember to select the GameObject in the Hierarchy and look for the Static checkbox in the Inspector.

Step 7: Prepare to bake the scene. Open the Lightmapping window via Window>Lightmapping. Click the Bake tab/button at the top. For this first pass, if using Unity Pro, change the Bounces setting to 2. Change the Bounce Boost and Bounce Intensity settings. Change both of these to 2 (Figure 7.24).

FIGURE 7.24 Settings for lightmapping.

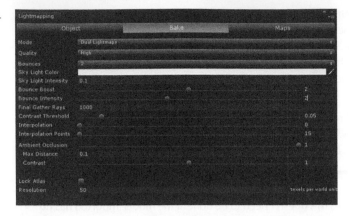

Why?

The default settings for lightmapping are generally reasonable for a first pass. For interior scenes, these settings will frequently result in some splotchy sections on the walls that will result in some adjustments of some of these specifics. However, for exterior scenes, and for first passes, the default settings are alright. If using Unity Pro, the settings that are changed here (Bounce Boost and Bounce Intensity Settings) are needed because of the huge overhang the scene has. "Bounce" in both of these cases refers to light bouncing, and without a bit of help, the light from the overhead Sun won't get back to the dark corners of the map.

Tips and Tricks

If you have Unity Pro, you also have access to the Global Illumination settings. For this scene, turn down the Intensity of the Sun to 0.4, then in the Lightmapping window, change the Sky Light Intensity to 0.5 and press bake. The results are more refined.

Step 8: Press the Bake button and go for a coffee/beer/soda/bathroom break. It's likely to take a while. The progress bar is shown in the lower right corner. The results are shown in Figure 7.25.

FIGURE 7.25 Results of single light baking with Bounces, Bounce Boost, and Bounce Intensity set at 2.

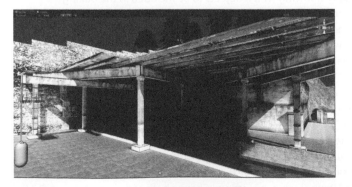

Step 9: Carefully examine the scene. Examine the scene as a player (Play) and within the Scene window. Carefully check that the shadows that should be there are indeed in place. Look for areas where light may be leaking through places it shouldn't. Similarly, Figure 7.25 shows the results of the scene baked with Unity Pro (and thus light bounces, etc.). If you are using Unity (as in without the Pro), you may need to add a few extra lights (sometimes low intensity directional lights work great to imitate the bounced light effect) and rebake.

Step 10: Compensate for areas with problems. Figure 7.26 shows an area inside the tunnel that has sunlight streaming in from above. This shouldn't be there, but has occurred because sections of the tunnel that wouldn't be seen were left without a roof. This can be a fairly common occurrence when carefully optimizing a scene. To fix it, create a Plane (GameObject>Create Other>Plane) and move the plane over the tunnel part (Figure 7.26). Name the plane `TunnelLightMask` and mark it as Static.

FIGURE 7.26 Compensating for unintended lighting holes.

Why?
There are actually a couple of ways to fix this issue. One is to go back into Maya and actually add the geometry needed to plug that light leak. However, creating and placing a plane that will never be seen is much, much quicker than opening Maya, changing geometry, exporting, Unity importing, and so on. Sometimes Unity's built-in polygon GameObjects are perfect for this sort of quick fix.

Step 11: Bake and examine again.

Deferred Lighting and Dual Lightmaps
Unfortunately (if you don't own Unity Pro), Deferred Lighting is a Unity Pro-only feature. If you are not using Pro, go ahead and skip down to the Foggy Day lighting section.

For those of you lucky enough to have Unity Pro, Deferred Lighting is one of the most powerful parts of Unity 3, especially when it comes to baked lighting and an important idea called Dual Lightmaps. Dual Lightmaps is the idea of creating two separate lightmaps—one for close up, which can also make use

Warnings and Pitfalls
Although Figure 7.27 is a clear illustration of how the two lightmaps are swapped out, this should usually not be seen in the game. Seeing a shadow change like that would be disconcerting and would pull the player out of the experience. To most effectively use this technique it would need to be done further away from the player so that he couldn't see the lightmaps changing out—it should be seamless magic.

Warnings and Pitfalls
For a sunny day where the shadows are crisp, shifting to real-time lighting can be a really nice solution. However, in the steps to follow, we will be taking a lot of care to try and make sure that the shadows are all sorts of soft. If the real-time lighting kicks in, suddenly the nice softly baked shadows transition into unsightly crisp ones (even with Soft Shadows turned on). So in some cases, like the foggy day, if you are using Unity Pro, make sure the Rendering Path is set to Forward.

of dynamic lights, and a second lightmap for objects further away. This means that when objects are far from the player, a lightmap is used to illuminate the surface and the painted shadows are used. Objects closer to the player use the second lightmap, but also make use of dynamic shadows. What is so cool about this is that Unity will dynamically transition from one lightmap to the other, and from not using dynamic shadows to making them visible. This allows for very sophisticated lighting schemes to be baked into the scene, yet allow dynamic elements to move and cast realistic moving shadows when close to the camera.

There are a couple of conditions that must be met to make use of this though. The first is that when baking, both lightmaps must be created. In the Lightmapping window, the very first option is Mode, which (by default) is set to Dual Lightmaps. Changing this to Single Lightmaps will speed the baking process, but means dynamic lighting will not be employed.

The second condition is that the Rendering Path must be set to Deferred. The way to set this is via Edit>Project Settings>Player. Look to the Other Settings section and change Rendering Path to Deferred.

Figure 7.27 shows dual lightmaps in action. This is not an optimal setup, because it is never preferable to have the player see the two maps swapping out (as we can here); but it shows how as the player gets closer, the one lightmap is fading into the other.

To change the distance from the camera that this transition takes place, either change the Shadow Distance setting in the Quality Settings (Editor>Project Settings>Quality) or, when the Lightmapping window is open (Window>Lightmapping), look to the bottom-right corner of the Scene window for the Lightmap Display window (Figure 7.28). There the Shadow

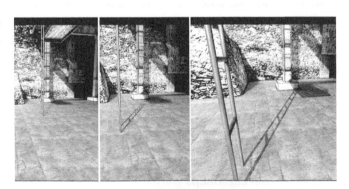

FIGURE 7.27 Dual lightmaps in action (with a Shadow Distance setting of 5).

FIGURE 7.28 Lightmap Display window present at the bottom right of the Scene window when the Lightmapping window is active.

Distance can be changed quickly and interactively and allow you to dial up or down until it works best in the game.

Foggy Day

In the Sunny Day section, the goal was to see how nice bounced light and shadows could be created via Unity's Lightmapping capabilities. Although it was a fun exploration, it isn't what the game calls for. So, for this section we will look at how to light the scene for the foggy situation.

First, take a look at a bit of research to understand how fog affects lighting. A quick Google Images search for "foggy park" or "foggy day" reveals a plethora of images that show some interesting things happening with shadows. While there is often a blobby shadow beneath objects, the shadow is quite soft, and it is very difficult to see where the sun is coming from. The fog just diffuses the light too much.

The next few steps will attempt to mimic this visual effect.

Step 12: Turn the Sun straight down. Select the Sun GameObject and in the Inspector change the Rotation X = 90 with Y and Z both equal to 0.

Why?
Turning the Sun straight down will make all the shadows be right beneath the objects, just like in the research.

Step 13: Change the Sun's shadows to Soft. Still in the Inspector for the Sun, change the Shadow Type drop-down menu to Soft Shadows.

Why?
Again, we are after soft, blobby shadows. This step alone won't soften the shadows sufficiently, but will get us closer.

Step 14: Reduce the Shadow Strength. If using Unity Pro, still in the Inspector, right beneath the Shadow Type, change the Strength setting to 0.5.

Why?
A shadow strength of 1 creates a solid black shadow (absent any bounced light or other lights to diffuse the shadow). Since in this case, the ground should show some shadows, but very diluted shadows, turning the Shadow strength down will help provide much gentler shadows.

Tips and Tricks
This trick of changing the shadow color to a value less than 1 can be a nice solution for even sunny days because it can allow areas that are deep in the recesses of a covering not to be completely covered by thick black shadows.

Step 15: Add a filler Sun. In the Hierarchy panel, select Sun and duplicate it (Edit>Duplicate). Rename it to SunFiller. Select it and open the Lightmapping window (Window>Lightmapping). Change the Baked Shadows setting to Off.

Why?

A filler sun will provide some added illumination that can help diffuse the shadows cast by the Sun directional light.

Step 16: Adjust the intensity settings of the two Suns. For a first pass change both's intensity to 0.2.

Why?

Now that there are two lights, the combined effect would likely be way too bright. We will be taking a few test renders to find out if the intensity here is a good choice or not. We will dial down the render settings to allow for quicker renders but this is where you get your money's worth out of bigger processors and more RAM.

Step 17: Further soften Sun's shadows. Select Sun and open the Lightmapping window. In the Object setting, increase the Shadow Samples to 100 and change the Shadow Angle to 45.

Why?

Both of these are baked-only settings, and both help the baked shadow render with softer edges. On a sunny day, this would not be preferable because outside shadows are often crisp; but on a cloudy or foggy day getting a really mushy shadow is the goal.

Step 18: Bake with faster preview options. Open the Lightmapping window and select the Bake Button/Tab. Change the Mode to Single Lightmaps, (if using Pro) make sure the Bounces is at 1 and change the Final Gather Rays to 200. press Bake.

Why?

Warnings and Pitfalls
Remember that the quality settings have been turned down. Eventually it will be important to get those back up for a final bake.

Finding the right lighting is a process of baking and then rebaking (like rendering and then tweaking and rerendering back in Maya). Taking some time to get the baked lighting just right always pays dividends in the final game play. However, with high-quality settings, the test bakes can simply take too long to get through. While the values for lights are being tweaked, baking a single lightmap with a single bounce and fewer Final Gather Rays will yield faster results that will inform future decisions.

Tips and Tricks

Again, in many of these steps we are dealing with bounced light that is a Pro-only feature. If you are using standard Unity, add some extra lights to simulate the bounced light.

Step 19: In the Hierarchy panel, select the Terrain. In the Inspector, turn off Static.

Why?

The terrain is automatically set to Static, which means it's automatically baked. To bake the terrain, a huge—and I mean huge—texture is created (although it doesn't take up any of the texture space created with Unity's generated lightmap UV). This means that baking the terrain is a long, long process. In this situation, turning off the Terrain when baking will result in several benefits. First, the scene will bake much faster. Second, we are using detail meshes (the rocks), which don't bake; they simply inherit the color value of the terrain beneath it. So, in spots where the terrain is beneath the dock, the detail meshes will bake black. In the final version of the game included on the web site (http://www.Creating3dGames.com), the terrain is never baked (it just can't be seen well enough in the fog to make baking worthwhile).

Step 20: Evaluate output. Open the Render Settings (Edit>Render Settings) and reactivate Fog. Play the game and run around checking to see how the baked solution is working (or not; Figure 7.29).

FIGURE 7.29 The in-game results of the first rendering pass. Too much shadow and the shadow is too crisp.

Step 21: Based upon the run-through, adjust the two Sun's settings and rebake. Reanalyze and rebake. The settings that I finally liked for the Sun were both Suns at Intensity = 0.15 (in the Inspector). The Baked Shadows settings (in the Lightmapping Window/Object section) were Shadow Samples = 100 and Shadow Angle = 45). Results are in Figure 7.30.

Step 22: Examine critical locations and double-check that there is enough light reaching these spots. For instance, the door that lets the player into the facility was too dark on my bakes (Figure 7.31), so an additional spotlight was needed at a very low intensity (0.5). Look for these sorts of areas on your version (Figure 7.31).

175

FIGURE 7.30 Results of light settings listed in step 20.

FIGURE 7.31 Adding extra spotlight to give light to overly dark areas.

Why?

Using little spotlights or even point lights to help paint in areas of needed detail is a common tool for lighting designers in theatre, homes, film, TV, and games. Especially when baking, take a moment and see if there is a particular part of the scene that needs a little boost.

Tips and Tricks

If these "cheater lights" shouldn't be illuminating characters in the game or casting shadows, there are a couple of easy fixes. First, after baking, cheater lights can be deleted and they will no longer affect the scene or game. Or (and this is better), the Inspector for a light includes a drop-down menu called Lightmapping. Change this to Baked Only and it will only be used in the baking process and not cause unwanted shadows in game play if the game is using deferred lighting/rendering.

Ambient Occlusion

Ambient Occlusion has all sorts of fancy descriptions depending on where you read. At its core (at least in how we are going to use it in Unity) ambient occlusion (AO) is the dark regions where two surfaces meet. In broad strokes, AO can simulate the blobby shadows on a foggy day. AO can also be thought of as the dirt that collects in corners. Either way, AO does some very important things in a scene and helps give definition to the objects in a scene.

Unity includes some dynamic AO (see the SSAO techniques), but these can quickly make the frame rate become a slide-show by the time the settings are at a place that provides good results. Luckily, with Beast's implementation, AO can be baked right in to the lightmap.

> **Step 23:** Activate Ambient Occlusion. Open the Lightmapping window and click the Bake Object/Tab. Turn the Ambient Occlusion to 1. Change the Max Distance to 5 and Contrast to 2.
> **Step 24:** Bake the scene (Figures 7.32–7.34).

FIGURE 7.32 Final output with loads of AO and appropriate shadows.

FIGURE 7.33 In-game screenshots of baked light.

FIGURE 7.34 One more.

Conclusion

There is almost always a bit of massaging that can be done with lighting and baking, even after you have to move on to other parts of the game. Lighting can be tricky because a scene may look too bright on one monitor and too dark on another. There are some predictable differences as a game moves from PC to Mac (Mac will be brighter), and it is hard to know when a scene will look its best on most platforms. I find that a baked solution that finally looks good on my machine needs to be run (as a build) on other machines before I'm confident with the solution.

The baked solutions that Unity produces can be further adjusted in Photoshop. When baking is done but before the results can be seen, a progress bar will pop up to show that new assets (the newly made lightmaps) are being imported. These new assets are actually accessible in the Project panel. In this case they

are in a new folder called Scene-EntryWay. Any of these lightmaps can be opened in Photoshop and lightened, darkened, or edited in any way desired.

There are a few functionalities that baking allows for (like emmisive materials—or lighting a scene with luminescent materials—no light instruments required) that have not been covered in this tutorial. They are assigned in the homework, but for a little extra help check out Appendix C, "Emmisive Light Baking."

Hopefully this chapter has given you a quick look at how to work with Unity lights, and some strategies to attack a lighting scheme in different weather situations. Through effective manipulation of shadows and even multiple lights, a refined ambient lighting scheme that is flexible in implementation can be achieved.

Homework and Challenges

Challenge 1: Light and bake the hallway. A few tips on this. Bring in and place a hanging light as modeled in earlier challenges. Within this light, place a spotlight with a very wide Spot Angle (Figure 7.35). Make the spotlight a child of the geometry. Make sure the geometry is not Casting Shadows. Copy and paste this hanging light in the places you plan to put them. This populates the level with geometry that indicates the light source as you light the scene. See my finished solutions in figures 7.36-7.38.

FIGURE 7.35 Creating a light source that includes geometry.

FIGURE 7.36 Lit hallway.

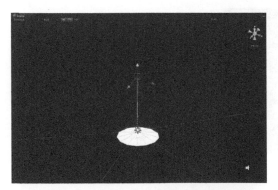
FIGURE 7.37 Lit loading dock.

FIGURE 7.38 Lit pit.

Asset Creation: Maya Character Creation

Depending on the type of game being played, the character design can be as important as the set. Standard third-person games mean that there is lots of looking at the back of yourself as the space is explored. Because this is the case, having a really well-designed protagonist (and more specifically, a protagonist with a well-designed back) becomes incredibly important to the visual impact of the game. Even in first-person games (like *Incursion* will be), having enemy characters that are interesting in design, beautiful (that includes gross) in texture, and dynamic in motion can make a huge difference in the level of engagement and visceral experience of the player.

In *Incursion*, the primary Play mode is going to be first person, which means that the player will hardly ever be seen (other than the hands when holding a weapon or tool). In fact, in a first-person situation, there may not ever be a need to develop a character (unless the game is multiplayer). But character creation is an art with some specific topology issues that should be covered in any discussion of game asset creation.

Because of this, in this chapter we will be modeling and texturing the player's character in *Incursion*. This character will be used in the opening screen and will be animated. This also means that this character is available if the game ends up (in your able hands) morphing into a third-person game or a multiplayer game.

Aegis Chung

The player's character is Aegis Chung, who is part of the US Government's Special-Ops Forces (or any imaginary government agency of your choosing). The specifics of this character would be found in the design document that would help define how the character should be designed. For this book, these conversations occurred between the character designer (Jake Green; www.jakegreenanimation.com) and the game designer (me). The design we settled on is shown in Figure 8.1.

Style Sheet

Character style sheets are an important part of the character design process—they define what a character will look like from at least a front and side view. Really accurate design sheets can be used as reference and the 3D model can be constructed right over the top of the drawing within Maya (or whatever the 3D application might be). Occasionally I will work with a student who can

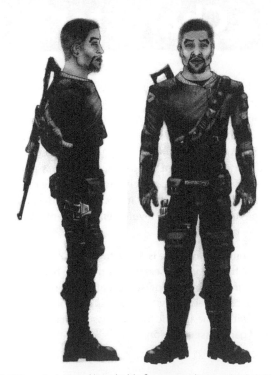

FIGURE 8.1 Aegis Chung (design by Jake Green; www.jakegreenanimation.com).

create a character in 3D effectively without visualizing it first in 2D—on paper. But overwhelmingly, the students who build the best models are working from of a well-designed character style sheet. In studios this is especially the case since a character design on paper is much quicker and much cheaper to create, approve, or send back for revision than one created in 3D.

This doesn't mean that character modelers are necessarily good character designers, or the other way around. Some of the best characters developed in class have been designed by one student and modeled by another; however, the language of visual communication has been that character style sheet.

Considerations of Style Sheets

The best style sheets will often begin on graph paper. This is because having the front and side views match up exactly is key. When the bottom of the nose is at the exact same height in both images, when the polygons that define that area are being constructed, the two images will help inform how those polygons will need to be assembled. Conversely, if any area of the face is slightly off, referencing the image can be murderously confusing in the modeling process.

However, just drawing the two images (front and side) lined up is just half the battle. After scanning in the image, be sure to use Photoshop's guides to assure that the image is still lined up. Get in close, very close, and make sure that the nose; eyes; tops and bottoms of ears; tops, middle, and bottom of lips; knees; crotch; and armpits are lined up correctly. A few extra minutes in Photoshop will save hours modeling. For further details on this preparation process see Appendix C, "Preparing Character Style Sheets."

Arm position is often a contentious issue in the 3D community. Some people insist on modeling characters in the T pose (arms straight out). The reason for this often has to do with rigging and skinning. It is definitely easier to skin an arm pit when it is easily seen because the arms are at the side of the body. Here's the reason I prefer not to use this: put your arm straight out and with the other arm feel what occurs at the top of your shoulder (your deltoid). There is a lot of compression of that muscle and indeed the entire shoulder deforms with a big bulge of muscle there. However, this bulge of muscle disappears when your arm is returned to your side. Modeling a character with arms outstretched then leaves the modeler with an impossible choice—either model the shoulder incorrectly when it is outstretched, or be left with a bulbous shoulder that is incorrect once the character is rigged, skinned, and the arm is back at the side. You have probably seen this sort of 3D character that seems to be in a perpetual shrug;

I prefer to model characters with their arms either at their side or at a 45-degree angle to their body. Yes, it does make skinning the armpit a bit more difficult since there are a lot of polygons next to each other, but since skinning tools have become more effective this is not as big a deal as it once was. The benefit is that this allows the shoulders to be modeled in the form that they usually are in—down and relaxed with the deltoids not compressed and balled up.

Chapter Overview

In this chapter we will be using the character style sheet of Aegis Chung as designed and created by Jake Green to model, UV map, and texture the game character. The image is downloadable on the accompanying web site (http://www. Creating3dGames.com), although you might want to use your own design if you have one that is better. Note that the Photoshop work of ensuring that the front and side images are lined up has been done and these drawings are reasonably close. So, if you are going to use your own, make sure you do the appropriate prep work.

Tutorial 8.1: Game Character Modeling: Aegis Chung

As is the case in most of 3D, there are many ways to skin this cat. There are almost as many methods of organic modeling as there are organic modelers. The method we are going to use here is based upon the idea that most muscles in our face tend to ring the orifice they manipulate. There are rings of muscles around the eye and mouth. By creating polygons in rings around these objects the forms are easier to find, and more importantly, the area can deform in a more lifelike manner.

This is largely an additive method then. The method will start with a single polygon, and the additional polygons will be extruded out from that.

As always, polycount will be important. Knowing how many extrusions to make and how close to make them can be a tricky thing and is largely informed by experience. It is not too hard to go back and eliminate unwanted rings. Similarly, it is fairly easy to go back and add rings if added detail is needed. So as the forms are built, use the screenshots as a rough guide to the density of polygons, but don't sweat it.

Polycount

For this character we will be aiming at the 15,000 tri mark. If there were going to be 300 of this character on the screen at a time, this is likely too high. If this is the only character to ever be seen we could probably go higher. But 15,000 is a very reasonable count with most hardware today and will allow for a good balance of efficient modeling with engaging detail.

Image Planes in Photoshop

Step 1: Prepare resource image in Photoshop. If you are using the preprepared images contained in the downloadable files on the resource web site (http:// www.Creating3dGames.com), you're set. There are four images of note: AC_ Front_Body, AC_Side_Body (both full body images), AC_Front_Head, and AC_Side_Head (just head shots). If you're using your own, be sure to review the steps in Appendix C, "Preparing Character Style Sheets." At the end, be sure to have two separate files, a Front view of the character and a Side view. Save the files that will be used for reference in the sourceimages folder.

Step 2: Chop the head off. Still in Photoshop, make a selection of the head and neck in the Front drawing. Copy and paste it into a new Photoshop document. Save it as `AC_Front_Head` in the sourceimages of the Maya project file (Incursion–Maya). Make note of the actual image size, and make a selection in the Side drawing of the same pixel height. Copy and paste this into a new Photoshop document. Save it as `AC_Side_Head`.

Why?

Figure 8.1 shows the completed character style sheets; this will be the basis of the model to be created. However, if this is imported into Maya at too high a resolution, Maya can be dragged to a crawl, but too low a resolution can mean that any detail (like the face) is just a patchwork of blotchy pixels. By working with a high-resolution head, most of the critical information will be available for that detailed modeling; then later, when it's time to do the body, this image can be swapped out for a lower-resolution body.

Image Planes in Maya

Step 3: Open Maya and set the project to Incursion–Maya (File>Set Project).
Step 4: Save the new file as `Aegis_Chung` (this should save to the Scenes folder; if it does not, return to step 3).
Step 5: Import the AC_Front_Head as an image plane in the front-view panel. Swap to four view (where you can see persp, top, front, and side view panels). In the front View panel, choose View>Image Plane>Import Image…. In the Open dialog box that pops up from there, choose AC_Front_Head and press Open.

Why?

Image planes are cool things that allow for a reference image to sit within a specific view panel. This image can either be visible in all views or in just one, which works great for a specific front image.

Step 6: Import the AC_Side_Head as an image plane. Repeat step 5 in the side-view panel and bring in AC_Side_Head. The results of steps 5 and 6 are shown in Figure 8.2.
Step 7: Move the images off of 0,0,0. In the front-view panel, choose View>Image Plane>Image Plane Attributes>imagePlane1. In the Attribute Editor, the specifics of the image plane will appear. Scroll down to the Placement Extras section. Look for Center and change the Z setting to `-20`.

Why?

The Center setting here refers to where in space the center of the image plane is placed. At placement it is sitting at 0,0,0, which means that in

the front-view panel, when polygons are constructed behind Z = 0 (or anything toward the back of the head), they will be hidden behind the image plane. Moving it back will ensure that the polygons will all be visible in front of the image plane.

FIGURE 8.2 Imported (but yet to be adjusted) image planes.

Step 8: Repeat for the side-view panel, changing the Center X setting to −20 (Figure 8.3).

FIGURE 8.3 Offset image planes. This leaves an empty spot that allows for the construction of the polys without being hidden.

Tips and Tricks

In tech review, my tech editor (who is using a Mac) pointed out that this step can be a little flaky. There appears to be a bug in the Mac build that makes it so you have to restart Maya before you can access the side-view panel's image plane settings if you've already accessed the front.

Step 9: Hide the image planes except in their respective view panel. Again, in the front-view panel activate the attributes of the image plane (View>Image Plane>Image Plane Attributes>imagePlane1), and at the top of the Attributes Editor click the Looking Through Camera radio button. Do this again in the side-view panel.

Why?

Image planes are most effective when they are visible only in the orthographic views that they are most relevant in (front and side) and not cluttering up the perspective view panel.

Eyeball

Step 10: Create an eyeball. Create a polygon sphere (Create>Polygon Primitives>Sphere).

Step 11: Reduce its polycount. Select the sphere and make sure the Channel Box is open. In the INPUTS section click polySphere1 and change the Subdivisions Axis and Subdivision Height to 10.

Why?

It's an eyeball that is very unlikely to be seen terribly close. Keeping the polycount low (as always) helps keep the frame rate high in the game.

Step 12: Move, rotate, and scale the eyeball into place. Looking at both the front- and side-view panels, move the eyeball into place so that it matches both sketches. Rotate it 90 degrees along its X-axis so that the pole of the image is pointing forward. Scale the eyeball to actually be the size of the eyeball (much bigger than the part of the eye that can be seen; Figure 8.4).

FIGURE 8.4 Placed eyeball.

Why?

Creating the eyeball first provides an important starting point. With an appropriately placed eyeball, the polygons that will become the eyelid can quickly and easily be organized to have the appropriate shape.

Step 13: Duplicate the eyeball. Ctrl-D (Cmd-D on Mac) will duplicate the eyeball. In the Channels Editor, change the Translate X value to a negative value (mine went from 3.022 to -3.022).

Step 14: Take time to name the spheres `Left_Eye` and `Right_Eye` in the Outliner. Remember to label these relevant to the character (the character's left and right).

Creating Polygon Rings

Step 15: Create the first polygon. Choose Polygons>Mesh>Create Polygon tool. In the Front view, create a four-sided polygon that approximates the shape of the start of the eyelid (Figure 8.5).

FIGURE 8.5 Starting out with the first polygon.

Tips and Tricks

The Create Polygon tool will allow for the creation of those dastardly n-sided polygons. When using this tool, be sure that after creating the fourth side, to press the Enter button to exit the tool.

Step 16: Adjust in 3D (via the side- and persp-view panels) to get the shape of this polygon correct in relationship to the eyeball.

Why?

This is essentially the core process: create new polygons in one view (in this case the front view panel) and then tweak in the other views to ensure this newly created polygon is the right shape in space.

Step 17: Extrude out the new polygon. Select the top polygon's edge and use the Extrude tool (Polygons>Edit Mesh>Extrude) to then pull out another polygon to roughly match Figure 8.6.

FIGURE 8.6 Extruding new polygons.

Tips and Tricks

Notice that in Figure 8.6 the eye is no longer visible. It's not deleted, it's just hidden. Sometimes having it there is important, but other times it just makes things like the side view cluttered and unwieldy. To hide the eye, select it and press Ctrl-H. It can be made visible again by selecting it in the Outliner, then in the Channels Box, changing the Visible setting to On.

Step 18: Repeat this process, being sure to rotate the new polys, to cover the top lid (Figure 8.7).

Step 19: Continue extruding and rotating around the bottom of the eye.

Step 20: Use Append to Polygon to close the final gap. When the extrusions have gone to where there would be one more polygon to complete the ring, exit the Extrude tool and choose Polygons>Edit Mesh>Append to Polygon Tool. Click the started edge of the first polygon, and then the ending edge of the last polygon. A new polygon will appear, thus closing the ring of polygons (Figure 8.8).

FIGURE 8.7 Top lid being formed.

FIGURE 8.8 Closing the ring with the Append to Polygons tool.

Step 21: Adjust the new polygons in 3D space. Change to vertex mode. In the side- and persp-view panels, select and move collections (often pairs) of vertices *only in Z* so that they move back to the appropriate place on the eyeball (Figure 8.9).

FIGURE 8.9 Adjusting vertices around the eyeball.

Step 22: Provide thickness to the eyelid. Once the general shape of the eye is complete, change to edge mode and double-click an edge of the inside of the ring of polygons (this will select the ring). Choose the Extrude tool (Polygons>Edit Mesh>Extrude), and then immediately swap to the Move tool. Move this newly extruded edge back into the eyeball along the Z-axis (Figure 8.10).

FIGURE 8.10 Providing eyelid with thickness.

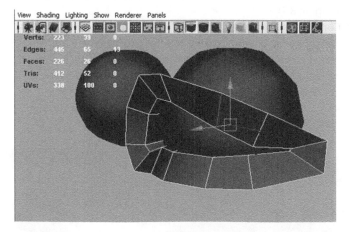

Why?

Every time the Extrude tool is selected it extrudes a new collection of polygons. If the Extrude tool's manipulators are used, the new polygons are moved, scaled, or rotated along the polygons' normals. But swapping to the Move tool allows this new collection of polygons (or edges) to be manipulated en masse along a global direction (in this case Z).

Step 23: Mirror the mesh. Swap to object mode and select the face thus far. Select Edit>Duplicate Special (Options). In the Duplicate Special Options window choose Edit>Reset Settings. Change the Geometry Type: to Instance. Change the Scale X input setting (the first column of Scale) to –1. Click the Duplicate Special button to finish the mirroring of the geometry (Figure 8.11).

FIGURE 8.11 Mirrored geometry for construction via Duplicate Special.

Why?

Scaling an object –1 in any direction will create a mirror version of the object. By making sure this duplicate is an instance, we ensure that as one side of the face is built up, this duplicate will also update. Now this –1 scaled half of the character will not be the one imported into Unity (the normals are funky), but as a construction method, this works well to see the whole face rather than just one half at a time.

Expanding Rings

Step 24: Expand the rings. Change to edge mode and double-click one of the outer edges (this should select the outer ring of edges). Choose the Extrude tool and then immediately swap to the Scale tool and scale (by dragging on the middle cube manipulator handle) this new collection of edges out in every direction (Figure 8.12).

FIGURE 8.12 Expanding new ring of polygons.

Why?

And thus it begins. The process from here on out is working with rings of polygons expanded out a ring at a time.

Step 25: Looking at all the view panels (and working in each as needed), continue to extrude edges and tweak vertices to find appropriate form.
Step 26: As the center of the nose is neared, align the vertices that lie on the axis of symmetry. Do this by selecting the vertices that will be the middle of the nose. Double-click the Move tool to bring up the Tool Attributes. Turn off the Retain Component Spacing check box. Back in persp, hold the X-key down (to snap to grid) and move the selected vertices to the middle (they should snap). The rough approximation of the form is seen in Figure 8.13.

FIGURE 8.13 Centered vertices of the middle of the nose.

Tips and Tricks

Sometimes when cleaning up the center of a face, there are some polys that are too small, or unneeded. Be sure to delete them along that mirror plane if need be so that there isn't an awkward bunch of polys there. Then, of course, be sure to clean up the center again.

Step 27: Continue extruding sans the edges in the middle of the nose. This can be done by continuing to double-click an outside edge, but be sure to deselect the edges across the middle of the nose before extruding (Figure 8.14).

FIGURE 8.14 Continued extrusion after centering the center of the nose.

Why?

Keep extruding until there is a Phantom of the Opera-esque mask complete. Do not worry about the mass at the end of the nose.

The Mouth

Step 28: Repeat steps 15 to 27 to create the mouth. Again, the flow is to create a new polygon, then extrude the edges around. The biggest difference here is that instead of creating a complete ring, create a half ring (Figure 8.15).

FIGURE 8.15 First pass of the mouth.

Step 29: Create an oral cavity. Do this by selecting the edges on the inside of the mouth and extruding back into the head. Finally take the very last collection of vertices and snap them to the center (hold X while using the Move tool). Marquee select these vertices and choose Polygons>Edit Mesh>Merge (Figure 8.16).

FIGURE 8.16 Oral cavity creation.

Why?

The oral cavity may not even be needed. If the game will never show the character with his mouth open there is no need to blow this chunk of the poly budget here. However, since this is the main protagonist, including an oral cavity will allow for future possibilities. Still, it is the inside of the mouth, so no need to use any more polygons here than needed.

Step 30: Add geometry as needed to finish lips. Figure 8.17 shows a new ring of edges created with the Insert Edge Loop tool (Polygons>Edit Mesh>Insert Edge Loop Tool). Don't bury too many polygons here, but an extra ring can help give the lips volume.

FIGURE 8.17 Rounded lips via additional edge ring.

Step 31: Extrude the outer ring to build up toward the upper face (Figure 8.18). Use the Extrude tool's move handles instead of the Scale tool. Since we are dealing with half the mouth, using the edge's normals gives a better result.

FIGURE 8.18 Extruding the outer ring to build geometry.

Step 32: Periodically clean the mirror plane. Select the vertices that should be on the mirror place and snap to the center (hold X down while moving in X). Figure 8.19 shows a quick cleanup of current progress.
Step 33: Continue building out (and up) toward the mask.

FIGURE 8.19 Cleaning up mirror plane.

Step 34: As the two shapes get close to each other, snap vertices to match. While in vertex mode, holding down the V-key when moving a vertex will allow it to be snapped to another vertex (Figure 8.20).

FIGURE 8.20 Building toward the two meshes and snapping when close.

Mask and Mouth Together

Step 35: Combine the mouth to the mask. In object mode select the mask and then Shift-select the mouth. Choose Polygons>Mesh>Combine.

Why?

Ultimately, most of this character (except for the weapons) will be one single mesh. Although Maya and Unity will both support multiple meshes skinned to one joint structure, it is quicker computationally to have fewer meshes being deformed at one time. So for efficiency's sake, and because our faces are a single mesh, it will be important to have the mask and mouth be one mesh. Combine does this.

Step 36: Merge appropriate vertices. Select the vertices that are at the seam where the two meshes combined (Marquee select) and choose Polygons>Edit Mesh>Merge.

Why?

Just because two meshes are combined so that it appears as though they are one mesh, that doesn't mean that the appropriate vertices are merged. And, in fact, if vertices are not manually merged, they remain separate after the Combine has happened. Manually merging makes sure that the seam is using shared vertices and not just lined-up ones.

Step 37: Along the mouth, extrude out further rings to continue connecting to the lower edge of what was once the mask (Figure 8.21). Be sure to merge relevant vertices to connect new polys to one solid mesh.

Step 38: Soften Normals. In object mode, select the mesh and choose Polygons>Normals>Soften Edge (Figure 8.22).

FIGURE 8.21 Extruding out to continue connecting the mouth to the bottom of what was the mask.

FIGURE 8.22 Results after softening normals.

Why?

As new polygons are built, the normals of those edges and faces are still hard, which can give the mesh a very 1980s 3D look. By softening the edge, the low-poly version of the model can look surprisingly smooth and much more complex than the underlying polygons alone.

Step 39: In object mode choose Edit>Duplicate Special (with X = –1). Make sure the center vertices are centered first.

Why?

Along the process of combining, the old duplicate of the mask will have been lost. By mirroring again (via Duplicate Special), once again the shape of the face will be easier to see.

Nose

Step 40: Close the centermost gap with the Append to Polygon tool (Figure 8.23).

Step 41: Create additional places to round the nose with additional polygons. Create these with the Insert Edge Loop tool (Figure 8.24).

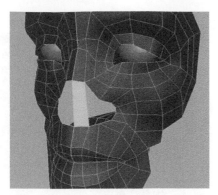

FIGURE 8.23 Beginning to add mass to the nose. Start with creating a new poly with the Append to Polygon tool.

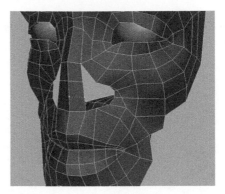

FIGURE 8.24 Adding geometry to the nose to allow for rounding of the form.

Step 42: Bend the new vertices to find the form of the nose. Be sure to use all the view panels to find this form (Figure 8.25).

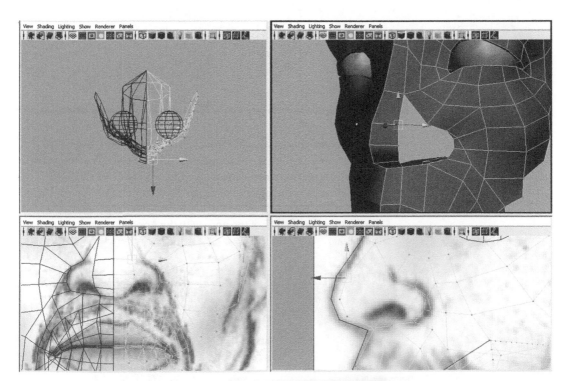

FIGURE 8.25 Roughing out the tip of the nose.

Step 43: Create the upper edge of nostril. Select a pair of edges where the nostril would be and extrude them around to create the rough outline of the nostril (Figure 8.26).

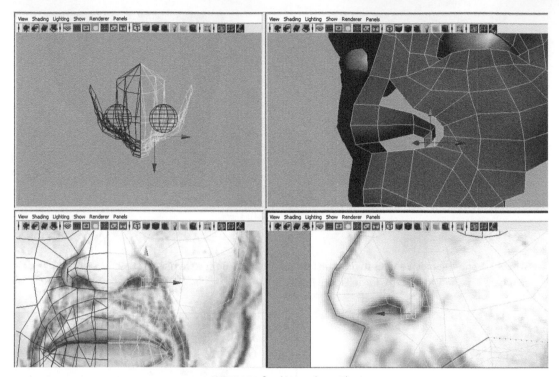

FIGURE 8.26 Roughing out the nostril.

Why?

Pairs of edges are very important in most all of organic modeling because it allows for some roundness to a form. Especially at a place like this where the geometry is making a corner (from the bottom of the nostril to the side), extruding pairs can greatly speed up the vertex sculpting process.

Step 44: Close up the top of the nose with the Append to Polygon tool (Figure 8.27).

FIGURE 8.27 Closing up the top of the nose.

Step 45: Complete the nostril. Select the edges that now make up the hole at the bottom of the nose that will become the nostril. Select Polygons>Edit Mesh>Extrude and then immediately swap to the Move tool. Move this new collection of edges up into the nose. Sculpt as needed by moving vertices (Figure 8.28).

FIGURE 8.28 Finishing off nostril by extruding up inner nostril.

Cranium

We'll leave the face area for a bit here. By building up the cranium for a minute we can lay the foundation for tricky areas like the ears and mandible (jaw bone).

Step 46: Select and extrude the edges at the top of the forehead (Figure 8.29).

Step 47: Continue extruding and sculpting the head until polygons are created over the area of the ear (Figure 8.30).

Step 48: Extrude off the back of the face area to meet up with the newly created cranium geometry (Figure 8.31).

Step 49: Clean up. Do this in two steps. First merge the vertices of this new seam between cranium and face mask (Marquee around pairs of vertices and use Polygons>Edit Mesh>Merge). Then do a quick pass across the middle of the head and make sure that all the vertices that should be on the mirror axis really are (Select, hold down X, and snap to the middle; Figure 8.32).

Mandible

One of the things Jake's models are always very good at is appropriate topology. The organization of polygons (and particularly, loops of polygons) is very important for face models because the face is a very complex form, and if the polygons are oriented incorrectly, and there just aren't the places to bend, it's impossible to get the right form. Picking where to extrude what polygons becomes a very important process, and is a big reason why I prefer this additive process to others that might be built from a cube.

197

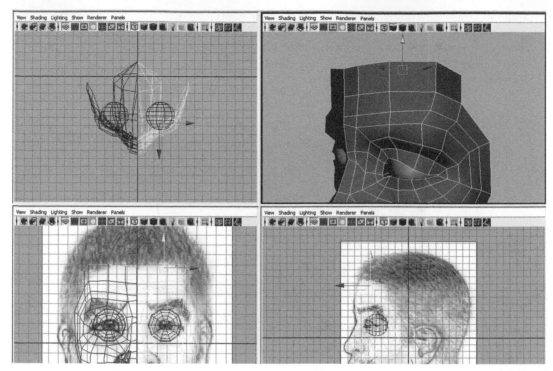

FIGURE 8.29 Begin extruding the cranium.

FIGURE 8.30 Continued extrusion over the ear.

Step 50: Select an edge off the face mask that would represent where the mandible would drop down and extrude down and around to create the edge of the jaw bone (Figure 8.33).

Tips and Tricks

In the style sheets (the drawings) there sometimes are some areas where the front and side don't line up perfectly. This mandible area is one of those. Be sure to be looking at the perspective view to get the right look and anatomy. While good style sheets are really close in the side and front drawings, it's very difficult to have them exactly right in every place.

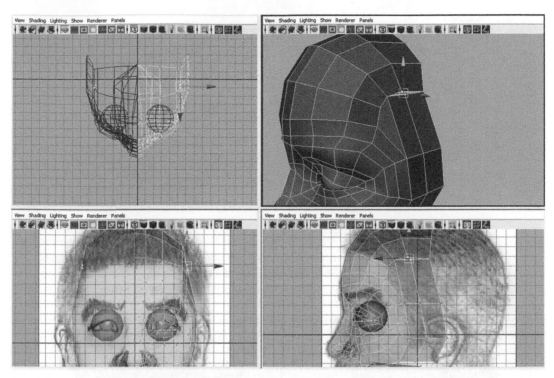

FIGURE 8.31 Connecting the new cranium geometry with the face mask.

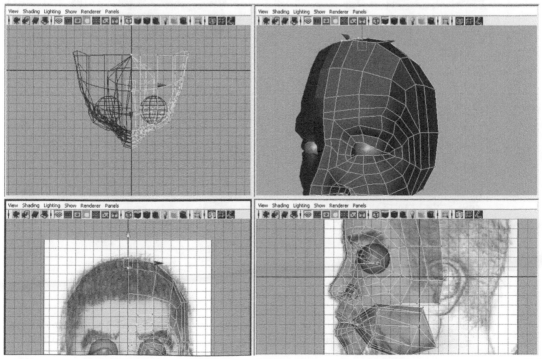

FIGURE 8.32 Cleaning up. Merging vertices and snapping vertices on mirror plane.

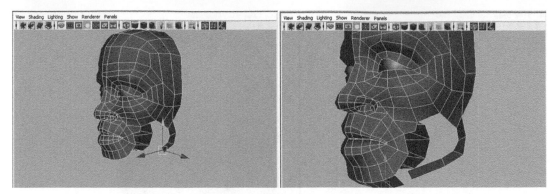

FIGURE 8.33 Roughing out the mandible.

Step 51: Attach this new strip to the bottom of the face mask (around the chin). Usually this is most easily done with the Append to Polygon tool.
Step 52: Fill in the cheek. This can be done with collections of the Append to Polygon tool and Extrude tool with some vertex merges (Figure 8.34).

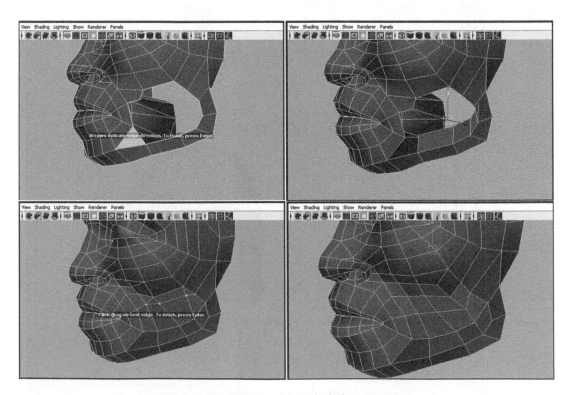

FIGURE 8.34 Filling in the cheek.

Step 53: Use the Sculpt Geometry tool (Polygons>Mesh>Sculpt Geometry Tool (Options)) to sculpt and smooth these newly created polygons (Figure 8.35).

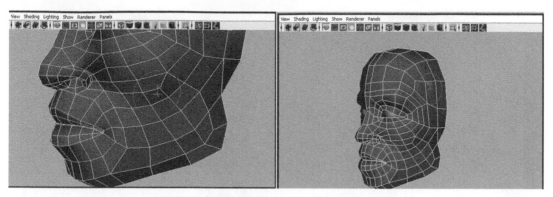

FIGURE 8.35 Sculpt Geometry tool to massage shape into good form.

Tips and Tricks

The Sculpt Geometry tool can be an incredibly great tool to nudge vertices into submission. The real key to this tool is quick changes in the brush size (hold down B while dragging left and right) and a low Opacity setting (the default is 1, but I usually paint with a 0.1 or even a 0.05). Remember that this tool has a push and pull function, but also has smoothing functions that can allow hard edges and awkward sections to be smoothed into a more organic form.

Cranium, Continued (and Ear Beginnings)

Step 54: Create the base shape of the ear by extruding off the back of the face mask (Figure 8.36).

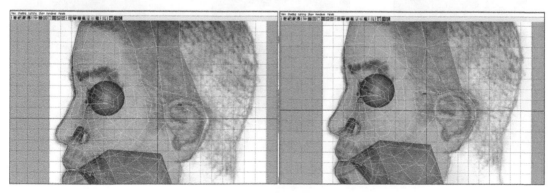

FIGURE 8.36 Laying the foundation for the ear.

Why?

The idea here is to leave some polygons (probably four rows) from which to build the ear, but do not worry about building the ear out at all.

Step 55: Continue building toward the occipital bun by extruding around the side of the head toward the back of the cranium (Figure 8.37).

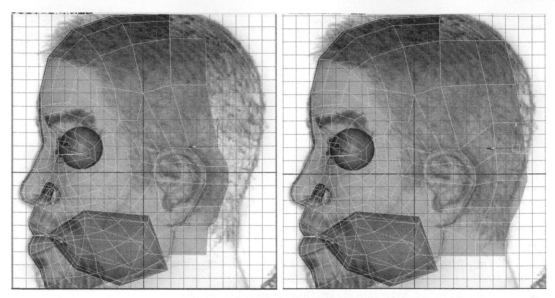

FIGURE 8.37 Building back toward the occipital bun.

Step 56: Close off the bun. Continue extruding until the new polygons are aligned across the back of the head (Figure 8.38).

FIGURE 8.38 Finishing off the occipital bun.

Why?

In Figure 8.38 notice that the bun was closed off and then additional subdivisions (via the Insert Edge Loop tool) were created. This could also have been done via several extrusions, but sometimes up-rezing a form by adding polygons to an already created form is easier than extruding, moving a bunch of vertices, then extruding again. Figure 8.38 really shows the idea of roughing out a shape, and then going back in to refine.

Step 57: Sculpt with the Sculpt Geometry tool to massage the head into shape (Figure 8.39).

FIGURE 8.39 Sculpting and softening the form into an organic one.

Step 58: Close off the top of the head. In Figure 8.40 this was done with by using the Extrude tool followed by Merge to merge up the vertices.

FIGURE 8.40 Extruding to finish off the head.

Ears

Ears in game models can be very tricky. In reality our ears are tremendously complex forms. There are more curves in the ears than on the rest of our body combined. It's easy to get lost in the folds and channels that are the ears.

In a game model, there simply are not the available polygons to create terribly detailed ears. Luckily, if the game player is spending a lot of time checking out a character's ears there is something seriously wrong with the game play.

So the strategy here is to change the silhouette of the face enough to represent the ears from the front, top, and back views, but to let the texture for the ear do most of the visual work.

Step 59: Select, Extrude, and rotate the ear polygons off the side of the head (Figure 8.41).

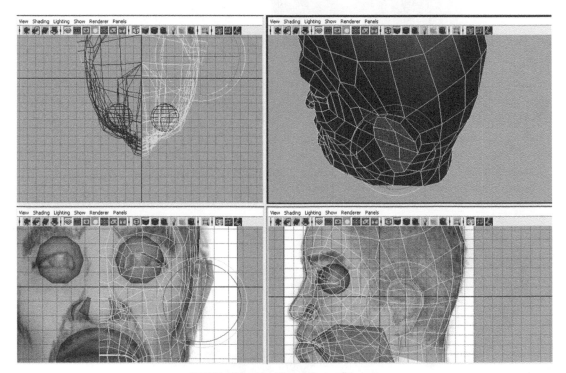

FIGURE 8.41 Extruding the ear polygons off the head.

Why?

Yes, this creates an ugly ridge on the front of the ear—a sort of "Shrek-ear" like a trumpet emerging off the head. Hang tight, we'll fix that.

Step 60: Use the Sculpt Geometry tool to massage out the front ledge created by the previous step. Use the Smooth function of the Sculpt Geometry tool to average out the vertices there on the front of the ear so that the ear ramps up off the side of the face (Figure 8.42).

FIGURE 8.42 Smoothing out the front of the ear with the Sculpt Geometry tool.

Tips and Tricks

The smooth part of the Sculpt Geometry tool works by averaging the value of the vertices included within the radius of the brush. For best results dial that brush in or out so that it includes approximately the number of vertices shown in Figure 8.42. Again, make sure to use a low Opacity setting (0.1 or less) to gently get the result desired.

Step 61: Create the back end of the ear by moving the vertices in to create the helix part off the head (Figure 8.43). If need be, use Insert Edge Loops to add geometry if added shape is desired.

FIGURE 8.43 Creating the trumpet part of the ear by moving existing vertices.

Step 62: Continue to tweak existing vertices to get the shape of the ear right. This may include a bit of work on the lobule section of the ear (ear lobe; Figure 8.44).

FIGURE 8.44 Continued tweaking of existing polygons; specifically working on the lobe.

Moving Down the Neck

Step 63: Select and Extrude the edges on the back of the head to create the rough outline of the back of the neck (Figure 8.45).

Step 64: Extrude the front of the neck from the chin/mandible down. Be sure to merge up the two flaps of polygons emerging down (highlighted in Figure 8.46).

FIGURE 8.45 Extruding back of the neck.

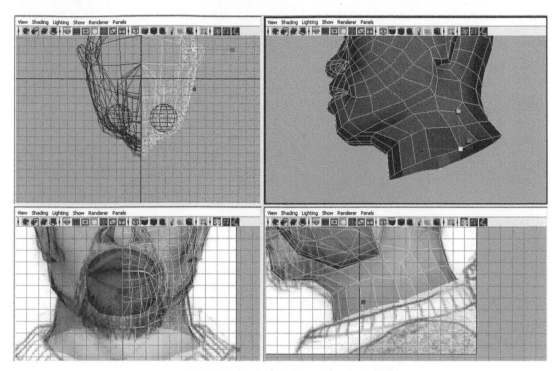

FIGURE 8.46 Extruded front of the neck from the chin.

Tips and Tricks

Notice in Figure 8.46 the ring of edges under the chin, one in the middle of the neck, and one at the bottom of the neck. Remember that polygons don't bend, and only at the edges and vertices can a mesh deform. Without the added edge loop in the center of the neck, this character would always appear to have a very stiff neck because there would be no bending from his clavicle to his mandible.

Step 65: Sculpt to refine. Use the Sculpt Geometry tool to build out cheek bones or strengthen the mandible. Much of this work will be done in the persp view panel with quick glances at the orthographic front and side views. It's time to get the form looking right in 3D regardless of the 2D sketches behind them (within reason of course—go too far and the character designer will be quite vexed and the model will be sent back to you anyway).

Step 66: Select the object and soften the normals (Polygons>Normals> Soften Edge).

Step 67: Harden some select edges. Swap to edge mode and select some edges where strong corners may be present (eyelid, nasal labial fold, chin (highlighted in Figure 8.47) and choose Polygons>Normals>Harden Edges.

FIGURE 8.47 Hardening select edges.

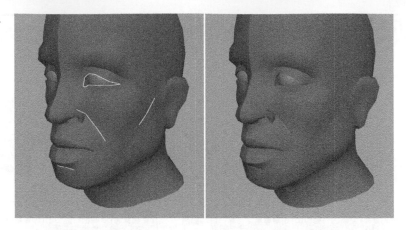

Why?

Often this combination of softened edges with select hardened edges can help provide the best of the high-poly look that softened edges provides along with hard edges to highlight attributes. Be on the lookout for any places in modeling organic forms where this combination can provide very effective visual effects.

Torso

The head is only one-eighth of the total height of most adults, yet modeling it is easily half the total effort of the form. Starting with the torso, we will be able to make great chunks of progress. In fact, while we were very careful to make adjustments as we went along on the head, for the body generally the process is about modeling with very broad strokes and then going back in to create the necessary detail.

Before continuing, be sure to swap out the image planes. Up to this point we've been using AC_Front_Head and AC_Side_Head. We need to use AC_Front_Body and AC_Side_Body for the rest of the steps. To do this, a bit of adjustment is needed. To swap the image out, select the image plane attributes in each view panel via View>Image Plane>Image Plane Attributes>[imagePlanex] (remember that on some machines Maya 2011 exhibits a bug that requires Maya to be restarted before the image plane attributes can be displayed). This will open up the image plane in the Attribute Editor. In the Image Plane input field, press the folder icon and choose the full body version for that view.

The problem is the general size of the image. When the new body images are brought in, they will be the same size as the head images. Adjusting them is done in the Placement Extras section of the imagePlane node.

To be honest, getting these setting right can be maddening because they have to be eyeballed into place, and the only way to move them is by entering values in the input fields. If you are using the version of style sheets downloaded from the web site (http://www.Creating3dGames.com), the center values that work are Center (0, –60.5, 0), with Width and Height set at 156. If you are using your own version, it just takes a bit of adjustment and tweaking.

Back to modeling, the key here is that the bottom of the neck (as shown in Figure 8.47) has a ring of edges that we can use to continue on developing the body.

Step 68: In a couple of extrusions, extrude out and down to create the top of the shoulders. Remember, sometimes the best way to manipulate this new collection of edges is to select Extrude and then immediately swap to the Move or Scale tools (Figure 8.48). Stop when the ring gets to the top of what will become the arms.

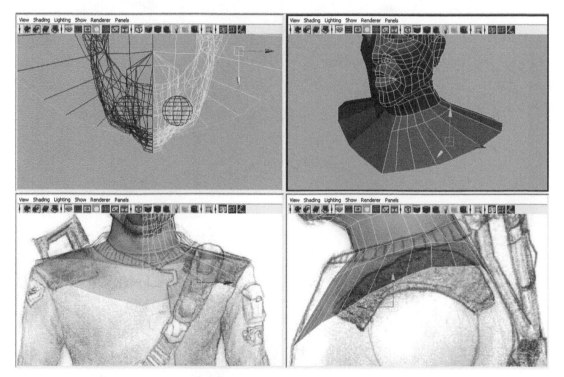

FIGURE 8.48 Extruding out the top of the shoulders.

Step 69: Select the edges across the back and extrude down to the bottom of the shoulder blade. Remember to be constantly looking at all the views to make sure that the new geometry being created makes sense in every view (Figure 8.49).

Step 70: Repeat the process of extruding a row of edges down the front of the chest (Figure 8.50).

Why?

The idea here is to create a ring of polygons that the arm will be extruded from. By coming down the back and then down the front we can create the chest and back as we go. The ultimate goal here is to make sure there are 10 edges around what will become the arm.

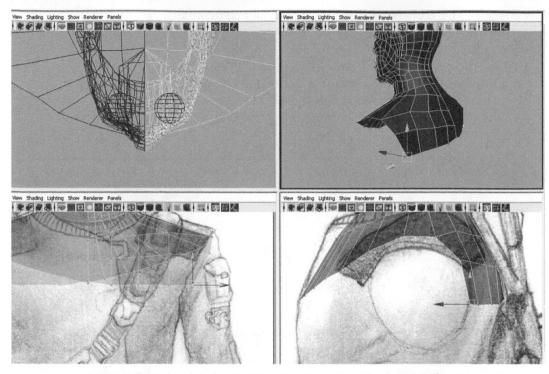

FIGURE 8.49 Working down the back (creating the shoulder blade and what will become the back of the arm).

FIGURE 8.50 Extruding down the front of the chest.

Step 71: Complete the ring of edges that will become the arm with the Append to Polygon tool to connect the chest flap of polygons to the back flap of polygons (Figure 8.51).

FIGURE 8.51 Completing the ring of edges that will become the arm.

Step 72: Use the Insert Edge Loop to split the new polygon (Figure 8.52). The Split Polygon tool could also be used effectively here.

FIGURE 8.52 Splitting the new polygon with the Insert Edge Loop tool.

Why?

Generating a poly mesh where the form is being covered by well-distributed polygons is part of the challenge of good character modeling. When modeling a level, it is perfectly acceptable to have a huge polygon to cover a big flat space, and then a cluster of polys to define a curve. In character work, we are building a mesh that is going to be deformed through joints. Providing a well-distributed collection of polygons will be key to a mesh that deforms correctly. Part of this is avoiding one polygon covering a big part of the body. Step 72 is about better distributing the collection of polygons used to describe the torso.

Step 73: Take some time to sculpt this big mass of vertices into the appropriate form. This can be done by moving each vertex one at a time, or by selecting the object in object mode and then using the Sculpt Geometry tool (Figure 8.53).

FIGURE 8.53 Sculpting and massaging new polys into place.

Tips and Tricks

My tech editor reminded me that another way to nudge tools into place is with the Soft Mod tool, and he's right. If you haven't dealt with this tool, give it a try and see how nice it is to select and move big collections of components (like vertices). Remember that holding down B and dragging will resize the area of influence.

Step 74: Continue extruding down to the belt (Figure 8.54).

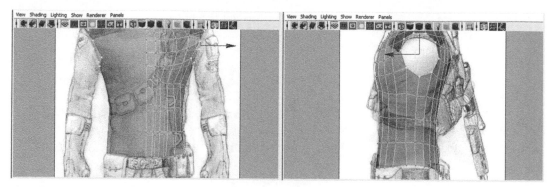

FIGURE 8.54 Continued extrusions to the belt.

Arms

In the previous steps we carefully created a hole from which to extrude the arms. It is important that this ring is carefully constructed since it will define how many polys will be used to describe the roundness of the arm. Remember these polygons will be the basis of not only the arm, but the hand as well. In this kind of modeling, you are looking to find the balance of having just the right amount of polygons to describe the surface, without having too many or too few; it is a skill that simply takes time to develop.

The important thing to note is that there are 10 edges. This will allow for four fingers later. If you have more or less than this, now is a good time to adjust. Adjusting can include adding new vertices by using the Split Polygon tool or Insert Edge Loop tool if you need additional edges, or selecting and deleting edges if you need fewer. It's also worth noting that the spacing of these 10 edges should be fairly even. Adjust the spacing now if you have undesired clusters because well-spaced edges will save you loads of time as you work down the arm.

> **Step 75:** Select the ring of edges that is around the arm hole, and begin extruding out to create the form that is the arm. Figure 8.55 shows two extrusions. Note that the second extrusion is a really long one that anticipates us going back to add needed detail.
>
> **Step 76:** Using the Insert Edge Loop tool, add a subdivision around the middle forearm, and then three around the elbow area (Figure 8.56).

Why?

At first glance, it seems rather silly to be dropping so much of the polygon budget on the elbow; I mean, surely there isn't that much visually happening there, right? Well, visually this is true, but remember that these meshes are going to be deformed by joints. Consider the following simplified illustration.

Figure 8.57 shows a simple joint chain and the real-world equivalency. Figure 8.58 shows how an elbow would deform if there was a single subdivision at the elbow. See the compression that occurs there? Figure 8.59 shows the

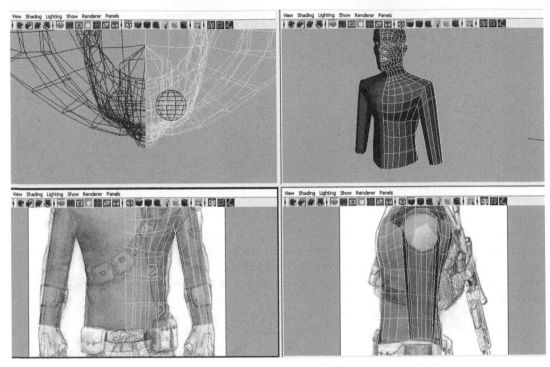

FIGURE 8.55 Extruding out the arm shape.

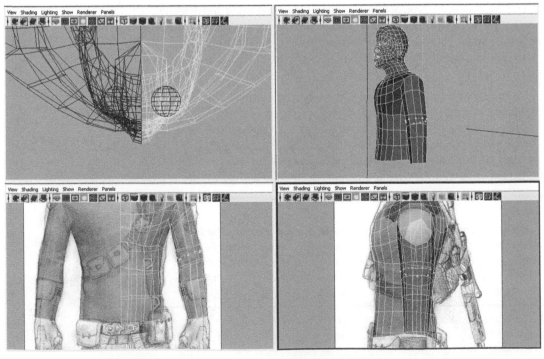

FIGURE 8.56 Adding extra loops to define form. Of special importance are the three loops around the elbow.

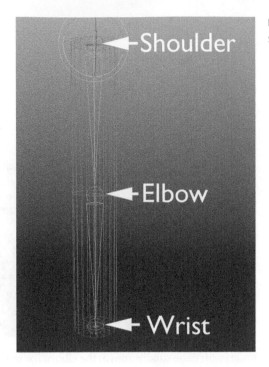

FIGURE 8.57 Joint layout for a simplified arm.

FIGURE 8.58 Result of an elbow topology with a single deformation at the elbow with unacceptable compression.

FIGURE 8.59 Results of elbow topology with three rings around the elbow. Results hold volume better and make for much more believable deformation.

results with three subdivisions at the elbow. The outside deformed area maintains its volume better, and with a bit of skin weight painting (more on this later), the inside nook of the elbow creates a more believable deformation.

Step 77: Add additional subdivisions and sculpt the results (Figure 8.60).

FIGURE 8.60 Additional rings added and sculpted.

Why?
These additional rings help lay the foundation for further details in muscle form and clothing folds.

Hands

Anyone who has done a figure drawing class or done any figure drawing knows that drawing hands is a particularly difficult task. It seems as though they should be simple—we work with them every day and everyone knows what hands look like. But because everyone knows what hands look like, they are pretty tough to get "right."

In 3D this can be a challenge as well. Of further complexity are the issues of deciding how many polys to drop into these bad boys. Should each finger be modeled separately or could we get away with a mitt and save the polys? How well defined should each joint of each finger be modeled and subdivided?

Most of the answers to these questions are defined by the nature of the game and nature of the character. If the character is only going to be seen from a long way off, there is little need—and in fact it is a waste of time—to put a huge amount of detail into the hand. It would be quicker to model and then quicker to rig and then quicker to skin and then quicker to animate the hand as a closed fist that would be grasping a gun (for instance). However, a character who will be close up and who might be swapping weapons might need to have more-articulate hands.

For this character, since he is the main protagonist, the hands will be given a fair amount of detail. In first person, the hands will often be the only part of the person's body that we see, so getting them right will be important.

> **Step 78:** Extrude the end of the arm down to create the polys that will become the palm (Figure 8.61).

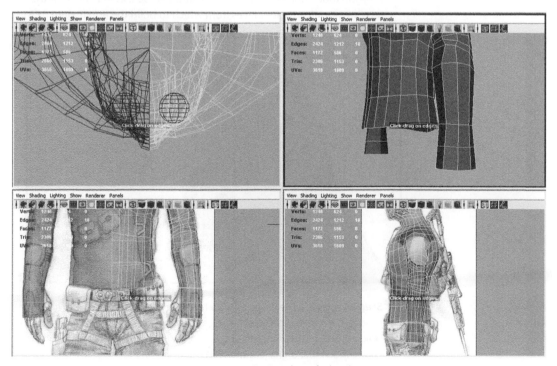

FIGURE 8.61 Creating polygons for the palm.

Step 79: Refine palm and create base of the thumb by moving new vertices around (Figure 8.62). Additionally, add a line of vertices with the split polygon tool that runs up the middle of the outer palm and terminates in a triangle near the elbow.

FIGURE 8.62 Palm refined with basis of thumb.

Step 80: Close off the bottom of the arm. Do this with the Append to Polygon tool. Notice that with the 10 edges we so carefully built for the arm, we are left with four faces from which to build the arm (Figure 8.63).

FIGURE 8.63 Fingers' base created by closing up the end of the arm.

Step 81: Extrude the fingers. To do this, first select the four faces (in face mode). Then go to Edit Mesh>Keep Faces Together (this will check off the box). Now Extrude and each of the polygons will extrude separately and create individual digits (Figure 8.64).

FIGURE 8.64 Extruding out base of fingers. Be sure to turn off Keep Faces Together before extruding.

Step 82: Add an extra loop around the palm for additional shape and then extrude out the thumb. Go back up to the nub created in step 79 and begin extruding out the polys that will form the thumb (Figure 8.65).

FIGURE 8.65 Beginnings of the thumb.

Step 83: With the new faces that define the fingers and thumb, pull out the rough shape for all the digits.

Step 84: Add additional edge loop to allow for roundness of fingers. Do this with the Insert Edge Loop tool and click the edge of any side of the finger (Figure 8.66).

FIGURE 8.66 Inserting extra subdivision to allow for round fingers.

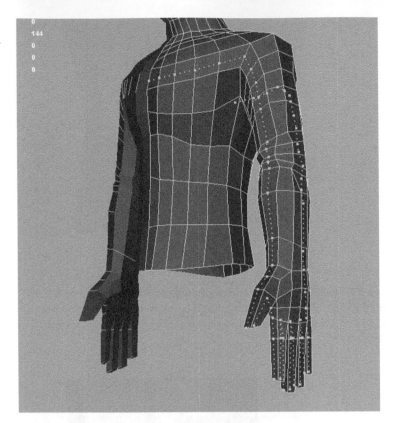

Why?

This will likely create new polygons all the way up the arm and into the chest—not to worry, we will make use of these later. However, without this additional collection of polygons, the fingers would always be square. With this one extra loop, we get a new edge on the inside and outside of every digit, which means a more rounded shape can be sculpted in.

Step 85: Add loops to the thumb. Sculpt the new vertices to refine the hands (Figure 8.67).

FIGURE 8.67 New vertices sculpted to better define the hand.

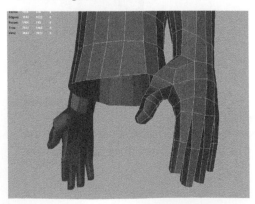

Step 86: Insert edge loops around knuckles to allow for proper bending and additional shape definition (Figure 8.68).

Step 87: Tweak new edges/vertices on the inside of fingers to help define fleshy parts of the finger (Figure 8.69).

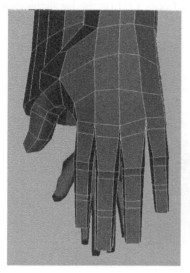

FIGURE 8.68 Added rings (via Insert Edge Loop tool) around knuckles.

FIGURE 8.69 Tweaking new rings for fleshy finger bits.

Why?

Deciding when to start manipulating vertices and edges and when to keep adding geometry is born of experience. In this case, it is easy to rough out some good finger flesh with very small collections of data (really four edges), so it makes sense to rough it out here instead of after further details are added.

Step 88: Extrude the knuckle base. Turn Keep Faces Together back on (Polygons>Edit Mesh>Keep Faces Together). Be sure to select two faces for each knuckle (Figure 8.70). Don't select all the faces for all the knuckles.

FIGURE 8.70 Building the basis of the knuckles.

First, select the first two polys for a knuckle. Extrude the faces, scale them inward, and then continue on to the next knuckle repeating the same process. We will reduce the number of polys in the next step.

Step 89: Using the Merge tool, collapse one of the newly extruded faces to create peaks for the knuckles (Figure 8.71). Do this for all the knuckles at the base of the fingers.

FIGURE 8.71 Optimizing knuckles via merge.

Why?

Having a profile change across the knuckles is an important silhouette attribute. However, there is no need to bury too many polys there. By extruding up, and then collapsing, the rise in the surface can be obtained with minimal poly investment.

Step 90: Add detail to the base of the thumb by extruding out a new collection of polys and then using the Sculpt Geometry tool to smooth them out (Figure 8.72).

FIGURE 8.72 Creating base of thumb via extrusion, scaling, and sculpting (smoothing).

Step 91: Add new geometry and sculpt as needed. Figure 8.73 shows one more ring of edges inserted to allow for some extra flesh on the outer end of the palm. At this point, there should be plenty of geometry to create a well-shaped hand. Sculpt to taste.

FIGURE 8.73 Added geometry to better distribute polys and allow for proper form.

Gloves

The general hand shape is complete but you might notice that they are a little bulkier than they should be. This is because (as per the style sheet) they are actually inside of gloves. We need to make sure the arm indicates this.

Step 92: Create an extrusion midway up the forearm to create the top end of the gloves. Select an entire ring of faces and use the Extrude tool to do this (Figure 8.74).

Step 93: Eliminate the bottom ledge of the new ring by merging vertices (Figure 8.75). Select the vertices around the bottom edge of the newly extruded faces, and choose Polygons>Edit Mesh>Merge (Options). Turn the Threshold setting up to probably 1 (this may need to be changed depending on the size of the model—the results should look like Figure 8.76).

Step 94: Create glove detail. Figure 8.77 shows details atop the top of the glove. It was created by inserting edge loops to allow for new collections of polygons to be extruded. These new polygons (with very little sculpting) are further defined by adjusting the edge normals (Polygons>Normals>Harden Edge).

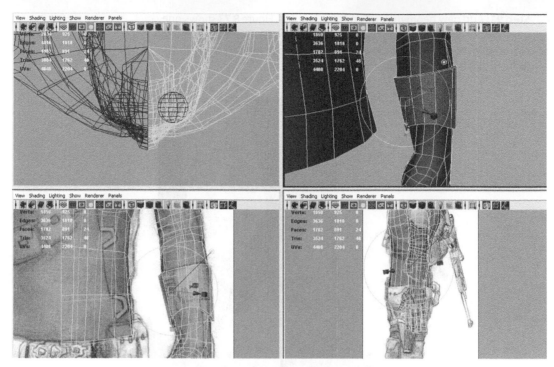

FIGURE 8.74 Creating the top part of the glove via extrusions.

FIGURE 8.75 Using the Merge tool to eliminate an unwanted ledge.

FIGURE 8.76 Results of the Merge tool.

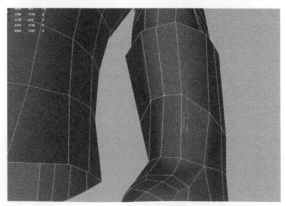

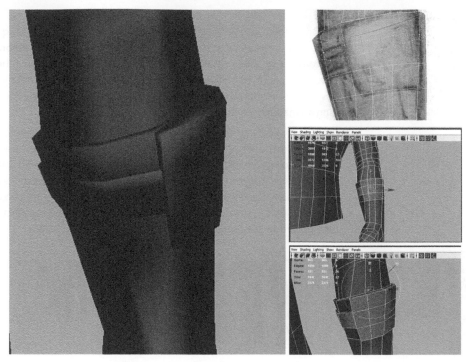

FIGURE 8.77 Detail added to the glove with new geometry extruded.

Pads

Aegis Chung has a lot of patches and pads on his outfit. Creating this geometry is done using similar techniques covered already; namely, taking extant polygons and extruding them to create a new raised section. If the needed geometry is missing, using the Insert Edge Loop tool or the Split Polygon tool can provide the needed polygons.

Be sure that along the process undesirable (as in five-sided polygons) topology is not created. If there is, be sure to clean it up with some careful vertex merging.

Step 95: Add upper body shoulder pads and shirt edge using the Insert Edge Loop tool. (Figure 8.78).

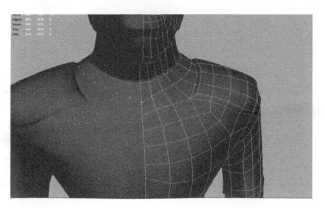

FIGURE 8.78 Upper body detail modeling via added extrusions.

Legs

Creating the crotch area and later the legs uses a few important techniques to ensure that the geometry created will actually be appropriately deformed later. A common problem among students is to get the visual form of the crotch and legs right, but end up with a collection of polys that is nearly impossible to skin appropriately. These steps will show a good technique for creating animatable geometry.

Step 96: Create the geometry that will be used to define the belt and crotch. Starting from the bottom of the torso modeled earlier, create one extrusion that will become the belt, and then another that goes down to the bottom of the crotch. Reshape this bottom "hem line" to match what a speedo or "tighty-whities" would look like (Figure 8.79). Be sure to sculpt this in the front and back.

Step 97: Add a G-string. Using the Append to Polygon tool, connect a long poly from the center front to the center back (Figure 8.80).

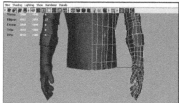 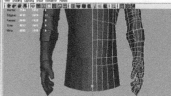 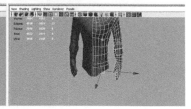

FIGURE 8.79 Creating the belt and crotch.

FIGURE 8.80 Adding a G-string polygon to connect front and back.

Why?

Note that this also creates a rough ring of polygons from which to begin extracting the leg. There still needs to have some work done on this shape, but you can see how the same technique used to create the arm is beginning to emerge here as well.

Step 98: Add subdivisions to the G-string and sculpt into form. Subdivisions again can be added with Split Polygon tool or Insert Edge Loop. After creating the new places to bend the form, bend the form to complete the ring for the leg (Figure 8.81). Be sure to keep the mirror plane clean.

Step 99: With a couple of quick extrusions, rough out the leg (Figure 8.82). Model down to the top of the boots with these extrusions.

FIGURE 8.81 Adding subdivisions and creating appropriate form.

FIGURE 8.82 Roughed out leg via two extrusions.

Step 100: Add rings for needed detail. Again, this is very rough. Give an extra ring on the upper thigh (near the crotch) and then a quick ring or two down the leg to rough out the general shape (Figure 8.83).

FIGURE 8.83 Added geometry to allow for added bending and to better define the form.

Step 101: Model the harness from existing polygons. Do this with previously discussed methods of extruding new faces and appropriately hardening the edges (Figure 8.84).

FIGURE 8.84 Harness modeling.

Step 102: Refine the knees. No new techniques here, but notice in Figure 8.85 that there are 12 rings to define this knee area. Some are for allowing the bend to deform properly with joints, but some are to help define the bunching of the pants over the top of the boots.

Step 103: Extrude down a rough boot shape (Figure 8.86).

Step 104: Close the bottom of the boot with the Append to Polygon tool.

Step 105: Add detail via extrusions and inserted edge loops (Figure 8.87).

Step 106: Add a sole to the boot. Further extrusions. Notice that a few extra loops are also added here to allow for the boot to deform right around the ball of the foot (Figure 8.88).

Step 107: Add pants (pocket detail). Use the same techniques as already covered, but remember to make careful use of hard and soft normals (Figure 8.89).

Step 108: Tweak and sculpt as desired. The model as constructed thus far is show in Figure 8.90.

FIGURE 8.85 Knee area (and coincidentally the top of the boot area).

FIGURE 8.86 Roughing out the boot with some careful extrusions.

FIGURE 8.87 Added detail to boot.

FIGURE 8.89 Pant details.

FIGURE 8.88 Boot with sole and added deformations for appropriate bending.

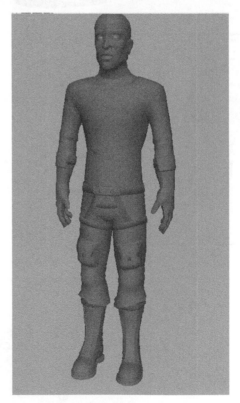

FIGURE 8.90 Aegis Chung in semirough form.

Tying It All Together

Step 109: Delete the instanced half of Aegis Chung. In my case this is the right side of the body (the character's right).

Why?

Up to now, all the things we've been modeling on his body have been symmetrical, so working with an instance makes sense. However, from here on out, most of the details are going to be asymmetrical so it's time to sew him up to one solid mesh.

Step 110: Clean up the mirror plane. Select all the vertices that should be right on the mirror plane and snap them in the middle (you may want to double-check that Retain Component Spacing is still turned off in the Move tool settings).

Step 111: Select the mesh in object mode, and choose Polygons>Mesh> Mirror Geometry Options. Click the –X radio button and check the Merge With Original check box. Press Mirror.

Why?

If you have the left side of Aegis (his left), the mirrored version would be in the –X direction (and thus the –X radio button). By clicking the Merge With Original check box, the mirrored version of Aegis will also merge up the middle, making it truly one mesh with shared vertices along the middle of the form.

Step 112: If needed, soften the edges along the middle of the new single mesh model.

Asymmetrical Details

Now is the chance to make that big leap from tutorial following to asset building. Figures 8.91, 8.92, and 8.93 show a completed Aegis Chung. Everything on him was modeled using techniques covered in this chapter with the guns using a few techniques from the level modeling chapter. All it takes is time and a bit of sweat equity to get him complete.

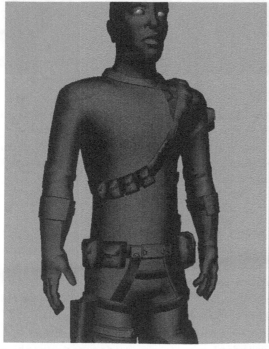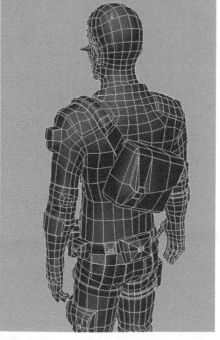

FIGURE 8.91 Aegis Chung.

FIGURE 8.92 Aegis Chung with some facial hair.

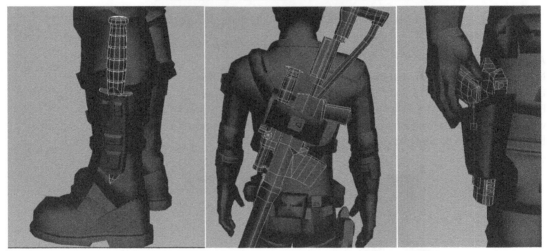

FIGURE 8.93 Aegis Chung's weaponry.

Of special note is Figure 8.93. This shows the three weapons: the pistol, rifle, and knife. Along with the eyes, these three objects are separate meshes. However, all the rest (including holsters and backpacks) are part of the core mesh. When all is said and done, there should be six meshes total (Aegis, left eye, right eye, knife, pistol, and rifle).

Conclusion

And there his is. He's ready to kick some serious butt. OK, well he's ready to try and sneak into an old cold war submarine facility anyway. In this chapter we have covered a lot of techniques that provide a mesh that is effective (mine is 14,280 tris) and will deform well when it is time to rig the character. Character modeling takes a good while, but frankly a good character helps separate the professional-looking games from the wannabes.

In the next chapter we will take this cold gray character, lay out his UVs, and create textures that will bring him to life and provide extra depth to his form.

Asset Creation: Maya Character UV Mapping and Texturing

Effective UV mapping and texture creation is what helps conceal the low polycount of characters. In reality, the form created in the last chapter paints the form with some pretty broad strokes (think of how the ears were modeled). But with a carefully constructed texture, all these minimalist polygon collections can have the final appearance of a quite complex form.

Although the form built in the last chapter is strong, in this chapter we will add this needed extra detail through a painted texture map that is based from photographs. But before we paint with photos to create the beautiful texture maps, it will be important to have a good UV map first.

UV Mapping

UV mapping characters can be a daunting task. When UV mapping the level, we were generally working with fairly simple shapes that lent themselves easily to planar maps and cylindrical maps. The human form really is much more complex than that at first blush.

Fortunately, there have been some important tools that have emerged in the last few years that can assist in efficient and quickly created UV maps. Maya actually has some of my favorite UV editing tools; however applications like Modo have emerged with some really powerful UV tools that are much more efficient than Maya's. To make matters even more complicated, there are free tools like RoadKill (http://www.pullin-shapes.co.uk/page8.htm) that integrate fairly seamlessly with Maya that allow for some extraordinarily fast UV mapping using all the latest pelt/LCSM mapping technologies. If you do a lot of UV mapping, or plan to, learning one of these two tools may be in your best interest.

With all that said, Maya's UV mapping tools have done some catching up in recent versions, and many of the tools and techniques available in Modo and Roadkill are available in Maya as well. There are enough available that we will stick to Maya's tool set for this chapter's tutorials. Many of the techniques used for UV mapping the human form are similar to those used for mapping the level, so building upon the toolset you are already familiar with will move us along quickest.

Tutorial 9.1: Character UV Mapping

In this tutorial we will be doing several things. First, Maya's UV tools are powerful, but sometimes require some very specifically created polygonal structure. Before we even start building UV maps, we will take a moment to make sure that the geometry built in the last chapter does indeed fit into these Maya-imposed requirements. The requirements actually are good to keep our eye out for (they are mostly concerned with the problems that arise from nonfour-sided polygons) since identifying and fixing them at this state will ultimately save time within Unity.

Mesh Inspection and Cleanup

> **Step 1:** Open Maya and set the project to Incursion–Maya.
> **Step 2:** Open AegisChung.mb.
> **Step 3:** Turn on Backface Culling. In the persp view panel, choose Shading>Backface Culling (Figure 9.1).

Why?
Figure 9.1 shows the results of the last chapter with backface culling activated. It appears that the entire body has the normals facing the wrong way. If you are using the version of Aegis Chung that is included

on the support web site (http://www.Creating3dGames.com), much of this cleanup has been done. But if you are using your own version there might be a lot of this type of cleanup. In the last chapter where this was modeled, we could have modeled with backface culling turned on to begin with, but I often find modeling that way tough to do as some objects that are modeled may not be seen at all at a certain angle, so I prefer to model characters with backface culling turned off. Unfortunately, that preference usually leads to a bit of cleanup later. Luckily, the cleanup is fast.

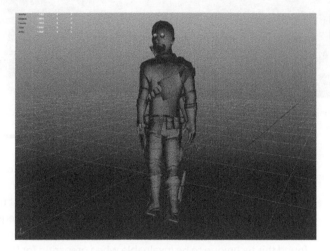

FIGURE 9.1 Results of activating backface culling. Uh oh.

Step 4: Fix errant normals. If your model has normals facing the wrong way, switch to face mode and double-click one of the incorrectly oriented faces. This will select outward until it hits polys that have normals facing in another direction. Select Polygons>Normals>Reverse.

Step 5: Double-check one more time that all normals are correct.

Why?

Reversed normals are just a general pain. It's always a major annoyance to discover a see-through polygon in Unity when you've moved on to other Unity-specific issues. With a bit of careful inspection, a lot of bothersome stops in procedure can be prevented.

Step 6: Hunt and destroy five-sided polygons. In object mode, select AC_AegisChung. Choose Mesh>Cleanup... In the Cleanup Effect section change the Operation radio button to Select Matching Polygons. In the Fix by Tesselation section check the Faces With More Than 4 Sides check box. Click the Apply button (Figure 9.2). This will highlight all the faces with more than four sides. Use the Split Polygon tool to cut these bad boys into three- and four-sided polygons.

FIGURE 9.2 Using the Cleanup to identify faces with more than four sides. Once these are identified they can be fixed.

Why?

This cleanup trick was discovered by one of my students, Giovanni Sabella, in our Advanced Game class. Giovanni was having problems getting meshes to work well in Mudbox and discovered that most of the normals painting applications also had some very specific requirements for polygon topology because they did so much subdividing. But I've found this technique to be invaluable when preparing for UV mapping as well. The UV Unfold tools and UV Smooth tools make shells disappear if the appropriate topology isn't present. You learn the best stuff from students—I refer to this in class as the Sabella Step.

Step 7: Repeat steps 4 through 6 on the weapons as well.
Step 8: Delete all history. Edit>Delete All by Type>History.

Why?

The cleanup steps have created bits of history throughout the scene. To make sure that steps in the future are working with the cleanest collection of data possible, always delete the history before moving onto other big steps.

Planning

In the last chapter we took great pains to make sure the model was one single mesh with the idea that calculations for joint-driven deformations were much faster with a minimal number of meshes. However, even though it is a single mesh doesn't mean that the UV map has to be made of one shell. For that matter, it doesn't even have to be one material (or texture). For instance, if a character had shiny armor plating part of his body but matte chunks of material on other parts, different materials could be created and applied on a per-poly basis. Then

in Unity the shaders could be constructed to provide that interesting balance of high specularity and matte surfaces. Of course this comes with a cost, a single object with multiple materials means more draw calls to draw that single object, so generally this nice effect has to be weighed against the performance cost.

In this case we will create a texture atlas for all three weapons, but the entire character mesh (AC_AegisChung) along with his eyes (AC_LeftEye and AC_RightEye) will use one texture. This means that all the UVs for the character must reside in the 1,1 quadrant of the UV Texture Editor. But, because there are obvious changes in what his "real" materials are (he wears a shirt tucked into a belt attached to his pants, for instance), there are some obvious places where seams can be allowed.

This should actually come as a great relief. Trying to get a form as complex as the human one into one seamless (or nearly seamless) UV shell without a lot of distortion is a very difficult task. With the ability to break the character up into various shells dictated by the change in fabric on his body brings with it tons of flexibility. When you build a game with a nude protagonist though, well, then you've got issues.

Figure 9.3 shows a quick schematic of places where obvious seams would occur. Although in your own work these zones can usually be identified by a quick visual glance at the form (no need to create this kind of schematic), this i mage should show the idea of breaking shells up by the breaks in fabric.

One other note about seams that we will address again later in the tutorial: an obvious place to plan seams are where there are clothing seams. Clothing

FIGURE 9.3 Locations for UV shell seams.

237

has seams where strips of fabric are sewed together. Look at most any shirt and where the sleeves are connected to the bodice section, there is a seam. Your pants likely have a seam down the inside of the leg and another on the outside. These clothing seams are perfect places to allow UV seams to occur and allow for much more easily created distortion-free shells.

New Material

Step 9: Create a new material for Aegis. Right-click-hold on Aegis and choose Assign New Material from the hotbox menu that comes up. Create a lambert material in the Assign New Material window. This should open the new material in the Attributes Editor. Name the material `AC_AegisChung_Mat`. In the Color channel import our good friend Checkerboard.psd (which should still be sitting in the sourceimages folder of the project). The results will be a tremendous mess (Figure 9.4).

FIGURE 9.4 Aegis with Checkerboard.psd assigned.

Tips and Tricks

Remember that to see any texture applied to a mesh, 6 must be pressed on the keyboard while the mouse is in the view panel the texture should be visible in.

Why?

A mess indeed. A close look at the mesh will show chunks of him without texture, and other parts with squished checkers and still others with stretched checkers. For an even better look at the mess, open the UV Texture Editor (Window>UV Texture Editor) and take a look at that (Figure 9.5). Basically, the UVs are all over each other. There are UVs that fill the entire quadrant, and others that may be just a sliver. Either way, ultimately, the goal is to take this jumbled collection of UVs and unfold them all into easy-to-see, easy-to-paint shells.

FIGURE 9.5 The UV Texture Editor before we work our magic.

Cylindrical Shapes and Projections

We'll start with the arms. UV mapping the arms is really picking some of the low-hanging fruit. The reason why the arms are fairly easy is that they are essentially cylinders, which lends themselves quickly to a cylindrical projection.

Step 10: Make a selection similar to Figure 9.6.

FIGURE 9.6 Initial selection for UV Mapping the arms.

Tips and Tricks

Often, when working with checkerboard textures, swapping to a smooth shade without texture display (press 5 on the keyboard) makes specific selection of polygons much easier.

Why?

This selection is important because it shows where seams are obviously going to be (at the seam of the shoulder and at the top of the gloves). But it also is an important selection for what it does not include (the pouch up on the outside of the deltoid). This pouch is likely sewn onto the arm

sleeve, and thus there would be a seam all the way around where the pouch attached to the sleeve as well. To minimize distortion on the arm, this pouch will be mapped separately.

Tips and Tricks

When selecting objects or components in Maya (especially when detailed selections like this are involved) it's important to remember a few things about Maya's selection paradigm. First, remember that Maya (by default) selects through the object. So as a Marquee selection is made around a collection of polygons, remember it is selecting the polygons on the back side of the mesh as well. Lots of students don't like this at first, but in the long run it can be a huge time-saver.

Second, remember that Shift-selecting an object or component will select the object if it is not selected, but will deselect an object or component that is already selected. Ctrl-selecting will always deselect, and Shift-Ctrl-selecting will always add the object or polygons to the selection.

Step 11: Create a cylindrical projection. Select Polygons>Create UVs>Cylindrical Mapping. A new set of manipulators should appear similar to Figure 9.7.

FIGURE 9.7 Immediately after a cylindrical mapping function and the new manipulator handles that appear (emphasis added).

Why?

It's important to understand what we're seeing in Figure 9.7. What the manipulator is displaying is a semicylinder wrapped halfway around the arm from the front. This means that the texture would be repeated for the back half (obviously not what we want). Additionally, the default projection of the cylindrical mapping is straight up and down, but the shape of the polygons being mapped are not straight up and down. Finally, currently, there would be two seams (one where the half cylinder starts and another where it ends), and one of these seams would be running down the outside of the arm—not a good place for a seam. We need to adjust this.

Tips and Tricks

These manipulator handles are important since they will allow us to refine the projection to closely match the shape of the polygons being mapped. Sometimes though, if a click goes awry, the handles can disappear. If this happens and they disappear, do the following. First, change to object mode and select the mesh. Next, open the Channel Box and look for a node (in the INPUTS section) called polyCylProj1 (or some other number). Select this node, and then choose the Show Manipulator tool (the ninth tool down in the toolbox (just beneath the Soft Selection tool).

Step 12: Expand the projection so it completely surrounds the arm. Do this by dragging the red rectangles that are at either end of the line that is at the cylinder's equator (Figure 9.8). Make sure they touch.

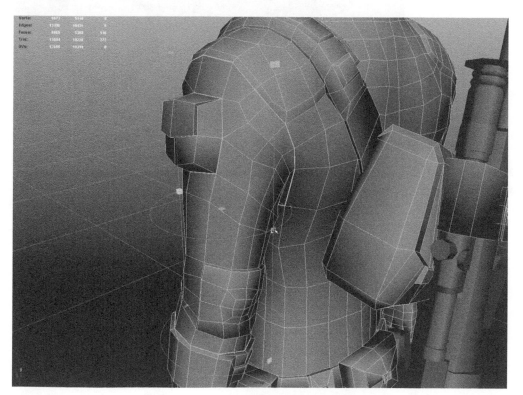

FIGURE 9.8 Expanding the coverage of the cylindrical projection.

Why?

This is an important step because it makes it so the texture does not repeat (it was using the texture once for the front of the arm and once for the back, which meant two seams). Now, the texture will wrap completely around the arm with no repeating, and leave us with one seam (currently across the back of the arm).

Step 13: Rotate the seam to the inside of the arm. The center circle of the projection manipulator is a handle itself. Click-drag this handle to rotate the seam (where the two red rectangle handles meet) to the inside of the arm (Figure 9.9).

FIGURE 9.9 Rotating the seam to the inside of the arm.

Why?

Of constant concern to the artist tasked with UV mapping should be where to hide the seams. Hiding the seam across the back of a character might seems like a good idea at first until the game becomes third person and suddenly all we see is the back of the character. A much smarter place to hide seams for things like legs and arms are where the seam is tucked between two surfaces. It turns out that the inside of the arm and leg also have natural seams since that's where the fabric of shirts and pants are often sewn together.

Step 14: Rotate the projection to match the rotation of the arm. At the bottom edge of the projection cylinder is a little red T (Figure 9.10, left). Clicking this T will reveal a new set of manipulator handles (Figure 9.10, right) that allows the projection to be moved, scaled, or rotated. Use the rotation handles to rotate the projection to more closely match the angle of the collection of polygons being mapped.

Tips and Tricks

Getting back to the first set of manipulation handles can be done by clicking the little red T again.

FIGURE 9.10 Rotating cylindrical projection to match rotation of the arm.

Step 15: Press 6 on the keyboard to see how the checkers are falling into place (Figure 9.11).

FIGURE 9.11 Checkers showing well-distributed texture.

Step 16: Adjust the scale if needed to eliminate most distortions in the checkers.
Step 17: Move this new shell to the side in the UV Texture Editor. Open the UV Texture Editor and this projection should still have its handles visible there. Grab the manipulator handles by either the yellow circle in the middle or the red triangle handle and move this projection (and its shell) away from the mass of other UVs (Figure 9.12).

Why?

Yes, this shell is much to big—it's taking up the size that the entire form will eventually take up. That's OK. Right now the shells should be big enough to easily illustrate the size of the checkerboard pattern so we can see relative sizes. Later the shells will be scaled and arranged.

FIGURE 9.12 Sequestering the newly created shell.

Step 18: Use the Smooth UV tool to unfold the new shell. In the UV Texture Editor right-click-hold and select UV from the hotbox (to tell Maya you want to deal with UVs now). Marquee select this new shell. Activate the Smooth UV tool in the top-left corner of the UV Texture Editor (Figure 9.13). This will show two little buttons at the bottom left corner of the shell called Unfold and Relax. Drag the Unfold button left and right to see the shell relax. Be sure to be watching the view panel as well to see the checker pattern relax into better proportions.

FIGURE 9.13 Using the UV Smooth tool to relax a shell.

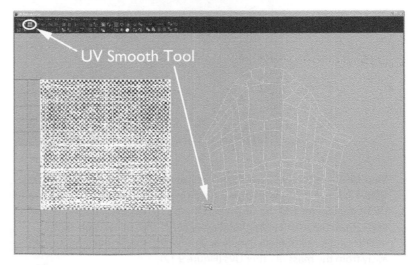

Step 19: Repeat process for the other arm.
Step 20: Repeat this technique for each of the legs (Figure 9.14). Project one leg at a time and come all the way up to the bottom of the belt with the selection. Treat the back pockets as though they were sewn-on pouches. Note that there will be several shells created through this process. Be sure to use the UV Smooth tool to unfold each individually.

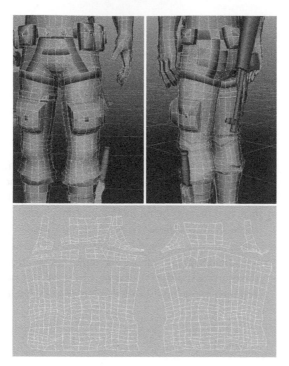

FIGURE 9.14 Cylindrical mapping the legs.

Tips and Tricks

Inevitably after making a projection you will discover that the projection didn't cover enough polygons or you ended up grabbing polys you didn't need. No worries. If a polygon is missing, just make the selection again and create another mapping. If you grabbed too many, just move the extras aside and pick them up in further mapping functions.

Sewing Up Certain Seams

Among the shells are two separate shells for the fly (crotch) area. While there usually is a seam that runs along the side of the zipper and then down through the middle of the crotch, getting the zipper flap to look right when the two shells are separate as they are can be quite difficult.

This can be an issue for the butt area and various other places as UV mapping occurs. The fly area just provides a quick and easy example of how projected shells can (and should) be combined to assist in later texture painting.

Step 21: Find the edges where the fly is split. In the persp view panel, select a few of the edges along the seam. Take a look in the UV Texture Editor to find out what these edges are (Figure 9.15).

245

FIGURE 9.15 Tracking down which edges in 3D are represented in the UV Texture Editor.

Step 22: Find matching-sized shells and remove faces that offset the balance of the new combined crotch. The steps ahead work easiest if there are no flaps of polygons hanging off of a shell (your particular UV layout may be different). In the UV Texture Editor, begin selecting down the fly on either shell until the end is reached of the smaller of the two shells. Select the edges along the end of that desired shell (where it connects to the unwanted flap) and choose Polygons>Cut UV Edges. Then, select a UV on the chunk of the shell to remove, Ctrl-right-click-hold and select To Shell, and then use the Move tool to move this new shell away (Figure 9.16).

FIGURE 9.16 Finding and creating two shells that will share a common edge without additional flaps.

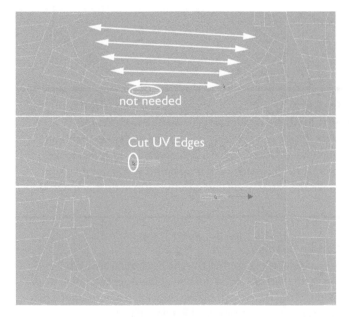

Why?

Remember that the idea here is that mapping the crotch will be much easier if things like the fly area are one shell. Your particular situation may vary, but in step 22, we're looking at getting rid of flaps of stuff that will make combining the crotch and then preparing the shells combine to finish the crotch.

Step 23: Sew edges. Still in the UV Texture Editor, select the edges that the two fly shells share (as you select the edge on one shell it will highlight selected on the other). Select Polygons>Move and Sew UV Edges. The not-quite-finished results are shown in Figure 9.17.

FIGURE 9.17 Sewing edges.

Step 24: Use Smooth UV tool's Unfold to relax the new shell.
Step 25: Rotate the shell so that the fly area is straight up and down (Figure 9.18).

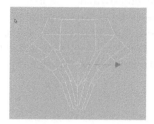

FIGURE 9.18 New fly region.

Why?

Rotating the shell is probably not mission critical. However, anytime there are areas that need to be precise (people will notice if the fly is all crooked), having it sit straight up and down will make the space easier to paint within Photoshop.

Pouches, Packs, and Sheaths

Cylindrical projects work for lots of areas of the body (arms and legs as illustrated are obvious cylindrical shapes). However, in our case there are other shapes (namely all the pouches on Aegis's pants, his pack, and the various holster and knife sheaths) that are essentially square.

In the next few steps we will look at how to UV map these sorts of forms. Much of this is similar to the methodology used to map the level, so we should be able to move through the steps quite quickly.

Step 26: Select the polygons of a pouch or pocket (Figure 9.19). Which one doesn't matter, but Figure 9.19 shows one that is mostly a cube in shape.

FIGURE 9.19 Pouch to map.

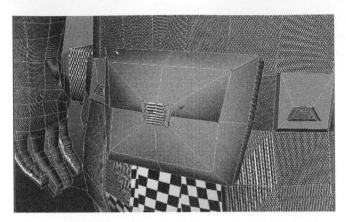

Step 27: Map the pouch. Choose Create UVs>Automatic Mapping (Options). Make sure the Planes setting is set to 6. Press Project. In the UV Texture Editor the faces that have just been mapped will be highlighted in salmon. Before selecting anything else, in the UV Texture Editor right-click-hold and choose UV. Immediately Marquee select all the faces that are in that top-right quadrant. At this point, all the other faces will show up in that space, but if the Move tool is immediately used, the UVs for the pouch can be moved off to the side (Figure 9.20).

FIGURE 9.20 Initial projection on the pouch.

Step 28: Sew it up. Figure 9.21 shows the pouch sewn up. The process was the same as sewing up the pillar back in the set design: select an edge on the outside of a shell (which will select an edge elsewhere on another shell), check in the 3D view if these edges should be sewn together, then use Polygons>Move and Sew UVs. Repeat until the pouch is assembled.

Why?
Note that there are two shells here—one is the pouch and the second is the clasp. Since the clasp is another type of material, it's an easy place to leave a seam. If this shell were to be sewn onto the larger shell, the results would be a very distorted shell.

FIGURE 9.21 Shells assembled via Move and Sew UV.

Step 29: Use the Smooth UV tool and Unfold the shell to relax it.

Step 30: Rotate and organize the shells. The big pouch shell will be rotated to make for easiest texture painting, while the latch will be tucked in to make use of the texture space (Figure 9.22).

FIGURE 9.22 Completed pouch.

Step 31: Repeat for all other squarish pouches (Figure 9.23).

FIGURE 9.23 UV-mapped pouches, holsters, and sheaths—anything that is square.

Tips and Tricks

As the number of shells increase, the number of functions will increase, which means the number of nodes increases and the file gets heavier and heavier with history. As I was working toward the previous steps, Maya began to get really sluggish as it tried to work through all that history for every step. A quick Edit>Delete All by Type>History cleans up the history and Maya is snappy again.

Step 32: Size shells to find constant checkerboard across all mapped surfaces (Figure 9.24).

FIGURE 9.24 Resized shells to create consistently sized checkers.

Why?

The checkerboard texture does more than just indicate distortion due to faulty UV map. They help indicate how much of the texture space any one section is getting. Objects that are smaller in world space generally should have less texture space. In world space (in the view panel), if the checkers have the same size across surfaces, Maya is indicating that they are taking up an appropriate amount of texture space for the physical size of the polygons.

Chest

The chest is (roughly speaking) another cylinder. This means that the chest could be mapped with one big cylindrical map. However on closer inspection, the chest is really more like a flattened cylinder, which means that a cylindrical map will result in some strange distortion if done by itself.

Often, a better approach to the chest are two cylindrical maps, one from each direction with some careful adjustment to the scale and placement of the manipulator.

Step 33: Make a selection of the front of the chest (Figure 9.25).

FIGURE 9.25 First selection in mapping the chest.

Why?

Why not the shoulders or the collar or the undershirt? On my version of Aegis, the character has some shoulder pad made of a different fabric. Since this is another fabric, it will be mapped with another more accurate mapping (a half-cylindrical map using the technique in the following steps). The collar will be best mapped with one cylindrical map that wraps entirely around that ring of faces.

Step 34: Create a cylindrical projection (Polygons>Create UVs>Cylindrical Mapping).

Step 35: Move the projection's center back in Z. Press the red T to manipulate the center of the projection. This is a little hard to show in screenshots, so take a close look at Figure 9.26. The persp view panel shows the results, while the actual movement takes place in the side-view panel. Using the move handles on the projector (the cone—specifically the blue cone for Z—it'll turn yellow when selected), move the projection's center back in Z. This will cause the distortion particularly visible in the shoulder area to gradually lessen until it is almost gone.

Step 36: Scale the projection to achieve square checkers (Figure 9.27).

Step 37: Unfold and move. In the UV Texture Editor, swap to UV mode and move this new collection of shells off to the side. Use the Smooth UVs tool and Unfold. Scale the shells so the checkers are the right size in relationship to the rest of the mapped surfaces.

Step 38: Repeat this step for the back of the chest and for areas like the shoulder pads (Figure 9.28).

FIGURE 9.26 Moving the projection center to reduce distortion on chest front projection.

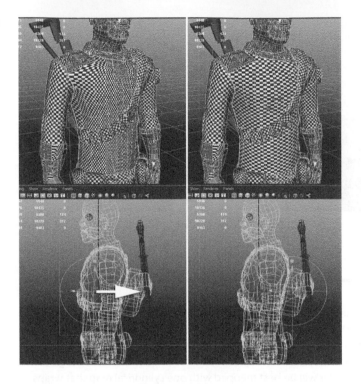

FIGURE 9.27 Scaling projection.

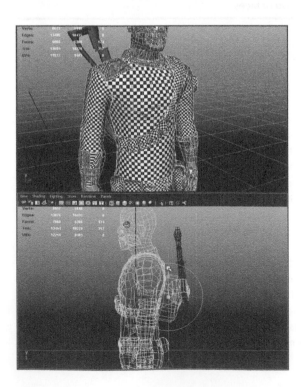

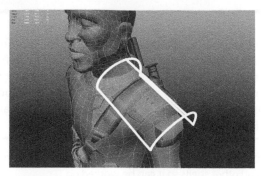

FIGURE 9.28 Projection for the shoulder pads (emphasis added).

Tips and Tricks

Notice that in Figure 9.28, projection has moved around a lot to get into that place. The manipulator handles can be really tough to see, especially with a strong texture pattern like the checkerboard. With lots of quick switches between textured or not (pressing 5 or 6), it can be easier to see and manipulate the handles, see the results, then back to seeing the handles.

The Face

Here's where the magic happens. In versions past, Maya required an incredible mess of projections that were painstakingly stitched together in an attempt to get a texture to crawl across a face correctly. With the newer UV technologies emerging in recent years, texturing the face has become almost... fun.

Step 39: Select the polygons of the head and neck (Figure 9.29).

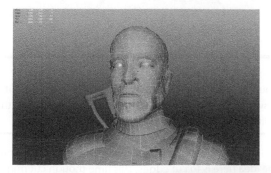

FIGURE 9.29 Selecting the faces of the head.

Step 40: Create a planar projection. Select Polygons>Create UVs>Planar Mapping (Options). For Fit Projection To, click the Bounding Box radio button. For Project From, click the Z-axis radio button. Click Project.

Why?

Making a quick planar projection ensures that all the polygons of the head have UVs (remember that this cannot be assumed). By projecting straight on from the Z-axis and making sure that it fits the Bounding box of the poly shapes, the most important polygons (those across the character's face) will have the most accurate projection from the start.

Step 41: In the UV Texture Editor move this new shell away from the quadrant and other shells so it can be worked on.

Step 42: Cut the edges across the top and back of the head. Figure 9.30 shows the edge selection to make in the view panel; it should start at about the hairline in the front and run clear to the end of the back of the neck. In the UV Texture Editor select Polygons>Cut UV Edges.

FIGURE 9.30 Selecting the edges to cut.

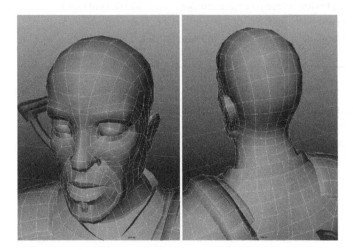

Why?

We are about to use Maya's handy Smooth UV tool again with its Unfold options. However, we need to make a slice in the head to give this head a place to split as it unwraps the form from 3D to 2D.

Step 43: Remove potential problem areas—the oral cavity and nostrils. Again, the idea here is to cut edges. This time though cut rings of edges. Figure 9.31 shows two selections. The first is a ring of edges just inside the lips; the second are two rings just inside the nostrils. Once these two selections are made in the view panel, go to the UV Texture Editor and select Polygons>Cut UV Edges. Move the two shells (for the nostrils and the oral cavity) away (Figure 9.32).

FIGURE 9.31 Three rings of edges (one inside the lips and one for each nostril) that will be cut.

FIGURE 9.32 The head moved away from the nostril and oral cavity shells.

Why?

When this head is unfolded, the geometry in the mouth and nostrils will need to be accounted for. The oral cavity is a really big space, which means that as Maya attempts to solve for the head, it will cheat the polygons around the mouth to make room for this big oral cavity. The same would happen for the nose. Because the oral cavity and nose will likely be mostly black (or a very dark red/brown), we can map that separately and leave more texture space for the mouth and nose. What we're doing here is cutting those parts of the face off into their own shell so that they aren't included in the Unfold function to come (Figure 9.32).

Step 44: Unfold the head. In the UV Texture Editor, swap to UV mode and select the shell that is the head (remember this might be done easiest by selecting one UV of the head, Ctrl-right-click-hold and select To Shell). Activate the Smooth UV tool, and drag (to the right) on the Unfold button. Do this until all movement in the UVs stop. This may mean that the Unfold button needs to be dragged several times (Figure 9.33).

Warnings and Pitfalls
Unfolding with the UV Smooth tool is truly one of the greatest inventions of all 3D-dom. However if the geometry isn't "right"—if there are any 5-or-more-sided polygons—when this tool is used the shell just disappears. If this happens, be sure to go back and look at the Cleanup process to get rid of any bad geometry.

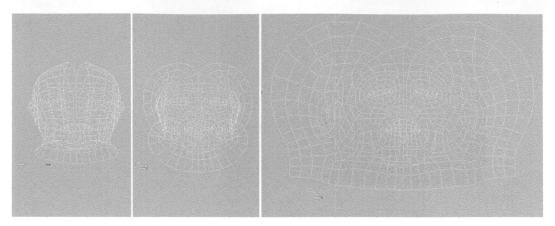

FIGURE 9.33 Unfolding the head.

Step 45: Look for overlapping regions of UV. In the UV Texture Editor toggle the UV-shaded display with the button shown in Figure 9.34. The dark purple or red areas indicate where UVs are overlapping and thus sharing texture space (this is bad).

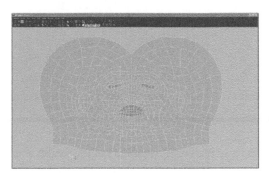

FIGURE 9.34 Tracking down overlapping UV spots.

Step 46: Relax. Select the region around one of the overlapping areas. Don't be too stingy; notice in Figure 9.35 that the selection is two rings of UV out from the overlapping area. Activate the Smooth UV tool and this time drag on the Relax button.

Step 47: Repeat for any other overlapping areas.

Step 48: Relax again. This time, select the entire shell. Go to Polygons>Relax (Options). In Pinning, choose Pin UV Border and in Other Settings activate World Space. Looking at the view panel and the UV Texture editor, press the Apply Button once or twice (this may need to be more or less—be looking to get a good balance of squares shifting to distribute checkers well, but not so much that they begin stretching too much around the lips and mouth). The solution for me was two applies (at Maximum iterations 5 (the default)) and is shown in Figure 9.36.

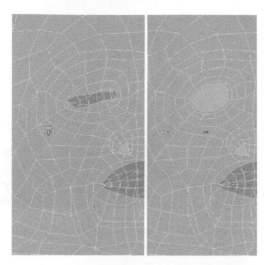

FIGURE 9.35 Using the Relax part of the Smooth UV tool to relax out overlapping regions.

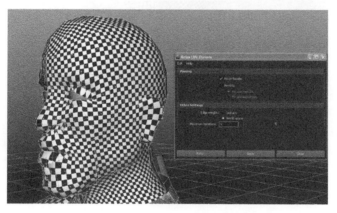

FIGURE 9.36 Using Polygon>Relax.

Hands

Sigh…hands. So beautiful, so complex, and so difficult to UV map. Often UV mapping the hands is an exercise in compromise. Getting all the digits unwrapped into a 2D space is just a tough job. The following steps are a quick compromise to generate a UV map that works very well for game situations where the hands are rarely the full-screen close-up.

The process will consist of two planar projects followed by some careful relaxation along the edges of the map.

Step 49: Select the faces along the outside of the hand (Figure 9.37).

Step 50: Apply a planar projection via Polygons>Create UVs>Planar Mapping (Options). Change the Project From setting to X-axis. Press Project.

Why?
We want to project from the side—thus along the X-axis.

FIGURE 9.37 Selecting the polygons for the first planar projection.

Step 51: Use the manipulator handles to scale the projection down to get more square checkers (Figure 9.38).

FIGURE 9.38 Using the manipulator handles to get better texture distribution.

Step 52: In the UV Texture Editor, move the new shell out of the top-right quadrant.

Step 53: Select the polygons of the hand that weren't involved in the first planar projection (all the palm and inner forearm).

Tips and Tricks

Sometimes the UV Texture Editor can be a great polygon selection tool. In the view panel, Marquee around the entire hand (the glove area extending up the forearm). Then, in the UV Texture Editor, Ctrl-Marquee around the faces that were just mapped in the previous steps. This will deselect those polygons in the view panel.

Step 54: Apply another planar projection via Polygons>Create UVs>Planar Mapping. The settings used for the last projection will work great here too. Be sure to scale the projection if needed to get those square checkers.

Step 55: Move the new shell out of the quadrant and toggle the shaded UV display to on (Figure 9.39).

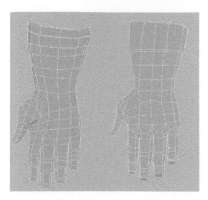

FIGURE 9.39 Two hand projections. With shaded UV display on, it's easy to see that the palm is projected backward (it's pink).

Why?

The planar mapping function was used twice on two sides of the hand. The projection was coming in from the positive X direction. This meant that the polygons on the outside of the hand were projected correctly—the projection hit the outside of the polygons. But the polygons on the inside of the hand (the palm side) also received their projection from the positive X direction. This meant that they were hit through the hand on the inside. The shaded UV display mode allows for the identification of UVs that are backward since they will show up pink.

Step 56: Flip the pink shell. In the UV Texture Editor, select the pink shell (the palm) and choose Polygon>Flip (Options). Make sure the Horizontal and Local radio buttons are checked. Click Apply and Close (Figure 9.40).

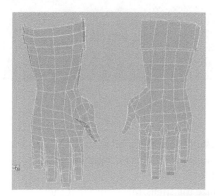

FIGURE 9.40 Flipped UV shell.

Step 57: Marquee select the UVs along the outer edge of each shell and use the UV Smooth tool's Unfold to unwrap the UVs that might be tucked behind (Figure 9.41).

FIGURE 9.41 Unfolding the edges of the shells.

Tips and Tricks

Note that Figure 9.41 shows the edge unfolded. Remember that when selecting the UVs along that outer edge, the UVs could be right on top of each other. Be sure to Marquee select to select all the UVs along that outer edge.

Step 58: Scale the shells to an appropriate texture space usage so that the checker sizes match the other shells in the view panel (Figure 9.42).

FIGURE 9.42 Scaled and completed hands.

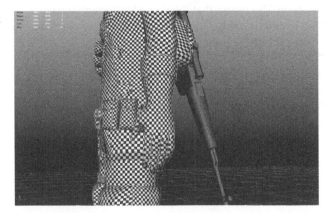

Finishing Up

Step 59: The rest of the unmapped parts, the boots and the collars, all use the same techniques used thus far. Apply what you've learned and map the rest of the form.

Step 60: Organize the shells. Make sure that there are equal-sized checkers all over the mesh. Then select all the UVs and scale them down en masse. It is important to scale them all together in order to keep the relative use of texture space consistent. This makes for an interesting puzzle—the idea here is to pack the shells in as tightly as possible without *any* overlapping UVs; but if one shell gets scaled, they all need to scale. Figure 9.43 shows my solution to the puzzle. Yours may differ.

FIGURE 9.43 UV layout.

Why?

A tightly packed set of UVs means that the texture (when applied) is efficient. A UV map that has a lot of wasted space means that the texture painted on that map will have a lot of pixels that aren't assigned to any polygons. This means that the polygons will not have as high a fidelity as they could.

In the old days, UV maps were so tightly packed that there was nary a gap between shells. In all reality this is not a bad technique although new hardware today makes large-texture maps possible and thus the absolutely most efficient map a little less critical. However, use all the space possible when laying out the map.

In Figure 9.43 there is (admittedly) a fair amount of empty space, although not too bad. For me, there is a balance of creating a map that is efficient and making a map that is usable to paint on. There is even a tool in the UV Texture Editor (Polygons>Layout) that will attempt to organize the shells into the absolutely most efficient layout. The problem with this is that it scatters shells all over the place. One part of the shirt is in one corner and another part is in an entirely different spot. This makes deciphering what is being painted pretty tough in Photoshop. By doing the layout manually, body parts can be left together, costume pieces can be left in clusters so that when it is time to paint it is easy to know what's being painted.

Tips and Tricks

Often you will see another way of working with character UVs that includes making a separate UV set for the face and head. The idea here is that the character will use two materials, one for the face (which is the most important part of most characters) and another for all the body. This often means that the face gets as much texture as the rest of the body combined.

If the game calls for close-ups of the character, this is indeed a great way to work. However, for this project, there will be no close-ups, so to keep the draw calls down there will be only one texture for the whole character, including the face.

However, to cheat just a bit, the head and face shell in Figure 9.43 is a little bigger than it should be. Since there is an easy seam between the neck and the clothes, we can make the head UV shell just a tad larger to use a bit more of the texture space without throwing off the balance of textures on the rest of the model.

Step 61: Delete all history. Keep the file clean.
Step 62: Export the UV Map. Select AC_AegisChung in Object Mode. In the UV Texture Editor select Polygons>UV Snapshot. For now set the resolution to 2048×2048 and save it as AegisChungUV. This will be the file used to paint the texture in the next tutorial. Changing the Image Format to TIFF will often yield more predictable results.

Conclusion

Now on to the fun part. The UV map is laid out, the snapshot is taken, and the file is available for painting in Photoshop. In the next tutorial we will look at a few quick techniques for using photos as our source for character texture painting.

Tutorial 9.2: Character Texture Painting

For the most part, texturing is texturing and the techniques used to texture the level are similar to those used to texture a character: lay down a base texture and layer on dirt, seams, and folds. Because of this, we will move quickly in this tutorial until we get to the area of the face.

The head is really the only skin we see on this character. There are many ways of attacking the face of a character. Many times students in class with some good painting skills are able to create really interesting textures from scratch by painting within Photoshop. Still others will print out the UV map and use more traditional media (often gouache) to paint a skin texture that they then scan and work back into the UV map within Photoshop. Often these result in very stylized textures, which can be really great for the right project.

For our project, our textures for the set design were all constructed using real photographs of real surfaces as the base. The clothes will also be done this same way, so to keep the texture style consistent the technique used here will also start with a photo reference. This technique takes a little finesse, but comes together quite quickly and is easier than the final product would lead you to believe.

Step 1: Prepare the AegisChungUV for painting. In Photoshop, open the file. In the Channels palette Alt/Command click the Alpha channel (to select it). Back in the Layers palette, copy and paste the selection to a new layer called UV Guide. Finally create a new layer and begin placing elements on that layer.

Tips and Tricks

Remember there really is no penalty to a whole lot of layers (assuming your machine has the RAM to handle it). More layers usually means more flexibility and quicker selections. Remember to group the layers and label as they are built.

Step 2: Lay down the base textures for everything but the head. All the textures shown in Figure 9.44 were retrieved from CGTextures.com. Your choices may vary.

FIGURE 9.44 Base textures for all Aegis Chung surfaces but the head.

Step 3: Save the file as a raw version (with all its layers) in the images folder and another flattened version in the sourceimages. Both files can be saved in the Photoshop format. Be sure to hide the UV Guide layer before saving the flattened version. Save the sourceimages version as AC_ AegisChung_Color.psd.

Step 4: In Maya, replace the checkerboard texture for the material AC_AegisChung_Mat with AC_AegisChung_Color.psd.

Ambient Occlusion Pass

In Unity we have used ambient occlusion to help better define corners. In Maya, this same trick can be used to help give depth to flat textures. In the next few steps, we will bake some AO and then implement that into the texture as it currently stands. The results will be a texture that highlights the geometry of the form.

Step 5: In Maya, save AegisChung (assuming that is the file that is open).

Why?

We are about to do some things to this model that we want the output of, but don't want the changes Maya will inflict on the model in the process. It will be important to be able to get back to the prebake state since all we want is the texture Maya will output.

Step 6: Create a new surface shader. Open the Hypershade. Select Create>Materials>Surface Shader. A new swatch representing this new material should appear in the Materials section.
Step 7: Create an ambient occlusion texture node. Select Create>mental ray Textures>mib_amb_occlusion. This will create a new node under the Texture tab.
Step 8: Bring both nodes into the Work Area to connect (if they aren't there already). Under the Materials tab, middle-mouse drag sufaceShader1 into the work area. Then under the Textures tab, middle-mouse drag the mib_amb_occlusion1 into the work areas as well. Ctrl-middle-mouse drag from the output of mib_amb_occlusion1 to the input of surfaceShader1 (Figure 9.45).

FIGURE 9.45 Connecting the ambient occlusion node to the color input of the surface shader.

Why?

Ctrl-middle-mouse-drag is a pretty complicated (but ever so Maya-esque) way of working. What is happening here is that the ambient occlusion is being defined as the color controller of the surface shader. This trick can

work for other materials as well and can allow for assembling of materials in the Hypershade rather than via the Attributes Editor as we have been doing in the past.

Step 9: Adjust the mib_amb_occlusion node. In the Hypershade, double-click the mib_amb_occlusion1 node. This will open its attributes in the Attribute Editor. Change the samples to 256 (the rest of the settings should be fine).

Why?

A low sample rate will render quickly but will be very grainy. In some cases this may be the desired effect, but not in this one. By turning up the sample rate, the AO will be smoother and more refined.

Step 10: Change the render settings to render with Mental Ray. Go to Window>Rendering Editors>Render Settings. Change the Render Using drop-down to mental ray. Click the Quality tab and change the Quality Presets to Production.

Why?

The ambient occlusion node we are using is a mental ray only node.

Step 11: Apply the surface shader to AegisChung. You can do this by middle-mouse-dragging the surface shader from the Hypershade onto the geometry in the view panel. Or, in the view panel, right-click-hold Aegis and select Assign Existing Material>surfaceshader1 from the hotbox menu.
Step 12: Render (Figure 9.46).

FIGURE 9.46 Render with a surface shader using AO.

Why?

He looks kind of ghostly. That's OK. The part that we are interested in is the dark parts—see how the dark parts are the crevices and corners? This is the desired effect as it will help define those edges.

Step 13: Bake the AO pass to an image file. In object mode, select Aegis. Go to Rendering>Lighting/Shading/Batch Bake(mental ray) (options). Change Objects To Bake, to Selected; Bake To, to Texture; Bake Optimization, to Single object. Check the Use Bake Set Override check box, which will activate a slew of options below that. The important ones are Color mode: Occlusion; Occlusion rays: 256; X resolution = 2048; Y resolution = 2048. Press Convert and Close (Figure 9.47).

FIGURE 9.47 Lots of settings to tweak. All provided here.

Why?

Most of the settings here should be reasonably self-explanatory. Do note that we are baking at 2048 because the texture file we are currently building from is at 2048 so this image will drop right on top of the current painting.

Step 14: Take a break. Baking this AO pass with high-quality render settings and our high number of Occlusion rays will take a while. When the process is done, the view panel will look something like Figure 9.48.

FIGURE 9.48 Results of AO baking in Maya.

Step 15: Close Maya—DO NOT SAVE.

Step 16: Open Maya and open AegisChung.mb. He should look like he did before baking.

Step 17: Open the baked AO texture in Photoshop (Figure 9.49). The results of the baking process in Maya will also yield an image. This image can be found in your project file (Incursion-Maya\renderData\ mentalray\lightmap). It will have some crazy name like bakedAO-surfaceShader1SG-AC_AegisChung. Open this image in Photoshop.

Step 18: Copy and paste this image into the AegisChung raw version of the texture. You can do this quickly by selecting all, Edit>Copy, then in the AegisChung raw texture Edit>Paste (it will automatically create a new layer).

Step 19: Make sure this layer is the topmost layer (except for the UV Guide layer).

Step 20: Change the Blend Mode to Multiply for this AO layer. Do this either in the Layers palette, or double-click the image and change the Blend Mode in the Layer Style window. The results can be seen in Figure 9.50.

Tips and Tricks

Note that a blend mode of Overlay will reveal a similar result but be a bit lighter. This is largely a matter of taste and can change based upon the project. Give both a look to decide which you like better.

Step 21: Save a new version of AC_AegisChung_Color.psd. Be sure the UV Guide layer is shut off. Remember to not save it with Layers and remember to save it in the sourceimages folder. Back in Maya, select AC_AegisChung.

FIGURE 9.49 Results of AO baking in Photoshop.

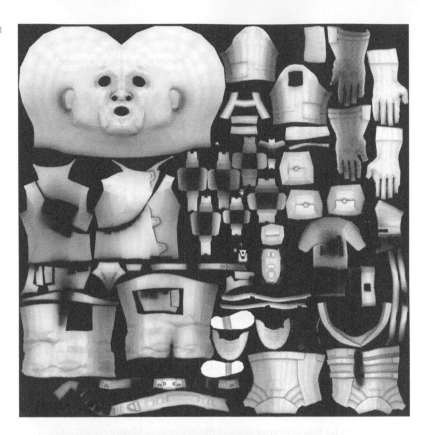

FIGURE 9.50 Results of multiply blend mode of the AO layer.

In the Attributes editor go to the AC_AegisChung_Mat tab, click the Output/
Input button in the Color channel and click the Reload button under the
Image Name input field to get Maya to take another look at the texture
(Figure 9.51).

FIGURE 9.51 Final Maya results of AO pass.

Face and Head

So why the head now? Why not do the head before the AO pass? Well, that's
a good question, and you may choose to actually use the AO pass across the
head at the end. Generally there are some seam issues that surround AO passes.
Seams are especially problematic on the head, so I prefer to paint the face at the
last and place it over the top of the AO pass. It helps to keep the seams clean.

A quick note about resources. Taking your own photos for skin textures is a great
way to work, especially if there is a readily available model since he can always be
rephotographed for needed imagery. However, this isn't always feasible.

Just as CGTextures is my favorite source for nonorganic texture resources, 3D.sk
is my favorite human resource site. Take a look at http://www.3d.sk to find a
fantastic treasure trove of photographs taken especially for artists and game
designers of all sorts of different body types and poses. 3D.sk is a great resource
for the modeling process and especially potent for the texture process.

Figure 9.52 shows a quick visual sampling of the kind of resource available on
the site. Extensive studies of all parts of the body are available for download and

FIGURE 9.52 Sampling of the types of image available at 3d.sk and the images we will be using for this tutorial.

use in your scenes. 3D.sk isn't free, it is a subscription service, but is well worth it. Even if you subscribe for a month for each character created, it is well worth it.

3D.sk has graciously agreed to allow a sampling of their images to be included on the supporting web site (http://www.Creating3dGames.com) for this book for use in the tutorial.

Step 22: Either grab the face textures package off the supporting web site, or go to 3d.sk and download a collection of images that provide a good front, side, and top image of the source texture.

Why?

Remember there is no need to find a subject that looks like your character (we are about to really change the shape of the image); but do look for skin tones and history (scars, etc.) that will help communicate who your character is and where he is from.

Step 23: In Photoshop, copy and paste the front view into the raw AegisChung texture (Figure 9.53).
Step 24: Use Liquefy for a quick pass of adjusting. Choose Filter>Liquefy. Move the pixels for the eyes, nose, and mouth (although we will give considerable attention to the mouth later), to more approximate the polygons they are to represent (Figure 9.54).

Tips and Tricks

Using the Liquefy tool is a lot of fun. The trick is to be sure to use varying sizes of brushes to avoid really noticeable smearing, and use Show Backdrop (bottom-right corner) to dial in the UV guides to make sure you are liquefying into the proper place.

FIGURE 9.53 Imported front view.

FIGURE 9.54 Liquefy to get rough pass of appropriate pixel placement.

Step 25: Copy and paste a side view into the raw texture (Figure 9.55).
Step 26: Apply a layer mask and using a soft-edged brush paint out the seam (Figure 9.56).
Step 27: Repeat for the other side of the face (Figure 9.57).

Tips and Tricks

Notice that at this point there are no ears or beard and the mouth is clearly problematic. No worries. We'll get back to that, and at this point it is preferable to not worry about those parts.

Step 28: Check progress in Maya. Again, hide the UV Guide and save a flattened version to the sourceimages folder. Reload in Maya and see how it's going (Figure 9.58).
Step 29: Back in Photoshop paste in details like the ears. Again, make sure to use layer masks (nondestructive) to mask out parts not needed (Figure 9.59).
Step 30: Finish up. The process is the same. Copy and paste source information in; be sure to carefully use layer mask to make it impossible to see where one patchwork of imagery begins and the next one ends (Figures 9.60 and 9.61).

FIGURE 9.55 Pasting in a side view.

FIGURE 9.56 Using layer masks to remove the seam.

FIGURE 9.57 First pass.

FIGURE 9.58 Checking progress. Not bad, but tweaks need to be made and attributes need to be added.

FIGURE 9.59 Added ears.

Conclusion

There is Aegis Chung textured. OK, so the guns still need to be textured (consider that homework), but the shapes of the weapons are fairly simple (cylinders and long planes or cubes), meaning that the UV mapping and texturing should go quickly.

Aegis suddenly has life. A bit of texture makes a huge difference in how a character breathes. In this chapter we looked at the sometimes complicated process of UV mapping for organic forms, and then the photo-based process of painting textures.

If he looks alive now, wait until the next chapter. In the chapter after this we will look at a quick sample rig for Aegis so that he can move. Then he will be imported into the scene within Unity and the basic visual building blocks of a scene (character and set) will be complete and we can start building the scripting and interactivity.

FIGURE 9.60 Finished texture.

FIGURE 9.61 Applied texture.

Asset Creation: Maya Rigging and Skinning and Unity Animated Character Importing and Implementation

Character creation is fun. Hard, but fun. Undoubtedly in the previous chapters you've seen how exciting (but challenging) it is to see a character come together and come alive with appropriate UV mapping and carefully constructed textures. Of course, up to now, all we have is a nicely painted mannequin that, though interesting to look at, is still, well…dead.

In this chapter this will change. It's time to get this character ready to come alive. The process of bringing a textured character to life is fun but can be a little bit tricky. However, with a bit of care, there is nothing quite like a lifelike character moving in a scene to help immerse a player into the game.

The Process

The process of getting a lifelike character into a game goes like this:

1. Clean up completed textured models.
2. Create a **rig**. A rig is a collection of **joints** that can deform the polygons of a model. This rig can vary greatly in its complexity and flexibility and will depend on how much animation is actually needed for a given character.
3. **Skin** the rig to the model. Skinning is the process of attaching the rig of joints to the polygons they will affect. Maya 2011 has some new skinning tools that help make this process faster.
4. Animate the rig. Animating the rig means rotating (mostly) and moving the joints and setting keyframes to record that motion over time. As the joints rotate or move, the polygons attached to them will move and viola! the character looks alive.
5. Bake the animation. Baking an animation is the process of simplifying animation of joints down to the simplest translation or rotation keyframes. This means that more-complex (but powerful) tools like IK (inverse kinematics) are baked out of the animated output; thus the baked version isn't particularly editable, but the results in Unity are much more predictable.
6. Export the baked animated character (as an .fbx).
7. Import the .fbx into Unity.
8. Divide the animations.
9. Call them up either via Play Automatically or via script.

I know. That looks like a lot at first blush; but it's actually very manageable in these sorts of short discreet steps. In this chapter we will be going through a simplified version of this entire process. The rig will be fairly simple but will allow us to create some animation quickly.

Since the game is a first-person shooter, we won't see the character very much. This would be very different for a third-person situation. However, knowing how to work with characters is an important part of Unity's game-creation capabilities, so we will make a small mini-level that shows what "you" (Aegis Chung) look like before he, er…you, undertake your mission.

Tutorial 10.1: Rigging

Cleanup

In the process of creating and texturing the character, there undoubtedly was quite a bit of Maya construction history that was built up. Each projection and every tweak generated a new node, which can be very helpful to be able to access while working, but at the end of the process represent a huge amount of extra data that we no longer need. Of further concern with these nodes is that the .fbx export doesn't always do well with the nodes and some strange output files can be the result.

Cleaning a file frequently is always a good idea. However, before rigging and skinning it is especially important to provide Maya with a simple mesh that is just polygons and texture without any of the heavy overhead that the extra nodes bring with them.

Remember that the point of all these Maya exercises is to get the assets into Unity. We have already seen some of the strange things that happen with scaling. Scaling a rigged character is certainly possible, but things go much easier if the meshes are scaled and positioned correctly within Maya's space before rigging and skinning. It keeps the Maya-centric process cleaner, and makes for more reliable translation from Maya to Unity.

Step 1: Open the latest version of Aegis Chung in Maya.
Step 2: Delete all history. Edit>Delete All by Type> History.
Step 3: Name the body mesh `AC_AegisChung`. Name the weapons `AC_Rifle`, `AC_Pistol`, `AC_Knife`, respectively. Name the eyes `AC_LeftEye` and `AC_RightEye`.

Why?
AC (of course) stands for Aegis Chung. Giving objects names that help to group them together has all sorts of benefits further down the road in Unity including the ability to quickly search for all assets dealing with the character by searching for AC within Unity.

Step 4: Select all the meshes and press Ctrl-G (Command-G on a Mac) to group them together.

Why?
We need to resize Aegis before moving on. By resizing the group, all the parts will remain correctly scaled in relationship to each other since they will all scale around the group's center. This is different than selecting all the objects and scaling; this will scale them according to each object's center, and all the meshes will separate from each other.

Step 5: Create a new cylinder to use as size reference. Create>Polygon Primitives>Cylinder. Select the Cylinder, and then in the Channels Box, click polyCylinder1 in the INPUTS section. Change the Radius to 0.25 and the Height to 2 (Figure 10.1). Move the cylinder up so that it's sitting on the "ground" or Y = 0 plane.

Why?
Back when we were modeling the scene, we discussed briefly that one unit in Maya roughly equaled one unit in Unity. In Unity, we know that the First Person Controller is 2 units tall (about 2 meters). If we can get Aegis scaled correctly in Maya it will save a lot of tweaking time when he's brought into Unity.

FIGURE 10.1 Reference cylinder created.

Step 6: Scale the Aegis **group** to visually match the cylinder. Be sure to select the group (probably best done in the Outliner). Use the Scale tool to scale the group down. Note that scaling him will undoubtedly also force the need to move him (Figure 10.2). Be sure he is moved so his feet sit on the "floor" or the grid at Y = 0. Also make sure to center him so the center of his body is at Z = 0, so that when joints are placed from the front view, they will be in the center of his body.

FIGURE 10.2 Correctly scaled Aegis.

Step 7: Ungroup and delete unused objects. Do this in the Outliner by expanding the group that contains Aegis and all his gear (and eyes). Select all the meshes and either middle-drag them out of the group or press Shift-P (as in capital P) to unparent them from the group. Delete the group and the cylinder.

Step 8: Clean transformations. Select AC_AegisChung, AC_LeftEye, and AC_RightEye, and select Modify>Freeze Transformations.

Why?

With all that scaling and moving, the values in the Channels Box are likely a mess. Before we get going on any rigging, having all this cleaned up will make for a cleaner data set. Freezing transformations resets the Translate and Rotate values to 0 and the Scale values to 1.

Step 9: Clean transformations for weapons. Select AC_Pistol, AC_Rifle, and AC_Knife. Choose Modify>Freeze Transformations (Options). In the Freeze Transformations Options window, turn off the Rotate and press Freeze Transform.

Why?

In modeling and placing the guns, you undoubtedly rotated them into their place on Aegis. If we freeze the transformation on the rotation for the weapons, their rotation values will return to 0,0,0. This makes getting the weapons back to point straight ahead very difficult to do. By not resetting their rotation values we know that a rotation of 0 (in X, Y, and/or Z) will likely return the weapon to an upright or flat position. It's also important that this relative rotation is maintained since it means the rotation handles would be aligned with the gun. So, we don't want to freeze the rotation transformation, but all the rest of the transform information (Translate and Scale) we do.

Step 10: Save a copy of this file for future use. Choose File>Save As... and save the file as AegisChung-Separate.mb.

Why?

This version of Aegis has the guns, knife, and eyeballs separate. In other versions of this game, having these parts separate could be important. For instance, if you were building a third-person game where we could see the character throughout the game we would need Aegis to be able to take his guns out of their various holsters and use them. In our version of the game the player will only see Aegis' arms and the transition from guns will happen off camera. This means that later we will want a version of Aegis that essentially is just arms with a much simpler rig setup. However, having an intact but clean version of the model is an important place to be able to go back to for stripped down assets or if the requirements of the game change.

Step 11: Combine all the meshes together. Do this by selecting everything (both eyes, all the weapons, and Aegis himself) and choose Polygons>Mesh>Combine.

Step 12: Delete all history (Edit>Delete All by Type>History). You should be left with one single polymesh in the Outliner.

Step 13: Name the mesh AC_AegisChung_SM (in the Outliner). Save the file as AegisChung-SingleMesh (File>Save As...).

Why?

Making Aegis a single mesh in this situation has several benefits. First, the plan is to have Aegis simply in an idle animation as an introductory level for the game. The animation will be simple and he won't be holding any of his weapons. By reducing Aegis from six meshes to one we are reducing the number of draw calls required to draw him in this animation because Unity only has to draw one object (although this object has several materials on it) instead of six. Further, joint deformation within Unity is a fairly expensive process. Every mesh that needs to be deformed costs processor cycles. So while we could skin all six objects to the same single joint structure, we will further optimize playback by having only one object deformed by that joint structure. Plus, the actual skinning process will be easier working with this single mesh.

Finally, saving as a different file name keeps the old version where Aegis is separated into his component parts.

Joints and Rigging

Generally, students intuitively think of placing *bones* in a character, and then the idea is moving the bones moves the character; in this paradigm, joints are just where the bones happen to meet. **Joints** are a little bit different way to think of moving a character. Maya makes the joints the important part and the bones simply visually connect these joints.

At its core, a joint is a **deformation object**, which means it can be used to deform another object, or more importantly, *parts* (including polygons) of another object. The work flow is reasonably intuitive: first, these joints are created and placed within the polygon mesh. Then, after these joints are bound to the mesh, when they rotate, the polygons that are skinned to those joints rotate with it.

There are a few things to remember about working with Maya's joints that will make working with them smoother. First, every bone has a joint at its start and end. This means that there will be joints at places that may seem a bit strange, like the tips of the fingers and top of the head. Second, when placing joints, as long as you are still in the Joint tool, each joint will automatically orient to point to the next-placed joint. This is good in some cases but problematic in others. Third, we want to make sure we're working smarter, not harder. This means we will only be creating one half of the skeleton and then have Maya figure out the other half. But to make this happen smoothly, we need to place joints in specific view panels; some will need to be placed in the side-view panel, others specifically in the front. Although joints can be moved and reoriented, if we simply place them in the right-view panel, some things (like being placed on the mirror plane) will automatically happen.

Step 14: Switch to a four-view setup. Do this by either pressing the space bar quickly (Figure 10.3) or, if you have other nested windows, by choosing the four-panel preset from the view panel presets beneath the Toolbox (on the left side of the interface).

FIGURE 10.3 Setting up the interface for effective joint placement.

Step 15: In the top-side- and front-view panels activate X-Ray (Shading>-X-Ray). Be sure to be viewing as either Smooth Shade (press 5 on the keyboard) or Smooth Shade with Textures (press 6 on the keyboard).

Root Joint

Step 16: Place the Root joint. Activate the Joint tool (Animation> Skeleton>Joint Tool), and in the side-view panel click once about halfway between the navel and bottom of the crotch. A really big joint (Figure 10.4) will appear. Press Enter to exit the tool.

FIGURE 10.4 Initial placement of Root joint. Yep, way too big.

Why?

Several why's here. First, the Root joint is going to be the one joint to rule them all. This joint is going to be the parent-most joint of all the joints in the skeleton. It will be important that it is sitting in the middle of Aegis because this will be the mirror point. By placing the joint from the side-view panel, we know that the X Position value of the joint is 0.

Second, we exited the tool right after placing the joint. Part of the reason for this is that we need to change the size of the joints, but also, it's important

that this Root joint is rotated at 0,0,0 (when animating, it's much easier to make sure the character is standing straight up if we can just zero out the rotation values of the joint in the Channels box). If we were to have clicked again with the Joint tool, another joint would have been created that is the child of the Root, and the Root would have turned to point at this new joint.

Step 17: Resize the size of the joints. Go to Windows>Settings/ Preferences>Preferences. Look or the Display section and select the Kinematics section beneath that. Change the Joint Size setting to 0.1. The one joint in the view panel should downsize. Click Save (Figure 10.5). **Step 18:** In the Outliner, rename joint1 to AC_Root.

FIGURE 10.5 Adjusting the size of drawn joints.

Why?
Naming matters. Taking the time to name joints not only saves time when it finally comes time to mirror the skeleton, but becomes vital when it comes time to animate.

Leg Joints

Step 19: Create the leg joints. Activate the Joint tool again and in the side-view panel create five joints to represent the hip, knee, ankle, ball, and toe joints. If you haven't used the Joint tool to create joint chains before, just click where a joint should be placed and then click where the next joint is to be placed. Maya will connect the joints with a bone and automatically make each joint a child of the joint preceding it (Figure 10.6). Be sure to press Enter when the toe joint is placed to exit the tool.

Tips and Tricks
After joints have been placed and the Joint tool has been exited, the joints can still be moved and adjusted with the Move tool. However, at this point, do not rotate the joints, just move them. When joints are placed and they orient to the next joint, their rotation values remain at 0,0,0, which is very handy later when we animate (we can get the character back to a neutral pose quickly); but if the joints are rotated in placement, this gets messed up.

Step 20: In the Outliner rename these joints AC_L_Hip, AC_L_Knee, AC_L_Ankle, AC_L_Ball, AC_L_Toe.

FIGURE 10.6 Placing the joints for the leg. This represents hip, knee, ankle, ball, and toe.

Tips and Tricks

Make sure to get that "L" in there and make sure it is capitalized. Later when we mirror one half of the skeleton, if we have carefully named things, the mirrored side will be appropriately renamed for us.

Step 21: In the front-view panel, move the leg chain of joints so they are in the leg (Figure 10.7). To do this you only need to move AC_L_Hip and

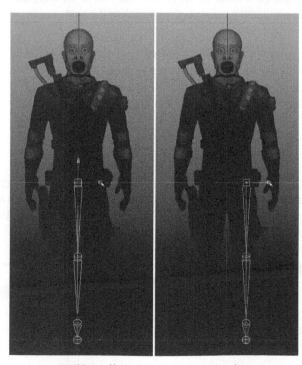

FIGURE 10.7 Moving leg joints into appropriate place.

Warnings and Pitfalls

Be very sure that the joints are not built in a straight line (as in the knee joint directly beneath the hip joint). We are going to animate the character's legs using something called IK (Inverse Kinematics) and the calculations are made much easier if the joints that are to be bent already have a bend to them (so Maya knows which direction to bend them).

Also note that the hip, knee, and ankle joints are in the middle of the leg (where these joints really exist in a person's anatomy), but the ball and toe joints are on the ground, which represents the axis that the polygons assigned to these joints should rotate around.

the children joints will go with it. Be sure to only move using the X handle (red cone) to maintain the positioning in Y and Z.

Why?

By building the leg joints in the side view, we were sure that they were straight up and down when looking at the character from the front (this also makes the future IK calculations cleaner). However, creating the joints from the side also ensured that the joints were along the X-axis. Moving them over is a pretty quick and painless process though.

Leg IK Chain

Kinematics refers to the movement of objects or groups of objects. In animation terms there are two types of kinematics that are used. The first is **forward kinematics** (FK), which is the process of animating a chain of joints by rotating a parent joint, then rotating the next joint down the hierarchy, then the next, and so on. The benefit of FK animation is that it moves body parts in nice arches (which is how real anatomy tends to move). However, it can sure be a slow process having to rotate each joint separately. Still, for the upper body, FK (because of its nice arches) is a great way to animate.

The second method is **inverse kinematics** (IK). IK works by moving a child joint (note, moving as in translating, not rotating) and the joints above it rotating to accommodate that movement. Using IK, you could move the foot and the hip and knee would rotate to allow the foot to get there (as opposed to manually rotating the hip, then the knee, then the ankle to get the pose desired). This can speed up the animation process considerably.

Of further power to the IK system is the ability to have **sticky IK**. Sticky IK actually has a fairly intuitive, although goofy, name. What it does is allows for the end of an IK chain to stick to a location. So when a foot at the end of an IK chain is set on the ground, it doesn't move even if joints above it do. This means that moving the hips up and down will automatically bend the knees, and that a character can walk with feet that plant on the ground without sliding.

For Aegis, we will set up IK for the legs.

Step 22: Create the leg IK chain. Select Animation>Skeleton>IK Handle Tool. In the side-view panel click first on the hip joint (AC_L_Hip) and then a second time on the ankle joint (AC_L_Ankle). The results should show a line between the hip and ankle and a very large IK handle at the ankle (Figure 10.8). Note that there is also a new object in the Outliner called ikHandle1.

Why?

Why just to the ankle? Why not to the toe? IK chains can be powerful, but can be tough to control if there are too many joints along the chain. Maya can have a hard time deciding how much to bend the joints along the chain to solve for the IK or get to the location of the IK handle. By going

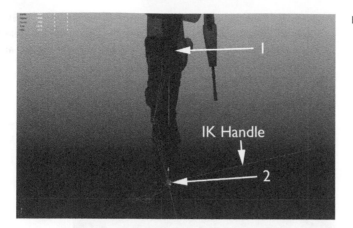

FIGURE 10.8 Creating a leg IK chain.

from the hip to ankle we are working with a simple three-joint chain that Maya can easily solve for. Try testing it by using the Move tool to select the IK handle and move it around. The knee and hip will rotate to allow for the motion to happen. Notice that the problem here is that the foot is also rotating, which isn't a problem when the foot is just being picked up, but will be a problem when we need control over how that ankle bends (like walking). We'll take care of the foot rotation via another IK chain in the coming steps. Be sure to undo any moves you make in this test so the leg gets back into position.

Step 23: In the Outliner, rename ikHandle1 to `AC_L_AnkleIK`.

Step 24: Create a second IK chain from the ankle to the ball. Again, select the IK Handle tool and in the side-view panel click once on the ankle joint (AC_L_Ankle) and a second time on the ball (AC_L_Ball). The results should look something like Figure 10.9.

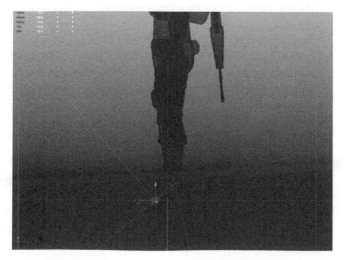

FIGURE 10.9 Creating the second foot-controlling IK chain.

Step 25: In the Outliner, rename the new IK handle to `AC_L_BallIK`.
Step 26: Create one more IK chain from the ball to the toe. Select IK Handle Tool and in the side-view panel, click once on the ball and a second time on the toe (Figure 10.10).

FIGURE 10.10 Last IK chain from ball to toe.

Why?

There are a lot of philosophies on foot rigs. This rig is one of the most basic but provides a great deal of direct control. There is still some organizing to do, but when all is done, the feet will have some great flexibility in movement that will allow for foot and even toe movement.

Step 27: Rename the ikHandle to `AC_L_ToeIK`.
Step 28: Resize IK Handles. Go to Windows>Settings/Preferences>Preferences. Again, look for the Display section and choose the Kinematics section from the menu on the left. Change the IK Handle Size setting to 0.1. The IK handles will size down to something more manageable in the view panels.
Step 29: Turn on Stickiness for all three IK handles. To do this select one of the handles in the Outliner. Press Ctrl-A to bring up the Attribute Editor and look for the IK Handle Attributes area. Expand this and change the Stickiness setting to sticky. Be sure to do this for all three handles.

Mirroring the Legs

After the IK handles have been created and named, the leg is done (except for the handles we will create to control it). That makes this a great time to mirror the joint chain and automatically create the other leg.

Step 30: Make AC_L_Hip a child of AC_Root. Do this in the Outliner by middle-mouse-dragging AC_L_Hip onto AC_Root. After expanding the chain, it should look like Figure 10.11.

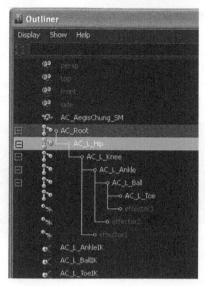

FIGURE 10.11 Appropriate hierarchy to this point.

Why?

Notice that once this happens in the Outliner, a new bone becomes visible in the view panel connecting the Root to the Hip. This connection is important and when we mirror we want this connection (that shows which joints are children of which) on the other side as well. So setting up this connection now is important.

Step 31: Mirror the leg. Select the AC_L_Hip (easiest to do in the Outliner). Choose Animation>Skeleton>Mirror Joint (Options). In Mirror Across check the YZ radio button and then in the Search for: enter L_ and Replace with: enter R_. Press Mirror (Figure 10.12).

FIGURE 10.12 Mirror Joint settings.

Why?

"Mirror across" is asking which plane to use as the mirror plane. If the character is facing forward (looking toward positive Z), YZ is the appropriate plane. The Replacement Names For Duplicated Joints just goes through all the joints and looks for L_ and replaces it with R_. This means that the left versions (designated by L_) are all renamed to right versions (called R_); this includes the associated IK handles. Cool, no?

Creating a Handle for IK

Step 32: Create a NURBS circle (Create>NURBS Primitives>Circle). If Interactive Creation is turned on, draw the circle on the ground near the foot (Figure 10.13). The absolute size is unimportant.

Step 33: Center circle on ball. Choose the Move tool and snap the circle to the ball joint by holding down the V key as you move it (Figure 10.14).

FIGURE 10.13 Creating the beginning of a handle (note the right leg joints are hidden here for clarity's sake).

FIGURE 10.14 Centering circle on the ball joint.

Tips and Tricks

As the screenshot shows, doing this in Wireframe (press 4 on the keyboard) makes it easier to know that it is indeed the ball that the circle is being snapped to.

Step 34: Adjust the shape of the circle. Right-click and hold on the circle and choose Control Vertex from the hotbox selector. Use the Move tool (but only along the X- and Z-axes) to adjust the shape of the circle to be more indicative of a foot (Figure 10.15).

FIGURE 10.15 Reshaping circle for a good handle.

Tips and Tricks

Remember that when in the Move tool, Ctrl-clicking a directional handle (like the Y (green cone)) will deactivate the ability to move an object/component in that direction. You may wish to do this to the Y-axis handle because it is important that all these vertices remain on the "floor." All the handles can be reactivated by Ctrl-clicking on the center yellow box.

Step 35: Swap back to Object Mode by right-click-hold on the circle and choosing Object Mode.

Step 36: Rename the circle to AC_L_Foot in the Outliner.

Step 37: Freeze AC_L_Foot's transformations. Still with AC_L_Foot selected, choose Modify>Freeze Transformations (Options). Make sure Translate, Rotate, and Scale are all checked and press Freeze Transform.

Why?

If the circles transform values for Translate and Rotate are at 0,0,0 you can always return the circle to this exact spot by zeroing out the values in the Channels Box. Freezing the transformations gives you clean values.

Step 38: Duplicate AC_L_Foot and rename to AC_R_Foot. Remember Ctrl-D will duplicate an object.

Step 39: Snap AC_R_Foot to the right ball joint. Remember holding down V will snap to joints (and vertices by the way). Figure 10.16 shows the current state of things.

FIGURE 10.16 Duplicated and moved foot handle.

Step 40: Mirror the AC_R_Foot handle in the Channel box. Change the Scale X setting to –1.

Why?

As an object is scaled down (or in this case as it is scaled in X (getting thinner and thinner), its scale value gets closer and closer to zero. If the object continues to scale down beyond zero, it begins growing out the opposite direction. Thus, a Scale X of –1 is the mirrored version of a Scale X of 1.

Step 41: Freeze the transformations for AC_R_Foot (Modify>Freeze Transformations).

Step 42: Make the IK handles children of their respective handles. This means in the Outliner, select AC_L_AnkleIK, AC_L_BallIK, and AC_L_ToeIK and middle-mouse drag them onto AC_L_Foot (which will make the IK handles children of the AC_L_Foot). Do the same for their right-side counterparts.

Step 43: Test the rig. Select the AC_L_Foot curve and use the Move tool to move it. The leg rig should bend up in natural ways. By rotating AC_L_Foot, you can rotate the foot around the ball (Figure 10.17). Then, the beauty of it all—enter 0 in the Channel box for the Translate X,Y,Z and Rotate X,Y,Z and watch the leg get back into place.

Warnings and Pitfalls
However, although the handle looks fine in the view panel, check out the transformation values in the Channels box. In mine Translate X is –0.025 and Scale X is –1. We really need to get this transform information clean again so we can easily get back to this position.

FIGURE 10.17 Testing the leg rig. Moving and rotating the modified circle allows the entire leg and foot to be modified.

Tips and Tricks

When working with this rig, further refinement can be done by moving the IK handles within the handle. For instance, moving the toe IK handles will raise the toe. Now, although this provides some quick-and-dirty access to foot movement, it is clumsy and crude. This version is saved in the files included on the web site (http://www.Creating3dGames.com) for this book as AegisChung-SingleMesh-SimpleFoot, but for an alternative foot rig (that's beyond the scope of this book), check out the AegisChung-SingleMesh also included in the sample files.

Spine

The next chunk of joints will be up the spine, neck, and head. In reality, our spines are actually 24 articulating vertebrae (and another 9 fused vertebrae in the sacrum and coccyx). However, we won't be putting nearly that many joints in Aegis.

There are two reasons for this. First, controlling that many joints without a complex back rig is unwieldy and would make animation much too painful. But, in games, the most important reason is we are attempting to keep our data set manageable. A mesh that is being deformed by hundreds of joints will be a slow real-time calculation and thus slow the game down. Keeping the number of joints low keeps the mesh deformation calculations light and the game snappy. Picking the number of joints is another of the choices in that never-ending challenge of game design in which the designers and artists must find the balance between quality and performance.

> **Step 44:** Activate the Joint tool (Animation>Skeleton>Joint Tool) and in the side-view panel, create a string of six joints to match Figure 10.18. Name them as indicated in the screenshot.

FIGURE 10.18 Creating the spine collection of joints.

Tips and Tricks
Remember when finished placing joints, press Enter to exit the Joint tool.

Why?
Notice that there are very few joints in the back. We really have one at the base of the back and one at the small of the back but none through the rib cage area. Although in real life there is definitely bending through ranges like the rib cage, it's unlikely we would notice such a thing in a game situation. However, do notice that the joints get pretty dense up near the neck area; be sure you have a joint at the base of the neck and the base of the head.

Be really sure that the joint at the base of the head is where the spine connects to the base of the cranium. If this is in the wrong place, the head will deform in very strange ways when animated. Also note that there is a joint at the top of the head; this simply gives the head base joint a location to point to.

Step 45: Make the AC_Back_Base a child of AC_Root. Do this in the Outliner by middle-mouse-dragging the back base on to the root.

Why?
Eventually all the joints will need to be in one skeleton. With this step, we again have all the joints as part of a skeleton lead by AC_Root.

Arms
The arms and hands can be a bit tricky. This is largely because the joints need to be placed and adjusted in more than one view panel at a time. No matter which view panel the joints are initially placed in, they will need to be adjusted in another. In the short term this creates some problems because once the joints are moved around (after placement), the orientation of the joint above them no longer matches. No big deal though; we will look at ways to get all this sorted out in the coming steps.

Step 46: Activate the Joint tool and in the front-view panel, click the AC_Clavicle_Base joint to tell Maya to build new joints off of this joint. Then create four new joints to represent the clavicle, shoulder, elbow, and wrist (Figure 10.19). Name them (in the Outliner) as indicated in Figure 10.19.
Step 47: In the side-view panel, use the Move tool to adjust the location of the joints to match Figure 10.20.

Warnings and Pitfalls
Remember to make the adjustments with the Move tool. Don't rotate them at this point.

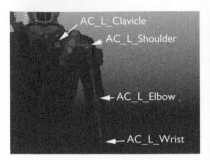

FIGURE 10.19 Creating the start of the arms.

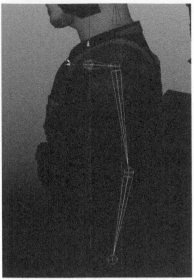

FIGURE 10.20 Adjusting the position of joints in the side view to more accurately match real anatomy.

Step 48: Create and position a string of joints to control the middle, ring, and pinky fingers. Do this in either the front- or side-view panels with the Joint tool. Be sure to grow this new chain off of the extant AC_L_Wrist joint (with the Joint tool activated, first click the wrist joint (it will highlight green) and then start clicking to create new joints). The final results should look like Figure 10.21 (which is a perspective view for illustration purposes).

FIGURE 10.21 Newly created finger joints.

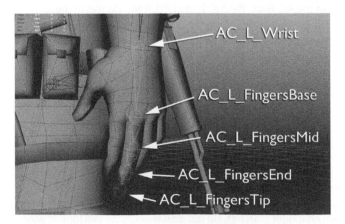

Tips and Tricks
Figure 10.21 is the perspective view with a few options turned on. It uses Shading>Wireframe on Shaded and Shading>X-Ray Joints. This shows the wireframe of all the meshes, which can help indicate where the joints of the mesh actually are, and always draws the joints on top of everything else. Note that Figure 10.21 is in the persp view panel with X-Ray turned off.

Why?

Fingers? Why fingers and not an individual finger? A lot of this depends on the needs of a game and a model. In our game the character will generally be holding a weapon or perhaps pressing a button. This means that the index finger and thumb would need to be separately articulated, but the middle, ring, and pinky fingers would not—they would generally function as a unit. This might be different for different games; the hand would be rigged in a different way if all the fingers needed to articulate separately. But to add joints to the ring and pinky fingers would be another eight joints (per hand) or 16 added joints for the model; considering that the entire rig now is 25 joints, rigging those extra fingers is a significant cost.

Step 49: Create a string of joints for the pointer finger as shown in Figure 10.22. Build this chain off the wrist (from either side- or front-view panels) and remember to tweak their positions in front-side- and perspective-view panels to get their positioning right.

Step 50: Create a string of joints for the thumb as shown in Figure 10.23. Again, build off the wrist in front- or side-view panels, and go back and adjust later with just the Move tool.

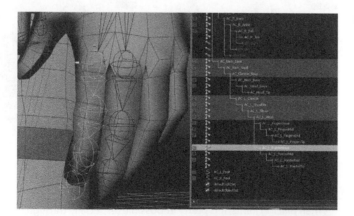

FIGURE 10.22 Pointer finger joints.

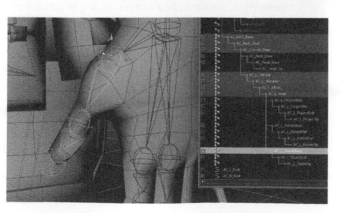

FIGURE 10.23 Building the thumb.

Tips and Tricks

OK, this is actually a disclaimer. There are a lot of joints in this hand that in nongame situations would definitely be needed. If you're screaming that there are no metacarpal joints, you're right. In most higher-rez situations these are a vital part of good hand rigging. To make matters worse, we are leaving out joints in the thumb that are critical for hand close-ups. But, for game situations on hardware today we want to strip down rigs to the joints we need. Five years from now, even on mobile devices we might throw joints in with reckless abandon. Today though, the compromises are necessary.

Step 51: Orient upper body joints. Select AC_Back_Base (probably easiest in the Outliner). Then choose Animation>Skeleton>Orient Joint. The results can sometimes be a little tough to see, but see the before and after shown in Figure 10.24.

FIGURE 10.24 Before and after Orient Joint. Notice how the joints (once oriented) point downward toward the next joint in the chain.

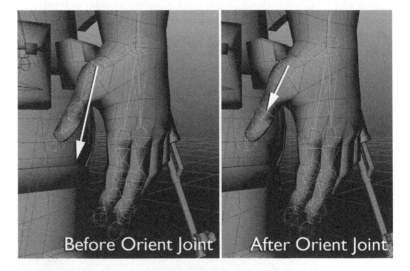

Before Orient Joint After Orient Joint

Why?

When placing joints, it is pretty impossible (especially through the hands) to get them in just the right place without having to go back and move them. The problem is that the orientation of the parent joint (to whichever joint is created) is defined on the first click of placement. So when the joints are later moved into their correct locations, the parent joints no longer are pointing toward the next joint, which makes for awkward animation later. The Orient Joint command (which by default orients all the children of the selected joint) tells all the joints to take a look at the next joint in their chain and point to that chain (although this isn't perfect; see the following steps). Importantly this only affects the joint's orientation, not its rotation (as can be seen in the Channels box). This means that later, zeroing out the rotation values of the joints will return them to this neutral pose.

Step 52: Examine the newly oriented joints and manually adjust any that are needed. Swap to the Rotate tool and examine the joints in the upper body. Try rotating them and seeing if the axis of the rotation handle makes sense for that joint (be sure to undo the rotation each time). For instance, the elbow will really bend only in one direction. Does rotating that joint require rotation along only one axis? If not, it should be adjusted. Figure 10.26 shows the adjustment of my wrist joint (yours may or may not require such an adjustment). To adjust the orientation first we need to be selecting by component type and be able to select what Maya deems "miscellaneous components." The easiest way to do this is in the top shelf (Figure 10.25—take careful note of the highlighted pressed buttons). Then when a joint is clicked it will show a few floating x, y, and z letters. Activate the Rotate tool and click any of these letters to get handles to adjust the orientation. Use the Rotation tool to rotate the orientation of the joint (Figure 10.26).

FIGURE 10.25 Setting up the ability to select and modify the joint orientation.

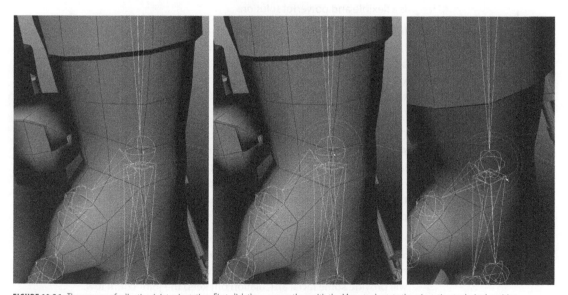

FIGURE 10.26 The process of adjusting joint orientation. First click the x, y, or z, then with the Move tool rotate the orientation to desired position.

Why?

This can be a tedious process. Hopefully, the Orient Joint function lines things up pretty well for you and there is very little manual adjustment that needs to take place. Much of it depends on how carefully the joints are organized as they are placed, but if a series of joints are even just a little out of line, Maya will tend to twist joints to try and orient toward the next, thus they need to be readjusted manually.

Still, remember that the idea here is that this yields dividends by having joints that are oriented in ways that make the animation cleaner with fewer axes needing to be rotated for any movement. Further, this makes it so the joints can be returned to this neutral position by entering 0 in the Rotate X, Y, and Z input fields of the Channel box.

Step 53: Swap to Object Mode and mirror from the clavicle down. Select AC_L_Clavicle and choose Animation>Skeleton>Mirror Joint.

Tips and Tricks

The settings from last time this was done should still be there (the mirror axis along YZ and the instructions to replace L_ with R_), although if the results are not as anticipated, undo and check the Mirror Joint options.

Facial Rig

Unfortunately, out of the box, Unity does not support blendshapes (often the preferred method of rigging the face for animation). However, if you're familiar with Maya, you know that there are several camps when it comes to facial rigs; one fairly persuasive group argues that rigging the face with joints is a flexible and powerful solution.

In Unity, this is the only solution; however, an extensive facial rig can become both a performance and time killer. If you're playing a first-person shooter and are spending a lot of time examining facial expressions, there's something wrong with the game. If you're playing a third-person game, the majority of the time is spent looking at the character's back, so again, an extensive facial rig is not called for.

Of course, in cinematic-cut scenes a good facial rig can really be valuable. And in fact, great strides are being made in facial animation in games as of late (take a look at the work coming out of Rockstar Games' L. A. Noire, for example). However, in this case, our budget doesn't allow for good voice talent (and animators and programmers hardly ever provide acceptable performances) so there is no need for a very complex facial rig.

However, a bit of facial movement, especially in the jaw and eyes can help a character have a bit of life so they don't feel quite so much like a walking mannequin. So in the coming steps we will create a very simple face rig that will provide some facial articulation but keep the joint count low.

Step 54: Create a two-joint chain for the jaw. Do this from the side view and build the chain from the AC_Head_Base joint. Create the first joint just in front of the ear (the hinge of the mandible) and put the second down at the end of the chin (Figure 10.27). Be sure to press Enter after creating the joint at the chin to exit the tool.

Step 55: Create an eye joint. Do not grow this joint out of any extant joints (we want it to be facing straight forward), but in the side-view panel activate the Joint tool again and create one joint (click and then press Enter) in the center of the eye. In the front-view panel, adjust its location to be in the center of the eye (Figure 10.28). Rename the joint AC_L_Eye.

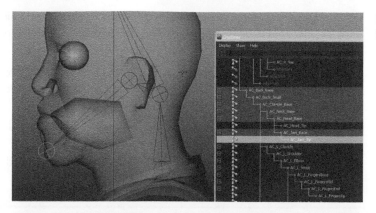

FIGURE 10.27 Creating and naming the jaw joints.

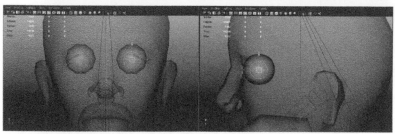

FIGURE 10.28 Creating the eye joint.

Step 56: Make AC_L_Eye a child of AC_Head_Base.

Step 57: Mirror Joint for AC_L_Eye.

Preparing the Rig for Animation

Technically speaking, the rig could now be animated (although only the joints would move, not the character). For the legs, the animation would occur via the IK chain controlled with the handle we created. For the upper body, the joints would be selected and rotated. The problem is that most of these joints are inside the mesh, making them difficult to actually grab. Maya has developed some tools to help in this. Maya allows joints to be drawn in other ways than the default three intersecting circles.

In the following steps we will change the appearance of many of the joints to make them easier to see and access. This will make animating faster and more fun.

To further optimize the animation process we are going to restrict the kinds of attributes that can be animated. Animation on a computer is really the process of setting key poses at various times (called keyframes) that the computer interpolates between; in essence Maya or Unity figures out the frames between the poses the animator defines. Moving joints and then setting keyframes and then adjusting those keyframes is what animating is. Adjusting keyframes is a pretty critical part of the process and so having a small data set that is easier to manage becomes critical.

Right now, all the joints we have created can be moved, scaled, and rotated. In reality, in realistic animation like this game calls for, the joints should really only rotate. By telling joints that their translate and scale attributes are locked,

we can avoid mistakes that would cause body parts to stretch unnaturally, and allow for keyframes to be set by simply pressing S on the keyboard (more on this later).

Step 58: Change AC_Root to draw as a circle. To do this select AC_Root and open the Attributes Editor (Ctrl-A if it is not open). Look to the Joint section and expand it. Change the Draw Style from Bone to Circle.

Why?
Move the mouse to the persp view panel and press 4 on the keyboard to go to Wireframe mode. The circle is probably too small. But we can change that.

Step 59: Resize the circle representing the joint. Still with AC_Root selected and still in the Joint section of the Attribute Editor, change the Radius value to 1.3. Figure 10.29 shows what the wireframe should look like.

FIGURE 10.29 Resized Radius of a joint with a Circle draw style.

Why?
The absolute size of the radius is subjective. The goal is to make the circle a bit wider than the pouches on his belt so that it is easy to see and grab. However it shouldn't be so big that it's always in the way of the hands. This size can be tweaked to taste.

Step 60: Change AC_Back_Base and AC_Back_Small to draw as CircleXY with a Radius of 0.75. Again, the process here is to select the joint, then in the Attributes Editor, in the Joint change the Draw Style from bone to (in this case) CircleXY. Then change the Radius setting immediately beneath it (Figure 10.30).

FIGURE 10.30 *AC_Back_Base* and *AC_Back_Small* drawn as CircleXY with radius of 0.75.

Why?

CircleXY simply changes and forces the direction of the drawn circle. Although the circles could remain parallel to the ground this sometimes makes the handle (joint) a bit harder to see. By rotating them up on their side they are easy to see sticking out of Aegis's back and help define a little easier what the back rotation will usually be doing.

Step 61: Repeat this process for the rest of the joints in the upper body. For each joint, make a choice as to which Draw Style will provide the easiest access to the circle that is going to be drawn. Or, if you'd prefer, choose something besides a circle (Figure 10.31 shows my finished setup; I used Square for the eye joints).

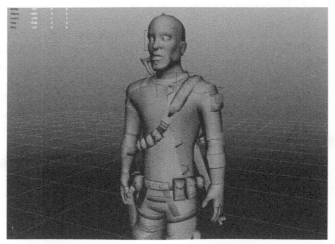

FIGURE 10.31 Completed upper body adjustments to joint Draw Styles.

299

Step 62: Change the color of the left-side joints to blue and the right side to red. To do this, select AC_L_Clavicle and open the Attributes Editor. Look for the Display section and the Drawing Overrides section beneath that. Click the Enable Overrides checkbox and use the Color slider to pick a pretty blue. This will change all the joints all the way down the arm (although you won't be able to see the change until you click away from the joint). Repeat this for AC_R_Clavicle and choose a red color (Figure 10.32).

FIGURE 10.32 Colored joints.

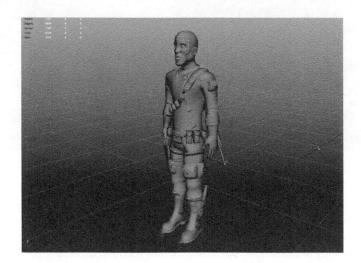

Why?

Once the animation process begins, there are going to be a lot of circles floating around. Sometimes, especially when animating from the side-view panel, it can become pretty difficult to see which side that circle represents. By color coding it becomes much easier to identify joints.

Step 63: Color code other upper body joints as desired. You may wish to color code all the back joints one color and the head another, and so on.
Step 64: Delete unnecessary joints. There are several joints that we placed that will actually not affect the polygons: the tips of all the fingers and thumbs (AC_L/R_FingersTip, AC_L/R_ThumbTip), the jaw tip (AC_Jaw_Tip), and the head tip (AC_Head_Tip). These joints were placed to give the joints that were their parents a location to point to, but they actually serve no purpose now. By deleting these joints (now that their parents are all oriented) we can further streamline the data set.
Step 65: Lock and Hide unwanted transforms. Start with AC_L_Shoulder. Select this joint and activate the Channel Box. Select the *words* Translate X, Translate Y, and Translate Z (not the input fields). Right-click-hold and choose Lock and Hide Selected. Next, do the same for Scale X, Scale Y, and Scale Z and Visibility (Figure 10.33).

FIGURE 10.33 Results of Lock and Hide selected.

Why?

We are only going to rotate the shoulder. We will never move or scale that joint. By locking the values, we can set quick keyframes by pressing S on the keyboard and not record move and scale keyframes. This makes editing much easier. Similarly, by hiding these transforms, we inform other animators who may inherit this rig that the only attribute meant to be animated is rotation.

Step 66: Repeat this process for all joints in the upper body. Remember you can do this for multiple joints at the same time.

Why?

Why not the lower body? In the legs, the rotation of the joints is not controlled directly by us; that is, we won't be selecting the knee (for example) and rotating it. Rather, we'll be moving (and rotating) the foot handles we created earlier. These foot handles happen to contain children that are the IK handles that control the rotation of the leg joints through IK calculations. So no need to mess with those.

Conclusion

And with that the rig is done. It is one of the more basic rigs that you may see in Maya but will still provide a very good level of control. If you've dealt with higher-rez rigging solutions there is likely some missing rig handles you're complaining of (no handle for the entire rig, etc.). But in game animation, the character will be doing most of the animations in place, so there is little need to move the entire rig at any one time; therefore, we can leave those sorts of handles out.

The next step will be to get these joints so that they actually influence the mesh they are inside of.

Tutorial 10.2: Maya Skinning

Skinning is the process of attaching vertices to joints. This means that each vertex can be influenced by one or more joints and as that joint moves (or rotates) the vertices go with it. Getting the right amount of influence for each vertex to the correct joint or collections of joints takes a little bit of refinement; however, getting the skin (the mesh) weighted (assignments to joints) correctly is a very important part of the process.

Step 1: Bind the skin to the joints. To do this, select AC_Root and then shift-select AC_AegisChung_SM. This selects the parent-most joint of the skeleton and the single mesh that is Aegis Chung. Select Animation>Skin>Bind Skin>Smooth Bind (the default settings should be fine).

Why?

Smooth binds are binds where vertices can share their influence between several joints. For most organic situations, smooth binds are the method of choice. It means places like the front of the knee can spread their influence across a couple of joints to get a gentle bend. Alternatives such as Rigid Bind work on the idea that each vertex is 100% assigned to one joint. Although there are some really interesting and compelling uses of Rigid Binds with other deformation objects (Lattices for instance), for our purposes we'll go with Smooth binds.

Step 2: Test the bind. Do this by moving Aegis. With the Move tool, grab AC_Root and move it around (he should bend his knees and squat), use the Rotate tool to bend the arms, wrists, head, jaw, and so on. Basically pretend he's a doll and pose him to see how the default bind holds up (Figure 10.34).

FIGURE 10.34 Posing with the default skin binding. I hope yours looks better than mine....

Why?

Maya is smart in a lot of ways, but when it comes to skin binding it's kind of dumb. Basically, on initial bind, each vertex looks around itself and allows some of its influence to be lent to the nearest five joints. This means that the pouches around the waist may lend a lot of their influence to the wrist joint and the gun will be influenced by the hip and wrist joint. Basically it's all a mess, especially with a tightly modeled character like this one. Frankly, this is one of the drawbacks of modeling with the arms down; should the character have been in a T-pose, or even if the arms were modeled at 45 degrees, it would be less likely that the areas around the waist would be influenced by the wrist. Either way though, adjusting the skin weights is a necessary part of the gig.

Step 3: Make sure to undo all the rotations or movements.

Binding Rigid Body Parts

There are a few parts of the body (the head for instance) and things attached to Aegis (like guns) that shouldn't bend; really they should be attached 100 percent to a particular joint. To do this we will start with a very numerically based method of adjusting skin weights and adjust the Component Editor.

The Component Editor allows for, well, editing of components—like vertices and specifically which joints those vertices are being influenced by. This method will be very Excel-esque, and might not be terribly appealing at first, but is the quickest way to take care of rigid parts of the body.

Step 4: Make joints unselectable. At the top-left corner of the Maya interface are a collection of tools that allow a user to mask which types of objects are selectable. Turn off the ability to select joints (Figure 10.35).

FIGURE 10.35 Turning off the ability to select joints.

Why?

We are about to do a whole lot of vertex selection. Maya has a sort of object selection hierarchy to actually assist in animation. This means that if a click is made in a view panel if there is a joint beneath the mouse (even if it is inside of a poly mesh) it will select that before the mesh that surrounds it. So, if joints are selectable, every time a marquee selection is made that touches a joint, whatever you were hoping to select won't be selected—instead the joint will be picked.

Step 5: Select the vertices that make up the head. Don't grab down the neck, just all of the head (Figure 10.36).

FIGURE 10.36 Selection of head vertices.

Step 6: Assign these vertices to AC_Head_Base. To do this, choose Window>General Editors>Component Editor. Click the Smooth Skins tab. Use the bottom slider to slide over to see AC_Head_Base (the joints will be listed alphabetically) column. Highlight the entire column and enter 1 (press Enter), and all the values for that column will change to 1 (Figure 10.37).

FIGURE 10.37 Setting a value of 1 to AC_Head_Base for all the vertices of the head.

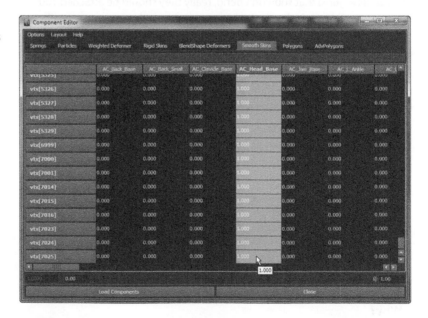

Why?

The paradigm here is between 0 and 1—0 is 0 percent and 1 is 100 percent. By changing the value of all the vertices (listed in the first column) for AC_Head_Base to 1, these vertices will be 100 percent assigned to this joint. When AC_Head_Base moves, all the vertices we've got selected will go with it…no sharing.

Step 7: Assign eye vertices to respective joints. For the eyes, this is actually a little simpler. Try this trick: Switch to Faces mode and double-click any of the faces of the left eye. This will select out until it finds the edges of the eyeball and go no further. Ctrl-right-click-hold and choose To Vertices and then all the vertices of the eye will be selected. Again, in the Component Editor enter 1 as the value for all the vertices under the AC_L_Eye column (be sure to press Enter after entering 1).

Why?

There are actually a few interesting things happening here that should be pointed out. Notice that when we selected the vertices and went to the AC_L_Eye column, all the values were 0. They were 0 because in the previous step they were part of the collection of vertices that were assigned to the AC_Head_Base joint. A vertex's total weight value will be 1. So if more influence is defined to one joint, the vertex must rob that influence from other places it may have been affiliated with. So when the eye vertices were assigned to the head, it zeroed out the influence AC_L_Eye had on it. Now that we've assigned all the influence to AC_L_Eye, the influence that was on the head is gone (which is what should happen).

Step 8: Repeat the process for the right eye, only assign the vertices to be influenced 100 percent by the AC_R_Eye joint.

Step 9: Use this same trick on the hip pistol and holster (assigned to AC_R_Hip), the knife (assigned to AC_L_Knee), the backpack, and the rifle (assigned to AC_Back_Small).

Why?

None of these objects should be bending. Other than the backpack, they are all very rigid. By assigning them to any one joint, we'll ensure that they won't tear away or bend when other surrounding joints are moved.

Painting Skin Weights

If you select AC_AegisChung_SM (the actual mesh) and look in the Channels box, there will be a node called skinCluster1 in the Inputs. The skinCluster node is actually the node that attaches the vertices to the joints, and it is part of the mesh (*not* the joints). We have already looked at how to adjust this skinCluster via the Component Editor, which works great for rigid parts of the body.

However, most joints are much softer in their deformation. Most vertices on the body need to lend their influence to a couple of joints at a time. Maya has some fairly effective methods of allowing for this fine-tuning via very visual workflows.

A note about skin weights first. We've already alluded to the idea that if a vertex has a setting of 1 assigned to any one joint, its influence setting for all

other joints is 0. Adjusting skin weights is constantly the battle of "robbing Peter to pay Paul." However, it should always be about paying Paul; that is, always think of painting vertices as painting where influence should *be*, not about where it shouldn't.

This means that as we paint in influence we want to be adding influence to joints, not taking it away. Although it is possible to paint a vertex so that its influence is zero in respect to a particular joint, painting away influence like this causes problems because you don't know where the influence goes.

But enough theory, let's look at how to use the tools.

Step 10: Select the mesh AC_AegisChung_SM and activate the Paint Skin Weights tool (Animation>Skin>Edit Smooth Skin>Paint Skin Weights (Options)). Be sure to select the Options square to get the interface shown in Figure 10.38.

FIGURE 10.38 Paint Skin Weights tool in Interface.

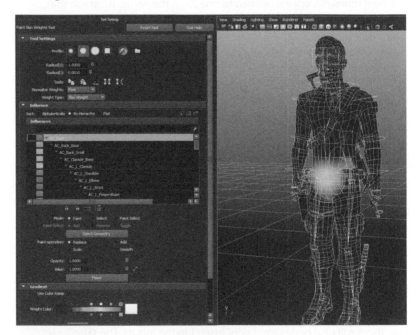

Why?

The Paint Skin Weights tool interface has greatly improved in Maya 2011. There are some really nice tools in Maya 2011 that help a lot in the sometime arduous process of painting skin weights (the Hammer tool rocks!). But for quite a while now, the basics of this tool has remained the same. The first section (Tool Settings) should be a bit familiar—it allows for the user to decide the type of brush including size that will be used to paint across the surface of the mesh. The second area (Influence) lists the joints that are attached to the vertices of the mesh selected.

The way this interface works is this: when a joint is selected in the Influence section, the vertices that are affected by that joint will highlight white (or gray) in the view panel. As the vertices show up closer to black, the influence is less. Painting on the mesh (only vertices matter) will allow influence to be defined (via the Paint Operation: Replace radio button), added (via Add radio button), scaled (via the Scale radio button), or smoothed (via the Smooth radio button, which really means share influence between the selected joint and the next nearest joint).

Step 11: Resize the brush to a more appropriate size. Move the mouse out into the view panel and look for a red circle (this is likely larger than the entire model). To resize the brush hold the B key while dragging the mouse left and right (this is the same as adjusting the Radius over in the Tool Settings).

Step 12: With the Replace radio button activated and an Opacity setting of 1, paint an influence that approximates Figure 10.39. Be sure to work around to the back side as well so the influenced area is a band around the belt.

FIGURE 10.39 Rough first pass of influence for AC_Root.

Tips and Tricks
Paint an influence range just a little bigger than what the joint will actually be influencing since we will smooth the transitions in later steps.

Step 13: Smooth the influence. In the Influence section of the Paint Skin Weights tool, change the Paint Operation to Smooth and click the Flood button twice (Figure 10.40).

Why?
Smoothing shares influence up and down a chain of joints. By painting in at 1 (which yields very harsh transitions of influence from joint to joint), and then flooding with smooth later, the core area of influence is preserved, but the transition from bone to bone remains gentle.

FIGURE 10.40 Smoothing influence through Smooth Flood.

Step 14: Repeat this process of painting at 1 and then smoothing starting from the extremities and working in. So start from the toe and work up to the hip, then start at the finger tips and move up to the shoulders.

Conclusion

In all the books I've written, writing about painting skin weights is always the toughest. They just don't lend themselves well to step-by-step tutorials. Although we could go joint by joint and look at painting the influence for each, the results would be maddeningly tedious and still yield results not identical to mine.

I've found through many years of teaching this that the best way to learn skin weights is to paint skin weights. So tear into it, test often (you'll need to re-enable the ability to select joints to test and then turn them off again) and discover the fun of making the form deform correctly.

As you work, consider the following tips:

1. Remember that when painting the influence of a joint, you are painting what vertices are influenced by that joint, not just the vertices that are around the joint. So a knee joint should not just be painted around the knee; rather the knee joint will be affecting from the knee down the shin and the top of the ankle (Figure 10.41).
2. Remember that painting skin weights is a dynamic process. As you paint skin weights on one area of the body, it is robbing influence from other parts. This means that the skinCluster is very fluid, and what you painted may not remain that way, so don't assume that once a joint has been painted it's complete and done. Multiple passes are necessary to get things right.
3. Be very careful not to paint areas not intended. This seems obvious, but very often I see a student oriented below their character painting the end of the toe and end up picking up the tip of the nose. So every time the character picks up a foot or moves the leg, the tip of the nose moves.

FIGURE 10.41 Influence area of the knee; notice it's from the knee down to where the ankle takes over.

4. Watch for vertex twitching. Even when you think the skin weight is painted well, test and look carefully for spots where the mesh is twitching (especially along the thighs near where the hands are). This twitching of vertices means that there is trace influence on a vertex (sometimes this can be cleaned via Animation>Skin>Edit Smooth Skin>Prune Small Weights).

5. Remember that there is a Mirror Skin Weights function (Animation>Skin>Edit Skin Skin>Mirror Skin Weights). This isn't an ideal situation to use it since the character isn't exactly symmetrical (especially with all the guns and knives and diagonal straps), but it can be useful as long as you're willing to go back and rework some of the rigid bind sections (guns, etc.).

6. Get that brush small and then big again. Especially when working on areas like the fingers, sometimes the process is working down one vertex at a time. A small brush will allow for exact painting. Scaling the brush up and down often makes for a much faster work flow.

7. Paint while posed. Painting skin weights is possible even when the character isn't in a neutral pose (called Bind Pose, or the pose the joints were in when they were bound to the mesh). So raise that arm up, pull that foot up and then paint on the mesh so that the deformed places look right, or so you know which vertices are being pulled away when they shouldn't. Then, zero out the rotation values for any joints you rotated in the upper body, and zero out the translation and rotate values for the foot handles if you moved the foot.

8. Remember that sometimes the easiest way to get to vertices (as in to paint them) is from inside the mesh. This is especially true for areas like the back beneath the backpack or inside the mouth.

9. Save often. [sarcasm] Not that Maya ever crashes [sarcasm]; but it crashes more often while painting skin weights. It's easy to get lost in the black and grays of the process, but it is especially painful to lose work due to a crash while painting skin weights. Save often.

10. Just as the desire to eat cake never really goes away (because, let's face it, cake tastes awesome, which contrasts with weighting), painting skin weights often feels like it's never done. Getting to a point that is acceptable is probably where you should decide to move on. Chances are, when you are animating, you'll find something that bugs you and you'll be back fixing it anyway.

Tutorial 10.3: Maya Animation

In this game we don't see a whole lot of Aegis moving (he'll move his arms, but not his whole body in game play). But, seeing how to prepare an animated mesh for export from Maya and import to Unity is an important part of the game creation process; so we're making a brief introduction level using our now rigged and skinned Aegis to illustrate these techniques.

But before we can get him exported we need to animate him. Getting all the intricacies of effective animation in is way beyond the scope of this book, but we will look at a few of the important concepts and techniques unique to animating an asset for game engine consumption.

If you're confident with your rig and skinning, use it for sure. If you grew tired of skinning, feel free to use the version of Aegis included on the web site (AegisChung-SingleMesh-Rigged).

General Notes on Game Animation

There are a few things unique to game animation that is worthwhile to point out. First, think cycles. Almost every game character animation should be a cycle; this means that the first and the last keyframe of each motion should match. For walks, animate from left foot fall to left foot fall. In an idle animation, have the character return to exactly the same pose as he began. The reason for this is that most animations in games are quite short and called up via script (programmatically). Different animations will be called up at different times, but sometimes (like in an idle animation) there might not be any new input and an animation needs to play through more than once. Without a cycle, the animation will jump and jerk in very awkward ways.

Second, remember that for game animations, most cycles should be short—or often shorter than they would be for high-rez projects. For example, a common problem for students is the jump animation. They've animated it before in a nongame situation with a lot of great squash and stretch that when used in game means the character hasn't even gotten ready to jump before they should be in the air. This doesn't mean that good concepts of animation (i.e., squash and stretch) shouldn't be used—in fact it's critical that they are. They just often need to happen quicker and subtler. The one exception to this would be an idle animation—the animation a character does when it's waiting for other instructions. A longer idle animation keeps the repeating cycle from being quite so obvious.

Third, do the animations in place. For animations like walk, run, or jump, imagine that the character is on an invisible treadmill and while his feet are moving as though he's covering ground, he needs to stay put, walking in place. The actual translation of the character will take place programmatically and the character will move forward, backward, or side to side based upon user input. Think of the walking-in-place character being in a capsule that is moved as the animation is played, thus giving the illusion of movement. For those of you who have done some high-rez work and worked with IK chains specifically to keep the foot from sliding this will be an adjustment; but in game walk cycles, the feet should always be sliding. For an illustration of what this would look like take a look at the animation between frames 300 and 330 in the AegisChung_SingleMesh. mb file on the web site (http://www .Creating3dGames.com). This frame range includes a quick animated-in-10-minutes walk cycle animated as a stationary cycle. A quick note though; for standing-still animations (like the idle), keep those feet stationary because when the character is not moving and the feet slide, any illusion of gravity, friction, and reality will be gone.

Keep it in one file and note the range. There are actually different ways to attack this issue. On the one hand Unity allows you to import several files, each with its own animation. Then these animations can be called up later and assembled on one mesh. However, I generally find it easier to have all the animations created in one Maya file and take note of the ranges (idle: frame 1–240, walk: frames 300–330, etc.). Then when Unity imports the .fbx we are going to export in a bit, you can tell Unity to interpret these different animation clips by defining the range of frames that that animation occurs in. This just keeps all the animations contained in one file and makes the housekeeping easier inside of Unity.

> **Step 1:** Save a backup copy of Aegis. Use File>Save As... and save the file as `AegisChung-SingleMesh-Rigged`. Close the file and reopen AegisChung-SingleMesh.

Why?

Once animation is started, the file contains keyframes and poses. Although it's not overwhelmingly difficult to get rid of all the keyframes or to get the character back into his bind pose (it's pretty easy actually), I always prefer to save sequential versions of the process in case something horrific happens. We will animate AegisChung-SingleMesh, but if need be the unanimated but ready to be animated version is always waiting for us.

Tips and Tricks

An alternative to saving multiple versions like this—and one that we teach at UIW—is to use referencing. Referencing is the process of importing an instance of a Maya file that can then be manipulated (including animated) but leaves the original referenced file untouched.

When doing a lot of scenes with a lot of different Maya files, this works really well since if a change is made to the original referenced rig file (adjustments to skin weights for example), the change will automatically be propagated to all the Maya scenes that the model is referenced in. In this game situation though, we will be putting all the animation into one file; so saving a backup will be just as easy without working through new interfaces.

Step 2: Hide things that won't be animated. In our current rig it's really just the leg joints. To hide them, select AC_L_Hip and press Ctrl-H or Display>Hide>Hide Selection. Repeat this for AC_R_Hip.

Tips and Tricks

These can always be made visible again later. Take a look in the Outliner, and the joints that have been hidden are grayed out. If those are selected (in the Outliner) they can be shown again via Display>Show>Show Selection.

Step 3: Make sure joints and curves are selectable and the mesh is not selectable. Do this with the selection masks we have looked at before. Your collection of masks should look like Figure 10.42.

FIGURE 10.42 Making sure that joints are selectable but the poly mesh is not.

Why?

When animating, it greatly speeds the process if objects that are animatable are easily selectable. We will be animating the mesh via the joints so we don't want to be able to grab hold of the mesh itself; thus we make surfaces unselectable. However, we do want to be able to quickly select joints (drawn as circles in our current rig) and the handles for the feet (which are curves).

Warnings and Pitfalls
Keyframes are stored on a per-object basis. This means that each joint that is moved must have its own keyframe. Forgetting to set keyframes means that Maya forgets that pose at that particular time and thus you have no pose to reference when the next keyframe is set, and thus no animation.

Step 4: Pose the character to start an idle animation cycle. First, click frame 1 in the Time Slider (the list of numbers at the bottom of the screen). Then, begin to pose Aegis. The key here is that after each joint is rotated, or each foot handle is moved or rotated, press S on the keyboard to set the keyframe (Figure 10.43).

Step 5: Make sure there is a keyframe for every animatable object (this means all the joints and the foot controllers, even if they haven't been posed). Do this by expanding the entire skeleton and selecting all the joints (select AC_Root and then Shift-select the very last joint (in mine it was AC_R_ThumbEnd). Press S. Do this for the feet handles as well. Keep the selection that you've made in the Outliner for the next step.

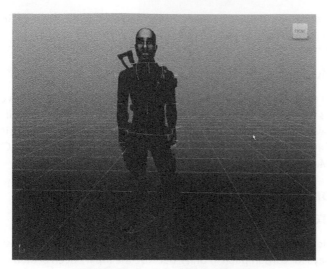

FIGURE 10.43 Starting pose for idle animation.

Why?

When making that initial pose, sometimes all the joints get moved, but not always. However, to make sure that there is a true loop of the animation, it is critical that there is a keyframe for everything that moves. By keyframing everything that could move, we will ensure that this state exists.

Step 6: Copy and paste the keys set at frame 1 to frame 240. In the Outliner, use the same selection as step 5 for all the joints and the foot handles (all these should have keyframes represented by a red line in the Time Slider). In the Time Slider, right-click-hold frame 1 and select Copy. Expand the Time Slider to 240 (enter 240 in the first input field to the right of the Power Slider just beneath the Time Slider). Move the time to 240 in the Time Slider and then right-click-hold frame 240 and choose Paste>Paste.

Why?

By taking the time to copy/paste the first keyframe to the last keyframe we can ensure that the animation is indeed a loop—a cycle.

Step 7: Fill in the animation. Shift his weight, wave at the camera, scratch his head, do whatever. No hard rules here. This is just for fun. For an actual animation in a game (if this were a third-person game), the idle would be fairly tight so he was staying focused ahead of him; but for this one, explore and have fun.

Tips and Tricks

Be sure that you are playing the animation in real time as you preview it. You can change the Playback Speed in Windows>Settings/Preferences>

Preferences. Go to the Time Slider section and change the Playback Speed option to real time.

Conclusion

Lots left to do. This is a seven-step tutorial that will probably take you a couple of hours to complete. Just animating a game character is worth an entire book on its own, so if you haven't a lot of animation experience, don't sweat it. Get a bit of animation in there and call it good; or feel free to use the AegisChung-SingleMesh-Animated.mb file to use for the next tutorial.

Tutorial 10.4: Getting Animated Characters to Unity

In previous chapters I've argued passionately for manually exporting assets from Maya for consumption in Unity. Because the topic's been beaten pretty hard, I'll avoid proselytizing too much in this chapter; however, it's important to note that for game characters manual export carries some real benefits.

The most important benefit has to do with how IK is calculated. In our current rig and animation, the rotation of all the leg joints has been done via IK chains, and specifically with the translate keyframes of the foot handles. These calculations are dynamic within Maya, meaning that each frame isn't just seen as an incremental rotation difference since it is in the upper body, but a much more complex calculation of incremental difference in translation of the IK handle, and then another calculation of how to rotate the involved joints to solve for this IK handle location. If you've used different 3D applications, you know that IK can work differently and have different personalities across different programming solutions. It's no different in the Maya/Unity marriage; and IK might solve great in Maya and not solve quite so nicely in Unity. Especially if using things like pole vectors, Unity doesn't always see the IK the same way Maya does.

To help alleviate this, we'll look at baking our animation into all joint rotation procedures. The IK will then not actually be calculated by Unity at all—Unity will simply see joint rotation keyframes.

Step 1: Save a backup version of the file. Save as `Aegis_Chung-Animated`.mb.

Why?
We are about to bake the animation. Once the animation is baked, it is very difficult to do any sort of meaningful editing. It's always good to have a nonbaked version of the file. You may never need to go back to this unbaked version, but if you need it and don't have it, the animation practically needs to be started over.

Step 2: Bake the animation. In the Outliner select AC_Root. Then choose Edit>Keys>Bake Simulations (Options). In the Bake Simulation Options

window, in Hierarchy click the Below radio button. In Time Range: click the Start/End option and for Start Time: enter 1 and for End Time: enter 240 (if you've only done the idle as listed earlier) or the last frame of all the animations you have (Figure 10.44). When everything is set, press the Bake button.

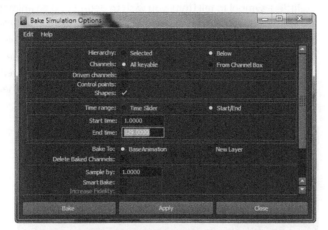

FIGURE 10.44 Baking animations.

Why?

Baking with these settings will set a keyframe for every joint below AC_ Root at every frame. After this has been baked, the foot control handles themselves can be deleted entirely since the IK that was controlling those legs is no longer needed. By doing this, the animation attached to this Maya file is much, much simpler for Unity to interpret. However, this is a suggestion (not necessary for successful completion).

Step 3: Export as .fbx. Choose File>Export All. Navigate to the Unity project folder (Incursion–Unity) and into the Assets folder. Change the file type to FBX Export and (as we've done in the past) be sure that Embed Media is checked (in the Include section) and that the Version is set to FBX 2010 (in Advanced Options/FBX File Format section). If you have not changed them, these should be the same as they were back when exporting assets for the scene files. Name the file AegisChung and press the Export All button.

Tips and Tricks

You're likely to get a Warnings and Errors window. Generally, this is not a big problem. Usually it is warning about Animation Tangent-type changes that are unavoidable in this situation and shouldn't affect much in the scene. If you get this error window, just press the Close button.

Step 4: Save your file and open Unity. Of course, make sure you are working in the appropriate project once inside Unity.
Step 5: Adjust AegicChung's import settings. Once Unity has opened (it may chug for a minute as it recognizes the new AegisChung.fbx file),

in the Project panel, select the AegisChung prefab. This will show it in the Inspector panel. Change the Scale Factor to 1. Then look carefully (you may have to scroll down) to the Animation section and an area that has columns of Name, Start, End, WrapMode, and Loop. Click the little + symbol to tell Unity you wish to define/add an animation. As soon as this is done a new animation will appear already named "idle." The Start column should read 1, but change the End entry to read 240. Change the WrapMode to Loop (not the Loop checkmark—this is something else.) By changing the WrapMode to Loop, the animation will, well, loop until told to stop. If you have animated other animations, add them here now. When done, click the Apply button (Figure 10.45).

FIGURE 10.45 Importing Aegis Chung including importing animations.

Why?

We carefully scaled Aegis in Maya to allow for this quick setting of Scale Factor of 1. The Animations area is where we get to define the multiple animations that may be attached to any one asset. This can really have any amount of animations. The key here is defining the animations with a good name that we can call up later. The default animation this asset will run (in the absence of other instructions) is that first one—idle. But, with script we could call up any of the others (more on this later).

Using Aegis

Technically, he's in. He's a prefab and ready to be placed, used, and abused. For fun, drag him into the Scene-EntryWay (drag from the Project panel

up into the Scene window); play the game and you should be able to walk around him (although he may be kind of dark because we haven't lit for characters yet), and he will be looping the idle animation. All that movement and no place to go. When you're done playing around, go ahead and select him in the Scene window (or the Hierarchy panel) and press the Delete key (on a PC) or Command-backspace (on a Mac).

Step 6: Create a new scene file. File>New Scene.

Why?

We're going to lay the groundwork for an opening scene—an opening level really—that will show Aegis, give a little bit of background, provide an explanation of the goals of the game, and then allow the player to press a Start button to start the game. Aegis is the eye candy. Although technically, all of this could be done in the EntryWay scene, having only Aegis in this scene will allow for some nicer lighting, and a very quick startup to the game (very few assets to load).

Step 7: Create a floor and then a back wall. Do both of these by creating a plane (GameObject>Create Other>Plane). Scale to match Figure 10.46. Make sure the floor plane (named Floor) is set at 0,0,0.

FIGURE 10.46 Setting up the floor and back wall.

Step 8: Place Aegis. From the Project panel, drag AegisChung up into the Scene window. New to Unity 3, he should snap so that he's standing on the floor as the mouse is moved over it. Place him in about the center of the floor (Figure 10.47).

Step 9: Light the scene. Figure 10.48 shows a lighting scheme using a fairly standard key light, two fill lights (amber and blue), a back light, and a light to light the back wall. Light for the dramatic effect you're after.

Tips and Tricks

Figure 10.48 shows the scene lit with all spotlights. Spotlights allow for a good amount of control but don't necessarily take a huge amount of horse power to draw. Do note, however, that lighting will often draw differently

FIGURE 10.47 Placed Aegis.

FIGURE 10.48 Basic lighting scheme. Specifics aren't important; light so you like it.

in the Scene window than in the game. Be sure to get the camera moved into an appropriate position to show Aegis, and play the game (which will just be a static camera) to see how the lighting looks. The Game window's appearance is the only one that matters since it's the only one the player will see.

Step 10: Turn off ambient light. Select Edit>Render Settings. Click the Ambient Light swatch and change it to black (Figure 10.49).

FIGURE 10.49 Game view with ambient light turned off.

Why?

Ambient light can work great in a lot of situations, but in dramatic lighting situations it's a mess. Turning it off may require some adjustments to the lighting scheme, but the look will be much more polished. Importantly, it will allow for some truly black areas where white text will show up well.

Tutorial 10.5: Animating in Unity

Unity continues to make improvements in functionality and interface. Among the biggest jumps has been within its built-in animation system. In many previous editions of Unity, everything (and I mean everything) needed to be animated outside for any reasonable control. There were eternal infernal processes of animating a null-object in Maya and then importing that and parenting a camera to it to get good camera motion; really a pain. And then there was the awkward time when Unity didn't include any animation at all. Luckily, all of that is behind us now and Unity has a quite reasonable and intuitive (if you're familiar with other animation tools) interface.

Still, most complex animation (like character for instance) is best done outside of Unity in your 3D application. But for some simple moves (camera cinematics for instance), Unity's built-in animation system works just fine.

In this tutorial, we will organize and animate Aegis so we see him spinning around slowly in the scene as he idles.

> **Step 1:** Create a new empty GameObject. Do this via GameObject>Create Empty. Make sure it's position is at 0,0,0 and name it `AegisGroup`.

Why?

In Maya, when multiple objects are grouped together, Maya automatically creates a null object to contain the new group. Unity does not do this. However, by creating the empty game object first, we can then have this as a container to hold other things.

> **Step 2:** Make Aegis, the floor, and any lights lighting Aegis children of this new AegisGroup. Do this in the Hierarchy by dragging those assets onto the AegisGroup GameObject (which will make them children of AegisGroup).
>
> **Step 3:** Create an animation for AegisGroup. In the Hierarchy panel, select AegisGroup. Choose Window>Animation. This will pull up the Animation window and timeline. In the top-left corner is a little red dot (for record). Click this and a Create New Animation dialog box will appear. Enter `AegisGroupRotation.anim` in the File Name input field and click Save.

Why?

What's going on? Think of animations as components of GameObjects. Whenever an object is to be animated in Unity, Unity will create a separate editable file (with a .anim label) that will store the information. What this means is that the animation can be used again and again on other objects (which is powerful in itself). It also means that there is this new asset that will be in the assets folder that is important not to delete.

Note that after the .anim file is created, the Animation window will show the record button in the top left highlighted in red as if pressed. This is Unity's way of telling you that you can now record animations by creating and editing keyframes.

Step 4: Set a rotation keyframe. In the Animation window, click once on the Rotation Y text under the Transform section of AegisGroup. Along the top of the interface is a little diamond with a plus next to it. Mousing over this should provide the screen hint of Add Keyframe. Click this button once. This will create a little diamond that actually records a keyframe for all the rotation values.

Step 5: Create a second rotation keyframe to create rotation animation. Along the top of the Animation window are the current time values. These can be a little tricky to understand at first. The format is Second:Frame. So 1:30 is one second plus 30 frames' worth of time. Unity's timeline here is working as though the game is playing at 60 fps so 1:30 would be about a second and a half. Slide the red time marker over to any place in the timeline (besides 0). In the Inspector, change the Rotation Y to 360. A new keyframe will appear in the Animation window with a yellow line to connect the two keyframes we have thus far for RotateY.

Step 6: Test the animation. In the Animation window, next to the Record button is a Play button. Press this to see how things are looking. Press it again to pause.

Step 7: Adjust the timing. This second keyframe can be dragged to a new location in time most easily by dragging the gray diamond (keyframe) symbol on the AegisGroup line (not the yellow keyframe in the graph section) along in time. The timeline will provide more time as the keyframe is dragged to the right. I chose a 15-second duration (Figure 10.50). Maya's navigation commands work here too; the window can be zoomed and panned by holding down the Alt button and dragging or middle-mouse dragging.

Step 8: Set the animation to loop. Still in the Animation window, look at the bottom left. Next to the Show button is a drop-down menu that will read Default to begin with. Click this and change the value to Loop (since we don't want the animation to stop).

Step 9: Play the game to see everything in action.

FIGURE 10.50 Finished animation of Aegis turning.

Conclusion

And there it is. It's easy to see how in a pinch, a bit of animation can be easily added to an object in Unity. To edit this animation later, just click the object (AegisGroup) and open Window>Animation. The animation will be shown there and keyframes can be moved, interpolation adjusted, and new keyframes added (the red Record button needs to be clicked to add additional keyframes).

Wrapping Up

Aegis is modeled, rigged, skinned, animated, and in the game. At this point all the 3D assets we are going to model for the game have been created and imported. Now it's time to move wholly into the realm of Unity to add some interactivity to the scene.

In the coming chapters we will be looking at how to develop scripts that turn the levels we have created into a game. Some of the assets needed for this game were assigned as homework and challenges in the past chapters. But if you didn't do those challenges, there is a package created that will include the other items and sections needed for the game.

Part of the power of Unity is that new art assets can be brought in and configured anytime along the way. We could do most of the scripting in the coming chapters first to work out the mechanics of the game, and then bring in the art assets. We could add assets as the game play brought up new ideas; it is a very nonlinear and flexible process.

If you are unhappy with your results thus far, an imported version of Aegis and a bunch of other character assets are available on the support web site (http://www.Creating3dGames.com) as CharacterAssets.unitypackage. Even if you are happy with the results, download this and import into your project (Asset>Import Package>Import Custom Package).

But with this we'll leave the creation and importing of assets behind. It's time to make this thing a game!

Homework and Challenges

Challenge 1: Create a walk cycle for Aegis.

Challenge 2: Create a separate rig that is just Aegis's arms. Just have joints for the clavicle and down. Make the weapons children of the wrist, and animate Aegis pulling out and putting away the weapons. Remember this is a first-person shooter, so all this animation will be viewed as though the arms are yours (Figure 10.51).

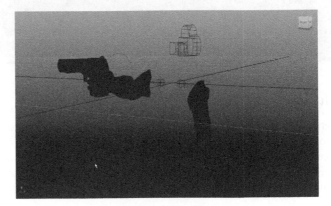

FIGURE 10.51 Rigged arms.

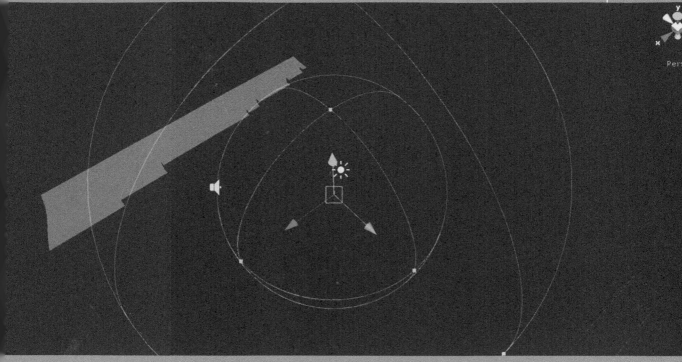

Unity Sound

Thus far we have imported levels that were modeled in Maya into Unity and used Unity's atmospheric effects to add fog and particle-generated steam. We've also brought in an animated character who runs an idle animation in a loop. We've even used Unity's animation tools to create animation in the game engine.

In this chapter we will make the experience further immersive with sound. Unity 3 includes some very nice additional sound mechanisms that allow for a very interesting experience for the player. Setting up sound is actually very quick and simple in Unity and is one of my favorite parts of the engine. So, this chapter will be short, but the overall effect with be huge.

Get the Sounds

This is often a problem, especially for students. Where to get those sounds that can be used legally? On the one hand, if you go and record your own sounds they are yours to use as desired. Unfortunately, most game designers haven't the equipment or know-how to record good quality audio samples. Luckily, online there are lots of good libraries that include some very reasonable licensing fees. Among my favorites is http://www.sounddogs.com.

It allows for low-resolution versions of its sounds to be downloaded and tested. Then if the sound clip is effective, a license can be purchased for (usually) very reasonable terms. For commercial projects this is a great way to go because it provides good quality sounds with a good license.

An alternative, especially for students learning, is http://www.freesound.org. The FreeSound Project has some great sounds released under a Creative Commons Sampling Plus License (although you need to register to download clips). Take a close look and read the full license for details of how to use the sound and how it can be included in your project.

For this chapter, go to either of these sites, or to some other sound source of your choosing, and pick up (as in download to the hard drive and save within the Unity project file for Incursion; see step 1 in the upcoming tutorial for details) the following sounds:

1. **Waves:** This should be a sound as though you are hearing the waves rolling up on the shore. The version I am using is "oceanwavescrushing.wav" (http://www.freesound.org/samplesViewSingle.php?id=48412). We will use this sound whenever around the water of the EntryWay scene.
2. **Mechanical rumble:** This should be a low rumble as though heavy machinery can be heard through a heavy door. We will use this sound when approaching the entrance to the facility. I used "low_register.mp3" (http://www.freesound.org/samplesViewSingle.php?id=33843).
3. **Walking sound:** This should be a subtle sound of someone walking (preferably on cement). This sound is easy to overdo, so be sure to remember this guy is supposed to be stealthy—so no stomping. I used "WalkGravelLoop.wav" (http://www.freesound.org/samplesViewSingle.php?id=31152). An alternative is "running gravel of dry leaves loop.wav" (http://www.freesound.org/samplesViewSingle.php?id=54778).
4. **Pistol shot:** This will be used when Aegis (the player) fires his pistol. I used "Gun-Pistol(One Shot).wav" (http://www.freesound.org/samplesViewSingle.php?id=37236).
5. **Others as desired.** As you walk through the model, other sounds will become obvious to use. Find some and place them as desired.

Tips and Tricks

Often a bit of editing is needed before a sound is "just right." There are many powerful audio editing tools on the market that can be purchased for high-end sound editing. However, if you are looking for a cheap (as in free) and reasonably powerful editing software, take a look at Audacity (http://audacity.sourceforge.net/). It's Open Source and available for Mac and PC. A very handy tool to have for those quick tweaks, or for the occasional need in format conversion (although Unity is very tolerant of sound formats).

Sound Listener and Sound Source Paradigm

Unity works with a fairly straightforward metaphor for sound—namely, one object contains or emits the sound, and another object hears it. Strictly speaking, an Audio Source (emits the sound) is a component of a GameObject placed in the scene. This means any object (ticking bomb, dripping pipe, etc.) can have an Audio Source component and thus can be the source of audio. However, an empty GameObject can also be created with the express purpose of emitting sound from a certain locale.

Similarly, the Audio Listener is also a component of a GameObject in the scene. Cameras automatically include the Audio Listener component. So our First Person Controller's Main Camera is always listening for any Audio Sources in the scene and then plays that sound through the player's speakers. Because this is already in effect (you can take a look at it in the Inspector when Main Camera is selected), and because the Audio Listener really has few options, our main focus will be on creating and adjusting our Audio Sources.

Tutorial 11.1: Placing Sound in Unity

As discussed earlier, Audio Source components can be added to any GameObject; however, I prefer to always assign static (as in not moving around within the scene) Audio Sources to GameObject specifically created to house them. It just allows for a much quicker understanding of the scene when I can *see* the Audio Sources in the Hierarchy as opposed to searching them out if they are attached to other GameObjects. This tutorial is built up on this preference.

> **Step 1:** Be sure that the audio clips have been imported in Unity. In the Project panel, choose Create>Folder. Name the new folder Sounds and make sure all the sounds downloaded and assembled reside here. Alternately, this organization could have been done previous to placing the assets into the Unity project folder and simply placing the entire Sounds folder within it.

Why?
Unity is pretty friendly when it comes to sounds. Among the sounds included in my project is an .aif, .wav, and .mp3; and all came in without so much as a complaint from Unity. It's one of the real benefits of Unity's open arms approach.

Tips and Tricks
If an audio clip is selected in the Project panel, the Inspector will show that clip. Of particular use is the Preview pane that will appear at the bottom of the Inspector. Here you can take a quick listen to any sound clip that is part of the Unity project.

Step 2: Create an empty GameObject to house the waves sound. Choose GameObject>Create Empty. This will create a new GameObject in the Hierarchy. Move this GameObject so it is just off the end of the dock (where the ocean is (Figure 11.1)). Name this GameObject Sound-Waves.

Step 3: Add Audio Source component. With Sound-Waves selected in the Hierarchy panel, choose Component>Audio>Audio Source. In the Inspector notice the new Audio Source component that is part of Sound-Waves.

Step 4: Define the Audio Clip. Still with Sound-Waves selected so the Audio Source component is visible in the Inspector, drag (from the Project panel) the waves sound into the Audio Clip input field (note the target icon next to the input field could also be clicked and the waves sound clip chosen that way).

Step 5: Make the clip loop. Still in the Audio Source section, ensure that Play on Awake and Loop are both checked.

Why?

The waves shouldn't stop. When the game starts, the sound for the waves should be playing (Play on Awake), and when the end of the clip is reached it should begin again (Loop).

Step 6: Play the game and adjust. Make sure you are wearing headphones to see how the sound works in stereo, and walk around the scene. Walk closer and further from the sound source. Open the 3D Sound Settings in the Inspector window. If the sound gets too loud or too quiet, change the Min Distance and Max Distance (within the Min Distance the volume is at 100%, and drops off until the player is outside of the Max Distance). The settings I settled on were Min Distance = 10 and Max Distance = 500.

Why?

It's fairly important in this scene that the sound of the waves never disappears completely—thus the very large Max Distance setting.

Step 7: Repeat for additional sound source in the tunnel. Duplicate Sound-Waves in the Hierarchy window by selecting it, then right-click it and choose Duplicate. Rename the copy to Sound-Waves Tunnel and then move it into place (Figure 11.2).

FIGURE 11.2 Additional wave source within the tunnel.

Why?
The idea here is that the waves lapping against the side of the tunnel will create additional audio vibrations (sound). Placing an additional sound source here will ensure that this effect is heard.

Step 8: Test, test, test. When working with sound, testing often is critical and is really the only way to make sure that the settings work.

Audio Reverb Zones

Audio Reverb Zones are areas of the model where effects are applied to the sounds that an Audio Listener is receiving. Audio Reverb Zones are fairly easy to place and are pretty handy in most simple situations. They simply create two spheres that define the effect of the reverb zone. The inner sphere indicates the area in which the reverb is in full effect, and the effect drops off to the volume of the outer sphere.

This works well, unless the zone is a cube (like the back of an enclosed truck). This can create goofy situations where walking around the outside of the truck can produce audio reverb effects as the player walks through the spheres that define the zone.

Still, in situations like ours, this will work fine since we don't need a terribly accurate zone (our zone will be the space under the covering).

Step 9: Create a new empty GameObject (GameObject>Create Empty). Place it in the back corner (where the entrance is). Name the GameObject Sound-ReverbZone.

Warnings and Pitfalls
When playing the game, it is possible to make changes to parameters of components (like Audio Sources) within the scene; and when these changes are made they will instantaneously be in effect. However, remember that these changes will revert once the game is stopped. So while tweaking things like volume while in-game are quick ways to find the right values, be sure to write these values down because they will need to be input again when the game is stopped.

Step 10: Add Audio Reverb Zone component to Sound-ReverbZone. With Sound-ReverbZone selected in the Hierarchy, choose Component>Audio> Audio Reverb Zone. A new component will appear in the Inspector. In the Scene view, adjust the Min Distance and Max Distance spheres (the blue squares allow for these regions to be resized) to roughly match Figure 11.3.

FIGURE 11.3 Adjusting the reverb zone.

Step 11: In the Inspector, change the Reverb Preset to Hangar.

Step 12: Test. Play the game with headphones, and take a listen to how the audio changes when the player is within the Audio Reverb Zone. Adjust the Min Distance, Max Distance, and Reverb Presets to taste.

Step 13: Add addition sounds as desired. For instance, I added another sound source near the doorway entrance using the mechanical rumbling sound. Be sure to adjust volumes and Min and Max distances to get this just right. Adjust, test, and adjust again.

Step 14: Organize the sound sources. Create a new GameObject (make sure it is at Transform Position 0,0,0) and rename it Sounds. Take all the sound GameObjects created thus far and make them children of this new Sounds (in the Hierarchy, just drag them onto Sounds).

Why?
We are starting to get a lot of objects floating around in the scene. By taking a moment to organize we can hide collections of stuff that we don't need.

Footsteps

So far we have created ambient sounds, which are great and help make the scene much more immersive. But there are other sounds (like footsteps) that can also help bring the scene to life.

There are many ways to work with things like footsteps. In third-person games the exact timing of footsteps could be very important—we'd want the sound to play at the exact moment that the character's feet (which we can see) hit

the ground. However, in this sort of game, where the player cannot see his own feet, this sort of exact timing isn't of concern. However, being able to hear those feet even if they can't be seen will help bring the player in.

To make this happen believably we will need to do just a bit of scripting. No worries though. Although we won't spend a lot of time explaining the script right now, after the next couple of chapters you can come back and take a look at it and it'll be much easier to understand what the script is actually doing.

But before we get into any scripting, we need to create the necessary assets.

Step 15: Create a new Audio Source for the footsteps. First, select the First Person Controller in the Hierarchy. Move the mouse over the Scene view, and press F on the keyboard (this will focus on the First Person Controller GameObject). Choose GameObject>Create Empty. Rename the GameObject Sound-Footsteps.

Why?
By first focusing on an object, when the empty GameObject is created, it will be created at the same location as the focused object. This means this new GameObject (which will contain our Audio Source) is already positioned correctly on the First Person Controller.

Step 16: Make this Sound-Footsteps a child of First Person Controller. Do this in the Hierarchy by dragging it on top of First Person Controller. You will be presented with a warning indicating that doing this will cause the loss of a "prefab connection." Go ahead and press the Continue button (Figure 11.4).

FIGURE 11.4 Losing prefab warning.

Why?
The footsteps are caused by the player's feet. Wherever the character goes, those footsteps should go with him. By making the source a child of the First Person Controller, when the footstep audio plays, the Audio Listener attached to the Main Camera (also a child of the First Person Controller) will always "hear" it.

Tips and Tricks
Losing prefab connection can be a hassle in some situations. Remember that when importing an object into Unity, Unity automatically creates a

sort of prefab that can then be dragged up into the Hierarchy and used. If any changes are made to the core GameObject, all the prefabs will update to reflect this change. Especially when bouncing back and forth between Maya and Unity, keeping a prefab connection can be of immense help because the updates made in Maya will automatically propagate into the scene when the new .fbx is brought in. However, in this case, where there is only going to be one First Person Controller in this scene, it is of no concern that we lose this prefab connection; go ahead and break it.

Step 17: Try this shortcut. From the Project panel, drag the footstep audio clip up and drop it onto the Sound-Footsteps GameObject. This will "automagically" add an Audio Source component to the GameObject. It's really the same as using the Component>Audio>Audio Source method—just quicker.

Step 18: Make sure the audio clip is set to Play on Awake and to Loop. Remember both of these options are available in the Inspector in the Audio Source component of the Sound-Footsteps GameObject.

Step 19: Play the game and adjust volume. It will be a little weird since right now, when the game is played, the footsteps will be running all the time. Ignore this little glitch and dial in the right volume for the sound clip. We will make it so that the sound isn't continuously running in a bit.

Scripting Sound

So we now have sound that we walk past. And we have sound that sticks with us as the player as we walk through the scene. Now we need to take a moment and make this sound only play on demand—when we're moving.

The process here will go like this: first, we'll make the Audio Source inactive so that it doesn't play. Then we'll construct a simple script that will activate the Audio Source when the player is moving; or more precisely, when the keys that move the character are pressed.

Step 20: Deactivate Sound-Footsteps' Audio Source component. Do this by selecting Sound-Footsteps in the Hierarchy panel. Then in the Inspector panel, click off the Audio Source component. Be sure to leave Play on Awake and Loop still checked.

Step 21: Create a new JavaScript. In the Project panel, choose Create>JavaScript. This can also be done via Assets>Create>JavaScript. A new icon will appear in the Project panel called NewBehaviourScript (Unity is built by Europeans, thus the funky spelling). Note that the icon next to it has a little JS on it for "JavaScript." Rename this script `SoundFootstepsControl`.

Step 22: Open the script. Do this by double-clicking the script in the Project panel. This will open another application. By default on a PC it will be UniSciTE and on a Mac it will be Unitron. There you will be presented with the basics of a script (Figure 11.5).

```
1   |
2   - function Update () {
3     }
```

FIGURE 11.5 Basics of a script as presented in UniSciTE.

Step 23: Enter the following text:

```
function Update () {
      if (Input.GetButton("Vertical") ||
Input.GetButton("Horizontal")){
            audio.enabled = true;
            }
            else {
                  audio.enabled = false;
            }
}
```

Tips and Tricks

Notice that there is that strange || symbol. That is the script symbol for "or" and is generally made by pressing Shift-\ (the key right beneath the Backspace key) on US keyboards. Also note that the line that begins with "if (Input.GetButton)" is all one line and doesn't end until the "{".

Why?

OK, I know I said we weren't going to go into great depth about what was happening here, but it's worth a quick look.

"function Update" just means "check every frame." So the script tells Unity to check every frame "if" the player is pushing the Vertical or Horizontal buttons. And if he is, it sets the audio component to be enabled (audio.enabled=true;), which means the audio is playing. If the player is not pushing either of these buttons (else), it sets the audio component to not be enabled (audio.enabled=false;) and thus turns the sound off.

Vertical and Horizontal are two inputs that are already defined in the Input section of Unity (Edit>Project Settings>Input). Don't worry too much about this for now, but Horizontal are the strafing A and D keys, and Vertical are the W and S keys. So when W, A, S, or D are pressed, the audio clip is enabled and the sound plays.

Step 24: Save the script (File>Save). When you return to Unity, open the Console (Window>Console) where Unity will tell you of any obvious syntax errors. If you find any errors, Unity will give point toward the line number where the error exists. Go back and correct.

Tips and Tricks

Usually the errors are things like forgetting to close parenthesis or forgetting the ";" at the end of a statement. Computers are pretty stupid when it comes to writing script/code and can't interpret what you mean—it has to be exactly right. Just be prepared to go back in and double-check things in the script if Unity complains.

Step 25: Apply the script to Sound-Footsteps. Once there are no errors, drag SoundFootstepsControl from the Project panel, up onto the Sound-Footsteps GameObject in the Hierarchy. This script will now appear in the Inspector if Sound-Footsteps is selected.

Step 26: Play and test. What should happen is every time the player moves forward, backward, or side to side, the sound clip of the footsteps will play. You can visually see this if you have the Inspector open for Sound-Footsteps. Notice how the Audio Source checkmark turns on and off when you push your A, D, S, and W buttons.

Conclusion

There it is. A short look at how Unity deals with sound. Pretty straightforward, eh?

Now of course, there are lots of details that can further enhance the power of sound. Just the specifics of how a sound attenuates (drops off in volume controlled via the Rolloff Mode settings for an Audio Source) based upon how far away the player is from the source can add tremendous interest to sound. However, in most situations, the baseline settings for Audio Source with a bit of adjustments to the Min Distance and Max Distance does the trick.

Don't cheat yourself on sound. Although the tools to control sound are fairly quick and straightforward, a good sound design can do a lot for a game. Spooky games are made downright scary with effective Foley (sound effects), and an adrenaline-inducing first-person shooter can be made even more intense with the right collection of sounds. Give it some love and sound will help take your games to new levels.

In the next chapter we'll start looking at adding some real interactivity to the game via a GUI.

Homework and Challenges

Challenge 1: Create a sound design for Hallway.

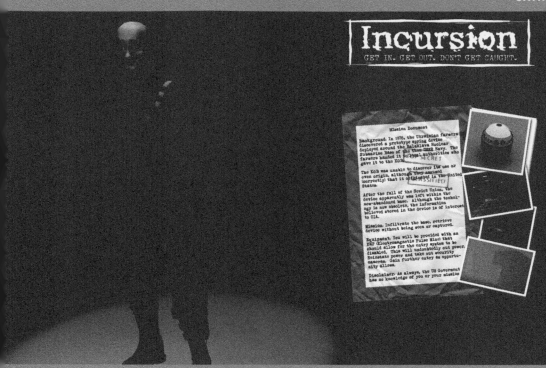

Introduction to Unity Scripting Basics and Graphical User Interface

In this chapter we are going to start to make this game a game! Now that we have imported game levels and game characters and populated those levels with light and sound, it's time to start making things interactive.

This is where the power of games starts to come through; without the scripting part games are pretty pictures, or at best walk-through models. And while there are markets for both of those, they both pale in comparison to the market for an engaging game.

While strong graphical elements are often an important part of an immersive game experience, they are not the primary driving force for games that are fun. The gutless Wii is a perfect illustration of weak graphics but fun game play driving big growth and big profits. Now, with the emergence of the PS3 Move system and Xbox's Kinect we may get a look at the Wii control paradigm tied to strong graphics; it's bound to be an exciting time in video game evolution. But I digress....

The point here is that game mechanics need to be developed through scripting; there's no way around it. Large studios (and even smaller multiperson studios) usually departmentalize the responsibilities of a game. The artists are the artists and produce the nonscripting assets, and the scripters/software engineers do the scripting. There is little need for all the artists to do a lot of scripting (or any, really) and the same goes for the scripters. Here at the Los Alamos National Laboratory, in our team, we have scripters and artists; and while the artists may mock up a game with a bit of basic scripting, before that game goes out to the client, the software engineer rebuilds the mechanics using more efficient and elegant code. However, for most indie developers or game developers getting started it's one person doing everything, and thus, even if you're coming from an art background, scripting is necessary to get working.

Now after you sell that first million copies of your game and are ramping up for the next, it might be worth it to hire a scripting specialist; it's probably just a better use of your time if you're not a scripting maestro. But even then, being able to speak a bit of the scripting language becomes an important part of the team dynamic. So here we go.

Unity's Scripting Languages

Technically speaking, when scripting we aren't *programming*. That is, we really need not know a great deal about the nuts and bolts of the game engine source code to start taking advantage of it. Unity does this through a collection of instructions or behaviors (called **classes**) that are accessible via a few scripting languages. Through these scripts, these classes can be accessed and utilized. Of further power, by writing scripts, new classes can be created that can further access functionality deep down in the game engine source code.

Unity uses three scripting languages, JavaScript (UnityScript), C#, and Boo. These three scripting languages are really multiple ways of accessing the same game engine core functionality; three tools with the same goal. One caveat though: It would seem that Unity—since it supports all three scripting languages—would be happy digesting all three within a project. And in fact, there are times (check out the iTween package at http://itween.pixelplacement .com) that a C# script can define classes that other scripting languages can't access. Generally, once you pick your poison (scripting language), the entire project should be built in that language. C# scripts and JavaScripts don't communicate well with each other.

Boo Script

Boo is a type of Python, so if you've been using Maya's new Python mechanism, you may find this is the way to go since it will be most analogous to your knowledge set; however, Boo is the least used of the scripting languages within the community, and in fact it can be a bit difficult to find help with it. A Boo

script will appear in the Project panel as an icon with a little Pac-Man ghost on it (those silly Unity guys!).

C#

This is probably the most powerful of the scripting mechanisms provided with Unity. In my experience with hard-core software engineers working with Unity, no matter which scripting language they start with, they end up settling here. Especially if dealing with "lower level" access (system-level stuff) and accessing things deep within Unity, C# provides better channels into the heart of the beast.

Either way, C# use and support has been rapidly increasing in the Unity community, and in fact, the documentation for Unity in Unity 3 includes C# examples, which makes it much easier to use in time-sensitive situations. In Unity, a C# script will have an icon with C# on it (imagine that!).

JavaScript

Alright, so excuse this technical detour but this is a bit tricky: Unity's JavaScript isn't really what the rest of the world knows as JavaScript. JavaScript for Unity is really very similar to Jscript.NET (much more than standard JavaScript). It's so different in fact, that sometimes people refer to it as UnityScript. However, on the forums or in the documentation, this sort of script is referred to as JavaScript.

JavaScript is generally how people begin scripting in Unity. To the untrained eye, it provides the most intuitive syntax. Additionally, scripts included on Unity's Wiki or forums are most usually authored in JavaScript. Because of these issues, in this book, we will be focusing on JavaScript to create our interactivity through the course of these tutorials.

Using Scripts in Unity

There are actually a few different ways to use scripts in Unity's environment. The way Unity knows to use a script is that it has to be attached to something in the scene—anything really. Because of this, often scripts are implemented into a scene by being attached to the object that the script is directly affecting. In the last chapter, we did this with the Audio Source; we wrote a script that turned that audio on and off, so we attached the script to the GameObject that contained the sound. There is something very intuitive about this—attach the script to the thing it affects. However, this can also cause some problems later or for other members of a team since it can sometimes be tough to track down or remember all the places that scripts have been squirreled away. It's very frustrating to be trying to squash a bug and have it be in a script you didn't even realize was in the scene because it was attached to an object deep, deep within a hierarchy.

Alternatively, scripts can also be attached to empty GameObjects that serve no other function but to hold scripts. So, for instance, an empty GameObject called Script Holder could be created in a scene, and then all the scripts that were in effect in the scene (or most of them anyway) would be attached to that object. This has several benefits; for instance, if someone else picks up the project, they know right where to go to find out what the functionality of the game was. My software developer colleagues always use this sort of mechanism; they are good at reading code and how code interacts with each other and find this methodology much, much faster. For the beginner though, this can be tough. The only way to know if an object is being affected by a script is to read through the scripts; trying to discern those tea leaves can be a daunting task. Another important benefit is this method can often keep prefabs intact. When a script is hung off a prefab, it breaks it, or simply makes it so it's not tied to the original any longer. By keeping the scripts elsewhere, these prefabs can be maintained, which can make the asset update game a little easier.

For us, in this book, we will be using a little bit of both methods. It really is easiest to get started by simply dropping a script on the object you want affected; but in the long run, the script holder that contains scripts does allow for some real benefits.

A Note about This Approach

Through the course of these scripting tutorials, we will be looking at concepts realized through specific project-based efforts. Sometimes, this means we won't be using the absolutely most efficient method on our first pass since sometimes the most efficient methods are harder to understand. This means that sometimes we'll create a script and then later go back and optimize our approach as we learn more.

Tools for Scripts

The following section describes some tools that are available for use with scripts.

Editors
Unity itself does not edit scripts. Although you can view the contents of a script within Unity, the actual editing of the asset is done in some other application. On a Mac the included editor is Unitron. On the PC the included editor is UniSciTE. There are many other editors that could be used; really any basic text editor (Notepad for instance) can be used to edit scripts as they are just basic text. Some of the more sophisticated script editors (MonoDevelop, Unity Script Editor, or UnityDevelop) have some very elegant and powerful functionality built in to assist in scripting.

Both UniSciTE and Unitron "understand" Unity's JavaScript, and thus will provide some visual clues about the script that is being written. Often this will include hints as simple as color coding recognized terms and can include suggestive options as the editor tries to guess what you mean. In these

tutorials we will use the default UniSciTE and Unitron; although give some of those other editors a look—they do some great things.

When scripts are created or edited in the editor, they are just text. When the script is saved (back into the Assets folder), Unity will take a look at the text and attempt to compile the script—this means it checks to see if it understands the script. If there are problems, they will show up in the Console and the game will not run until the errors (mostly syntax) have been corrected.

Console

The Console is actually built into Unity, but is not (by default) shown (although the last line of the Console is visible at the bottom left corner of the interface). It's accessible via Window>Console. The Console can provide some important information. First, if there are errors in a script, the error will be listed in the Console. The Console will even attempt to let you know which line of which script has the problem. None of the errors can be corrected in the Console, but after fixing the problems, the Console will let you know all's well by not complaining.

Additionally, the Console can be used to report what's happening in a script. Scripts can include commands that print values, or list what's called a (Debug. Log) that can help track where a script was fired in game, or what Unity thinks the values of a particular variable are. Being able to see the Console while creating script is critical. Be sure it is visible (Window>Console), and docked within the interface. To dock it, just drag the Console tab to where you wish the Console to reside within the Unity interface.

What Is a Script?

A script contains commands (statements), organized in blocks and functions, as described next.

Commands and Statements

At its core, scripts are collections of instructions or **commands** (sometimes also called **statements**). In JavaScript, each command ends with a semicolon. Without a semicolon, Unity will throw an error and require you to go back and add that bit of punctuation before it will even bother reading the statement. An example of a JavaScript command can be as simple as:

```
height = 6;
```

Blocks

A collection of commands are called **blocks** of code. JavaScript recognizes a block of commands by { and }. It's important that for every single { there is a }. Again, without this piece of punctuation, Unity won't bother trying to listen to what you're saying. See the functions example next for how this works.

Functions

Commands can be just floating around within a script, but generally, blocks of commands are grouped within a **function**. Grouping commands within a

function allows for control over when a collection of commands are actually called on. For instance, if we're pulling a power switch, we only want the animation to play when the character clicks the power switch on; by grouping the collection of commands that do this into a function, we can tie that function to a player's action (like clicking an object).

Any script may contain multiple functions. Some functions just are named by you, the scripter, but there are also some predefined functions in Unity that dictate how a block of code will be carried out, or more importantly, when. These include things like `function Update()`, which means, "do these instructions every frame of the game," and `function OnMouseDown()`, which means, "do these instructions when the player clicks on the object this script is attached to." Much more on these later.

The key to writing functions is to remember all the appropriate punctuation hints. The format works like this:

```
function TurnSoundOff(){
        audio.enabled = false;
}
```

We tell Unity we're building a function named TurnSoundOff with `function TurnSoundOff` and tell it there are no particular parameters for the function with the empty `()`. Then Unity knows we're starting the block of commands for this function by the `{`. Then, the command `audio.enabled = false;` is included and ended with a semicolon. Finally, we tell Unity we're done with this function by ending it with a `}`.

Capitalization matters. "function" is not the same as "Function". When defining a function, always use lowercase function. Generally, the name of the function is capitalized. The organization of this example block of code is mostly for readability. The closing `}` is at the same indentation as the function (so it's easy to see that the function has been closed. However, technically, it could also look like this:

```
function TurnSoundOff()
        {audio.enabled = false;}
```

which is really tough to read, or like this:

```
function TurnSoundOff()
    {
                audio.enabled = false;
    }
```

which is easier still to see how the function is created, but can make the code very long and difficult to read in the book. Usually, the way code is formatted is with the fairly standard:

```
function TurnSoundOff(){
        audio.enabled = false;
}
```

Variables

Variables are most often described as containers or named locations of information. Variables can contain numbers (**integers**—whole numbers with no decimal; or **float**—number with decimals), on/off switches (**Booleans**), collections of text (**strings**), and XYZ values (**Vector3**) among others. The way scripts work is by *declaring* the variables that will be used by the script at the beginning of the script (although they can be declared in other places along the way as well). Then, the functions that follow know of these variables and more importantly of the value that they contain. These values can be defined, accessed, or changed in the blocks of code that follow.

Variables are defined with a declaration statement with the `var` label and should start with lowercase. They can include letters and numbers but shouldn't start with a number. Lastly, it's important that a variable not use the name of other reserved terms that Unity uses for other purposes (so no naming a variable "boolean," for example, since that is used to define a variable type). So, for instance, a variable declaration and access could look like this:

```
var litScene : GameObject;

function TurnLightsOff (){
        litScene.active = false;
}
```

So what's happening there is the script is starting off by declaring the variable litScene (notice it's all one word with lowercase to start and uppercase to define each new word) and we are assigning a **type** with the `: GameObject` (this could also be `Boolean`, `String`, `int`, or `float`). Then, in the function TurnLightsOff, we are deactivating this GameObject (which could be any object in Unity) that we've given the name of `litScene`.

Of course, this script is pretty ineffective right now since we've defined a function but have not told Unity when to "fire" it. It has the instructions, but doesn't know when to use them. We would use other functions like OnMouseDown to trigger that.

Dot Syntax

This is a very useful mechanism within Unity's JavaScript. Basically it is a way of drilling down through objects to components and then to individual attributes of components. It's a way of accessing information in a hierarchical manner from biggest or most general to smallest or most specific. So for instance if we wanted to set the rotation value of a GameObject that we have defined (with a variable that we've named in the script as enemyTank) we could do it like this:

```
enemyTank.transform.rotation.y = 60;
```

It starts with the GameObject enemyTank, then goes to the transform component, then drills down to the rotation part of that component and then the Y value and enters 60 for its value. Note that enemyTank is a name known only to the script; the name of the object in the hierarchy could be something entirely different. Later, we'll look at how to let the script know that enemyTank is actually the object that we named MyAwesomeTank in Maya. Also later we will look at how this can be used to define variables in other scripts, and even other scripts attached to other GameObjects. When any script can talk to any other script, very sophisticated things can happen.

Getting to It

That of course isn't everything about scripting. There's loads and loads of powerful functionality there (if–then statements, counting, lerping, etc.), but much of this is best understood in practice rather than endless descriptions of what code is. In the tutorials of this chapter, we will be writing some scripts using the basics described here, and then talk about what we've done. Along the way new ideas will be presented, so be sure to read the Why? sections.

To get going on scripting, we're first going to build a GUI that we can use the scripting mechanism on.

Tutorial 12.1: Graphical User Interfaces

Graphical User Interfaces (GUI—often pronounced "gooey") are basically the way the user interacts with the computer or program, and usually in ways besides entering text (like through a command line). Computer and web users are very familiar with GUI today, and in fact, most users would be lost without it.

GUI in games are important parts of the gamer's experience. At its most basic level, a GUI will help a player know how to start playing the game after he's been given instructions. In games, GUI has also come to include screen hints or other information that helps the player know what to do and when to do it. The most elegant games provide this guidance in much more intuitive ways, but we will look at some straightforward (but clumsy) methods of providing guidance in the game for the player.

To start with, though, we will use our opening scene as a vehicle to provide a bit of background on the character as well as define the goals of the game. To do this we will make use of Unity's GUITexture mechanism.

GUITexture

The name of GUITexture gives us some hints as to what sorts of assets it likes to work with—textures. Because it is a texture, it means that Unity will be using an image that it draws on the screen. For this opening GUI (Figure 12.1), we will be using several images—a logo, three buttons (mission, bio, begin), two data panels (one to show the mission and another for Aegis's bio info), and finally a Loading plate.

FIGURE 12.1 Interface with
GUITextures.

You can make these yourself if you'd like, or they can be downloaded
on the supporting web site (http://www.Creating3dGames.com) as
2DAssets.unitypackage and imported into your project via Assets>Import
Package>Custom Package.

A few notes about these textures for use in GUITextures:

- They were created in Photoshop.
- The size of the textures are all power of two. The buttons are 512×128,
 the logo is 1024×256, the data panels are 512×512, and the loading
 plate is 1024×1024. Although not strictly necessary, coming in as
 power-of-two textures makes the compression faster and keeps the
 images cleaner.
- Each of the textures (except for the Loading plate) have a distinct Alpha
 channel (not just a transparent background in Photoshop).

Step 1: Make sure the assets are present in the project. They should be
visible in the Project panel. If you imported the 2DAssets.unitypackage,
they will be within a folder called 2D Assets.

Step 2: Open the Unity scene Scene-Opening by double-clicking it in the
Project panel. Remember that this is the scene we created earlier with
Aegis spinning.

Step 3: Organize the interface to allow the Game window to be clear
and large. If you have a dual-monitor setup, setting up the Game
window to fill an entire monitor is very helpful. Even if you don't
optimize by grabbing the Game tab and tearing it away from the
interface so that it is a floating window, resize the window to fill much of
your available screen.

Warnings and Pitfalls
Remember that
when bringing
packages in, always
use Assets>Import
Package—dragging a
package into your Assets
folder will not work.

Warnings and Pitfalls
When this 2DAssets
package is imported, you
are likely to get some
errors in relation to an
"Unknown identifier:
'iTween'" This is due to
some things that we'll
work on later, so for
now, don't worry about
these errors. They'll be
fixed later when iTween
is brought into your
project.

Why?
Laying out GUI requires that the game can be seen. Making sure it's not
nested or squished within the Unity interface will provide a better chance
of getting the look of the final game upon construction.

Step 4: In the Scene window, move the Main Camera in the scene so that (in the Game window) Aegis appears on the side with room for the GUI on the right side of the screen.

Step 5: Create a GUITexture GameObject. Choose GameObject>Create Other>GUI Texture. A new GameObject will appear in the Hierarchy panel called UnityWatermark-small (or possibly New Texture, depending on your system setup). You will also likely see a Unity logo appear in the middle of both the Scene and Game windows. This is the GUITexture that Unity automatically and narcissistically assigns its own logo to.

Step 6: Assign the Incursion_Logo texture to the GUITexture. Do this by either dragging the Incursion_Logo texture from the 2D Assets folder in the Project panel to the Texture input field of the GUITexture component in the Inspector, or by using the target icon button next to the Texture (of the GUITexture component) input field.

Step 7: Resize the texture. Do this in the Inspector under the GUITexture component. Expand the Pixel Inset section and change the Width to 512 and the Height to 128 (or smaller if need be on your monitor).

Tips and Tricks

Defining the Width and Height defines the absolute size of the GUITexture on the screen. Although the image was built at much larger (1024×256), upon placement it just seemed too big. But because we can define the absolute size in the GUITexture component, the original size doesn't carry a huge importance. Do keep in mind though that if the Width and Height are set larger than the original image, there is always some degradation of quality, and sometimes it's just worth it to go back into Photoshop and rebuild the image at a more appropriate size.

Step 8: Position the logo by changing the Transform X = 0.5, the Transform Y = 1, and changing the Pixel Inset X = 0 and Y = −200. All of this of course is done in the Inspector (Figure 12.2).

Why?

Step 7 resized the texture while step 8 gets it in the right spot. The way that GUITextures work can be a little confusing. Notice that by default the Transform component for the New Texture object is set up with X = 0.5 and Y = 0.5 (note that these are not the Pixel Inset values, they are the Transform values); this is the center of the screen. What's happening here is Unity looks at the total size of the screen and defines it at 1×1. X = 0 and Y = 0 is the bottom-left corner of the screen while X = 1 and Y = 1 is the top right. Unity takes the bottom-left corner of the GUITexture, and places it at the Transform Position coordinates, then offsets the image according to the Pixel Inset section of the GUITexture component.

So, since Unity thinks of the image's axis point as the bottom left if the Pixel Inset X and Y are both set to 0, and the Transform's X and Y are both at 0, the image will be nested against the bottom-left corner of the screen. Give it a try.

If Transform's Position X is 0.5, the bottom-left corner of the image will be in the middle of the screen horizontally. Then, if the Pixel Inset for X is set to the negative value of half the size of the image (offsetting the image half the width of the image to the left), the center of the image will be sitting at exactly halfway on the screen horizontally. So if the image is 512 pixels wide, having the Transform's Position X = 0.5 and the Pixel Inset X = −256, the center of the image (horizontally) will be at the horizontal center of the screen.

If the assumption is that the screen will be split about in half with the left half being Aegis spinning and the interface on the right half (or a little more than the right half), we can align the left corner of the image in the center of the screen (Transform's Position X = 0.5). Then, if it should be at the top we can change the Transform's Position Y = 1. Then change the Pixel Inset Y = −200 (this pulls it 200 pixels off the top of the screen).

FIGURE 12.2 Settings for the title logo.

Step 9: Rename the GameObject to `Incursion_Logo`.
Step 10: Create another GUITexture and assign the texture Button_ Mission to it. Change its Pixel Inset Width to 256 and Height to 64. Rename New Texture to `Button_Mission`.
Step 11: Change the Transform Position X=0.5 and Y=0.

Why?
This will roughly place this button at the bottom center of the screen. From here we can finesse its placement on the screen.

Step 12: In the Inspector window, move the mouse so that it rests over Pixel Inset X. Notice that the mouse grows a pair of arrows (Figure 12.3). By clicking-dragging here, the value of Pixel Inset X will dial up or down. Correspondingly, the image will slide left and right in the Game window. Position it toward the bottom of the screen to allow for additional content between it and the logo (Figure 12.4).

FIGURE 12.3 Grown arrows allowing for values to be slid up and down.

FIGURE 12.4 First button placed.

Step 13: Copy and paste Button_Mission. Change the Texture from Button_Mission to Button_Bio. Rename in the Hierarchy to `Button_Bio`. Use the sliding value trick to adjust the Pixel Inset X to slide this new one over to the right.

Step 14: Repeat step 13, but use Button_Begin. Be sure to rename appropriately. The final output should look something like Figure 12.5.

FIGURE 12.5 Placed and named buttons and data panels.

Step 15: Create biography data panel. Do this by creating a GUITexture, using DataPanel_Biography (in 2D Assets) to define the Texture. Center it on the screen (Transform Position X = 0.5 and Y = 0.5). Set the size to 512×512 (Pixel Inset Width = 512, Height = 512) and offset Y to taste (Pixel Inset Y = -256 on my screen). Rename to `DataPanel_Biography`.

Step 16: Repeat step 15 and create a data panel `DataPanel_Mission`. You could also just copy/paste DataPanel_Biography, swap the Texture (use DataPanel_Mission from the 2D Assets), and rename to `DataPanel_Mission`.

Why?

Note that both of the DataPanels will be active and right on top of each other. Don't worry, we'll hide them in just a bit.

Step 17: Change the color of each of the buttons to a dark gray. Do this by selected each button in the Hierarchy panel. Then in the Inspector panel, click the Color swatch. Pick a darker gray (I used RGB all equal to 50).

Why?

The idea here is to make the buttons highlight white when the player mouses over them. Although we could define this programmatically, we can also manually start with the buttons unhighlighted.

Scripting the GUI

Step 18: Nest the Console in your interface. First make the Console visible with Window>Console. Grab the console tab and drag it over the Unity interface. Unity will attempt to snap and dock it into place. When the mouse is released, the console will stay there.

Step 19: Create a Scripts folder to hold the script assets. In the Projects panel, be sure nothing is selected (click some empty gray space if need be), and choose Create>Folder. Rename the folder `Scripts`.

Step 20: Create a new script in the Scripts folder. To do this, select the Scripts folder and choose Create>JavaScript. This will create a NewBehaviourScript that is already inside the Scripts folder.

Step 21: Rename the NewBehaviourScript to `OpenSceneButtonsScript`.

Step 22: Open the script by double-clicking OpenSceneButtonsScript. This will open either Unitron or UniSciTE (or another script editor if you've defined it to do so).

Step 23: Delete all the contents of the script (highlight it all and delete).

Why?

By default these new scripts contain the built-in function, function Update() and the {} that sandwich the function Unity is sure you're going to write. In this case, we are going to write a function that doesn't fire every frame

(which is what Update does) but rather fires only when the mouse is over an object—in this case a GUITexture. So delete the suggested script start.

Step 24: Enter the following script:

```
function OnMouseEnter () {
        guiTexture.color = Color (1,1,1);
}
```

Why?

OnMouseEnter is a built-in function Unity knows and includes. Basically, when using it Unity is saying, "when the mouse enters the space of the object this script is attached to, do the commands within the {}." In this case, the commands between the {} is to define the color of the GUITexture to be RGB = 1 (the three values there (1,1,1) are (R,G,B). So when this script is attached to one of the GUITextures that are buttons, when the mouse rolls over it, it will pop up white.

Step 25: Save, and go back into Unity. Check the Console for errors (usually a forgotten ";" or a missing ")" or "}"). If the Console remains quiet, all's well with the syntax of the script.

Tips and Tricks

If there are problems with the script's syntax, Unity will point out which line numbers they are on. Annoyingly, UniSciTE is set up so that the line numbers don't appear by default. To display them, in UniSciTE, choose View>Line Numbers. Having access to that makes fixing syntax problems much, much faster.

Warnings and Pitfalls
Before Unity will let you run a game, all the script errors must be fixed. If (for some reason), you have scripts that were brought in from a unitypackage that you aren't using and they're throwing errors, you can just delete, or even better, copy them to some place outside of the Unity assets folder and then delete them from the Unity project (be sure to delete from within Unity).

Step 26: Apply the script. Drag the OpenSceneButtonsScript script from the Project panel onto the Button_Mission GameObject in the Hierarchy. Also drag the script to Button_Bio and Button_Begin.

Tips and Tricks

Note that what's happening here is we are using the same script on multiple objects. Reusing scripts like this can be a tremendous time saver.

Why?

Right now we are draping individual objects with scripts that affect those objects' direction. It's worthwhile to point out that the dot syntax is in full effect here. In the script, the command reads guiTexture.color, but what this really means is this.guiTexture.color. The "this" means this GameObject the script is attached to. So it's looking at the GameObject the script is attached to, then down to the guiTexture component, and the color attribute of that component.

Step 27: Play the game. Move the mouse over the buttons and watch them light up.

Why?

But there's a problem, no? The buttons light up but they stay lit. The reason for this is that the script is looking for the frame where the mouse moves over the button and on that frame it fires the command guiTexture.color = Color (1,1,1);. Then it doesn't do anything to this GameObject until the mouse again is over it. It means that the guiTexture node never gets the instructions to go back to gray. But we can fix that.

Step 28: Reopen the OpenSceneButtonsScript script by double-clicking it in the Project panel. Add the following text to the script:

```
function OnMouseExit (){
        guiTexture.color = Color (.2,.2,.2);
}
```

Why?

Taking a look at this, you can see that the script just watches for when the mouse exits the object, and then changes the color to RGB = 0.2 (which happens to be the gray of the unhighlighted buttons). So we now have a function that does one thing when the mouse is on the button, and another when it leaves.

Step 29: Save, check the console for errors, fix any that appear, and test the game. The buttons should highlight and darken appropriately.

Recognize What's Being Clicked

Alrighty. The buttons highlight and dehighlight, but they do nothing when clicked. To make this happen we need to flush out the script still further. Now, on the one hand we could create a custom script for each button that said OnMouseDown activate the corresponding DataPanel. However, this would have to be custom to each button since the Bio button would need to activate the DataPanel_Biography object and deactivate DataPanel_Mission, but it would be the opposite for the Mission button. Then, the Button_Begin would need yet another collection of script to launch the next game level.

If Statements

Instead, let's look at a little more elegant approach and modify the existing script to do all of this for us. To do this, we need Unity to check the name of the object it is clicking. To do this we need to look at the idea of **if statements**.

The format for if statements goes like this (this isn't real code, just an illustration):

```
if(this is true){
        do these things;
}
```

There are a few ways to ask Unity to check if (this is true). One way is to check if two values equal each other. To check this, JavaScript uses two equals signs (==). One equal sign is used to define a value, two checks for equivalency. So (with some more pseudo code):

```
if (pieceofClothing == "hat"){
        PutOnHead
}
```

This checks if the piece of clothing is a hat. If it is (=="hat"), then go ahead and fire the command Put On Head.

What we're going to do there is when a button is clicked, Unity is going to check to see if the name of the object matches "Button_Bio" for instance, and then if it does, activate the DataPanel_Biography GameObject.

But before we do that, we need to create some variables to hold the DataPanel objects. Then these variables can be used in the code to turn the DataPanels on and off.

> **Step 30:** Open OpenSceneButtonsScript. At the top of the script make the following variable declarations (the entire code is included here with the additions in italics):
>
> ```
> var dataPanelBiography : GameObject;
> var dataPanelMission : GameObject;
>
> function OnMouseEnter () {
> guiTexture.color = Color (1,1,1);
> }
>
> function OnMouseExit (){
> guiTexture.color = Color (.2,.2,.2);
> }
> ```

Why?

We know it's a variable declaration because it begins with var. Then we name the variable (dataPanelBiography and dataPanelMission) and define its type (tell Unity what kind of information will be housed in this variable—in this case a GameObject). This means anywhere else in the code we can do things to, or get information from, these new variables. Of course, we aren't doing anything with them and we have not linked them to our GUI Textures quite yet, but we will.

> **Step 31:** Save and return to Unity.
>
> **Step 32:** Assign the contents of the variables. Select any of the three buttons where this script is attached and look for the Button Highlight (Script) component that will show up in the Inspector. Notice that there are two new input fields there (Data Panel Biography and Data Panel Mission). These are the variables we just declared. Both should read None (Game Object). To assign a GameObject to this variable, just drag the GameObject from the Hierarchy onto the input field. So for Data Panel

Biography, drag the DataPanel_Biography GUITexture object from the Hierarchy to its input field. Do the same for Data Panel Mission. Repeat this process for each of the buttons.

Why?

Now each button knows what the DataPanels are. Now it's time to define what to do with them.

Step 33: Open OpenSceneButtonsScript (or just swap to UniSciTE or Unitron where the script is likely still open).
Step 34: Add the following block (italicized):

```
var dataPanelBiography : GameObject;
var dataPanelMission : GameObject;

function OnMouseEnter () {
        guiTexture.color = Color (1,1,1);
}

function OnMouseExit (){
        guiTexture.color = Color (.2,.2,.2);
}

function OnMouseDown(){
        if (name == "Button_Bio"){
                dataPanelBiography.guiTexture.enabled = true;
                dataPanelMission.guiTexture.enabled = false;
        }
}
```

Why?

The first part of the script (function OnMouseDown ()) should be pretty clear now. We're telling Unity that when the mouse is clicked on this object do the things within {}. Then comes the powerful part; when the object (what this script is attached to) checks to see if the name is "Button_Bio" (if name == "Button_Bio", and it is important that the name typed here matches exactly the name listed in the Hierarchy). If it is, turn on the dataPanelBiography's GUITexture component (dataPanelBiography.guitTexture.enabled=true) and turn off the dataPanelMission component (dataPanelBiography.guiTexture. enabled=false).

If the name of the object clicked is not "Button_Bio" it moves on to the next block of code.

Tips and Tricks

Enabled vs Active: Generally GameObjects are activated (this .active = true), while components are enabled (this.component .enabled = true).

Step 35: Further flesh out the checking mechanism to include the Mission button:

```
var dataPanelBiography : GameObject;
var dataPanelMission : GameObject;

function OnMouseEnter () {
        guiTexture.color = Color (1,1,1);
}

function OnMouseExit (){
        guiTexture.color = Color (.2,.2,.2);
}

function OnMouseDown(){
        if (name == "Button_Bio"){
                dataPanelBiography.guiTexture.enabled = true;
                dataPanelMission.guiTexture.enabled = false;
        }
        if (name == "Button_Mission"){
                dataPanelMission.guiTexture.enabled = true;
                dataPanelBiography.guiTexture.enabled = false;
        }
}
```

Why?

Now, when the object is clicked it checks to see if the name of the object is "Button_Bio"; if it is not, it checks to see if its name is "Button_Mission" and if it is, it disables dataPanelMission's GUITexture and enables dataPanelBiography's GUITexture.

Step 36: Allow the game to start on clicking the begin button.

```
var dataPanelBiography : GameObject;
var dataPanelMission : GameObject;

function OnMouseEnter () {
        guiTexture.color = Color (1,1,1);
}

function OnMouseExit (){
        guiTexture.color = Color (.2,.2,.2);
}

function OnMouseDown(){
        if (name == "Button_Bio"){
                dataPanelBiography.guiTexture.enabled = true;
                dataPanelMission.guiTexture.enabled = false;
        }
        if (name == "Button_Mission"){
                dataPanelMission.guiTexture.enabled = true;
                dataPanelBiography.guiTexture.enabled = false;
```

```
        }
        if (name == "Button_Begin"){
            Application.LoadLevel ("Scene-EntryWay");
        }
    }
```

Why?

Lastly, if the object is named "Button_Begin" it will load the level or go to the level Scene-EntryWay, which is the Unity scene created in earlier tutorials.

Step 37: Save and return to Unity. Adjust any errors with syntax; this can take a little while and some careful scrutiny, but remember Unity won't run until the syntax is acceptable.

Step 38: Deactivate DataPanel_Biography and DataPanel_Mission GameObjects' GUITextures. One at a time, select the GameObject in the Hierarchy, then in the Inspector click off GUITexture component. This will make these DataPanels disappear from the Game view.

Why?

When the level starts, both of the DataPanels should be off and only be visible when their corresponding button is clicked.

Step 39: Play. Test the game. The mission and bio buttons should both work and show the corresponding DataPanels when clicked. The begin button assuredly will not work yet—we'll fix that in a bit.

Further Optimization

The script works (well mostly, but we'll fix that Begin button in a bit). However, it's fairly clumsy to have to define manually the DataPanels for each pesky button. It would sure be nice if Unity would do that for us.

function Start and function Awake

So far we have used functions that are activated when a specific user-defined event occurs (the player moves the mouse over an object, leaves the object, or clicks the object). We can also write functions that happen when the game begins on an object (containing a script) that is activated.

function Awake is a function that is called when the game launches. Well, in theory it fires after all the objects in the scene are loaded, but before the player can interact with the rest of the game. This means certain settings can be set here, or variables defined.

A close cousin to function Awake is **function Start**. The difference is that function Start fires after function Awake, and will fire only if the object is active. This means an object could be turned off and the game started, and

the function Start would remain dormant but would fire up as soon as the object was activated. However, anything that is in a function Awake will still fire whether the object is active or not.

The reason all this matters to us is we can have the script go and find our two DataPanels and populate the variables of the OpenSceneButtonsScript for us (no need to manually populate). For most cases where we're defining variables, function Awake should be used because the definitions should happen right at the beginning.

Step 40: Reopen OpenSceneButtonsScript . Replace the variable declarations with the following:

```
private var dataPanelBiography : GameObject;
private var dataPanelMission : GameObject;

function Awake (){
    dataPanelBiography =
GameObject.Find("DataPanel_Biography");
    dataPanelMission =
GameObject.Find("DataPanel_Mission");
}

function OnMouseEnter () {
    guiTexture.color = Color (1,1,1);
}

function OnMouseExit (){
    guiTexture.color = Color (.2,.2,.2);
}

function OnMouseDown(){
    if (name == "Button_Bio"){
        dataPanelBiography.guiTexture.enabled = true;
        dataPanelMission.guiTexture.enabled = false;
    }
    if (name == "Button_Mission"){
        dataPanelMission.guiTexture.enabled = true;
        dataPanelBiography.guiTexture.enabled = false;
    }
    if (name == "Button_Begin"){
        Application.LoadLevel ("Scene-EntryWay");
    }
}
```

Warnings and Pitfalls
Some of the lines of code are longer than the format of a book will allow. Remember that there is usually a new line at the end of each statement, and that each statement ends with a ";". So if a line shown here doesn't end with a ";" or a "{" (for blocks of code), keep it as a solid line of code.

Warnings and Pitfalls
GameObject.Find is a very handy tool to have. However, it can quickly be abused. For instance, if GameObject. Find is contained within a function Update, this means that Unity is being asked to go find an object on every single frame. Very many of these and suddenly Unity is more busy looking for objects than it is running the game. Generally, use GameObject.Find when it can fire once (like in function Awake situations or within another function that is called at a very specific time).

Why?
There are two things happening here. First, private was added before each of the variable declarations. A private variable is a variable that can be defined, but it isn't defined in the Unity Editor via dragging items as we did before. Although these could remain public, since they are going to be defined in the script, it keeps another developer from trying (or feeling like they need) to populate variables.

Next is the function Awake section. It uses the handy GameObject.Find functionality. The code statements are defining the two variables we've declared earlier, and doing so by going out and finding the GameObjects whose names match DataPanel_Biography and DataPanel_Mission, respectively.

Step 41: Save and return to Unity.

Step 42: Select any of the buttons and notice that the public variables are gone. But note that when the game is played, everything still works.

Application.LoadLevel

The last button, the Begin button makes use of the Application.LoadLevel function. This allows us to move from one Unity scene to another. However, if the Begin button is clicked now a warning will pop up in the console that says "Level 'Scene-EntryWay' (-1) couldn't be loaded because it has not been added to the build settings." We haven't talked much of builds, and we will much more later, but it will be important to cover a bit of it here.

Build Settings

Builds are actually what Unity outputs. People play the builds that Unity produces. Part of Unity's strength is the ability to author once and then output builds for multiple platforms. Incursion is undoubtedly too heavy for mobile devices, although with a bit of poly paring down and the appropriate licenses it could ultimately be published to Android or iOS.

The Build Settings are where the target platform is defined, and the levels to be included are indicated. To access the Build Settings go to File>Build Settings (Figure 12.6).

FIGURE 12.6 Build settings.

The top part of the Build Settings window (Scenes in Build) is where the scenes that are to be included in the build are dragged to. Figure 12.6 shows what it looks like after this area is populated for Incursion. Below that is where the Platform and details of that platform (Windows vs Mac) are defined. Down at the bottom also includes options to adjust the Player Settings (this is Player as in the container that holds the game, not the player that is the person playing the game). There are also the Build and Build and Run buttons. These will actually output the game as it presently stands.

But don't output yet; for now, just populate the Scenes in Build with Scene-Opening and Scene-EntryWay and close the window.

> **Step 43:** Populate scenes to be included in the game by dragging the scene files from the Project panel into the Scene In Build section of the Build Settings window.
>
> **Step 44:** Play the game. This time, when the begin button is pressed you'll be immediately transported to the EntryWay built in past tutorials.

Conclusion

So there's your first script. Well, ok, maybe the second, but hopefully the first where you understand how things were constructed and why.

There's actually a lot that was covered in this introduction to scripting. You now know how to construct a block of code, what a function is, several types of functions, and how to declare variables, and how to populate them in the editor or populate them via script.

But, there is still lots to do and lots to learn. In the next chapter we'll start looking at more advanced functionality and setups that will allow the player to enter a blackened base with a flashlight, find the power switch, and turn everything on.

Homework and Challenges

> **Challenge 1:** Going from the Opening scene to the EntryWay scene works, but is a little abrupt—everything freezes and then jumps suddenly to the next scene. Use the OpenButtonsScript to add a big Loading Plate that comes up when the Begin button is pressed so the player doesn't think the game has frozen.

Hints:

1. Remember to build a new GUITexture object.
2. Account for this new GUITexture in the script both as a variable and when the variable is populated.
3. Be sure to pull up this new GUITexture before the command that takes us to the new level.
4. Note that in addition to Transform X and Y, there is still a Transform Z. This determines which GUITexture (if there are several) is closer to the camera, and thus drawn on top.

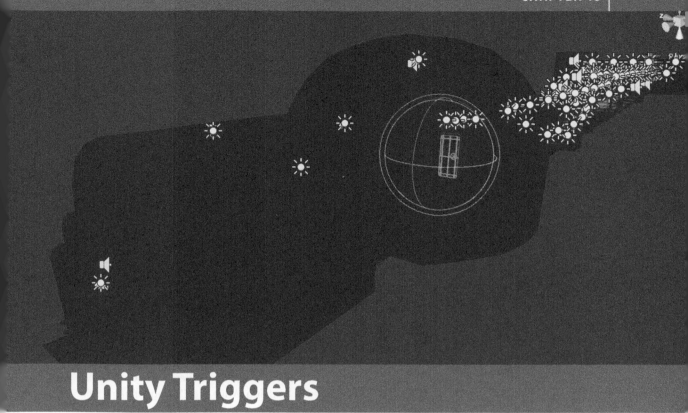

Unity Triggers

Thus far we have looked at causing commands to be fired on user-driven events (such as mouse over, mouse down, etc.). We've looked at firing commands at the game's opening. In this chapter we will begin looking at firing commands based upon where the player is in the level. We'll do this via **triggers**.

Specifically we will look at using this sort of mechanism to provide screen hints via GUIText. Additionally, this will allow for a new way to move from this EntryWay level to the Hallway level. Triggers can be used to trip any event though. Booby traps could be sprung, lighting changed, objects created or destroyed, all through a trigger.

The First Person Controller has a collider around it that's actually part of the Character Controller script. Remember that colliders are Unity's way of keeping track of when objects bump into each other or penetrate each other (referred to as **collision detection**). When we imported the EntryWay level from Maya, we activated the Generate Colliders option in the FBX Import section. This ensured that we didn't fall through the floor—the collider of the level and the collider on the First Person Controller kept this from happening.

Any object can be a trigger. With a bit of script the collider that is attached to an object won't act as a stop for other objects coming into contact with it, but rather will make note that it's happening. On the frame that another collider collides with an object that is designated as a trigger, other events can be triggered via linked functions.

Designating Triggers

Any object with a collider can be a trigger. Usually though, the easiest thing to do is create a cube (Asset>Create Other>Cube) since it already comes with an efficient Box Collider component. Then, to make it a trigger, just click the Is Trigger checkbox in the Inspector under the Box Collider section (Figure 13.1). Then, checking off the Mesh Renderer component makes the trigger invisible to the player.

Tutorial 13.1: Activating and Changing Screen Hints with Triggers

In this chapter we are going to tackle a couple of Unity tricks at once. We are going to use triggers to help the player understand where he is supposed to go and what he is supposed to be doing. While a really elegant game will provide this in a much more subtle way (sometimes providing a training level, sometimes simply by great game mechanics design), for our short game we'll be more overt and just tell the player what to do.

To do this we will first look at how Unity works with GUIText. GUIText is simply text that is drawn on the screen above everything else; this is similar to GUITextures except this uses a font and can be dynamic (the text can change in game).

FIGURE 13.1 Designating a trigger.

Then, once we have set up some GUIText, we will set up triggers that designate when certain text should appear. Lastly, we'll tie it all together and work with the particularly powerful idea of firing functions contained in one script through the commands of another. A quick disclaimer: The method we're employing here will be a great illustration of some concepts within Unity. However, some of these things can be done more efficiently and we'll revisit this mechanism later to tighten things up.

Step 1: Open Scene-EntryWay in Unity.

GUIText

Step 2: Create a GUIText GameObject. GameObject>Create Other>GUIText. This will create a new GameObject in the Hierarchy that contains a GUIText component accessible in the Inspector. It will also draw the words "GUI Text" in the middle of the Game and Scene windows.

Step 3: Rename the GUIText GameObject to `GUITextHints`.

Step 4: Select GUITextHints in the Hierarchy and in the Inspector change the Anchor to Lower Center. Change Alignment to Center. Change the Font Size to 30 (or to taste). Finally use Unity's sliding value arrows to change the Pixel Offset Y and pull the GUIText to the bottom of the screen (Figure 13.2).

FIGURE 13.2 Settings and results of the GUIText adjustments.

Why?

GUIText has a few more options than the GUITextures, and some that are quite handy. For instance, Anchor allows for a different axis for the text. With a lower center for the Anchor setting and a center setting for the Alignment, we can easily make sure that the text is centered at the bottom of the screen. This is especially powerful because later we will be dynamically adjusting the text that actually appears, and these settings will ensure that the block of text down there has a quick and reliable typographical layout.

Custom Fonts

GUIText allows for the use of outside fonts. True to Unity's work flow paradigm, fonts are considered just another asset, and thus are imported by dropping them into the Unity project Assets folder. True Type Fonts work great and are readily available all over the web. I'm using a font called Mom's Typewriter that is easily found with a quick Google search. Find a font you like and download it to your hard drive.

> **Step 5:** Import your font. Do this in your OS and drag the downloaded (or installed font) into the Assets folder of the Incursion–Unity project folder. I placed my copy of the font in my 2D Assets folder.
>
> **Step 6:** Use the font for GUITextHints. To do this, just select GUITextHints and drag the font from the Project panel to the Font input field of the GUIText component. The GUIText on screen will update to this new font (Figure 13.3).

FIGURE 13.3 Updated font.

> **Step 7:** Deactivate the GUIText component for GUITextHints (in the Inspector).

Why?

We don't want text always visible—only when prompted by triggers. Turning it off here allows us to flip it back on via script when we want it there.

Creating Triggers

There's actually very little new information here. Creating triggers (in this case) will be the process of creating and placing Cubes in the spots of the game where we want screen hints to appear.

> **Step 8:** Move the First Person Controller to approximate Figure 13.4, as though he has just come up over the mountain after being dropped off in the vicinity.

FIGURE 13.4 Rough starting location of the First Person Controller.

Step 9: Create and place a cube to match Figure 13.5. Create the cube with GameObject>Create Other>Cube. Move, scale, and rotate the cube so its location approximates Figure 13.5.

FIGURE 13.5 Placed cube to act as first trigger.

Why?

Basically we're boxing in the First Person Controller. No matter where the player goes, he will hit this box and get the first bit of information that will tell him to go find the door.

Step 10: Rename the cube `Trigger-FindDoorHint`.

Step 11: Make Trigger-FindDoorHint a trigger. Do this in the Inspector with the object selected. Look for the Box Collider component and click the Is Trigger option.

Why?

Visually nothing will change, but functionally things are different in Unity. Go ahead and try playing the game right now and you will walk right through that box. The collider is no longer stopping you, just noting that you have collided (or entered) its volume.

Scripting the GUIText

The scripting for this section will be in two parts. One script, which will be attached to the GUITextHints object (the GUIText) will control what text is shown and for how long. The second script that will be attached to the triggers will be responsible for determining when a trigger is tripped, and then sending the message to the GUIText object to display the appropriate text. We'll build the GUIText controlling script first.

Step 12: In your Project panel, select the Scripts folder (where you'll want to store scripts). Create a new JavaScript and name it `EntryWayGUITextScript`. Double-click the script to open it in your script editor.

Step 13: Delete the default information contained in that script and enter the following:

```
function FindDoorHint (){
     guiText.enabled = true;
     guiText.text = "Find the secure entrance to the
base.";
     yield WaitForSeconds (3);
     guiText.enabled = false;
}
```

Why?

This function is a bit different than those we've written in the past. While most of the functions we've built included a call to action (OnMouseDown, OnMouseEnter, etc.), this one simply provides a name, FindDoorHint—we are creating a custom function that we're are deciding to name FindDoorHint. In this case, our function is a block of instructions waiting to be told to jump into action, but presently there is no such instruction; we'll build that into the other script.

The first line of this block just turns on the GUIText component (remember we turned it off earlier?). Then it defines what the text should actually say (it's defining the text part of the GUIText component). The third line says, "after you've shown the text, wait for 3 seconds," and then the fourth line turns the GUIText component off so the onscreen text will disappear.

Step 14: In the same script, create two more similar functions with a water warning and a hint to use the EMP. Here's what the whole thing should look like up to this point:

```
function FindDoorHint (){
     guiText.enabled = true;
     guiText.text = "Find the secure entrance to the
base.";
     yield WaitForSeconds (3);
     guiText.enabled = false;
}

function StayOutOfWaterHint (){
     guiText.enabled = true;
     guiText.text = "Stay out of the water! At this
temperature, it's lethal.";
     yield WaitForSeconds (5);
     guiText.enabled = false;
}

function TryEMPHint (){
     guiText.enabled = true;
     guiText.text = "Try using EMP to disable exterior
security system.";
```

```
        yield WaitForSeconds (5);
        guiText.enabled = false;
}
```

Why?

These are literally copied and pasted with the specifics of what the text says and how long to display it altered. Again, what we have here are a lot of instructions waiting for the nod to fire. Note that we also haven't created the triggers for the StayOutofWaterHint and TryEMPHint. That will come.

Step 15: Save, return to Unity, and check for syntax errors in the Console. Fix if needed.

Step 16: Attach this script to the GUITextHints GameObject. Remember this is done by just dragging the script from the Project panel to the GameObject in the Hierarchy.

Scripting Triggers

It's all fairly anticlimactic at this point. This script is attached to the object it needs to be and is all set to start displaying and changing text, but nobody's told it to do so yet. With this next script we will add real functionality to the trigger created earlier and instruct it to start firing functions created in the first script.

Step 17: In your Project panel, select the Scripts folder. Create a new JavaScript and name it `EntryWayTextTriggerScript`. Open it by double-clicking it.

Step 18: Delete the default code and enter the following:

```
private var guiTextObject : GameObject;
```

Why?

This script we are writing here will be attached to the triggers. But this script needs to talk to another script attached to another GameObject. The other GameObject is GUITextHints, which we're going to call guiTextObject here.

Step 19: Add the following to define the new variable:

```
private var guiTextObject : GameObject;

function Awake () {
        guiTextObject = GameObject.Find("GUITextHints");
}
```

Why?

Similar to the last chapter, this function Awake runs at the start of the game and goes out and finds the object GUITextHints and defines that as guiTextObject within this code.

Tips and Tricks

Knowing where to put spaces and new lines can be a point of concern for many beginning scripters. In some cases, Unity is very tolerant of spaces (for instance in the preceding code there could be spaces here guiTextObject = GameObject or not (guiTextObject=GameObject) and both would work. However, when describing a "phrase" (like GameObject .Find("GUITextHints")) or using dot syntax, leave the spaces out.

Step 20: Create the trigger functionality with the following code:

```
private var guiTextObject : GameObject;

function Awake(){
     guiTextObject = GameObject.Find("GUITextHints");
}

function OnTriggerEnter (other:Collider){
     if (name == "Trigger-FindDoorHint"){
     guiTextObject.GetComponent(EntryWayGUITextScript)
.FindDoorHint();
     }
     if (name == "Trigger-WaterHint"){
     guiTextObject.GetComponent(EntryWayGUITextScript)
.StayOutOfWaterHint();
     }
     if (name == "Trigger-EMPHint"){
     guiTextObject.GetComponent(EntryWayGUITextScript)
.TryEMPHint();
     }
}
```

Why?

So here we get to the meat of triggers. The function OnTriggerEnter (other:Collider) line is simply saying, "when another collider enters the volume of the trigger, do the following." What follows is an extension of techniques we learned in the last chapter; when a collider enters the trigger, it first checks to see if the name of the object this script is attached to is Trigger-FindDoorHint. If it is, it goes to the guiTextObject GameObject (which is our GUITextHints), gets the component EntryWayGUITextScript (the script we wrote earlier in this chapter), and fires the function FindDoorHint. Pretty cool eh?

If the trigger this script is attached to is not named Trigger-FindDoorHint it moves on to check for the next name on the list and so on.

The exciting idea here is one script on one object is going out finding another object, finding a script on that object, and executing a function within that other script.

Step 21: Save and return to Unity. Fix any syntax errors that pop up in the console.

Step 22: Attach this script to Trigger-FindDoorHint (the big cube acting as a trigger).

Step 23: Play the game. The cube is probably big and dark in your scene, but will be easy to see. As you walk through it, the text "Find the secure entrance to the base" will appear at the bottom of the screen and disappear after 3 seconds. If this doesn't happen, double-check all the names called for in the scripts.

Tips and Tricks

The approach we've used here of nesting all the variables in private variables and using the GameObject.Find and GetComponent methodologies keep the Unity editor clean. We don't need to connect a bunch of objects manually to any scripts, we are taking care of it in script. The benefit of this is if for some reason an object is deleted and we recreate it, we don't have to remember the places where it had to be plugged in. The drawback is that the connections of objects to scripts can only be seen in the scripts and not directly in the Editor. There are trade offs either way.

Step 24: Create additional cubes (converted to triggers) for the Trigger-WaterHint (around the water areas) and Trigger-EMPHint (as the player approaches the door) triggers. Be sure that these triggers also include the EntryWayTextTriggerScript. Remember this can also be done by copying/pasting the Trigger-FindDoorHint GameObject and moving/scaling/rotating/renaming the copy. Notice that in Figure 13.6 there are two large triggers covering the canal part. As long as both of these triggers have the same name, our mechanism will work.

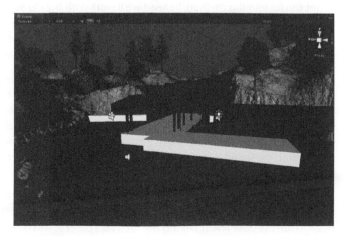

FIGURE 13.6 Additional triggers in the scene to provide additional on-screen hints.

Step 25: Test the triggers. Play the game and see if indeed the text appears and changes at the appropriate places.

Step 26: Turn off the trigger's Mesh Renderer components. Select each trigger in the Hierarchy and then in the Inspector panel, and click off Mesh Renderer. This will make the triggers disappear from view.

Why?

They are no longer visible, but still functional. When we were building the mechanism it was handy to have the triggers visible because it made placement easier, and it made it easier to see when we actually had hit a trigger when playing the game. However, obviously we don't want these seen in the final game, so once we're confident that they are working, making them invisible is required.

Step 27: Test again. Play the game to ensure the triggers are still working as planned.

Triggers to Swap Levels

In the last chapter we used a GUITexture as a button that when clicked invoked the Application.LoadLevel process that exited Scene-Opening and entered Scene-EntryWay. Triggers are another nice way of doing this. As a player walks to a certain place in a level, Unity can exit that level and take the player to a new one.

Now, in today's games, this sort of Loading screen between levels is not as elegant as many other games. And in fact, Unity's new Occlusion Culling mechanisms would allow (in theory) for very large levels or even collections of levels to all be in one scene file. Occlusion Culling simply wouldn't draw the parts or levels that aren't seen (as opposed to the default behavior where Unity draws everything within the camera's frustrum but just draws the things closest to the camera last). But Occlusion Culling is a Unity Pro feature and requires some careful construction of assets to begin with, so we're not going to get too far into this method. Instead we'll work with the old school scheme of having one Unity scene be the EntryWay and another be inside the base. If you plan to expand the game, you might consider other parts of the base as still further separate Unity scene files that are called up only when the character moves into that part of the facility.

For the next few steps it will be important to have the inside of the base available. These assets have been part of the Homework and Challenges of the past tutorials, but if you have not been doing those, they are also part of a package on the supporting web site (http://www.Creating3dGames.com). Be sure to grab those and import the package into your Unity project (Hallway_Chapter13-Start.unitypackage).

The results of the import will be a new Unity scene called Scene-Hallway. It should already be baked, but if the baking doesn't look right, you may need to fire the bake again. During the tech edit process we have found that some assets when moving between operating systems sometimes lose their lightmap connections.

Step 28: Create a new trigger and place it just behind the EntryWay doors (Figure 13.7). This can be a bit hard to make out in the screenshot, but think of this trigger as being just inside the doors so that as the doors open and the player walks in, he'll hit this trigger. Name the trigger `Trigger-HallwayPortal`.

FIGURE 13.7 Placed Hallway portal trigger.

Step 29: Ensure this trigger still has the EntryWayTextTriggerScript attached to it.
Step 30: Open EntryWayTextTriggerScript.
Step 31: Include the following statement:

```
private var guiTextObject : GameObject;
function Awake(){
    guiTextObject = GameObject.Find("GUITextHints");
}
function OnTriggerEnter (other:Collider){
    if (name == "Trigger-FindDoorHint"){
    guiTextObject.GetComponent(EntryWayGUITextScript)
.FindDoorHint();
    }
    if (name == "Trigger-WaterHint"){
    guiTextObject.GetComponent(EntryWayGUITextScript)
.StayOutOfWaterHint();
    }
    if (name == "Trigger-EMPHint"){
    guiTextObject.GetComponent(EntryWayGUITextScript)
.TryEMPHint();
    }
    if (name == "Trigger-HallwayPortal"){
        Application.LoadLevel ("Scene-Hallway");
    }
}
```

Why?

Just like in the last chapter, what this will do is that when the trigger is penetrated by another collider (like our First Person Controller), if the trigger's name is Trigger-HallwayPortal (which this trigger is), then the current level (Scene-EntryWay) will close as Scene-Hallway is loaded.

Step 32: Save and return to Unity. Fix any syntax errors that pop up in the console.

Step 33: If Scene-Hallway has not been added to the Scenes in Build section of the Build Settings, do so now (File>Build Settings).

Step 34: To test this trigger, we will need to temporarily deactivate the doors. If you are using the version included on the web site (http://www .Creating3dGames.com) these are called EntryWayDoorGroup. If you're using your own, select the GameObject in the Hierarchy and turn it off in the Inspector (be sure to include the children when deactivating).

Why?

When the game is actually finished, these doors will (of course) be active. The goal of this part of the game will be to use the EMP to short out the card reader that will open the doors. When the doors are open, the player can then walk into them where he would hit the trigger. The key is that we don't want the player to be able to hit this trigger before the doors are open so the trigger needs to be back behind the doors.

Step 35: Test; walk through this trigger and see if you end up in the hallway.

Step 36: If all's well, reactivate the doors.

Step 37: Apply all the changes you've made to the First Person Controller prefab, so that it can be used elsewhere. Select First Person Controller in the Hierarchy, and in the Inspector press the Apply Button on the Prefab line. We want all the interface details to be included here in other levels. We'll discuss much more about prefabs later (Chapter 15).

Step 38: Create a new prefab and name it GUIElements (remember to do this in the Project panel). Drag GUITextHints from the Hierarchy panel to this new GUIElements prefab in the Project panel (this populates the new prefab). Now, delete GUITextHints from the Project panel and drag GUIElements up to the Hierarchy. Finally, make sure that GUIElements' Transform Position XYZ are all set to 0 (this is done by selecting GUIElements in the Hierarchy and changing the values (if needed) in the Inspector).

Why?

We've carefully arranged these GUITextHints to be at the bottom of the screen, and we've done this with the Transform Position settings. If the parent of the GUITextHints is not at 0,0,0 then Unity has to do some funny tweaking to the values of its children to get them in the same place as they were before being children. So taking just a second and making sure that empty parent objects are indeed at a position of 0,0,0 will help solve all sorts of problems later.

Conclusion

So far we have used triggers to provide on-screen help via GUI Text. We've also used a trigger to transport us to a new level. Triggers can really be used to launch anything. In the next tutorial we will look at using a trigger to open a door automatically as we approach.

It's worth pointing out some of the limitations of this method and some alternatives. Our current method uses OnTriggerEnter and attaches the script to the actual trigger. Alternatively, Unity has a built-in function of OnControllerColliderHit that is built specifically for use with the First Person Controller (and should be applied to the First Person Controller). This can also do some great things and can help avoid situations where a trigger might be set off by other colliders moving within the scene. However, it requires a bit of extra theory that we haven't covered yet, and for this particular scene (that doesn't have other random colliders moving through the scene) the solution we've used is quick and easy.

Tutorial 13.2: Triggers and Doors

Using triggers as automatic door openers can work well in simple situations. As the situation increases in sophistication (you need to have a key, or the door is opening toward you) there are some better methods dealing with Raycasting (more on this later). For instance, with the trigger solution we are using now, an opening door will open whether we are looking at it or not; using Raycasting we can mitigate problems like that. However, let us look at how triggers can be used in some simple situations.

For this tutorial we will be using the Scene-Hallway. There are loads of doors there that need to be opened. So, if you need this scene, be sure to download the package from the web site (http://www. Creating3dGames. com).

Once the Scene-Hallway (see step 1) is open, there are actually two versions of the hallway—one that is lit and baked (called Hallway_BakedGroup) and a second one called Hallway_Unbaked. When the scene is opened, Hallway_Unbaked will be deactivated. This is because it's dark—really dark—and pretty tough to work with. Although much of what we'll do here has to do with that version of the hallway, we'll set up our mechanics on the Hallway_Baked version for ease of use.

> **Step 1:** Open Scene-Hallway.
> **Step 2:** Reuse our First Person Controller prefab and the GUIElements prefab for this scene. Do this by dragging them from the Project panel up into the Hierarchy. Position the GUIElements to Transform Position (0,0,0). Maneuver the First Person Controller into position at the front of the scene.

Why?

This is the power of our prefabs. Make them once, reuse them again and again. Of further power is that if we make changes in this scene—if we press Apply on the Prefab line of the Inspector—those changes will show up back in the Entryway scene as well.

Step 3: Locate the Hallway_DoorBulkhead_Group that is located in the second room after the entrance. Be careful because there are several of these in the scene. Be sure to get the one shown in Figure 13.8. Also note that this is a group and should include both the objects Hallway_Door_Bulkhead and Hallway_Door_BulkheadWheel.

FIGURE 13.8 Hallway_Door_Bulkhead_Group to work with.

Step 4: Rotate the group closed. This can most easily be done in the Inspector by entering 0 for Rotation X, Y, and Z.

Step 5: Create a new trigger named Trigger-BulkheadDoor1. Remember to do this create a cube, check Is Trigger in its Box Collider, and move it into place in front of the door. The size of the trigger will determine how early the door opens before the player reaches the door (Figure 13.9).

FIGURE 13.9 Trigger-BulkheadDoor1 in place.

Divergent Methods

At this point, when we are ready to start writing the script, there are a couple of ways we could proceed. The first method would be to animate the door in Maya, reimport, and use the trigger to play the animation nested on the door. The second way is to create the animation within Unity and call up that animation with the trigger. The third way is to use a collection of custom classes developed by Bob Berkebile called iTween. We are going to look at calling up animations in later tutorials so in this tutorial we will focus on the iTween method.

Unity has a lot of built-in classes and functions that help provide access to core Unity game engine functionality. However, custom classes can be authored that further expand scripting ease. iTween is one of those expansions. Bob Berkebile has authored and released for free to the community a collection that is so flexible and powerful, I find myself using it on every single project.

iTween is available at http://itween.pixelplacement.com/index.php. Go download it. The way to install it is simple. In Unity, create a folder called Plugins. Out in your OS place iTween (really a C# script) into this folder and you're ready to go. Alternately, this could be done all in the OS by creating a folder called Plugins inside the Assets folder of the Unity project, placing iTween there, and then reentering Unity.

Tips and Tricks

Although Mr. Berkebile has released iTween free for use, it is provided on a donation-based system. If, after this book, you find yourself using iTween a lot, contribute—I did. It'll help encourage further development and updates.

Step 6: Create a new JavaScript called `HallwayDoorsTriggerScript`. Open it in your editor.
Step 7: Start by declaring a variable for the door:

```
var door : GameObject;
```

Why?

This time we're using a public variable (var) as opposed to a hidden private variable (private var). This is because this script is going to be useable all over the place with pretty much any door anywhere. This sort of flexibility will mean that we need to do a little bit more work implementing the script, but this will work all over the place.

Step 8: Create the OnTriggerEnter functionality:

```
var door : GameObject;

function OnTriggerEnter (other:Collider){
        iTween.RotateTo(door, Vector3(0,-120,0), 5.0);
}
```

Why?

The first line of that function should be familiar by now. The second line is where iTween becomes helpful. The RotateTo function allows us to define (object to rotate, angle to rotate to, duration of rotation). The documentation for iTween is at http://itween.pixelplacement.com/documentation.php. There all the new functionalities are listed along with the specifications of how to use them. There's a lot of customization possible with iTween (charts of "hashable args"); however the basic functionality is outlined as shown in Figure 13.10. Generally following these format lists does the trick.

FIGURE 13.10 iTweens web site with the core functionality highlighted.

Do note that there aren't necessarily any examples so being aware of what the arguments mean is important. In this case "Vector3 rotation" must take the format Vector3(x,y,z). Similarly the duration of rotation (float time) must be a float so it can have a decimal.

It sometimes takes just a bit to get used to some of this terminology, but the more script you write, the more natural these sorts of specification will find their way into the scripts.

Step 9: Save and return to Unity. Fix any syntax errors that pop up in the console.

Step 10: Apply this script (HallwayDoorsTriggerScript) to Trigger-BulkheadDoor1.

Step 11: Define the door to be affected. In the script, we declared a public variable that will show up as "Door" that will appear empty. This script and its variable are visible in the Inspector when Trigger-BulkheadDoor1 is selected. To define Door, drag Hallway_Door_Bulkhead_Group from the Hierarchy panel to the input field for Door (Figure 13.11). For now, use the one that is in Hallway_BakedGroup/

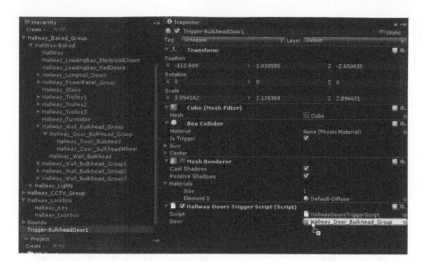

FIGURE 13.11 Public variable being defined via drag and drop.

Hallway-Baked (there are actually two versions of the Hallway if you're using the imported package, one that's unlit for use with a flashlight (next chapter) and one that is baked. For now we'll use the baked version since it will just be easier to see).

Why?

This tells the script which object to rotate when the trigger is tripped. This can be the only way to work if there are many objects that have the same name; if we were using the GameObject.Find method, Unity could get very confused. With this method, Unity knows exactly which object to be working with and doesn't have to use cycles when it starts going out and finding GameObjects.

Step 12: Make sure that the door is not set to Static. Select Hallway_Door_Bulkhead_Group and in the Inspector, be sure the Static button is not checked (Figure 13.12). Be sure this is also the case for the children.

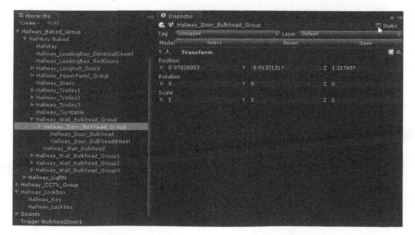

FIGURE 13.12 Ensuring the door is not Static. Static objects won't animate.

Why?

This might seem like a blast from the distant past, but when we were baking lighting, we marked objects or entire levels as Static. If an object is not marked as Static it won't be included in the baking. However, if it is marked as Static, Unity assumes that it's unmoving, that it's, well, static. Luckily, an object can be marked as Static and used in baking, but be dynamic later (as in this case) by just turning the Static option off after baking.

Step 13: Test. Play the game and walk through that trigger and see if the timing is good. If the values of how far the door opens or the timing is not to your liking, adjust in the script.

Step 14: Turn off the Mesh Renderer for the trigger Trigger-BulkheadDoor1.

Sound and Scripts

The door should now open for us as we approach, but it's fairly creepy (and unrealistic) that it produces no sound as this door in an old sealed-up base opens. In this section we will add sound to the door and trigger it with our already extant script.

Step 15: On the web, track down a sound clip that you think would be appropriate for this big door. I used "elevator door opening.wav" from FreeSound.org. Edit any unnecessary dead noise at the beginning or end of the sound (Audacity will do this quickly if you haven't any other sound application).

Step 16: Import it to your Sounds folder by dragging it there in the operating system.

Step 17: Create an empty GameObject (GameObject>Create Empty). Name it `Sound-DoorOpenBulkhead1`. Position it near where the opening door is. Drag the sound clip from the Project panel to this GameObject so that it contains an Audio Source component.

Why?

Potentially this could also be attached to the character, but by actually placing it near where the sound would be emitting, we get the benefits of Unity's positionally aware sound system.

Step 18: Turn off the Play on Awake option within the Audio Source component.

Why?

By not playing on awake, the audio source stays silent until we ask it to play sound (which we will do in just a bit).

Step 19: Open the HallwayDoorsTriggerScript.

Step 20: Add a variable to store the object that emits the sound and a line to play it. Note that there are two lines in italics here:

```
var door : GameObject;
var doorOpenSound : GameObject;

function OnTriggerEnter (other:Collider){
      iTween.RotateTo(door, Vector3(0,-120,0), 5.0);
      doorOpenSound.audio.Play();
}
```

Why?

The public variable declaration allows us to define (for each trigger down the road) the actual object that the sound belongs to (and it can be a different sound for each door). The last line of code there says, "go find the doorOpenSound, find the audio attached to it, and play it."

Step 21: Save and return to Unity. Fix any syntax errors that pop up in the console. Populate the door variable for the script by dragging the door that is to open from the Hierarchy view to the variable entry in the Inspector.

Step 22: Test. Make any adjustments to the Audio Source component that you feel is needed to make the sound softer/louder, and so on.

Cleaning Up with Destroy and Booleans

So the sound now runs as the door opens. The only problem here is that the trigger is still sitting there. Now, if part of the game included shutting the door as well, this could be good as the trigger could check the state of the door and close it if it were open when we passed through it again. However, in this case, there is little need for this trigger since the door doesn't do anything else after this. With just a little bit of extra code we can get rid of elements (GameObjects and or components) that we simply won't have need of later in the game. This keeps the game snappy because Unity has less to keep track of, and importantly makes sure that these triggers aren't used later.

But, sometimes we might not want to destroy a trigger. Perhaps there are times when the trigger is meant to play a thump or something every time the player walks up to it (for instance a locked door). It would do no good to destroy the trigger after our first approach. So in our script we'll build in a switch that allows us to tell the script on a case by case basis if it's to destroy the trigger or not.

Booleans are either true or false; think of them as a switch. They can keep track of whether a state of being is true or false. Once this state is remembered or available, scripts can check with it to see if they should execute a particular task based upon the Boolean state.

Step 23: Add the mechanism to destroy both the sound and the trigger. For HallwayDoorsTriggerScript add (in italics):

```
var door : GameObject;
var doorOpenSound : GameObject;

function OnTriggerEnter (other:Collider){
      iTween.RotateTo(door, Vector3(0,-120,0), 5.0);
      doorOpenSound.audio.Play();
      Destroy (doorOpenSound);
      Destroy (gameObject);
}
```

Why?

The first destroy destroys the GameObject that contains the sound (that we declared at the top of the script and populate in the editor). The second destroy destroys the GameObject that this script is attached to, which in this case is the trigger.

Step 24: Make the destroy wait—specifically wait for the duration of the sound clip before destroying things. Add the following line:

```
var door : GameObject;
var doorOpenSound : GameObject;

function OnTriggerEnter (other:Collider){
      iTween.RotateTo(door, Vector3(0,-120,0), 5.0);
      doorOpenSound.audio.Play();
      yield WaitForSeconds (doorOpenSound.audio.clip
.length);
      Destroy (doorOpenSound);
      Destroy (gameObject);
}
```

Why?

Without our yield statement, the sound wouldn't be heard at all. Looking at the script in step 21 shows a script that destroys the sound object immediately after telling it to play—thus the sound would be gone before we got a chance to enjoy it. Yield in JavaScript means "wait" or "allow something to finish first." In this case we are using yield to wait for a specific duration of time (WaitForSeconds). The seconds that this waits for can be defined with a simple integer (for instance: yield WaitForSeconds (3); would wait for three seconds before executing the next step). However, we want this script to be more flexible so it can be used with different situations and sounds. So we tell it to check out the length of the audio clip attached to doorOpenSound (doorOpenSound.audio.clip.length) and wait that long.

As is, this script would work in this situation. However, currently it always destroys the trigger and sound after the sound is played. We need to add further flexibility to this script so we can choose whether to destroy the trigger or not.

Step 25 : Declare a Boolean variable:

```
var door : GameObject;
var doorOpenSound : GameObject;
var destroyWhenFinished : boolean;

function OnTriggerEnter (other:Collider){
       iTween.RotateTo(door, Vector3(0,-120,0), 5.0);
       doorOpenSound.audio.Play();
       yield WaitForSeconds (doorOpenSound.audio.clip
.length);
       Destroy (doorOpenSound);
       Destroy (gameObject);
}
```

Why?

By making this Boolean a public variable, we will make it a check box that is accessible in the Inspector later.

Step 26: Make the script check to see if the Boolean destroyWhenFinished is true before destroying:

```
var door : GameObject;
var doorOpenSound : GameObject;
var destroyWhenFinished : boolean;

function OnTriggerEnter (other:Collider){
       iTween.RotateTo(door, Vector3(0,-120,0), 5.0);
       doorOpenSound.audio.Play();
       yield WaitForSeconds (doorOpenSound.audio.clip
.length);
       if (destroyWhenFinished){
               Destroy (doorOpenSound);
               Destroy (gameObject);
       }
}
```

Why?

Take a close look at that—it really adds one line of code (if (destroyWhen Finished)), but be careful to notice that it puts the destroys inside { }. What's happening there is if the Boolean state of destroyWhenFinished is true it executes the block of code that does the destroys.

Tips and Tricks
Just a side note, if we wanted it to do something only if the Boolean was false, it would look like this: if (!destroyWhenFinished){

Step 27: Save and return to Unity. Fix any syntax errors that pop up in the console.

Step 28: Select Trigger-BulkheadDoor1 and look at the Inspector (Figure 13.13). Here is where the Door (Hallway_Door_Bulkhead_Group) is populated and the Door Open Sound (Sound-DoorOpenBulkhead1) is populated by dragging those GameObjects from the Inspector to their respective variable location. Lastly, notice the Destroy When Finished boolean is available there to be checked (or not, if the trigger is meant to be reused).

FIGURE 13.13 Populated variables for our new HallwayDoorsTriggerScript.

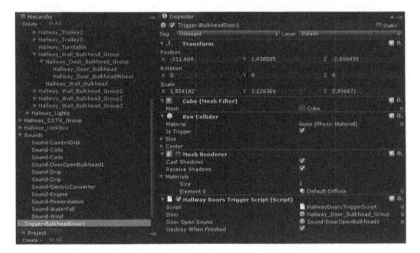

Step 29: Test. To see if the destroy is happening, make sure the Hierarchy panel is still opened and watch what happens to the trigger after it is tripped the first time.

Step 30: Further allow the script to be customized by exposing a variable to control the angle to which the door angles. Adjust as follows, save it, and then return to Unity to see the results in the Inspector for Trigger-BulkheadDoor1:

```
var door : GameObject;
var doorOpenSound : GameObject;
var destroyWhenFinished : boolean;
var openAngle : float;

function OnTriggerEnter (other:Collider){
     iTween.RotateTo(door.gameObject,
Vector3(0,openAngle,0), 5.0);
     doorOpenSound.audio.Play();
     yield WaitForSeconds (doorOpenSound.audio.clip
.length);
```

```
        if (destroyWhenFinished){
                Destroy (doorOpenSound);
                Destroy (gameObject);
        }
  }
```

Why?

Note that we declared a new variable (openAngle) that is defined as a float (a numerical value that can include a decimal). Then, in the iTween command, for the Y value, instead of listing a number, we plug in the variable (now listed on Trigger-BulkheadDoor1 in the Inspector as Open Angle). So when Unity runs this line, it checks for what the game designer has defined the angle to be. This will add tremendous flexibility since not all doors will open the same amount.

Conclusion

And with that we're going to leave triggers. They can be a very handy way to make things happen as a character moves through the scene.

Triggers are handy, but sometimes clumsy. A trigger can cause problems if there are other things moving in the scene. If, for instance, there is an object animated in the scene that has a collider on it and it passes through the trigger, suddenly things can begin happening that are only meant to happen when the character walks through it. Some of this can be mitigated by checking the object colliding with the trigger for specific names or tags, but this takes some extra overhead.

Alternately, there are some exciting and interesting alternatives to triggers that make use of Unity's raycasting functionality. In the next chapter we'll start to look at this very powerful ability in Unity and how to make use of it in our game.

The fun is just beginning.

Homework and Challenges

Challenge 1: In this chapter we looked at using triggers to open doors, and we've looked at using triggers to provide on-screen hints. Scene-Hallway is full of doors that shouldn't open. Create triggers for these doors that bring up a screen hint indicating that "This door appears to be locked or sealed."

Challenge 2: Our current method of displaying screen hints when we hit a trigger did some important things in illustrating communication between scripts. However, it's actually more complicated than it needs to be. Design a script that is applied to any triggers that are meant to display screen hints, that simply defines what the text should be, turns the text on, waits 5 seconds, and then turns the script off. Even better, make it so flexible that we can enter the message in the Inspector on a trigger by trigger basis and not have to hard code it into the script (one solution is included in the downloadable versions of the game as ScreenHintsTriggerScript).

Unity Raycasting

Collision detection as shown in the last chapter is an easily accessible way of driving interactions in Unity. It's easy to think of triggers as triggering specific events or commands, and setting these things up is simple. However, there are some clear potential drawbacks, the biggest of which is something called **frame miss**.

Frame Miss

Unity looks for events on frames. If a game is running at 30 frames a second, Unity is checking for and potentially firing commands 30 times each second. Frame miss is a term that refers to actions (like a collision detection) happening between frames. If it happens between frames, Unity misses it—Unity just doesn't see it happen. In most cases involving a moving First Person Controller this is unlikely—the character just doesn't move that fast (unless the collider is super small); however, let's take a look at a very likely and classic scenario.

Guns are part of a lot of games. They are part of Incursion (although we'll be shooting cameras and not people). Bullets are fast, really fast, which means they travel a very long distance in a very short time, or more relevant to us, they travel a long distance in each frame. Let's assume that a 0.22 bullet travels at 1500 feet per second. That means if the bullet we create in Unity is traveling at a realistic speed, if the game is playing at 30 frames per second,

that bullet travels 50 feet every frame. Unity then "sees" the bullet and checks for collisions every 50 feet. So a thin object that was 10 feet, 20 feet, 30 feet, 40 feet from the gun would not be registered as hit by that bullet because Unity simply wasn't looking when the bullet would have been in that object's space. In fact, only objects that were 50 feet, 100 feet, 150 feet, 200 feet, and so on from the gun would be registered as hit. Of course if the object were 50 feet thick, it would register, but we digress.

Frame miss is a very real problem for other issues as well. In one of the projects we use here when we are briefing on our technology, we have a pipe filled with particles flowing through it to show how we can illustrate building infrastructure. The particles are colliding off the inside of the pipe that keeps the particle stream contained. Occasionally, one of the particles gets moving so fast that Unity misses the frame where it's supposed to calculate the end of the pipe and it escapes, flying through the facility, and often then bouncing off walls and other equipment. Although it's pretty funny for whoever is being briefed, it always makes me cringe as it yanks the viewer right out of the experience of the space.

Avoiding frame miss is an important thing to be paying attention to in the construction of a game.

Raycasting

One way to avoid issues involved with frame miss is to use a sort of sister technology to collision detection called raycasting. Raycasting is the process where an invisible ray is "cast" or thrown from an object. This ray is cast outward (in the direction of the object's forward direction (Z)) and can be defined to have a particular length (or to shoot out infinitely until it hits something).

Figure 14.1 shows a screenshot of a ray being cast from the camera attached to the First Person Controller. The ray shoots out until it hits the wall right ahead of it. The cool thing about this is that this ray is pretty smart and fast. In one frame, the ray shoots out until it strikes a collider (thus avoiding frame miss issues possible in things like collision detection) and the ray can report back about what it's hit. The ray can tell us information about what the object is, where in world space it was stopped by an object, and all sorts of other useful data. We can utilize this data for some preemptive functions like deciding whether a bullet would hit an object.

We are going to explore using raycasting for use in several situations. First, we are going to make use of raycasting as an alternative to the OnMouseOver functionality we used in the GUITextures tutorials. For GUITextures, OnMouseOver works fairly reliably and is a great way to work. In the 3D world though, it's often more accurate to highlight objects via raycasting than OnMouseOver.

Using raycasting we will highlight actionable items in the game. Namely, we'll use this method to flip the main power switch in the base. Then later, we'll also use it to identify and pick up a key that opens a locked door.

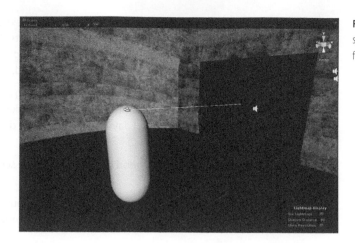

FIGURE 14.1 Visual debugging shows a ray from a raycasting function.

Second, we will use raycasting for firing Aegis's pistol. After the power is restored, the security cameras will be on in the base and the player will need to take these out with his pistol. Using raycasting we will "fire" bullets that will affect and destroy the cameras. With raycasting we will avoid the problems previously discussed inherent in actually using a projectile moving through space at a high velocity.

Finally, we are going to use raycasting to give us hints on placing an object. Among Aegis's tool kit is an electromagnetic pulse mine that the player will use to disable the EntryWay electronic lock. Using raycasting we will instantiate (create in game) an object that will show the player where he potentially can mount the device.

Lots of fun stuff to do with raycasting once the mechanics of it are realized. Let's get to it.

But First ... a Few Notes on Scripting and Help

Up to this point, the scripts we have written have been pretty straightforward and fairly short. However, as our scripts begin to increase in length it's worthwhile to note some practices that we should be following as we work.

Comments via //

Scripting languages provide mechanisms to help document scripts as they are written right within the script itself. JavaScript (along with some other languages) allow comments to be injected anywhere as long as there is a // before the comment. Whenever Unity sees // it ignores whatever comes after that until it reaches the end of a line (where you press Enter). It just takes a moment to notate the script you are writing, but can save tons of time when it comes to trying to figure out what you were thinking when the script is accessed later in the project.

Figure 14.2 shows the script we built to open doors with a bit of extra functionality; note that UniSciTE color codes things like comments. A habit I like to establish is to include the comments on the line that the comment is referring to and tab them all over so they are easy to see and read.

Even though a script might make perfect sense as you are writing it, you will be amazed at how long it takes to get back into the mode of thinking you were in when you wrote the script several days later when you're deep in the script again bug squashing.

And if you're working as part of a team, good grief, comment the script. It will keep teammates happy.

Lastly, if there is one line that needs to be temporarily disabled, putting // in front of that line of code will cause it to be ignored by Unity at runtime.

Commenting Blocks of Script with /*

Perhaps there are scripters who write perfect code on the first pass. I'm not one of them, and frequently what I think is going to work simply doesn't. The problem is that sometimes I'm uncertain if it's just a syntax problem I've got, or my whole approach is flawed. On occasion this means that I need to try

```
HallwayDoorsTriggerScript.js * UniSciTE
File  Edit  Search  View  Options  Language  Buffers  Help

1 HallwayDoorsTriggerScript.js *
 1    //Built as a very general script to be applied to triggers in front of each door.
 2    //Provides the capability to self-destruct if trigger is to be used only once.
 3
 4    var door : GameObject;
 5    var bulkheadHandle : GameObject;
 6    var doorOpenSound : GameObject;
 7
 8    var isBulkhead : boolean;
 9    var destroyWhenFinished : boolean;
10
11    function OnTriggerEnter (other:Collider){
12        iTween.RotateTo(door.gameObject, Vector3(0,-120,0), 5.0);        //Opens door.
13        if (isBulkhead){                                                  //If door is marked as bulkhead, spins bulkhead door handles
14            iTween.RotateBy(bulkheadHandle.gameObject, Vector3(3,0,0), 5);
15        }
16        doorOpenSound.audio.Play();                                      //Plays door open sound.
17        yield WaitForSeconds (doorOpenSound.audio.clip.length);
18        if (destroyWhenFinished){                                        //If set to destroy, destroys trigger and sound.
19            Destroy (doorOpenSound);
20            Destroy (gameObject);
21        }
22    }

Line 13 / 22, Col 131. INS (LF)
```

FIGURE 14.2 A commented script.

something else, but don't want to necessarily get rid of blocks of code that are already written. Within JavaScript for Unity a block of code can be "commented out" by surrounding it with /* at the start and */ at the end (Figure 14.3).

Unity will then disregard anything that lies between those two markings. This allows blocks of code to be saved in case they are needed later.

Accessing the Documentation

Help>Scripting Reference opens the help files for Unity's scripting languages in a web browser. Now to be honest, this scripting help document is built for folks who have a background in scripting. It very often uses terms and language that is very opaque to the scripting newbie. I can tell you from personal experience that there are many, many entries that left me with an utterly hopeless feeling after I read them. Sometimes the explanations are so scant they provide nearly no information, and other times they are so dense with scripting jargon, that a mere mortal is left hopelessly floundering.

Further, the scripting guide is often only as good as your vocabulary. If you know you're looking for information on RaycastHit, it'll pull it right up. But without knowing that particular phrase, it's tough to stumble upon it. In many cases it's not a "tell me how to do this" kind of guide.

FIGURE 14.3 Commenting out blocks of code.

But even with the things that it isn't, it still can be a very valuable tool. On occasion the details in the explanations can get you to the right place. For instance, if you wanted to know how to play a sound, "play sound" can be entered in the Search input field where a plethora of classes and variables will be presented. It certainly takes a bit of wading from there, but do the wading. Lots of important stuff can be learned along the way when trying to secure knowledge of one topic.

Keep in mind that there is more than one word for a lot of concepts. So for instance if "play sound" isn't providing the information you think it should, try "play audio." Frequently a bit of rewording provides much more usable results.

In the best-case scenario, some of the entries are indeed fleshed out well and even provide some examples of how to use a particular class or variable. Many, many a script has begun with a quick copy/paste of the example followed by a bit of tweaking for the specific situation at hand.

F1 in UniSciTE

On the PC, the script editor UniSciTE has one function that alone is the reason I do my scripting on my PC rather than my Mac. Select any term within a script (OnTriggerEnter, for example) and press F1 on the keyboard and the browser will automatically open and Unity's scripting help will open to that term. Especially when trying to understand someone else's script or script snippet that was obtained through the help file, the forums (http://forum.unity3d.com), the wiki (http://www.unifycommunity.com/wiki/), or Unity Answers (http://answers.unity3d.com)—all of which are excellent supplemental help materials—being able to select a function or variable and get that quick feedback keeps the learning and script building less slow.

Decoding a Help Page

So why talk about the help now? Well, in our past examples, accessing the Scripting Reference would have provided little help—we simply needed to provide the starting terms to get going. However, as your scripting prowess grows, knowing how to decipher the Scripting Reference will help you make the leap beyond this book's tutorials and onto your own killer games.

So take a look at what the Scripting Reference has to say about raycasting. Select Help>Scripting Reference and enter `raycast` in the search input field. Look for Physics.Raycast and click that link. (I know, how would you know to click that one instead of any of the other options? You don't, it's likely this would require some wading, but we'll save the time today and jump right to where we need to be.)

This will bring up the page for the Runtime Class of Physics.Raycast (Figure 14.4). There is lots of information on this page, in fact so much it can be tough to know what's relevant for our particular situation. But focus for a minute on the line immediately below Physics.Raycast.

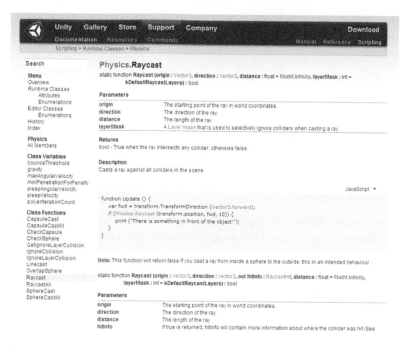

FIGURE 14.4 Scripting reference for Physics.Raycast.

That line reads:

```
static function Raycast (origin : Vector3, direction :
Vector3, distance : float = Mathf.Infinity, layerMask :
int = kDefaultRaycastLayers) : bool
```

There's a lot of stuff there, but here's how to interpret it. Raycast has several parameters that are definable. Those parameters are laid out within the (). Each of the parameters are separated by a comma. Each of these parameters are typed with the colon. So for instance, the first parameter is the "origin" of the ray and this value must be a Vector3; the second parameter is the "direction" of the ray, which is also expressed as a Vector3; the third is the "distance" the ray casts and will be written as a float, which means it can contain decimals; finally, the fourth parameter is the layerMask (which layers to ignore when casting the ray), which will be expressed as an integer (layers are numbered).

Further down the page are other formats where this class can be used. These will include other parameters that can be expressed and the order in which they must be expressed. So for instance, a little way down the page, the following appears:

```
static function Raycast (origin : Vector3, direction :
Vector3, out hitInfo : RaycastHit, distance : float =
Mathf.Infinity, layerMask : int = kDefaultRaycastLayers) :
bool
```

Notice that it has the same parameters of the origin, the direction, but then includes a parameter for something called a RaycastHit, which is a variable that will be used to hold information about the things the ray hits. Later if we want to (and we will) we can access this RaycastHit and check the name of the object or find its exact location. This is followed by distance and layer mask.

Now not all of these parameters must be expressed; however, if they are, they have to be laid out in the order listed there. So, for instance, the line of code:

```
Physics.Raycast (transform.position, transform.forward, hit, 100);
```

means, "Cast a ray. As its origin, use the position of the object this script is attached to (transform.position). For the direction, cast the ray along the object's Z-axis (transform.forward, which is really shorthand for 'along the Z-axis'). Keep track of what we hit in the variable 'hit' and cast the ray 100 units out—ignore everything further away than that." That's a lot of information in one line of script, no?

Now of course that line of script by itself is pretty useless. And in fact if it were just floating around in a script it would be fired once and therefore be pretty useless. However, if we told it to do that every frame we could start to gather a lot of information.

So consider the following function:

```
function Update () {
    var hit : RaycastHit;
    Physics.Raycast (transform.position, transform
.forward, hit, 100);
}
```

`function Update()` just says, "do the things within the {} every frame." `var hit : RaycastHit` just declares that we want to keep track of the RaycastHit with a variable called "hit." Technically, this could go way up at a higher level and we could declare this variable at the top of the script, but since it is absolutely only going to be accessed within the raycasting mechanism, declaring the hit variable here helps keep relevant ideas together. Then comes the power line of code starting with Physics.Raycast. What this block of code is doing is always shooting out a ray that looks in the same direction as whatever this code is attached to (like a camera). The ray is keeping track of what it's hitting (via the RaycastHit), which we can use later.

And all of that comes from that Scripting Reference. It may still be a little abstract here, so let's get going in some tutorials to look at how to use this newfound knowledge.

Tutorial 14.1: Highlighting Actionable Objects with Raycasting

The first tutorial we're going to use raycasting for is to highlight an object that can be acted upon. Specifically, in this game we have a key that needs to be picked up and a power main switch that needs to be thrown. In games

like this, it can be tough to know what items the player can actually do something to and which are there for visual fodder. Different games handle this in different ways, but a fairly consistent convention is to have the item glow, or change color, or otherwise highlight when the player moves his mouse or crosshairs over the item. This is the convention we are going to build.

Raycasting will do this really well. We'll set up a raycasting mechanism that shoots a ray from the camera and shoots it straight forward. When the center of the screen (where we will place a crosshairs) lines up on an object, the ray will strike it and let us know what the name of that object is. In the script we will compare the names of the objects the ray strikes with a list of actionable items; if it matches, we will turn up all the material's color values so that the item looks white hot. When the ray is not striking the object, the material will return to its regular color.

To do this, we'll need to make use of a crosshairs image. There is one included with the 2D Assets package imported in earlier tutorials (it's called Crosshairs) or you can make your own. The image should be a power of 2 in size (mine is 32×32) and have an alpha channel built into it in Photoshop.

We'll be doing these steps within the Scene-Hallway scene within Unity (continuing on from the last chapter).

> **Step 1:** Create crosshairs. Create a GUITexture to house the crosshairs (GameObject>Create Other>GUI Texture). Rename the GameObject `Crosshairs`. Use the Crosshairs image within the 2D Assets folder as the Texture for the GUITexture. If using the provided image, change the Pixel Inset X and Y to `-16` and the Width and Height to `32`.
>
> **Step 2:** Reduce the transparency of the crosshairs. With the Crosshairs GUITexture object selected, click the color swatch and reduce the Alpha (the A slider) to around 50 (Figure 14.5).

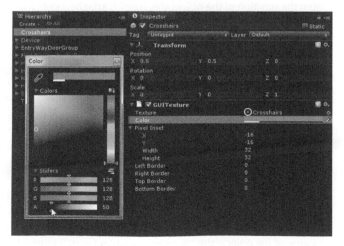

FIGURE 14.5 Setting up the crosshairs.

Why?

This all provides a crosshairs that sits exactly in the middle of the screen. This also happens to be the location of where the ray that will be generated by the raycasting will be terminating. Later we'll be locking the mouse down and hiding it so the player can't see it unless he is picking a weapon/tool from the inventory. So giving the player a location for the crosshairs allows him to have some idea of where the computer is looking for input from.

By making the texture a bit transparent, we can try and allow the crosshairs to be a good visible hint, but not become overly important in the overall visual impact of the game. In fact, if you still find the crosshairs to be too dominant, turn the Alpha down further.

Step 3: Create a new JavaScript. Rename it `AC_ToolFunctionality Script`. Open the script.
Step 4: Within the extant function Update, add the following:

```
function Update () {
        var hit : RaycastHit;

        if (Physics.Raycast (transform.position, transform
.forward, hit, 100)){
                Debug.DrawLine (transform.position, hit
.point);
                Debug.Log (hit.collider.gameObject.name);
        }
}
```

Why?

This is one of the first times we've used the function Update. We're telling Unity to do something every frame: first, create a variable to store the object that the ray hits (RaycastHit); then, check if there is indeed anything that the ray strikes, and specifically, that the ray that emerges from the position of the object this script is attached to (it'll be attached to the camera) shoots straight forward for 100 units; and finally (for illustration purposes) we're including a couple of Debug functions there. The first one actually draws the ray the raycasting mechanism is using (Debug.DrawLine) and the second is writing the name of the object that the ray strikes to the Console (Debug.Log).

Step 5: Save and return to Unity. Fix any syntax errors that pop up in the console.
Step 6: Attach this script to the Main Camera that is a child of the First Person Controller (add a First Person Controller if needed). Go ahead and click OK if Unity warns of breaking the prefab.
Step 7: Play the game. Take special note of the Scene view and the Console. Look to see the bright white line emanating out of the camera that is the Debug.DrawLine and check out the Console to see how it is returning the name of the objects the ray comes in contact with (Figure 14.6).

FIGURE 14.6 Using Debug to check if the raycasting is working as anticipated.

Tips and Tricks

Note that in Figure 14.6 the Collapse button is clicked in the Console. The script (as it now exists) is checking for the name of objects the ray is colliding with every single frame. This means that there will be 30 Debug .Log's per second (at least) showing up in the Console making it hard to read much of what's going on. The Collapse button collapses repeating warnings or Debug.Logs into one entry making it a bit easier to see what's happening down there.

Why?

Why bother with these Debug thingies? True, true, Debug anything is most often used when trying to squash bugs, and in fact can be a very important part of trying to figure out if a script is going wrong and where it's going wrong. However, I find that using some basic Debug stuff early on in the process of developing a script helps me find out if the early drafts of the script are doing what I think they're doing. In fact, for some really elegant Debug stuff, try changing the last line to `Debug.Log ("Selected object is " + hit.collider. gameObject.name);`

Step 8: Create an independent highlighting function. Further down from the function Update create a new function that reads thusly:

```
function Update () {
    var hit : RaycastHit;

    if (Physics.Raycast (transform.position, transform
.forward, hit, 100)){
        Debug.DrawLine (transform.position, hit
.point);
```

```
                    Debug.Log ("Selected object is " + hit
.collider.gameObject.name);
            }
    }

function AddHighlight(hiOb:GameObject){
        hiOb.renderer.material.color.r = hiOb.renderer
.material.color.r*10;
        hiOb.renderer.material.color.g = hiOb.renderer
.material.color.g*10;
        hiOb.renderer.material.color.b = hiOb.renderer
.material.color.b*10;
        yield WaitForSeconds (0.1);
        hiOb.renderer.material.color.r = hiOb.renderer
.material.color.r/10;
        hiOb.renderer.material.color.g = hiOb.renderer
.material.color.g/10;
        hiOb.renderer.material.color.b = hiOb.renderer
.material.color.b/10;
    }
```

Why?

Lots to discuss here. First, what we're creating here is a new function that we can call on at other places within this script, or even call from other scripts. Of course, at this point we haven't called out to use this function quite yet, but we'll get to that in a bit. For now, let's look at what this script will do when it's called.

The first line simply creates a name for the new function (AddHighlight). But additionally, it declares a new variable that will be used just within this function (hiOb:GameObject) but can be called to from other functions (hiOb is just short for highlightObject and is a term I made up to use here—you could name it differently). Specifically, this means that when we call for this script we can call for it and include what the GameObject is that this function will use for hiOb. We're essentially allowing a variable of one function to be populated by another function elsewhere. Really powerful stuff.

Now below that, in the meat of the meal are lines that just say, "take the object to highlight, look in its renderer component, find the material, and then take whatever the red value is for the color of the material and multiply it by 10." Then do this for the green and blue values and the net results will be that the object highlights in bright white.

After that is a little trick that essentially says, "wait for 1/10th of a second, and then change it all back." The reason we're doing this is that we want to make sure that when the ray is no longer casting on the object to highlight, the object turns back to the way it was.

The function AddHighlight being separate means we can reuse this chunk of code multiple times without retyping it. We can start to develop mechanisms

that say, "if you Raycast onto the power switch, highlight it (using the code in the AddHighlight function) and then if the mouse is clicked, turn the lights on." Then, later we can say, "if you Raycast on the key, highlight it (using the code in the AddHighlight function) and then if the mouse is clicked pick the key up." And so on. In each case we're using the exact same highlight mechanism, but not having to retype all those instructions.

Step 9: Check to see if the object being hit by the ray has the same name as "Hallway_PowerPanel_Switch," and if it does, call up the AddHighlight function:

```
function Update (){
        var hit : RaycastHit;
        if (Physics.Raycast (transform.position, transform
.forward, hit, 100))}
                Debug.DrawLine (transform.position, hit
.point);
                Debug.Log ("Selected object is " + hit
.collider.gameObject.name);
                if (hit.collider.gameObject.name ==
"Hallway_PowerPanel_Switch"){
                        AddHighlight(hit.collider.gameObject);
                }
        }
}
function AddHighlight(hiOb:GameObject){
        hiOb.renderer.material.color.r = hiOb.renderer
.material.color.r*10;
        hiOb.renderer.material.color.g = hiOb.renderer
.material.color.g*10;
        hiOb.renderer.material.color.b = hiOb.renderer
.material.color.b*10;
        yield WaitForSeconds (0.1);
        hiOb.renderer.material.color.r = hiOb.renderer
.material.color.r/10;
        hiOb.renderer.material.color.g = hiOb.renderer
.material.color.g/10;
        hiOb.renderer.material.color.b = hiOb.renderer
.material.color.b/10;
}
```

Why?

So what's happening there is that (every frame) the ray is cast, the two debug lines are still happening, and then it compares the name of the object hit to "Hallway_PowerPanel_Switch" and if the names do match, it calls up the AddHighlight function and passes to it the very object it is casting on (which is the switch). The AddHighlight receives the message to fire, and upon which object to fire, and does its thing (turns up the RGB values; then turns them down again).

Step 10: Repeat for the Hallway_Key.

```
function Update () {
       var hit : RaycastHit;
       if (Physics.Raycast (transform.position, transform
.forward, hit, 100)){
             Debug.DrawLine (transform.position, hit
.point);
             Debug.Log ("Selected object is " + hit
.collider.gameObject.name);
             if (hit.collider.gameObject.name == "Hallway
_PowerPanel_Switch"){
                    AddHighlight(hit.collider.gameObject);
             }
             if (hit.collider.gameObject.name == "Hallway
_Key"){
                    AddHighlight(hit.collider.gameObject);
             }
       }
}

function AddHighlight(hiOb:GameObject){
       hiOb.renderer.material.color.r = hiOb.renderer
.material.color.r*10;
       hiOb.renderer.material.color.g = hiOb.renderer
.material.color.g*10;
       hiOb.renderer.material.color.b = hiOb.renderer
.material.color.b*10;
       yield WaitForSeconds (0.1);
       hiOb.renderer.material.color.r = hiOb.renderer
.material.color.r/10;
       hiOb.renderer.material.color.g = hiOb.renderer
.material.color.g/10;
       hiOb.renderer.material.color.b = hiOb.renderer
.material.color.b/10;
}
```

Why?

This is just doing the same thing as the power switch. Notice that the script lists this next if statement after the power switch comparison. Essentially, Unity simply looks to see if the object is called "Hallway_PowerPanel_Switch" and if it isn't, it moves down to the next set of instructions. It then checks to see if the object its ray is casting on is called "Hallway_Key" and if it isn't, it does nothing.

Now, these two if statements look an awfully lot alike. And in fact, it could be simplified into `if(hit.collider.gameObject.name == "Hallway_PowerPanel_Switch || hit.collider.gameObject.name == "Hallway_Key"{`. However, we want to make sure that there are actually two very different things that happen if these objects are clicked. So separating them into different commands allows for an easy way to distinguish that.

Step 11: Save and return to Unity. Fix any syntax errors that pop up in the console.

Step 12: Test the game. As the player walks up to the key (inside the large dome-like room) or the power closet (down the long hall and in the closet to the left of the loading bay), the objects should highlight bright white as the crosshairs go over them (Figures 14.7 and 14.8).

FIGURE 14.7 Highlighted power switch.

FIGURE 14.8 Highlighted key.

Turning on the Lights

Now that we've highlighted that actionable items, we need to make an action happen when they are clicked. The first thing we're going to do is make the scene so that when the player enters the scene all the lights are turned off. The player will be able to use a flashlight to find his way to the closet where the main power switch is on (the one we created the highlight mechanism for). When the player clicks on the highlighted switch, the switch itself needs to animate, and then the lights need to come on. We will build all this into our current script. However, before we continue on with the script, let's make some adjustments to the scene file to make this mechanism work.

Step 13: Turn off the baked version of Hallway, and activate the unlit version. In the scene file that was imported (if you're using that one), there will actually be two versions of the hallway. One is within the group Hallway_BakedGroup and the second is called Hallway_Unbaked. Select the Hallway_BakedGroup and in the Inspector, turn the group off (click off the check mark up by the object's name). Click the Deactivate Children button in the resulting Deactivating Game Object dialog box (Figure 14.9). Activate the Hallway_Unbaked version (it should show up completely black).

FIGURE 14.9 Deactivating an entire hierarchy.

Why?

Our method of turning the lights on and off here is going to be a little clumsy, but it is very easy to see how things are happening in the script. The way we are going to manage this light switching is by deactivating and reactivating big collections of stuff. Specifically in this scene there is an unbaked version of the scene that will show up completely dark (except for a flashlight we'll create in a minute). There is also the baked version of the scene that we have now deactivated. When the switch is thrown, we'll reactivate the baked version and deactivate the blacked-out version. It's a bit like weeding the garden with a backhoe, but it'll do the trick.

Tips and Tricks

If you built your own version of this hallway, by this point, hopefully it has been lit and baked. To replicate the preceding situation, simply bring up another instance of the Hallway from the project into the Hierarchy (this will be unbaked). Relabel it as Hallway_Unbaked, and relabel the baked version as Hallway_BakedGroup. My version of the file Hallway_BakedGroup also includes the lights, cameras, and keybox. These will just be hidden when working through the base with the flashlight to keep the player on task.

Step 14: Create a flashlight for the First Person Controller's camera. In the Hierarchy, select First Person Controller. In the Inspector make sure its Rotation XYZ values are all set to 0. Back in Hierarchy, select the Main Camera object that is a child of the First Person Controller. Move the mouse into the scene view and press F to focus on the camera. Choose GameObject>Create Other>Spotlight. Make the Spotlight a child of Main Camera and rename it `Flashlight`. Finally, make the Flashlight a child of Main Camera.

Why?

By rotating the First Person Controller to 0,0,0 we are orienting the controller (and thus the camera) in the direction that the spotlight will be in when it's created. By pressing F on the keyboard when the Main Camera is selected, we focus on the Main Camera, which means that when the spotlight is created, it will match the position of the Main Camera. It just takes a minute to do these things but is much easier than creating a spotlight somewhere in space and then attempting to get it positioned and rotated correctly.

Step 15: Add a Flashlight cookie to the Flashlight. A cookie is a sort of texture for a light source. Unity ships with a few easy-to-use cookies. Choose Assets>Import Package>Light Cookies. After completing the import process, there will be a new folder in the Standard Assets folder called Light Cookies. In the Hierarchy panel, select Flashlight and then drag the Flashlight cookie from the Project panel into the Inspector and into the Cookie input field of the Light component of the Flashlight.

Step 16: Test and adjust the light settings to taste (Figure 14.10).

FIGURE 14.10 Flashlight with cookie.

Tips and Tricks

Let the flashlight remain a bit dim. This part of the game should be a bit spooky. The way that the flashlight is set up now is that when the player looks around, the flashlight goes with him, which works great. Don't worry about any shadows (although they would be creepier). At this point we should be using Forward rendering (Edit>Project Settings>Player) and thus we won't be getting real-time shadows anyway. The shadows would be directly behind objects and tough to see in many cases, so leaving this flashlight as a very light (not a lot of resources needed to make it work) instrument will work great for as long as it's needed.

Step 17: Adjust bulkhead trigger. In the last chapter on triggers, we set up the first bulkhead door to open via our trigger. The version we opened was the baked version because it was just easier to see, but now we need the Trigger-BulkheadDoor1 to open the door that's in the unbaked version of Hallway. So select Trigger-BulkheadDoor1 in the Hierarchy this time and redefine the Door using the version of Hallway_DoorBulkhead_Group within the unbaked version of Hallway.

Why?

This is actually one of the benefits of making these variables public (as opposed to using private variables that we populate on a function Start with a find function). If we have multiple objects named the same thing, or if we want to make adjustments without having to descend again into the script, the public variables are there and flexible.

Tips and Tricks

When working with this unlit version of the map, things can be dark, really dark. Sometimes, when working with a dark scene it can be very helpful to turn off the lighting in the Scene window. Just turn off the lighting as shown in Figure 14.11 and the scene view will show everything well lit, although the in-game lighting will remain true in the Game window.

FIGURE 14.11 Turning off lighting in the Scene window.

Step 18: Test. The player should be able to walk through the scene and the bulkhead door should open. Make any other adjustments using triggers to accommodate this new darker version.

Step 19: Create a new function that swaps the unlit and lit models. Add the following to the bottom of AC_ToolFunctionalityScript:

```
var hallwayBaked: GameObject;
var hallwayDark: GameObject;

function Update () {
        var hit : RaycastHit;
        if (Physics.Raycast (transform.position, transform
.forward, hit, 100)){
                Debug.DrawLine (transform.position, hit
.point);
                Debug.Log ("Selected object is " + hit
.collider.gameObject.name);
```

```
                if (hit.collider.gameObject.name ==
"Hallway_PowerPanel_Switch"){
                        AddHighlight(hit.collider.gameObject);
                }
                if (hit.collider.gameObject.name ==
"Hallway_Key"){
                        AddHighlight(hit.collider.gameObject);
                }
        }
}

function AddHighlight(hiOb:GameObject){
        hiOb.renderer.material.color.r = hiOb.renderer
.material.color.r*10;
        hiOb.renderer.material.color.g = hiOb.renderer
.material.color.g*10;
        hiOb.renderer.material.color.b = hiOb.renderer
.material.color.b*10;
        yield WaitForSeconds (0.1);
        hiOb.renderer.material.color.r = hiOb.renderer
.material.color.r/10;
        hiOb.renderer.material.color.g = hiOb.renderer
.material.color.g/10;
        hiOb.renderer.material.color.b = hiOb.renderer
.material.color.b/10;
}

function TurnOnLights(){
        hallwayBaked.SetActiveRecursively(true);
        hallwayDark.SetActiveRecursively(false);
        Destroy(hallwayDark);
}
```

Why?

At the beginning of the script we declare two public variables (`hallwayBaked` and `hallwayDark`). Then at the end of the script we create a new function (`TurnOnLights`) that uses the `SetActiveRecursively` function. This means that an object and all of its children are set active (or inactive). Note that what's happening there is that the lit version is all turned on, and then the dark version is all turned off. Finally, since the lights are going to stay on, we can destroy the unlit version of the hallway so we needn't deal with it later or keep it in the dataset that Unity is working with.

Step 20: Define when the TurnOnLights function is to fire. We'll want this to happen on a mouse click, but only when the power switch is highlighted. Add the following code:

```
var hallwayBaked: GameObject;
var hallwayDark: GameObject;
```

```
function Update () {
    var hit : RaycastHit;
    if (Physics.Raycast (transform.position, transform
.forward, hit, 100)){
        Debug.DrawLine (transform.position, hit
.point);
        Debug.Log ("Selected object is " + hit
.collider.gameObject.name);
        if (hit.collider.gameObject.name ==
"Hallway_PowerPanel_Switch"){
            AddHighlight(hit.collider.gameObject);
            if (Input.GetMouseButtonDown(0)){
                TurnOnLights();
            }
        }
        if (hit.collider.gameObject.name ==
"Hallway_Key"){
            AddHighlight(hit.collider.gameObject);
        }
    }
}

function AddHighlight(hiOb:GameObject){
    hiOb.renderer.material.color.r = hiOb.renderer
.material.color.r*10;
    hiOb.renderer.material.color.g = hiOb.renderer
.material.color.g*10;
    hiOb.renderer.material.color.b = hiOb.renderer
.material.color.b*10;
    yield WaitForSeconds (0.1);
    hiOb.renderer.material.color.r = hiOb.renderer
.material.color.r/10;
    hiOb.renderer.material.color.g = hiOb.renderer
.material.color.g/10;
    hiOb.renderer.material.color.b = hiOb.renderer
.material.color.b/10;
}

function TurnOnLights(){
    hallwayBaked.SetActiveRecursively(true);
    hallwayDark.SetActiveRecursively(false);
    Destroy(hallwayDark);
}
```

Why?
In the area of the code that's telling Unity what to do if the name of the object being raycast against is Hallway_PowerPanel_Switch, we're saying, "If the user clicks the mouse button 0 (the left mouse button), go run the TurnOnLights function."

Step 21: Save and return to Unity. Fix any syntax errors that pop up in the console.

Step 22: Populate the two variables hallwayBaked and hallwayDark by selecting the script AC_ToolFunctionalityScript (which is attached to the First Person Controller), then (from the Hierarchy) dragging Hallway_ BakedGroup to the hallwayBaked variable in the inspector, and then dragging Hallway_Unbaked to hallwayDark.

Step 23: Test. If you didn't accept the challenge in the last chapter of a trigger to open the door to this closet, either create one now or hide the closet door. Then, when you enter the closet, the power switch should highlight when the crosshairs are over it, and if the player clicks the mouse, the lights will turn on (actually swaps models out).

Step 24: Refine the script to turn off the flashlight and animate the switch rotating up. We can do this with iTween, which also gives some really powerful tools that allow for a function to be fired. To do this we'll need to do a bit of work with what are called Hashtable Args. Replace the TurnOnLights(); command with the following:

```
var hallwayBaked: GameObject;
var hallwayDark: GameObject;

function Update () {
        var hit : RaycastHit;
        if (Physics.Raycast (transform.position, transform
.forward, hit, 100)){
                Debug.DrawLine (transform.position, hit
.point);
                Debug.Log ("Selected object is " + hit
.collider.gameObject.name);
                if (hit.collider.gameObject.name ==
"Hallway_PowerPanel_Switch"){
                        AddHighlight(hit.collider.gameObject);
                        if (Input.GetMouseButtonDown(0)){

iTween.RotateTo(hit.collider.gameObject, {"x": 0,
"time": 1, "oncompletetarget" : gameObject, "oncomplete" :
"TurnOnLights"});
                        }
                }
                if (hit.collider.gameObject.name ==
"Hallway_Key"){
                        AddHighlight(hit.collider.gameObject);
                }
        }
}
function AddHighlight(hiOb:GameObject){
        hiOb.renderer.material.color.r = hiOb.renderer
.material.color.r*10;
        hiOb.renderer.material.color.g = hiOb.renderer
.material.color.g*10;
```

```
        hiOb.renderer.material.color.b = hiOb.renderer
.material.color.b*10;
        yield WaitForSeconds (0.1);
        hiOb.renderer.material.color.r = hiOb.renderer
.material.color.r/10;
        hiOb.renderer.material.color.g = hiOb.renderer
.material.color.g/10;
        hiOb.renderer.material.color.b = hiOb.renderer
.material.color.b/10;
}

function TurnOnLights(){
        hallwayBaked.SetActiveRecursively(true);
        hallwayDark.SetActiveRecursively(false);
        Destroy(hallwayDark);
}
```

Why?

That's a long line of code, so let's look at what's happening there. `iTween.RotateTo` is calling up the custom class RotateTo that iTween provides. Then, `hit.collider.gameObject` is the object being rotated (in this case it's the power switch that the ray is casting upon). Then are the Hashtable Args. The format for these is **argumentToChange : value,** so in order these arguments are saying "rotate to X = 0 (`"x":0`), do it over 1 second (`"time":1`), when done look back to the object the script is attached to, not the object you were rotating (`"oncompletetarget":gameObject`), and when you're done, fire the TurnOnLights function (`"oncomplete" : "TurnOnLights"`)." Cool power in one line of code.

Tips and Tricks

If you're using your own version of the hallway, you may need to take some special notes on the rotation of the power switch. The power switch of the unlit version should begin the game rotated down; but should rotate up so it ends the animation at the rotation of the power switch in the lit version.

Step 25: Turn the flashlight off automatically when the big lights come on.

```
var hallwayBaked: GameObject;
var hallwayDark: GameObject;
var flashlight : GameObject;

function Update () {
        var hit : RaycastHit;
        if (Physics.Raycast (transform.position, transform
.forward, hit, 100)){
                Debug.DrawLine (transform.position, hit
.point);
```

```
            Debug.Log ("Selected object is " + hit
.collider.gameObject.name);
            if (hit.collider.gameObject.name ==
"Hallway_PowerPanel_Switch"){
                AddHighlight(hit.collider.gameObject);
                if (Input.GetMouseButtonDown(0)){

        iTween.RotateTo(hit.collider.gameObject,{"x":0,
"time":1, "oncompletetarget":gameObject, "oncomplete":
"TurnOnLights"});
                }
            }
            if (hit.collider.gameObject.name == "Hallway
_Key"){
                AddHighlight(hit.collider.gameObject);
            }
        }
    }
}

function AddHighlight(hiOb:GameObject){
    hiOb.renderer.material.color.r = hiOb.renderer
.material.color.r*10;
    hiOb.renderer.material.color.g = hiOb.renderer
.material.color.g*10;
    hiOb.renderer.material.color.b = hiOb.renderer
.material.color.b*10;
    yield WaitForSeconds (0.1);
    hiOb.renderer.material.color.r = hiOb.renderer
.material.color.r/10;
    hiOb.renderer.material.color.g = hiOb.renderer
.material.color.g/10;
    hiOb.renderer.material.color.b = hiOb.renderer
.material.color.b/10;
}

function TurnOnLights(){
    hallwayBaked.SetActiveRecursively(true);
    hallwayDark.SetActiveRecursively(false);
    flashlight.active = false;
    Destroy(hallwayDark);
}
```

Why?
Just two lines of text (both in italics in the code snippet). The first declares a variable, and the second within the TurnOnLights function sets the flashlight object to be inactive.

Step 26: Save and return to Unity. Fix any syntax errors that pop up in the console.

Step 27: Populate the new flashlight variable in Unity by dragging your flashlight from the Hierarchy to the flashlight variable on the AC_ ToolFunctionalityScript (attached to the First Person Controller).
Step 28: Test. The handle should highlight, when clicked it will swing up, and then the lights will appear to come on (Figure 14.12).

FIGURE 14.12 The power switch mechanics (before and after).

Conclusion

The functionality of the game is starting to emerge. We've looked at ways to make things happen by clicking things directly (OnMouseDown), we've made things happen by running into triggers (OnTriggerEnter), and now we've used raycasting to highlight objects, and then while an object is positively identified trigger other actions and functions.

But we're not done yet, not by a long way. In fact there are some things we left undone in this chapter. Currently, we can highlight the key, but do nothing with it. In later chapters we will build a "state engine" and an inventory system that will make use of our present system. But first, in the next chapter we will look at the ideas of Prefabs and instantiation. We will build upon what we know and build a Raycast-driven system that will allow for the player to shoot out the CCTV cameras to avoid detection. In that same chapter we will instantiate new objects like our EMP Mine to get into the facility.

Homework and Challenges

Challenge 1: The power closet could be already open, or another trigger could be set up to allow it to open as the character approaches. Or, a raycasting system could be set up that would allow the door to open, but only if the player was facing the door (as in, the ray was cast upon it) and if the player was within a certain distance of the door (length of ray), and if the door matched a certain name. Try and build a door-opening mechanism using your new raycasting skills.

Unity Prefabs and Instantiation

Prefabs

If you come from a long Maya lineage, you are undoubtedly familiar with the concept of instances. An instance in most of the 3D world is the idea of simply displaying an object multiple times rather than having multiple copies of the object. In applications like Maya, this means that if I made a change to the original object (candle modeled onto the cupcake), the change is automatically made to every instance of that object (500 instances of the cupcake suddenly all automatically have candles).

In Unity, this same idea is present, but uses slightly different nomenclature. In Unity this idea of displaying an object multiple times and having those additionally displayed versions inherit changes is called prefabs. We've talked of these before, but when constructing a game these can be tremendously powerful, and changes can be quickly propagated through the model. Of special use for us is the ability to add functionality to an object and have the prefabs throughout the model instantly inherit that capability.

In the first tutorial of this chapter we are going to write a script that allows the CCTV cameras in the scene to become "smart." They are going to really be looking for intruders (actually just raycasting along the camera's line of sight), and when the player does indeed come within the line of sight (collides with the ray), the camera's LED will begin to flash and a countdown will begin unless the player destroys the camera.

Prefabs versus Prefab Connections

If you are working from the imported assets (brought in from Chapter 13), the CCTV cameras are already placed within the scene and roughly oriented for reasonable coverage. Take a look at Figure 15.1 to see how the camera is arranged.

The camera is organized to allow for quick rotation of the camera (via rotating the Hallway_CCTV_Camera object). The LED actually will be doing a few things for us that are important. The camera itself is organized so that the orientation axis is down on the post that connects to the base. The problem with this is that the forward direction for the camera is straightforward rather than along the axis that the camera is pointing. The LED, however, is actually oriented so that its forward direction is straight out to where the camera would actually be looking. The reason for this piece of trickery will become a little more clear in a moment.

This camera, of course, was modeled in Maya and brought into Unity via FBX. When this model is imported, its icon will look like Figure 15.2 (as we've seen before).

Notice that the blue square (the traditional symbol in Unity for a prefab) has a little document symbol in front of it. As we've seen, the great thing about these objects is that if the model is adjusted in Maya and then replaced in

FIGURE 15.1 Diagram of camera organization.

FIGURE 15.2 Imported model.

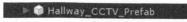

FIGURE 15.3 Prefab build within Unity.

the Assets folder of the Unity project file, this object automatically updates to represent these changes.

Here's the thing though—if in Unity changes are made to this object (objects added, scripts added, objects deleted etc.), they will not propagate to any other copies of this placed GameObject in the model. As soon as any changes are made to this GameObject, Unity will warn that "This action will lose the prefab connection. Are you sure you wish to continue?" and upon clicking Continue, the connection is indeed lost. The only option after that is to Revert to the state of the object when it was imported, or leave this orphaned object as is.

Conversely, look at Figure 15.3, which is a **prefab** constructed from an imported model.

The difference in the icon is subtle, and it is why I prefer to name Unity-created prefabs as such, but the difference in functionality is big. With a prefab constructed within Unity, if changes are made to the prefab (objects added or taken away), Unity will warn of the prefab connection being broken, but then after the changes are as desired, the Inspector allows for the changes to be applied (via an Apply button; Figure 15.4), and those changes are inherited everywhere this prefab has been placed.

Creating a prefab in Unity is very simple. To create one simply choose Assets>Create>Prefab. This will create a new object in the Project panel that shows a white cube (Figure 15.5). This represents an empty prefab. After the prefab is named, the prefab can be populated/filled by dragging any object on top of the empty prefab. It will then turn blue in the Project panel and you're in business.

FIGURE 15.4 Ability to apply changes to prefabs.

FIGURE 15.5 Empty prefab.

Once a prefab is populated, it can be placed within the scene, copied and pasted there, and all the copies will be tied to this prefab. If any of the instances of the prefab are altered, those changes can be inherited to all other instances of the prefab.

Sometimes, building scenes with combinations of imported assets and prefabs can save huge amounts of time. Consider how the Hallway scene included in the downloadable assets was built.

The main body of the hallway was created in Maya and combined (mostly) into one object so the drawcalls remained low. This did *not* include any of the light fixtures or the cameras. The light fixtures (the hanging lights and the mounted lights) were modeled in Maya and exported individually and brought into Unity. Once inside of Unity, a new prefab for the hanging lights was created and a Unity light source (a spotlight) was added. Then this prefab was placed, copied/pasted, and placed throughout the model. When the lighting was being worked out, the color balance of the light could be changed on one light, applied, and then automatically updated everywhere. Even things like specifications of a light's angle or shadow characteristics were quickly distributed throughout the model by adjusting just one.

A similar flow happened with the CCTV camera. The camera was modeled in Maya and brought into Unity. Within Unity, a new prefab was created and the CCTV camera was added to it. Then, the LED light was created from a Unity sphere and organized so it would be the raycasting agent. The cameras were placed throughout the scene in Unity. As we work to increase the functionality of these cameras, we only need add the functionality to one, apply the change, and all the placed cameras will instantly become smarter.

Even if you're creating your own cameras, take a minute and download and install the CCTV_Cameras Unity package available on the supporting web site (http://www.Creating3dGames.com). Once these are within the project file, you'll have all the tools to take some dumb GameObjects and make them aware of all sorts of things.

So let's make them smarter.

Tips and Tricks

If you are working from your own assets, you'll need to model a camera. Or, even if you are working from your own Hallway assets, for time-saving's sake, use the CCTV that is within the Scenography Assets folder (specifically the Hallway_CCTV_Prefab). Place and organize the camera prefab. Of course, if you're using the provided assets from the Hallway package, the cameras are already placed.

Tutorial 15.1: The Power of Prefabs

Step 1: Open Scene-Hallway.
Step 2: Deactivate Hallway_Unbaked and activate the Hallway_BakedGroup (and all its children). Remember, to do this, just select the object in the Hierarchy panel, and then check (or uncheck) the box next to the object's name.

Why?

When the game is run we'll eventually want the baked version to be turned on later, but the CCTV camera will only be active when the power is on, and thus we want to build the functionality in as though the scene has already turned on the lights.

Step 3: Create a new JavaScript and name it `CCTV-CameraSearchingScript`. Open it in your script editor.
Step 4: Create the raycasting mechanism. Start with this familiar code:

```
function Update () {
        var hit : RaycastHit;
        if (Physics.Raycast (transform.position,transform
.forward, hit, 100)){
            Debug.DrawLine (transform.position, hit.point,
Color.yellow);
        }
}
```

Why?

Everything there should be familiar—it literally is the same code as used in the last chapter. The only variation is the `Color.yellow` part. This is just coloring the debug ray so it's easy to see and differentiate from any other rays that might be cast in the scene.

Step 5: Save and return to Unity. Fix any syntax errors that pop up in the Console.
Step 6: Apply this CCTV-CameraSearchingScript to any of the camera's Hallway_CCTV_Led GameObjects in the Hierarchy (Hallway_CCTV_Group/Hallway_CCTV_Prefab/Hallway_CCTV_Camera/Hallway_CCTV_Led). When a new script is added to the prefab, Unity will warn that the prefab connection is about to be broken. Go ahead and click Continue.
Step 7: Apply this change to all the CCTV_Camera_Prefabs in the scene. To do this, in the Hierarchy just select the prefab to which the script was added (Hallway_CCTV_Led), and in the Inspector, click the Apply button that is on the Prefab line of buttons.
Step 8: Test. Play the game and take special note of what's happening in the Scene window (Figure 15.6).

FIGURE 15.6 Loads of rays being casted (represented in yellow); all from adjusting one prefab and applying the change.

Why?

And just like that all the cameras in the level can "see." Quick and powerful prefabs are. Next—tags.

Tags

Thus far, our scripts have identified objects by their names (hit.collider .gameObject.name == "Object's Name"). There is something direct about this method because we have the script looking directly for something solely based upon the name we typed. However, this can also be fairly brittle as well. Especially during the prototyping process, objects can very easily end up renamed in either Maya or Unity to help suit this artist or that scripter. If this happens, all the scripts that are looking for that object by name break. It can be pretty icky trying to track down which script called for that object by name, especially if you don't know what the name was. Alternatively, Unity can compare other attributes as well. One of my favorites is to compare an object's tag.

When any GameObject is selected in the Hierarchy, the Inspector will allow for the object to be given a tag and/or assigned to a layer. By default the tag on objects is set to Untagged. To assign a tag to an object, just use the drop-down menu next to tag in the Inspector (Figure 15.7). While we're

FIGURE 15.7 Assigning a tag to an object.

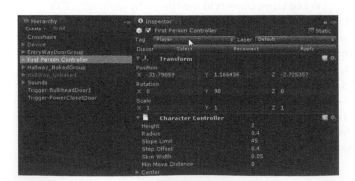

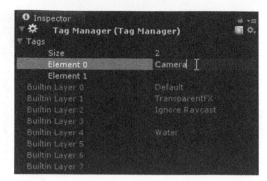

FIGURE 15.8 Defining new tags.

here, it's worthwhile to point out that custom tags can be created as well. Just select Add Tag…from the Tag drop-down menu, and the Inspector will appear like Figure 15.8 where the user can define a new tag name.

So the power of this idea is that a script can look for objects with a matching tag (say "Player"). So the main character can be called Fred at the beginning of development, Aegis midway, and be Janine when it's finally ready to be built, and as long as all three are tagged as Player, the script referencing it never breaks throughout the development process.

Step 9: In the Inspector panel, give First Person Controller a Player tag.
Step 10: Make our camera searching script watch specifically for objects whose tag is Player. If the ray strikes an object whose tag is "Player," change the LED to red (RGB value is 1,0,0):

```
function Update () {
        var hit : RaycastHit;
        if (Physics.Raycast (transform.position, transform
.forward, hit, 100)){
                Debug.DrawLine (transform.position, hit.point,
Color.yellow);
                if (hit.collider.gameObject.tag == "Player"){
                        renderer.material.color = Color (1,0,0);
                }
        }
}
```

Why?
This should look a little familiar. Instead of checking for name, `hit.collider.gameObject.tag` is checking for the tag. If they match, it takes the `renderer.material.color` of the object this script is attached to (which is the LED) and changes the color values to R = 1, G = 0, B = 0.

Step 11: Save and return to Unity. Fix any syntax errors pointed out in the Console.
Step 12: Test. Walk through any part of the level and as the camera "sees" you, the LED on the top of the camera will change to red (Figure 15.9).

FIGURE 15.9 The camera "seeing" the First Person Controller.

Step 13: Make the light pulse. To do this we will make a looping function. To create this looping function we'll create a mini-state-engine to define the state of things. The looping function will continue to loop as long as this state is true. So we'll need to do a few things to the script: add a Boolean (true/false switch), define that this Boolean is true when the ray hits the Player tag, and then fire the looping function:

```
var seenSomething : boolean;

function Update () {
      var hit : RaycastHit;
      if (Physics.Raycast (transform.position, transform
.forward, hit, 100)){
            Debug.DrawLine (transform.position, hit.point,
Color.yellow);
            if (hit.collider.gameObject.tag == "Player"){
                  seenSomething=true;
                  PulseLight();
            }
      }
}
function PulseLight(){
      while (seenSomething){
            var textureColor : Color;
            textureColor.r = Mathf.Sin (Time.time * 10.0);
            renderer.material.color = textureColor;
            yield;
      }
}
```

Why?

So note the three new things. `var seenSomething` is the declaration of the Boolean variable. Then in the Update function, note that we define seenSomething as true when the ray collides with something with the tag "Player." Then, when seenSomething is true, we tell Unity to go fire the function PulseLight.

PulseLight is the looping function. After defining the name of the function we are saying, "while seenSomething is true, then create a

variable that's only accessible in this function called textureColor that is of type Color. Then use a sin curve (looks kind of like a sound wave if it's been too long since your last math class that has gentle slopes up and gentle slopes down) to define the red value of the textureColor Color. This sin curve means that the red value is slowly being turned up, and then slowly turned down. Then, use the textureColor to define the color of the LED (`renderer.material.color`). `yield`; just means "wait" and keeps the looping function from being an infinite loop and crashing Unity.

Step 14: Save and return to Unity. Fix any syntax problems.
Step 15: Test. When the camera sees the player we should have a flashing LED.

Adding Sound

Step 16: Find an alarm sound you like (I'm using alarms.wav from FreeSound.org; http://www.freesound.org/samplesViewSingle .php?id=54048). Download it and place within the Unity project file.
Step 17: On any CCTV_Camera prefab in the scene, select the LED (Hallway_CCTV_Led) and add an Audio Source component (Component>Audio>Audio Source). Place the alarm sound in the Audio Clip input field (either use target icon or drag and drop from Project panel). Turn off the Audio Source component, but make sure Play On Awake and Loop are both checked (Figure 15.10).

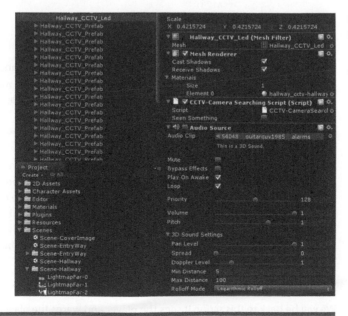

FIGURE 15.10 Settings for the CCTV camera.

Why?

We don't want this sound to always be playing; we want to trigger it in the script (which is why we're turning off the Audio Source component), but once it does awake (and thus play) we want it to loop.

Step 18: Click the Apply button up in the Prefab buttons to spread the love to all the other LEDs in the scene.

Step 19: Adjust the CCTV-CameraSearchingScript to include turning the Audio Source component on within the PulseLight function:

```
var seenSomething : boolean;

function Update () {
        var hit : RaycastHit;
        if (Physics.Raycast (transform.position, transform
.forward, hit, 100)){
                Debug.DrawLine (transform.position, hit.point,
Color.yellow);
                if (hit.collider.gameObject.tag == "Player"){
                        seenSomething=true;
                        PulseLight();
                }
        }
}

function PulseLight(){
        audio.enabled = true;
        while (seenSomething){
                var textureColor : Color;
                textureColor.r = Mathf.Sin (Time.time * 10.0);
                renderer.material.color = textureColor;
                yield;
        }
}
```

Step 20: Save and return to Unity. Fix any syntax problems.

Step 21: Test. Make adjustments to the Volume and Min Distance/Max Distance settings on the Audio Source to make the sound do what you want. Be sure that when a change is made, the Prefab Apply button is pressed so all the other prefabs get the message.

Tips and Tricks

Note that when a value is changed within a component on a prefab, the entry goes bold. This is also a powerful idea since it allows for prefabs to be customizable within a scene. Just because a change is made to one prefab doesn't mean it *has* to be propagated to the other prefabs. Each prefab can be customized. However, in this case we want a fairly constant sound, so as changes are made, don't forget that Prefab Apply button.

Conclusion

We will be back to this script. It sees the player and warns the player that he has been seen; however, there currently are no consequences. We'll need to build a timer into this mechanism so that if the player doesn't destroy the camera within a certain amount of time, he is assumed caught/seen and loses the game. But we'll take care of that in a future chapter.

For now, we'll look at how to shoot the cameras and how to show that the cameras have been shot.

Instantiation

Instantiation is the idea of creating objects at runtime (when the game is running). Actually, you've been doing it all along. When Unity runs the game, the prefabs that have been placed in your scene via the Hierarchy are all instantiated, and that's what the player actually runs through. This protects the original assets and these **instances** of the objects can be destroyed or otherwise changed and mucked up without long-term consequences.

Instantiation can also happen in a much more deliberate and controlled manner as well, and can create some very interesting visual tricks. For example, in our case we're going to play a bit of sleight of hand when the player shoots a camera. When a camera is hit, we will destroy the existing camera and instantiate a broken version of the camera at the same location. It will appear that we've destroyed the camera, when we've just swapped it out. We'll cover the trickery a little bit with a little explosion and some smoke.

But before we can do that we need to set up a gun-firing mechanism. And to do that we need to make use of some Aegis arms.

Download from the supporting web site (http://www.Creating3dGames .com) the AegisArms.unitypackage. This is an animated model (done in Maya of course) that uses the same texture as Aegis's entire body. Upon importing the package (Assets>Import Package>Custom Package), the model AegisChung_Arms should be placed inside a Character Assets folder in the Project panel (Figure 15.11).

It has a much simpler rig than the whole body (for performance issues and ease of animation). This rig can also be downloaded as the .mb file on the supporting web site (http://www.Creating3dGames.com) if you'd like to see how it's set up. There is very little new rigging technique there, so there is not

FIGURE 15.11 Aegis Chung arms as included in the AegisArms .unitypackage.

a new tutorial on it. Additionally, the polygons that are not part of the arms have been deleted to keep the polycount low.

This file will only include three animations—PistolReady, PistolFire, and FlashlightReady—since this version of the game will not use the rifle and knife. However, notice in Figure 15.11 that there is an awful lot going on in Aegis's right hand. He's actually holding all the weapons and tools at once. In a more robust version of the game, we'd include RifleReady, RifleFire, KnifeReady, KnifeStab animations, then via script we'd just turn off the weapons that weren't being used. Note that this also includes a prefab called PistolSparks that is a simple particle system that we'll use in coming tutorials.

For us, in the next tutorial we will turn off the rifle and knife and call up the animations for the pistol.

Tutorial 15.2: Setting Up the Armed Arms

Step 1: Check to see if there is a file in the Character Assets folder called AegisChung_Arms_Prefab, which should have come in through processes in Chapter 10. However, if you skipped Chapter 10 for some reason, or if the AegisChung_Arms_Prefab is not there, be sure to import the AegisArms unity package (Assets>Import Package>Custom Package and then find where you've downloaded the package to).

Step 2: In the Hierarchy, select First Person Controller and make sure its Rotation XYZ are all set to 0. Move the mouse over the Scene view and press F to frame the First Person Controller.

Why?
Again, the idea here is that when the arms are placed as children of the Main Camera, that everything is lined up.

Step 3: Expand the First Person Controller group so that Main Camera is visible.

Step 4: Place AegisChung_Arms in the scene as a child of Main Camera. The quickest way to do this is to drag AegisChung_Arms from the Project panel directly on to Main Camera (Figure 15.12).

Why?
This will look weird for a minute. The arms will be embedded in the white capsule and will be difficult to see. Similarly, all the weapons may be visible. Not to worry, we'll fix that in a minute.

We're making the arms a child of the camera so that wherever the camera moves, the arms move—which means the guns will always be pointed at where we're looking.

FIGURE 15.12 Placed AegisChung_ Arms (child of Main Camera).

Step 5: Play the game. It's going to look weird (Figure 15.13).

FIGURE 15.13 What the game looks like at this point—just wrong.

Why?

The arms are too high, we can see through the inside of the arm, all the weapons are active and on top of each other, there's no way those weapons if fired would hit where the crosshairs are pointing. The list of things that are wrong go on and on. No worries though, we just need to get those arms adjusted.

Step 6: If the gun, knife, and flashlight are visible, deactivate them. If they are not visible, they have already been deactivated. These three meshes are children of the wrist so you have to dig way down. Be sure to work in the Hierarchy and expand the AegisChung_Arms GameObject and keep expanding down until AC_R_Wrist is expanded. Select AC_Knife and deactivate it in the Inspector panel. Do the same for AC_Rifle and AC_Flashlight.

Step 7: Move AegisChung_Arms down and out a bit (Figure 15.14). The exact Position settings for me were X = 0, Y = –.35 and Z = 0.4 (all visible in the Inspector for AegisChung_Arms). However, move them to get your best guess. Play the game and adjust again.

FIGURE 15.14 AegisChung_Arms cheated out so they will be seen.

Why?

When testing and moving be sure to stop playing the game to make adjustments. Moving the arms while the game is playing will work well right then, but the position of the arms will revert when the game is stopped. Also, undoubtedly, you'll notice that the arms strangely disappear altogether on occasion, leaving just the pistol. We need to fix that.

Step 8: Fix the disappearing arm. In the Hierarchy, expand AegisChung_Arms and look for the ArmsCenter object. This (in Maya) was the actual first joint of the rig. Here in Unity, it has a Skinned Mesh Render component. Check the Update When Offscreen option (Figure 15.15).

FIGURE 15.15 Tracking down and activating the Update When Offscreen option.

Why?

Unity (and all game engines, really) work hard to make sure no processor cycles are being wasted on things that aren't seen. Among the strategies it employees is not to calculate certain things that are not visible to the player's camera—it doesn't update them when off screen. Joint deformations are one of these things that Unity doesn't bother with when it can't see them. But, sometimes, Unity gets a bit confused at what it considers on screen and thus the arms disappear intermittently when they are right on the edge of what the camera sees. By forcing updates even when the arms aren't on screen, we ensure that they always stay visible.

Step 9: Create a prefab for this complete First Person Controller with arms. First, rename First Person Controller to FPC_AegisChung. Then, in the Project panel, choose Create>Prefab. Rename this new prefab to the same FPC_AegisChung. Then drag the FPC_AegisChung that is in the Hierarchy down on top of the FPC_AegisChung prefab in the Project panel.

Why?

We've spent a lot of work getting this character set up and we'll want to be able to use it in our other level, EntryWay. By creating the prefab, we'll have quick access to it later when we replace the First Person Controller in EntryWay with this one.

Conclusion

So there is still some functionality missing here. Once the game starts, the gun comes up. This is because the arms are set to automatically play the first animation attached to it. This means that currently, the gun is always visible once the game starts, which we probably don't want it to be; and we don't have any way of using the PistolFire animation yet. Don't worry, we'll return to controlling these arms later. For now though, let's move on to being able to have the gun actually hit stuff.

Tutorial 15.3: Firing a Gun

Fortunately, we actually have a lot of the mechanism for the gun already created. We created it in the raycasting tutorial that build the AC_ToolFunctionalityScript script. Open that script and take a look. We have set up already a raycasting system that shoots a ray from the camera and understands what it hits. In this tutorial we'll build upon that mechanism to use raycasting to fire our gun.

Step 1: Open the script AC_ToolFunctionalityScript.

Step 2: Make the script know whether or not the pistol is out and ready to be fired. Declare the following variable at the beginning of the script (since the script is getting long, the needed added snippet will be called out by itself):

```
...
var pistolActive : boolean = true;
...
```

Why?

We're actually doing several things here. We're declaring the variable `pistolActive` and telling Unity it's going to be a type Boolean (on/off switch), and in the same line we're telling Unity its value is true (on). Later, we're going to adjust this so we can determine if the pistol is active via our inventory system, but for now, we just want to turn it on and leave it on.

Step 3: Have the script check to see if the pistolActive is true, and if it is, instantiate something that we'll call gunSpark (which will be a particle system). Add the following code:

```
    ...
if (hit.collider.gameObject.name == "Hallway_Key"){
                AddHighlight(hit.collider.gameObject);

    }
    if (pistolActive){
            if (Input.GetMouseButtonDown(0)){
                    var hitDirection = Quaternion
.LookRotation (hit.normal);
                    Instantiate(gunSpark, hit.point,
hitDirection);
                }
    }
    ...
```

Why?

So this new snippet checks to see if pistolActive is true; if it is, it listens for the player to press the left mouse button (`if (Input .GetMouseButton(0)`); when the player does this Unity creates a temporary variable (called hitDirection) and has it look at the normal of where the ray is striking the surface. Remember that the normal of a surface is the front of the surface, or the direction the surface is facing. This is laying the groundwork so that when the gunSpark fires, it will fire out from the direction of the surface it hits.

The last line there is the important one for our purposes. It's instantiating or creating while the game runs an object called gunSpark, at the location of hit.point facing the hitDirection that we defined in the line before. So the syntax of Instantiate is Instantiate (an object, at this spot, rotated like this).

Step 4: Declare a gunSpark variable. We're telling the script to instantiate whatever is residing in gunSpark, but we haven't declared a variable to hold it yet. At the top of the script, include the following variable declaration:

```
…
var gunSpark : GameObject;
…
```

Why?

We still need to build this gunSpark, but we have the container and mechanism now to access it.

Step 5: Save and return to Unity. Fix any syntax problems that pop up in the console.

Step 6: Populate the Gun Spark variable. The AC_ToolFunctionalityScript is (or should be) attached to Main Camera (the one that is a child of the now FPC_AegisChung). Select Main Camera in the Hierarchy, and then in the Inspector look for the "AC_ToolFunctionalityScript (Script)" component. From the Character Assets folder in the Project panel (in the Character Assets folder), drag the PistolSparks prefab onto the Gun Spark variable input field of the Inspector.

A Few Notes about Pistol Sparks

If PistolSparks is selected in the Project panel (Figure 15.16), you can see the settings of this particle system. It's actually just a variation of the Sparks prefab that was included back when we imported Unity's Particles package. In the Ellipsoid Particle Emitter section it has smaller values for Min Size (0.005)

FIGURE 15.16 The very critical AutoDestruct for PistolSpark.

419

and Max Size (0.05) and a lower value for Max Energy (0.1). In the Particle Renderer, it has a shortened Length Scale (1). All this was found by duplicating Unity's Spark, relabeling it PistolSparks, and then dropping a copy of it into the Scene window, tweaking to taste and pressing the Prefab Apply button. Feel free to tweak further if you don't like my settings.

However, the critical setting that does need to be there is in the Particle Animator section. The Autodestruct option is checked. This means that after the particle fires once, it destroys itself. Since this particle system is going to be instantiated at each point where the player fires his gun, it will be important that once the spark fires, it dies and doesn't create a geyser of sparks for every move.

> **Step 7:** Play the game. Shoot around. Since the pistol is active from its declaration, wherever the player fires, the little PistolSpark particle system will be instantiated on the surfaces where the ray collides and will be sparking away from the surface (Figure 15.17). Fire away (we'll still be here when you're done playing).

FIGURE 15.17 Instantiating a spark where the ray shooting from the Main Camera strikes a surface.

> **Step 8:** Download and import Unity's explosion framework, "Detonator." This is available at http://unity3d.com/support/resources/unity-extensions/explosion-framework. When downloaded, this will be a unitypackage that can be brought in as usual via Assets>Import Package>Custom Package.
>
> **Step 9:** Download and import the package CCTV_Cameras.unitypackage from the support web site (http://www.Creating3dGames.com). This will include some assets already in the scene, and some (like a broken version of the camera) that you do not have.

Quick Note about Detonator and Explosion Framework

These scripts all with a Detonator prefix are part of the Unity Explosion Framework. On Unity's web site, Unity provides some very handy tools for download and manual implementation. If you are working from the Unity scenes provided on the web site (http://www.Creating3dGames.com),

these will be included, and by importing the CCTV_Cameras Unity Package earlier, you installed some of these scripts within the project. The entire Detonator package is available at http://unity3d.com/support/resources/unity-extensions/explosion-framework. It's a package that includes scripts, textures, and sample prefabs for all sorts of explosions. The prefabs can be dropped into a scene, or (as in this case) the particular features desired for an explosion can be plucked from the menu of Detonator scripts and dropped on the object you wish to explode.

Some Detonator functionalities (heat wave) are Pro-only features, but most things work just fine in Unity as well. In this broken version of the camera, I've dropped on the Detonator script and the Detonator Sparks script (with a few minor tweaks to color and size). To see the explosion in action, just play the game and the explosion will fire (Figure 15.19). In fact, what's happening is the explosion fires when this broken version of the camera (Hallway_CCTV_Broken) is instantiated. In the upcoming script we will instantiate this broken version of the Camera when it is shot, which will trigger the explosion and hide the swap of objects.

Step 10: Explore the broken version of the CCTV camera (in Scenography Assets called Hallway_CCTV_Broken). Drag it out anywhere in the scene, select it, and press F on the keyboard to focus on it (Figure 15.18). Notice

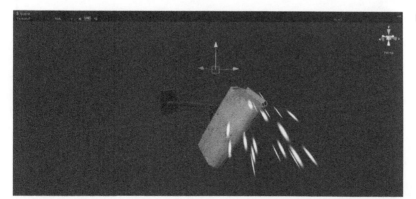

FIGURE 15.18 The broken camera.

FIGURE 15.19 When playing the game, the Detonator scripts attached to the camera will fire.

that it contains a Sparks particle system, and some curious scripts that are attached to Hallway_CCTV_Base....Detonator Scripts.

Step 11: Declare a variable to hold the broken version of the camera. Add the following declaration to the beginning of the AC_ ToolFunctionalityScript script:

```
var brokenCamera : GameObject;
```

Step 12: Create the instantiation mechanism to pull off the ol' camera switcheroo. This needs to happen only *if* the raycasting mechanism hits something, *and if* pistolActive is true, *and if* the player presses the mouse button when this is happening, *and if* the object the ray hits is indeed a camera. Since some of the lines are getting long and for clarity's sake, the entire function Update is shown in Figure 15.20 with the new script highlighted.

FIGURE 15.20 Added mechanism that checks to see if the object is tagged "Camera," and if it is, replace it with the broken version of the camera.

Why?

Notice that this if statement is within several if statements and only fires if the mouse button is pressed while the pistolActive Boolean is true. Then, the instantiate statement is saying, "instantiate brokenCamera at the position of the camera that was hit, and make sure it's rotated at the same angle as the camera that was hit." Finally, the Destroy command destroys the object that was hit (the old camera).

Step 13: Save and return to Unity. Fix any syntax problems.

Step 14: Populate the brokenCamera variable. Select the Main Camera, and look to the AC_Tool Functionality Script (Script) component. Drag Hallway_CCTV_Broken from the Project panel's Scenography Assets folder to the input field for Broken Camera. Be sure to press the Prefab Apply button.

Step 15: Play and test. Since the pistol is always visible, you should be able to start shooting cameras. They'll explode as the broken version pops into existence (Figure 15.21).

FIGURE 15.21 The shooting camera mechanism working.

Conclusion

We still haven't built in the mechanism for the cameras to end the game. However, using raycasting, prefabs, and instantiation, we have created a working pistol. Let's look at how to continue to use raycasting and instantiation to place other items, like the EMP Mine.

Tutorial 15.4: Sound Revisited

The first-person controller is coming together nicely, and is becoming the central depository for many of the functionality scripts. However, the version of the first-person controller that we've been constructing in the Hallway scene is different than the one out in the EntryWay. Of particular worry is the fact that the controller outside has our footstep script and sound and the controller out there is lacking all the raycasting capability created here.

Eventually, since we've created a prefab of the controller in here, we will be using this version out in the EntryWay. So we'll quickly rebuild the footstep functionality of the EntryWay controller and add a bit more functionality, including gunshot sounds to round him out.

Step 1: Select FPC_AegisChung in the Hierarchy. Press F to focus on the object.

Warnings and Pitfalls

When the technical editor was going through the chapters, he found and pointed out some of the trickier aspects of what happens sometimes in Unity's scripts. Be very careful of capitalization issues. His note read like this: "Dang, it's not working. And I'm not getting any errors, so some of the conditions must not be being met. . . .

"Going back and looking at the Script, it seemed to me that 'Camera' is wrong. It should read Hallway_CCTV_Prefab, but then I realized the script is already doing that through .tag text.

"Come to find out I didn't capitalize the O in gameObject. Tricky stuff."

Unity needs to see things just the right way for things to go right. Pay special attention to things like capitalization to make sure stuff like that doesn't sneak past you.

Step 2: Create two empty GameObjects (GameObject>Create Empty). Name one `Sound-Footsteps` and the other `Sound-Gunshot`.

Step 3: Make both of these children of FPC_AegisChung (go ahead and continue through the breaking prefab warning).

Step 4: For each, add an Audio Source component (Component>Audio> Audio Source).

Step 5: Define the sound for each by dragging the desired sound from the Project panel to the Audio Clip input field for the Audio Source component.

Step 6: For Sound-Footsteps, be sure to disable the Audio Source component (the footsteps script simply turns it on when needed). Be sure Play on Awake and Loop are both checked.

Step 7: Drag the SoundFootstepsControl script (that we wrote back in our sound chapter and should currently be in the Project panel) onto Sound-Footsteps (you'll be warned about breaking a prefab). The footsteps should be done. Play to make sure and adjust the volume to taste.

Step 8: For Sound-Gunshot we're going to run things a bit differently. Leave the Audio Source active, but turn off Play on Awake (also, leave Loop off).

Step 9: Open AC_ToolFunctionalityScript and create two variables— one for the GameObject that contains the audio (we'll call it gunshotSoundSource) and one for the actual AudioClip (we'll call this one gunshotSound). So at the top of the script add these two variables:

```
var gunshotSoundSource : GameObject;
var gunshotSound : AudioClip;
```

Why?

We'll be using the function PlayOneShot to trigger the sound (just looking at many different ways to handle sound). PlayOneShot requires an object, its audio component, and the specific audio clip to play. While we could declare these variables within the body of the script, it can be easier to tell what's going on in a script sometimes when the variables can be quickly read up top.

Step 10: Find the place where the player fires the gun in the script (Figure 15.22). Add the following line:

```
gunshotSoundSource.audio.PlayOneShot(gunshotSound);
```

Why?

This line finds the object gunshotSoundSource, finds its audio component, and plays the audio clip gunshotSound once.

Step 11: Save and return to Unity. Fix any syntax errors that the Console complains about.

Step 12: Populate the two new variables. For gunshotSoundSource, drag Sound-Gunshot from the Hierarchy to the Gunshot Sound Source input field in the Inspector. For the Gunshot Sound input field, drag the file from the Project panel (it's the easiest way to get the name right).

FIGURE 15.22 Complete script at this point including highlighted location of new gun sound command.

Step 13: Play and test. Fire around and see how the gun sound fires off every time the gun is active (all the time) and the player pushes the fire button.

Step 14: Save all these additions to the prefab by selecting the parent FPC_AegisChung in the Hierarchy and pressing the Prefab Apply button.

Step 15: Save the Unity scene (File>Save); we're finally about to leave the hallway.

Scope and Optimizing Script

Scope refers to the parts of the code that have access to a given variable. If a variable is declared at the beginning of a script, all the functions that happen in that script have access to it. We can even declare Global variables, or variables that are accessible to all scripts in a game (more on this later). But we can also declare local variables, or variables that are accessible only within the

block of code that they are declared in. Keeping track of what parts of a script (or project) have access to what information is important to understanding what values are floating around, and to keeping the script tidy.

This AC_ToolFunctionalityScript script is getting quite powerful, but also quite long and has some inefficiencies when it comes to reading the document. Perhaps expert scripters are able to construct script flawlessly from the get-go, but for most of us mere mortals, scripts tend to evolve quite organically and thus sometimes need a little bit of trimming.

The main trimming for us at this point will entail a few important things. First, we can strip the Debug functions. They were a valuable instrument when trying to understand concepts like raycasting, but for now they are just visual clutter. If we need them later to figure out a problem, it's easy to add them back.

Second, we can look at certain objects or components that we are accessing again and again within a function and create a local variable (a variable that is only available within the function in which they were declared) to house the object, and just call on that variable. So for instance, if you look at the code right now we are accessing hit.collider.gameObject a lot. In nearly every block of code this particular chunk of script appears. Right after we cast the ray (which creates the hit), if we declare a variable that houses the object that the ray hits (which is what hit.collider .gameObject is), we can save a lot of typing and make the code much easier to read. So add the following line (surrounding code included):

```
...
function Update () {
        var hit : RaycastHit;

        if (Physics.Raycast (transform.position, transform
.forward, hit, 100)){

                var hitObj = hit.collider.gameObject;
                if (hitObj.name == "Hallway_PowerPanel_Switch"){
        ...
```

Then, everywhere in the code (except for line that defines hitObj) where `hit.collider.gameObject` appears, just swap out `hitObj`. This can quickly be done with the search and replace function of the editor.

Similarly, in the if(pistolActive) block of code, we create a local variable for a LookRotation (the rotation of an object we instantiate). Unfortunately, this means we tie that variable into that block of code, and it would be nice to access it throughout the function. And in fact, we want access to it as we work toward setting up the EMP Mines functionality. However, with it nested down inside the pistolActive block of code, it can be tough to track it down later when we're bug squashing, and really annoying for someone else who inherits the script and has to try and figure out what's going on. For these reasons, it makes sense to lift this particular variable declaration up to the top of the function as well. So...

```
21   function Update () {
22       var hit : RaycastHit;
23       if (Physics.Raycast (transform.position, transform.forward, hit, 100)){
24           var hitObj = hit.collider.gameObject;
25           var hitDir = Quaternion.LookRotation (hit.normal);
26           if (hitObj.name == "Hallway_PowerPanel_Switch"){
27               AddHighlight(hitObj);
28               if (Input.GetMouseButtonDown(0)){
29                   switchSoundSource.audio.PlayOneShot(switchSound);
30                   Destroy(switchSoundSource);
31                   iTween.RotateTo(hitObj, {"x": 0, "time": 1, "oncompletetarget" : gameObject, "oncomplete" : "TurnOnLights"});
32               }
33           }
34           if (hitObj.name == "Hallway_Key"){
35               AddHighlight(hitObj);
36               PickUpKey();
37           }
38           if (pistolActive){
39               if (Input.GetMouseButtonDown(0)){
40                   gunshotSoundSource.audio.PlayOneShot(gunshotSound);
41                   Instantiate(gunSpark, hit.point, hitDir);
42                   if (hitObj.tag == "Camera"){
43                       Instantiate (brokenCamera, hitObj.transform.position, hitObj.transform.rotation);
44                       Destroy (hitObj);
45                   }
46               }
47           }
48       }
49   }
```

FIGURE 15.23 Tightened script with local variables.

```
...
function Update () {
    var hit : RaycastHit;

    if (Physics.Raycast (transform.position, transform
.forward, hit, 100)){
            var hitObj = hit.collider.gameObject;
        var hitDir = Quaternion.LookRotation(hit.normal);
            if (hitObj.name == "Hallway_PowerPanel_Switch"){
...
```

The entire function Update can be tightened up and can look like Figure 15.23.

Tutorial 15.5: The EMP Mines

The EMP mines are meant to allow electronic systems to be overloaded and disabled. They are meant to be mounted on the floor or wall next to an electronic device, and then when they go off, do their damage and disable any electronics around them. These are particularly valuable when trying to get through things like electronic security systems like the one near the entrance to the base.

Placing things in a game is always an interesting challenge. Different games have attempted to this in different ways, but among my favorites is how the engineer works in Team Fortress 2. He sets up turrets. The player playing the engineer has to decide where the turret is set up and how it is oriented. The methodology is sort of a ghosted version and blueprint that appears before the player, which shows where the turret will be placed once the player activates it. We will use a very similar methodology for this game.

The mechanism will work like this: When the player activates the EMP Tool, a ghosted version of the EMP will appear centered on the screen. As the character moves and moves his mouse, the ghosted EMP will crawl along the surfaces of the level. When the player is happy with the placement, he will click the mouse button and the real (armed) EMP will be placed and will detonate after a short delay.

This is going to be an interesting problem to solve. It's going to require an object to be instantiated once, and then moved around the scene based upon where the player looks. Then, this object will need to be destroyed as another object is created in its place. Then this last object will need to have scripts attached to it activated after a short wait. Fun stuff—let's do it.

Step 1: Download and import the Unity package EMPs from the supporting web site (http://www.Creating3dGames.com).

Why?

This will bring a few things into a Character Assets folder. It should bring an .fbx EMP that was used to create EMP_Prefab and EMP_Ghost (both of which are prefabs). The EMP_Prefab has attached to it a Detonator script that is inactive (we'll activate it via script later). EMP_Ghost has a separate shader that allows it to be semitransparent. There's nothing particularly special about either, but they do use some shaders we haven't talked about yet—feel free to explore them.

Step 2: Open Scene-EntryWay. Disable the fog (Edit>Render Settings) so we can see the scene.
Step 3: Ensure that you have an entryway with a digital lock within the scene (Figure 15.24). Hopefully this was created in earlier steps if you're using your own model. However, if you don't have one, or if you want another, an EntryWayDoors Unity package is available on the supporting web site (http://www.Creating3dGames.com).

FIGURE 15.24 EntryWay.

Step 4: Delete the old First Person Controller that is placed within this scene (the one we worked with back with sounds).

Step 5: Place our newly constructed FPC_AegisChung prefab (drag it from the Project panel into the Scene window). Put it back in about the same place as the other unit (Figure 15.25).

FIGURE 15.25 Placement of FPC_AegisChung prefab, which replaces First Person Controller that was in the scene.

Step 6: Turn off the flashlight. Select it and deactivate it in the Inspector panel. You may need to also deactivate the rifle and knife again.

Step 7: Open AC_ToolFunctionalityScript.

Step 8: Declare two variables: empGhost and empReal. Do this at the top of the script. Both should be typed as GameObject:

```
...
var empGhost : GameObject;
var empReal : GameObject;
...
```

Why?

These two objects don't exist when the game starts—they are not part of the scene. But by declaring these public variables, we can populate them with assets from the Project panel so Unity knows what to instantiate when the time comes.

Step 9: Declare two private variables (placingEMP and placedEMP) that will act as the holders of the instantiated ghost version and placed version. Again add this to the top of the script:

```
private var placingEMP : GameObject;
private var placedEMP : GameObject;
```

Step 10: Declare a Boolean variable for when the EMP is active (empActive). Create a second one for when the EMP Ghost is active (empGhostActive). I like to group my variable declarations, so the total variable declaration pack looks something like this:

```
var hallwayBaked : GameObject;
var hallwayDark : GameObject;
var flashLight : GameObject;
var gunSpark : GameObject;
var brokenCamera : GameObject;
var gunshotSoundSource : GameObject;
var switchSoundSource : GameObject;
var empGhost : GameObject;
var empReal : GameObject;
private var placingEMP : GameObject;
private var placedEMP : GameObject;

var gunshotSound : AudioClip;

var pistolActive : boolean;
var empActive : boolean;
var empGhostActive : boolean;
...
```

Why?

We could make this new variable public, but nothing but this script ever sees it or ever needs to access it. Keeping it private keeps the Unity Editor space from getting cluttered and helps future users of the scene not feel like they need to populate it.

Step 11: Check to see if empActive is true, and if it is, start doing things (that we haven't defined yet). Do this at the end (but still within) the function Update block of code (since we want this to be happening every frame).

```
...
if (empActive){
    }
    ...
```

Why?

This seems like a bit of empty code, and indeed it is. It says, "check to see if empActive is true and if it is, do nothing." It's a trick I learned from our team's hard-core software developer. What he does is every time he creates a function or an if statement, he creates the start { and end } right from the beginning, and then fills in the middle. It helps him keep track of all the opening and closing brackets.

Step 12: Have the script instantiate empGhost only if empGhostActive (the Boolean) is not true, and then once the object is instantiated, set empGhostActive to be true:

```
...
if (empActive){
      if (!empGhostActive){
            placingEMP = Instantiate(empGhost, hit.point,
hitDir);
            empGhostActive = true;
      }
}
...
```

Tips and Tricks

As you've probably gathered by now ! means "not." So (!empGhostActive) means empGhostActive is not true. Or != means "not equal to."

Why?

Some important things are happening here. This collection of code is within a function Update. This means that the code is firing every frame. If we were to just use empPlacement = Instantiate(empGhost, hit.point, hitDir); without checking to see if empGhostActive was not true (!empGhostActive), Unity would be instantiating empGhost every frame and leaving a trail of ghosted EMP mines.

What this block does is create the empGhost object and assign it to the variable empPlacement, and then immediately sets the empGhostActive state to true (empGhostActive = true;)—all in the same frame. So in the next frame, since empGhostActive is true, it doesn't fire the code to Instantiate again.

The problem with the code right now is that this creates the empGhost (and has this newly instantiated object populate the empPlacement variable), but this new ghost is sitting right where it was created. We need it to move around according to where the player looks.

Step 13: In the code check to see if empPlacement has been populated, and if it has, have empPlacement's position and rotation match the raycast hit's location and normal direction:

```
...
if (empActive){
      if (!empGhostActive){
            placingEMP = Instantiate(empGhost, hit.point,
hitDir);
            empGhostActive = true;
      }
      if (empPlacement != null){
            placingEMP.transform.position = hit.point;
            placingEMP.transform.rotation = hitDir;
      }
}
...
```

Why?

We don't want Unity to be chugging away trying to move an object that isn't there yet. The if statement there (`if (empPlacement != null){`) makes sure that empPlacement has indeed been populated. If it has not, it doesn't fire the two lines beneath it that move it. But if it has been populated (if its value is not null), then go ahead and set empPlacement's position to match the point the ray hits (hit.point) and rotate in the direction of hitDir.

Step 14: Actually place the "real" EMP:

```
if (empActive){
     if (!empGhostActive){
          placingEMP = Instantiate(empGhost, hit.point,
hitDir);
          empGhostActive = true;
     }
     if (placingEMP != null){
          placingEMP.transform.position = hit.point;
          placingEMP.transform.rotation = hitDir;
     }
     if (Input.GetMouseButtonDown(0)){
          Destroy (placingEMP);
          placedEMP = Instantiate(empReal, hit.point,
hitDir);
          ExplodeEMP(placedEMP);
     }
}
```

Why?

This last block of code says, "if the user presses the mouse button (if (`Input.GetMouseButtonDown(0)){`), then destroy the empPlacement object (which is the instantiated ghost version of the EMP), and instantiate the object empReal at the point and rotate it to the surface's normal. Then, run the function ExplodeEMP (that we haven't created yet). When you run ExplodeEMP pass to this function the object that we just used to populate placedEMP.

This is another instance of the importance of understanding scope. We defined placedEMP with the line `placedEMP = Instantiate(empReal, hit.point, hitDir);`. But because this definition is within an if statement block and inside an Update function, this would not carry on down to the ExplodeEMP function (that we're going to write in a minute). This is why we have to manually pass down to the ExplodeEMP the parameter of what placedEMP is.

Step 15: Clean up. We're going to add one more block of code that may seem a little obscure right now but will be important later. This will make sure there aren't extra ghost EMPs floating around:

```
if (empActive){
        if (!empGhostActive){
                placingEMP = Instantiate(empGhost, hit.point,
hitDir);
                empGhostActive = true;
        }
        if (placingEMP != null){
                placingEMP.transform.position = hit.point;
                placingEMP.transform.rotation = hitDir;
        }
        if (Input.GetMouseButtonDown(0)){
                Destroy (placingEMP);
                placedEMP = Instantiate(empReal, hit.point,
hitDir);
                ExplodeEMP(placedEMP);
        }
}
if (!empActive){
        if (placingEMP != null){
                Destroy (placingEMP);
                empGhostActive = false;
        }
}
}
```

Why?

We want to make sure that if the player uses the EMP tool, but doesn't actually place the EMP, that the ghost version gets deleted. This is especially important later when there are multiple tools that the character can use. So the code says, "if empActive is NOT true, and placingEMP is not empty (as in there is one in the scene), destroy the placingEMP object, and set empGhostActive to false."

Step 16: Create the ExplodeEMP to fire the Detonator script. This is another function and so should happen further on down the script (Figure 15.26). Enter the following:

```
function ExplodeEMP(placedEMP:GameObject){
        yield WaitForSeconds (2);
        placedEMP.audio.enabled = true;
        placedEMP.GetComponent("Detonator").enabled = true;
        placedEMP.renderer.material.color = Color (0,0,0);
}
```

Why?

The first line defines the name of the function and that it can include the parameter of a variable that is a GameObject. Then, when the function is fired, it immediately waits 2 seconds before activating the audio component on placedEMP (placed.audio.enabled = true;) and enabling the script called Detonator on that script (placed.GetComponent("Detonator"). enabled = true;), and then changes the color of the material to black (placedEMP.renderer.material.color = Color (0,0,0);).

```
AC_ToolFunctionalityScript.js - UniSciTE
File  Edit  Search  View  Options  Language  Buffers  Help

1 AC_ToolFunctionalityScript.js
1     var hallwayBaked : GameObject;
2     var hallwayDark : GameObject;
3     var flashLight : GameObject;
4     var gunSpark : GameObject;
5     var brokenCamera : GameObject;
6     var gunshotSoundSource : GameObject;
7     var switchSoundSource : GameObject;
8     var empGhost : GameObject;
9     var empReal : GameObject;
10    private var placingEMP : GameObject;
11    private var placedEMP : GameObject;
12
13    var gunshotSound : AudioClip;
14    var switchSound : AudioClip;
15
16    var pistolActive : boolean;
17    var empActive : boolean;
18    var empGhostActive : boolean;
19
20  - function Start (){
21        pistolActive = false;
22        empGhostActive = false;
23    }
24
25  - function Update () {
26        var hit : RaycastHit;
27  -     if (Physics.Raycast (transform.position, transform.forward, hit, 100)){
28            var hitObj = hit.collider.gameObject;
29            var hitDir = Quaternion.LookRotation (hit.normal);
30  -         if (hitObj.name == "Hallway_PowerPanel_Switch"){
31                AddHighlight(hitObj);
32  -             if (Input.GetMouseButtonDown(0)){
33                    switchSoundSource.audio.PlayOneShot(switchSound);
34                    Destroy(switchSoundSource);
35                    iTween.RotateTo(hitObj, {"x": 0, "time": 1, "oncompletetarget" : gameObject, "oncomplete" : "TurnOnLights"});
36                }
37            }
38  -         if (hitObj.name == "Hallway_Key"){
39                AddHighlight(hitObj);
40                PickUpKey();
41            }
42  -         if (pistolActive){
43  -             if (Input.GetMouseButtonDown(0)){
44                    gunshotSoundSource.audio.PlayOneShot(gunshotSound);
45                    Instantiate(gunSpark, hit.point, hitDir);
46  -                 if (hitObj.tag == "Camera"){
47                        Instantiate (brokenCamera, hitObj.transform.position, hitObj.transform.rotation);
48  -                     if (hitObj!=null){
49                            Destroy (hitObj);
50                        }
51                    }
52                }
53            }
54  -         if (empActive){
55  -             if (!empGhostActive){
56                    placingEMP = Instantiate(empGhost, hit.point, hitDir);
57                    empGhostActive = true;
58                }
59  -             if (placingEMP != null){
60                    placingEMP.transform.position = hit.point;
61                    placingEMP.transform.rotation = hitDir;
62                }
63  -             if (Input.GetMouseButtonDown(0)){
64                    Destroy (placingEMP);
65                    placedEMP = Instantiate(empReal, hit.point, hitDir);
66                    ExplodeEMP(placedEMP);
67                }
68            }
69        }
70    }
71
72  - function AddHighlight(hiOb:GameObject){
73        hiOb.renderer.material.color.r =hiOb.renderer.material.color.r*10;
74        hiOb.renderer.material.color.g = hiOb.renderer.material.color.g*10;
75        hiOb.renderer.material.color.b = hiOb.renderer.material.color.b*10;
76        yield WaitForSeconds (0.1);
77        hiOb.renderer.material.color.r = hiOb.renderer.material.color.r/10;
78        hiOb.renderer.material.color.g = hiOb.renderer.material.color.g/10;
79        hiOb.renderer.material.color.b = hiOb.renderer.material.color.b/10;
80    }
81
82  - function TurnOnLights(){
83        hallwayBaked.SetActiveRecursively(true);
84        hallwayDark.SetActiveRecursively(false);
85        flashLight.active = false;
86        Destroy (hallwayDark);
87    }
88
89  - function ExplodeEMP(placedEMP:GameObject){
90        yield WaitForSeconds (2);
91        placedEMP.audio.enabled = true;
92        placedEMP.GetComponent("Detonator").enabled = true;
93        placedEMP.renderer.material.color = Color (0,0,0);
94    }
95
96  + function PickUpKey(){
```

FIGURE 15.26 Total script thus far.

So why do all this as a separate function? Couldn't it all be done with the rest of the instructions on what to do when the user clicks the mouse button? Well, it could if it wasn't for that pesky yield statement. Yields are considered "coroutines" and coroutines cannot be part of a function Update (since function Update is firing every frame). By breaking this function out, though, we can play with time and when to fire what based upon things like `yield WaitForSeconds`. The reason for waiting 2 seconds in the first place is to allow the player to place the EMP and then get back before it goes off.

Step 17: Save and return to Unity. Fix any syntax errors that might pop up.

Step 18: Populate the new variables for the script. Remember that the script is attached to the Main Camera. Drag EMP_Ghost and EMP_Prefab into their respective spots (drag them from the Project panel (Figure 15.27). Make sure Pistol Active and Emp Ghost Active are both unchecked to be inactive.

FIGURE 15.27 Populated AC Tool Functionality Script.

Tips and Tricks

Notice that currently some of the variables are not populated. Namely, the objects that are only available in the Hallway scene. While this might not be as elegant as it could be, it's still alright. In the version of this prefab that lives in the Hallway scene, these variables are populated so all should be OK.

Step 19: Play and test. Since EMP Active is turned on from the start, there should be a ghosted version of the EMP floating around. As the player moves, it will move in front of them. When the mouse button is clicked, the ghosted version will be replaced by the real EMP that will fire its detonator script (and sound) after two seconds.

Step 20: Play again and walk up to any of the triggers set up in the scene and notice how the ghost EMP ends up sticking to these invisible surfaces (Figure 15.28).

Layers

This is an annoying, but fixable, predicament. The triggers need to have a collider on them or they won't work as colliders. But these colliders are what cause the raycasting to see them, and then the ghosted EMP to crawl up the sides of these imaginary objects.

Luckily, the fine folks at Unity have foreseen such troubles and created a method of allowing objects to live on layers. These layers aren't like Photoshop layers—they don't actually (by default) live in a particular order over the top of each other. But they are very handy for Unity mechanisms that "see" things.

For instance, cameras and lights can be told to only "see" certain layers. For lights this means that a light might illuminate certain objects (that are on certain layers) and not illuminate adjacent objects (that are assigned to different layers). It means that a camera could be told to ignore certain layers and thus not to draw some objects that exist in the scene. This can be a handy way to handle things like X-rays or night-vision goggles.

In the case of raycasting this can be very important. Via script, a raycasting mechanism can be told to ignore certain layers, or, lucky for us, there is already an Ignore Raycast layer that does some of this for us.

If an object, like a trigger, is assigned to this Ignore Raycast layer, all raycasting functions see right through the object (they don't stop the ray).

Which layer a GameObject is assigned to is seen in the Inspector and is right next to the Tag drop-down menu. Creating new layers is actually within the same mechanism as creating new tags (use the Layer drop-down menu to select Create New Layer). We aren't going to be doing much with layers for this project, but be aware that it's there.

> **Step 21:** Assign each of the triggers to the layer Ignore Raycast. Do this by selecting each trigger in the Hierarchy and then using the Layer drop-down menu (Figure 15.29).

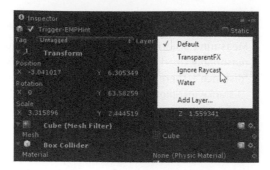

FIGURE 15.29 Adjusting the trigger's layer so they won't be seen by the raycasting mechanism.

Make the EMP Effective

So now we can place the EMP. This visually explodes, but we need to make it actually do something. The first thing we need to do is check if the EMP has been placed within a certain distance of the keypad. If it has, it needs to short the keypad out. We'll indicate that by changing the color of the texture on the keypad, turning on some smoke, and then opening the doors.

We can nest all of this within the ExplodeEMP function. But first we need to create some variables to hold everything.

Step 22: Create public variables for keypadLock, keypadSmoke, entryWayLeftDoor, and entryWayRightDoor. Place them all at the beginning block of the script:

```
var keypadLock : GameObject;
var keypadSmoke : GameObject;
var entryWayLeftDoor : GameObject;
var entryWayRightDoor : GameObject;
```

Step 23: Down in the ExplodeEMP function, add the following code:

```
function ExplodeEMP(placedEMP:GameObject){
    yield WaitForSeconds (2);
    placedEMP.audio.enabled = true;
    placedEMP.GetComponent("Detonator").enabled = true;
    placedEMP.renderer.material.color = Color (0,0,0);
    if (Vector3.Distance(placedEMP.transform.position,
keypadLock.transform.position) <= 1){.
        keypadLock.renderer.material.color = Color
(.5,.5,.5);
        keypadSmoke.active = true;
        iTween.RotateTo (entryWayLeftDoor, Vector3
(0,45,0), 8);
        iTween.RotateTo (entryWayRightDoor, Vector3
(0,-45,0), 8);
    }
}
```

Why?

Measuring distance is actually pretty straightforward and is presented reasonably clearly in the documentation (just do a search for "distance"). There are several ways to measure distance; Vector3 .Distance just means to measure distance in all dimensions. What this code is doing is saying, "if the Vector3.Distance between the position of placedEMP and keypadLock is less than or equal to 1, then do the following things." The next four lines should be familiar to you by now—they change the color of keypadLock, activate keypadSmoke, and then use iTween to rotate open both doors to 45 and –45 degrees, respectively, over 8 seconds.

Now this has some limitations. It assumes we are only using the EMP to break open the keypadLock (which we are). But if in an expanded version of the game the EMPs were going to be used for other objects, we'd need to include some other mechanism (perhaps additional Booleans) to do this. But for now, this is going to work out great.

Step 24: Save and return to Unity. Fix syntax problems.

Step 25: Populate the new public variables (Figure 15.30). These should be populated from objects in the Hierarchy (not the Project panel). If you're using the Unity packages, the names will largely match. But feel free to use your own.

FIGURE 15.30 Populating the new variables.

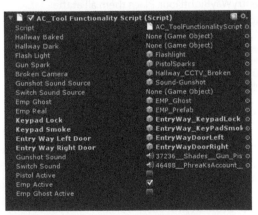

Tips and Tricks

As a side note, the EntryWay_KeyPadSmoke (Figure 15.31) is actually just a slightly modified smoke particle emitter from Unity's built-in Particles (accessible in the Standard Assets/Particles folder if you've already imported the Particles Unity Package). Pick one and then put it into the scene next to the keypad. Make any changes you want to the smoke. Then use that smoke to populate the Keypad Smoke entry field.

Step 26: Test and play.

FIGURE 15.31 EntryWay_
KeypadSmoke. Just a modified version
of Unity's built-in smoke.

Conclusion

If all is working right, after the EMP is placed next to the keypad, it should
explode, turn itself black, turn the keypad black, start the smoke coming from
the keypad, and open the doors. If you've been following all the tutorials,
there should also be a trigger set within those open doors that will move us to
Scene-Hallway.

There's some important things left to do. Right now, we have no inventory
system, so it's clumsy (we have to manually activate or deactivate the tool
before running the game). We need to build in a system so that the player can
determine which tool or weapon to use. We also need to build in mechanisms
that kill the player if he falls in the water, and that make the player lose if the
alarms in the building go off for too long. Lastly, we need to build in some way
for the player to win.

In the next chapter we'll build in this endgame sort of mechanics. At that
point we'll have a functioning game that's ready to be built and distributed.

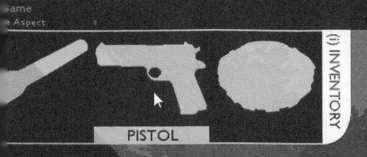

Unity: Creating Inventory Systems

Thus far we have created several weapons and tools (our flashlight, EMP, and pistol). However right now, in order to use any of the three, they have to be activated in the script manually before running the game. This, of course, is a useless method to the player. What we need to do is create an inventory system that allows the player to choose which tool he wants to use and when. This inventory system will also do the work behind the scenes of turning various tool functionality on and off in the scripts.

Right now, the gun is active even when placing an EMP. The flashlight is shining even when the flashlight isn't visible. We need to get these tools so we use them one at a time. Before we get to the nitty-gritty, though, there are a few core ideas to cover.

State Engine and How Many Scripts?

A state engine is a mechanism that (for our purposes) will keep track of what state the game is in. Or more directly, what state the player is in. Or more specifically, what weapon/tool the character is using. It turns out we've actually been creating one as we've been building the AC_ToolFunctionalityScript.

So far this script's main chunk of code is a big Update function that checks if a list of Booleans are true or false. Depending on which Boolean is true, the script fires a block of code, or calls on another function within the script. Currently, the only way to define which Boolean is true is via the public variables accessible in the Inspector.

But this state engine can be much more robust. We can build in functionality that allows other scripts to call back to AC_ToolFunctionalityScript and tell it that a certain state (Boolean) is now active, or deactivate a Boolean. With this new information, AC_ToolFunctionality can fire new blocks of script at the appropriate times.

Currently almost all these blocks of script are housed within AC_ToolFunctionalityScript. And this script is getting a bit unwieldy to show in this book since it's getting long. In fact, large chunks of this script could indeed be broken out into other distinct and discreet scripts and this AC_ToolFunctionalityScript could simply call out to these particular scripts when needed. There are some real benefits to working this way: the gun functionality can be included in a GunFunctionality script. Someone coming into the project can look at a script folder and see quickly what things are happening and what's doing it without having to read through too much script. The drawback to a whole lot of scripts is the temptation to start letting multiple scripts control the same thing, like locking and hiding the mouse.

I've been involved and have authored projects (to my shame) that have multiple scripts hanging around the project that have access to things like hiding the cursor. The problem is that as the game development progresses and there's a bug that the mouse isn't becoming visible when needed, it is a nightmare tracking down which script is turning it off, and which script should be turning it on when multiple scripts have that capability.

Using a centralized script to house things like the mouse turning off and on, and what the state of the game is in means there is only one place to go when searching out and squashing bugs. This centralized script houses the state engine and coordinates what's happening with other scripts. Other scripts can call out to it, but it keeps track of the central state of the game. Once script to rule them all.

My colleague here at Los Alamos National Laboratory who is the central programmer for our team works hard to develop sophisticated state engines. The training modules he authors are a thing of beauty since the prefabs are hardly ever broken, and all of his scripts sit in an empty GameObject in the game called ScriptContainer. All the functionality is contained in that one little package. Of further interest is how few scripts actually sit in there—oftentimes a complex game will have only three or four scripts (he also is constructing custom classes similar to iTween that reside in the Project panel that he can call on within the few scripts he hangs in the Hierarchy panel).

Eventually, this is where you will end up if programming is your path of choice. The problem (for beginners) with this methodology is that it can be fairly opaque and abstract to understand how things are working. It is why in Incursion we have focused on hanging scripts off of objects. However, with the complexity of the AC_ToolFunctionalityScript, you can see the start of fewer scripts controlling more things.

We've looked a little bit at scripts talking to each other already. But understanding inner-script communication is a critical part of an effective project, and central to the state engine concept. It also happens to be one of the most frequently asked questions on the forums.

To further illustrate this, we'll create another script that controls our inventory system. This inventory system will communicate with the tool functionality script (AC_ToolFunctionalityScript) to let it know which tool to fire up.

To do this, we'll return to where we started and create a new inner-game GUI system.

Tutorial 16.1: Setting Up Inventory GUI and Script

Step 1: Open Scene-EntryWay if it is not already open.

Step 2: Create GUI layout with GUITextures. Create four GUITexture objects (GameObject>Create Other>GUI Texture). Name them `InventoryButton_EMP`, `InventoryButton_Flashlight`, `InventoryButton_Pistol` and `InventoryButton_Tab`.

Step 3: Populate the GUITextures with textures. In the 2D Assets folder (from the 2DAssets Unity Package imported earlier) are a bunch of texture files that start with ButtonInventory. Use ButtonInventory-EMP for the InventoryButton_EMP GUITexture, ButtonInventory-Flashlight for the InventoryButton_Flashlight, Inventory-Pistol for the InventoryButton_Pistol GUITexture, and Inventory-Tab-Vert for the InventoryButton_Tab GUITexture.

Step 4: Size the GUITextures. For all but the Inventory_Tab GUITexture, change the Pixel Inset Width and Height to 128. For the InventoryButton_Tab GUITexture, change the Pixel Inset Width to 32 and the Height to 128.

Step 5: Arrange all four GUITextures to be aligned in the top-left corner of the game screen. Do this by selecting each and in the Inspector, under the Transform, enter Position X = 0 and Position Y = 1. Since GUITextures are set up from the bottom-left corner of the texture image, this will make them all disappear. We'll fix that in the next step.

Step 6: Offset all −128 in Y. Select each, and in the Inspector, under the GUITexture component, change the Pixel Inset Y to -128. This will show all the GUITextures, but they'll be on top of each other.

443

Why?

Each of these images are 128 pixels tall. Offsetting by –128 when the Transform Y = 1, make the texture aligned to the top of the screen.

Step 7: Change the Pixel Inset X value to spread out the GUITextures. Leave InventoryButton_Flashlight as is. Change the InventoryButton_Pistol's Pixel Inset X = 128 (slides it over an additional 128 pixels). Change InventoryButton_EMP's Pixel Inset X = 256, and finally change InventoryButton_Tab's Pixel Inset X = 384.

Step 8: Change the Alpha value for each texture to 64. Do this for each GUITexture, but click the color swatch (in the Inspector panel in the GUITexture component) and change the A slider (Figure 16.1). The final results should look like Figure 16.2.

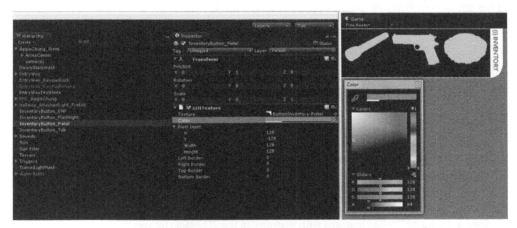

FIGURE 16.1 Adjusting the alpha.

FIGURE 16.2 Initial GUI Layout for inventory system.

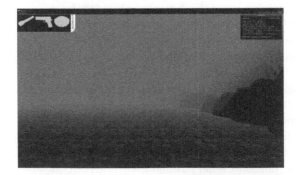

Why?

We're going to turn down the alpha values to make the buttons more transparent. In a bit we'll create a script that swaps out these versions of the buttons with a highlighted version that includes the name of each tool. Those versions will be at full opacity.

Step 9: Create the mouse over scripts to highlight each button as the mouse moves over them. Create a new JavaScript. Name it `InventoryButtonScript`. Open this script in your script editor and enter the following:

```
var buttonReg : Texture2D;
var buttonOver : Texture2D;

function OnMouseOver () {
    guiTexture.texture = buttonOver;
}

function OnMouseExit(){
    guiTexture.texture = buttonReg;
}
```

Why?

First we're declaring two variables, both of which are of type Texture2D, which just means they are images used as textures. Then in a bit of code that should look a bit familiar we say, "when the mouse is over this object, go to the guiTexture component, and make its texture be buttonOver. When we move out of this object, change the guiTexture's texture to be buttonReg."

This script will be assigned to each button, and for each button we'll drag and drop the two versions of the texture for that button.

Step 10: Save and return to Unity. Fix syntax problems.

Step 11: Assign this script to the EMP, Flashlight, and Pistol buttons in the Hierarchy.

Step 12: Populate the Button Reg and Button Over variables for each by dragging the respective textures from the Project panel's 2D Assets folder. So, for instance, for InventoryButton_EMP, the Button Reg variable should be populated with ButtonInventory-EMP texture (from the Project panel) and the Button Over variable should be populated with the ButtonInventory-EMPText texture, and so on (Figure 16.3).

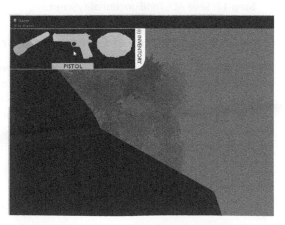

FIGURE 16.3 The button-swapping script in action.

Step 13: Play and test. This will be a little weird because the character will be looking around wildly as the mouse moves to get over the buttons.

Step 14: Further refine by telling the texture to not only swap out, but to turn up its Alpha value so it becomes more opaque. And then tell it to turn it back down when the mouse exits:

```
var buttonReg : Texture2D;
var buttonOver : Texture2D;

function OnMouseOver(){
    guiTexture.texture = buttonOver;
    guiTexture.color = Color (.5,.5,.5,.5);
}

function OnMouseExit(){
    guiTexture.texture = buttonReg;
    guiTexture.color = Color (.5,.5,.5,.25);
}
```

Step 15: Save. Return to Unity and fix any syntax issues.

Step 16: Ensure the engine state is ready. Open the AC_ToolFunctionalityScript. Toward the top of the script (in all the variable declarations) there should be several Booleans. Change all the Booleans to private variables (we don't want to control them in Unity's editor, we want the buttons to do it), and create a new variable for flashlightActive. Your variables should look like this:

```
private var flashlightActive : boolean;
private var pistolActive : boolean;
private var empActive : boolean;
private var empGhostActive : boolean;
```

Why?

The only ones that really matter to us for the inventory system are flashlightActive, pistolActive, and empActive. Remember that empGhostActive is part of the EMP mechanism.

Step 17: Save AC_ToolFunctionalityScript.

Refresher on Interscript Communication

Remember that in the AC_ToolFunctionality script, we are calling functions within the script, and we do so by just calling out the name of the function (AddHighlight(hitObj), for instance, says, "go fire the function AddHighlight with the parameter hitObj. And this function is included here in this script"). However, we can fire functions that exist in other scripts as well. We just need to tell Unity where that script is; particularly, what object it's attached to.

We do this with the following format:

```
GameObject.GetComponent("name of script").NameOfFunction;
```

We can also send a message that defines one of the variables (like a Boolean) in much the same way:

```
GameObject.GetComponent("name of script").BooleanVariable
= true;
```

Eventually we're going to want to do both in the inventory script; we're going to want Unity to understand that when we click a button, it needs to activate a particular Boolean in AC_ToolFunctionality.

We'll be talking to this same script a lot, so we can shorten things a bit by declaring some additional variables and then referencing those variables throughout the script.

Step 18: Open InventoryButtonScript. Create a new variable to contain the object that holds the script we'll be referencing. Then have the script find Main Camera on Awake.

```
var buttonReg : Texture2D;
var buttonOver : Texture2D;
private var mainCamera : GameObject;

function Awake(){
    mainCamera = GameObject.Find("Main Camera");
}
```

Why?

Remember that AC_ToolFunctionalityScript is attached to the Main Camera that is a child of our prefab FPC_AegisChung. So in order to reference that script, we need to make sure this script knows where that object is.

Now, we're taking a calculated risk here. In this case, we're making the var mainCamera a private variable, and having the function Awake go and find it. This is in contrast to the method we've been using of manually defining public variables within Unity. In this case, we're making the reasonably safe assumption that there will only be one object named "Main Camera" in the scene. And since this script is attached to three objects, having Unity go and find it on start is a bit easier on us since we needn't populate the variables manually.

Step 19: Create another private variable that will hold the reference to the actual script; then have this script also found on awake:

```
var buttonReg : Texture2D;
var buttonOver : Texture2D;
private var mainCamera : GameObject;
private var toolFunctionality;

function Awake(){
    mainCamera = GameObject.Find("Main Camera");
    toolFunctionality = mainCamera.GetComponent("AC_Tool
FunctionalityScript");
}
```

447

Why?

Note that this new private variable isn't typed. This is a funky reality of JavaScript—the type does not have to be defined. It can usually help in performance, but in this case where we're accessing a particular script, we can leave the type blank, which is often the practice when working with scripts.

Step 20: Create a new OnMouseDown function that starts setting Booleans via this script. Now that the script is going out and finding the script, start passing commands to it:

```
...
function OnMouseDown (){
    if (name == "InventoryButton_EMP"){
        toolFunctionality.flashlightActive = false;
        toolFunctionality.pistolActive = false;
        toolFunctionality.empActive = true;
    }
    if (name == "InventoryButton_Pistol"){
        toolFunctionality.empActive = false;
        toolFunctionality.flashlightActive = false;
        toolFunctionality.pistolActive = true;
    }
    if (name == "InventoryButton_Flashlight"){
        toolFunctionality.empActive = false;
        toolFunctionality.pistolActive = false;
        toolFunctionality.flashlightActive = true;
    }
}
```

Why?

That looks like a lot of script, but it's a pretty straightforward concept. It says, "when the user clicks on this object (function OnMouseDown), check if this object's name is InventoryButton_EMP. If it is, go to toolFunctionality (which we just defined as the component (script) attached to mainCamera) and there, set the Boolean flashLightActive to false, set the boolean pistolActive to false, and set the Boolean empActive to true. If the object clicked is not InventoryButton_EMP, then check if it is InventoryButton_Pistol and if it is…" and so on. There are more elegant solutions as well (take a look at Switch Statements or Singletons); but this one is particularly easy to use.

Firing Animations in Script

So far we've got the InventoryButtonScript so that it can go talk to the mini-state-engine included in AC_ToolFunctionalityScript and turn on and off Booleans contained there. But before this works really smoothly, we need to do a bit of additional beefing up of the functions that are included in AC_ToolFunctionalityScript.

For instance, right now, the pistol is always out since the AegisChung_Arms prefab has the PistolReady animation running first thing. This was great when we were setting up the firing of the gun, but is a little awkward now since it's pretty unbelievable that the gun will make the EMP work or shine light like a flashlight.

So we need to create a couple of functions to bring the pistol out and put it away. We'll create these functions within the InventoryButtonScript (with the idea that this script handles all the defining when tools are used with their respective buttons), and call them up when the buttons are pressed to activate or deactivate a weapon/tool.

The way we'll put the pistol away (and the flashlight for that matter) is by playing the animation PistolReady (and FlashlightReady) forward (to bring it out) and backward (to put it away). The way animations are called on is like this:

GameObject.animation.Play("Name of Animation");

Let's call up some animations.

Step 21: Still within InventoryButtonScript, at the top of the script, declare a new variable to hold the object that has the animations attached to it (Aegis's arms).

```
private var aegisArms : GameObject;
```

Step 22: Create a new function to ready the pistol. And when the pistol is ready set the pistolReady Boolean to active. Do this at the bottom of the script:

```
function ReadyPistol(){
    aegisArms.animation["PistolReady"].speed = 1;
    aegisArms.animation.Play("PistolReady");
    yield WaitForSeconds (aegisArms.animation.clip.length);
    toolFunctionality.pistolActive = true;
}
```

Warnings and Pitfalls
Note that there is a subtle but important difference when working with attributes of an animation (like changing the speed)—namely that the name of the animation is contained in [] and not () like it is when the clip is being played.

Why?

The first line there simply says, "on the GameObject aegisArms, find the animation called "PistolReady" and set its speed to 1 (play at regular speed). There usually is little need to change the speed of an animation (if it's animated correctly); however, in a bit, we're going to play this animation backward by setting the speed to –1. If we don't make sure it's set to positive 1 here, we won't know if the animation is playing forward when it's called up in the next line.

Next we're telling Unity to wait for the animation to play—or more specifically wait for the amount of seconds it takes for the animation to play before going to the script contained in the toolFunctionality variable (which we declared on Awake as the AC_ToolFunctionalityScript that is attached to Main Camera) and setting pistolActive to true.

Step 23: Create another function to store the pistol. Add this to the bottom of the script:

```
function StorePistol(){
    aegisArms.animation["PistolReady"].speed = -1;
    aegisArms.animation["PistolReady"].time = aegisArms
.animation["PistolReady"].length;
    aegisArms.animation.Play("PistolReady");
    yield WaitForSeconds (aegisArms.animation.clip.length);
    toolFunctionality.pistolActive = false;
}
```

Why?

This StorePistol function says, "set the speed of the animation PistolReady to −1 (plays backward), then set its current time to the length of the animation (think of this as fast-forwarding to the last frame), and then play the animation." This will play the animation backward, having Aegis put the gun away. Finally, Unity waits until the animation of putting the pistol away before it makes pistolActive false over in AC_ToolFunctionalityScript.

Step 24: Create similar functions to ready the flashlight and put it away:

```
function ReadyFlashlight(){
    aegisArms.animation["FlashlightReady"].speed = 1;
    aegisArms.animation.Play("FlashlightReady");
    yield WaitForSeconds (aegisArms.animation.clip.length);
    toolFunctionality.flashlightActive =true;
}

function StoreFlashlight(){
    aegisArms.animation["FlashlightReady"].speed = -1;
    aegisArms.animation["FlashlightReady"].time = aegisArms
.animation["FlashlightReady"].length;
    aegisArms.animation.Play("FlashlightReady");
    yield WaitForSeconds (aegisArms.animation.clip.length);
    toolFunctionality.flashlightActive = false;
}
```

Why?

Again, this is just the same thing, only talking to the animation FlashlightReady. Remember that the names of these animations were declared when the asset was first imported. We did this way back when we brought in the full-body Aegis as well.

Note that since we are now turning the Booleans off and on in these functions we'll need to remove them from the OnMouseDown function.

Step 25: Look to the OnMouseDown function. Look at the new functions when buttons are pressed. In each place where the line `toolFunctionality.pistolActive = false;` appears, we need to replace it with the block of code:

```
if (toolFunctionality.pistolActive){
    StorePistol();
}
```

Why?

Instead of just turning pistolActive to false (which would leave the arms showing the pistol even though it couldn't be fired), we're telling Unity, "if in the component toolFunctionality, the state of pistolActive is true, run the function StorePistol." Then in the StorePistol function the pistolActive Boolean will be shut off in toolFunctionality.

Step 26: Continuing in the OnMouseDown function, replace everywhere that the script says `toolFunctionality.flashlightActive = false;` with the following block of code:

```
if (toolFunctionality.flashlightActive){
    StoreFlashlight();
}
```

Step 27: In the block of code that is checking to see if the button pressed is InventoryButton_Pistol, remove the `toolFunctionality.pistolActive = true;` line. Remember we are now turning that on in the ReadyPistol function. Instead, we just need to tell the script to go and fire the ReadyPistol, which will switch the Boolean on for us. This will make sure the gun gets pulled out before we can fire it. So the block of code that deals with the InventoryButton_Pistol should look like this, with new code in italics:

```
if (name == "InventoryButton_Pistol"){
    toolFunctionality.empActive = false;
    if (toolFunctionality.flashlightActive){
        StoreFlashlight();
    }
    ReadyPistol();
}
```

Step 28: Further expand this chunk of code to be a toggle. This will make it so that when the InventoryButton_Pistol is clicked, Unity will pull the pistol out if it's not the active tool, but put it away if it's already deployed:

```
if (name == "InventoryButton_Pistol"){
    toolFunctionality.empActive = false;
    if (toolFunctionality.flashlightActive){
        StoreFlashlight();
    }
```

```
    if (toolFunctionality.pistolActive){
        StorePistol();
    } else {
        ReadyPistol();
    }
}
```

Why?

So when the InventoryButton_Pistol is clicked, this script goes out to the toolFunctionality script and turns off the Boolean empActive. Then, it checks to see if flashlightActive is true, and if it is, it runs the function StoreFlashlight (which sets flashlightActive to false). Then, it checks if pistolActive is true. If it is, it fires the StorePistol function (which sets pistolActive to false). If pistolActive is not true, it fires the ReadyPistol function (which sets pistolActive to true).

Step 29: Create an identical structure for the flashlight. Make sure it's set up to work as a toggle as well:

```
if (name == "InventoryButton_Flashlight"){
    toolFunctionality.empActive = false;
    if (toolFunctionality.pistolActive){
        StorePistol();
    }
    if (toolFunctionality.flashlightActive){
        StoreFlashlight();
    } else {
        ReadyFlashlight();
    }
}
```

Step 30: Get Unity to wait around for just a bit while animations play and mouse clicks are registered. Add the following yield WaitForSeconds commands:

```
function OnMouseDown (){
    var toolFunctionality = mainCamera.GetComponent
("AC_ToolFunctionalityScript");
    if (name == "InventoryButton_EMP"){
        if (toolFunctionality.flashlightActive){
            StoreFlashlight();
        }
        if (toolFunctionality.pistolActive){
            StorePistol();
        }
        yield WaitForSeconds (.75);
        toolFunctionality.empActive = true;
    }
    if (name == "InventoryButton_Pistol"){
        toolFunctionality.empActive = false;
```

```
            if (toolFunctionality.flashlightActive){
                    StoreFlashlight();
            }
            yield WaitForSeconds (.75);
            if (toolFunctionality.pistolActive){
                    StorePistol();
            } else {
                    ReadyPistol();
            }
    }
    if (name == "InventoryButton_Flashlight"){
            toolFunctionality.empActive = false;
            if (toolFunctionality.pistolActive){
                    StorePistol();
            }
            yield WaitForSeconds (.75);
            if (toolFunctionality.flashlightActive){
                    StoreFlashlight();
            } else {
                    ReadyFlashlight();
            }
        }
    }
}
```

Why?

Currently, in one frame, this script is doing things like enabling the empActive (which then means that the click is also registered as placing the actual mine). Of other problems, in one frame we're doing things like telling Unity to fire the StorePistol function (which plays an animation backward) *and* telling it to play ReadyFlashlight. These commands are happening right after each other, which means it abandons playing the first animation and just plays the second. By providing a few yields, we allow the animations to play before firing the next batch. This also ensures that the mouse click that Unity registers when the button is clicked does not register as firing the gun or placing the mine.

Step 31: Save and return to Unity. Don't try running the game yet, we've got some other things to do, but do check to make sure there are no syntax problems.

Hiding and Showing Weapons

Currently, the pistol is likely active, but the flashlight is not. This means that even though the animations for the arm are firing, Aegis is always holding the gun—and holding it very strangely when he's supposed to be holding the flashlight.

We already know how to turn objects on and off (GameObject.active = true/false;), we just need to declare the variables and then have them turned on and off in the right places.

Step 32: Declare three new private variables at the top of the script:

```
private var aegisFlashlight : GameObject;
private var aegisFlashlightLight : GameObject;
private var aegisPistol : GameObject;
```

Why?

We're declaring a variable to house the geometry of the flashlight (aegisFlashlight), the light (created way back when working in the hallway), and the pistol geometry (aegisPistol). We'll populate these here in our Awake function in a bit.

Step 33: Populate these new private variables in the Awake function. So it should read like this:

```
function Awake(){
    mainCamera = GameObject.Find("Main Camera");
    toolFunctionality = mainCamera.GetComponent("AC_Tool
FunctionalityScript");
    aegisArms = GameObject.Find("AegisChung_Arms_Prefab");
    aegisFlashlight = GameObject.Find("AC_Flashlight");
    aegisFlashlightLight = GameObject.Find("Flashlight");
    aegisPistol = GameObject.Find("AC_Pistol");
}
```

Why?

Again, the assumption at this point is that we won't be renaming things, and that we go out and find only one of the objects. Again, the benefit of this is that we needn't populate them within Unity's editor—the drawback is that if we rename something, this script will break.

Step 34: Activate these and deactivate them in the appropriate places within the ReadyPistol, StorePistol, ReadyFlashlight, and StoreFlashlight functions:

```
function ReadyPistol(){
    aegisPistol.active = true;
    aegisArms.animation["PistolReady"].speed = 1;
    aegisArms.animation.Play("PistolReady");
    yield WaitForSeconds (aegisArms.animation.clip.length);
    toolFunctionality.pistolActive = true;
}

function StorePistol(){
    aegisArms.animation["PistolReady"].speed = -1;
```

```
    aegisArms.animation["PistolReady"].time = aegisArms
.animation["PistolReady"].length;
    aegisArms.animation.Play("PistolReady");
    yield WaitForSeconds (aegisArms.animation.clip
.length);
    aegisPistol.active = false;
    toolFunctionality.pistolActive = false;
}

function ReadyFlashlight(){
    aegisArms.animation["FlashlightReady"].speed = 1;
    aegisArms.animation.Play("FlashlightReady");
    aegisFlashlight.active = true;
    yield WaitForSeconds (aegisArms.animation.clip
.length);
    aegisFlashlightLight.active = true;
    toolFunctionality.flashlightActive = true;
}

function StoreFlashlight(){
    flashLight.active = false;
    aegisArms.animation["FlashlightReady"].speed = -1;
    aegisArms.animation["FlashlightReady"].time =
aegisArms.animation["FlashlightReady"].length;
    aegisArms.animation.Play("FlashlightReady");
    yield WaitForSeconds (aegisArms.animation.clip
.length);
    aegisFlashlight.active = true;
    toolFunctionality.flashlightActive = false;
}
```

Why?

Most of that is pretty straightforward (i.e., turn on the aegisPistol right before running the animation that shows it and turn it off after the animation that stores it). The strange one is where the flashlight is. This is placed so that the light doesn't turn on until after the FlashlightReady animation has been run, and turns off right before the flashlight is put away.

Step 35: Make sure both pistol and flashlight are turned off when the game begins. Do this within a Start function (if you don't have one). Usually this is done toward the top of the script after the variable declarations and any Awake functions but before any other functions:

```
function Start(){
    aegisFlashlight.active = false;
    aegisFlashlightLight.active = false;
    aegisPistol.active = false;
}
```

Why?

This makes sure that the pistol and flashlight are turned on only when they are called (i.e., in the ReadyFlashlight or ReadyPistol functions). If we carefully turned them off in the editor before running the game, this wouldn't be a problem, but including this little code snippet helps protect us against future carelessness.

Step 36: Save and return to Unity. Fix any syntax problems.
Step 37: Turn on Flashlight, AC_Flashlight, and AC_Pistol. In the Hierarchy, select each of these objects and make sure they are active in the Inspector.

Why?

One of the potential drawbacks to populating variables in Awake (or Start) functions with a GameObject.Find command is that if an object is inactive, Unity can't find it. If the variable is a public variable that is populated by dragging the item from the Hierarchy, this isn't an issue. But with the method we're using here (private variables that are populated with Find), we need to make sure that when the game starts the objects are active to find. Remember that up in step 33, we immediately turn them all off again, but Unity now has an understanding of what they are and can reactivate them when told.

Step 38: Select AegisChung_Arms_Prefab and in the Animation component, turn off Play Automatically.

Why?

Now we are carefully calling up when to play the animations of bringing up the pistol and flashlight. Without turning off Play Automatically, the pistol would always come up at the beginning of the game rather than when the player tells it to.

Step 39: Open AC_ToolFunctionalityScript.
Step 40: Turn off all the Booleans. Add the following lines to make sure that Unity knows on start up that there are no tools active.

```
function Start(){
    pistolActive = false;
    empActive = false;
    empGhostActive = false;
    flashlightActive = false;
}
```

Step 41: Save and return to Unity. Fix any syntax errors or typos.
Step 42: Play and test. There is still the pesky problem of the character looking up and to the left as the player attempts to select a piece of inventory (which we'll fix in a minute); but at this point, the player should be able to activate any of the tools and they should work.

Step 43: Apply these changes to the prefab. With FPC_AegisChung selected in the Hierarchy, in the Inspector click the Apply button on the Prefab line.

Why?

We want to make sure that all this work on the inventory system is functional in the Hallway too (and any other levels we create). By applying the changes to the prefab, we know that these new functionalities will work later as well.

Bulking up the GUI System

We need to solve a couple of problems with our inventory system. First we don't want it visible all the time; with it always there, it detracts from the immersive experience and the player assumes he can reach up and select a tool. The second problem is that we don't want the mouse visible usually. It'd be necessary to have it visible when selecting tools, but it needs to go away when the game is running in noninventory mode. We'll solve both of these problems by authoring a couple of new functions to show and hide the inventory.

But before we go too far, let's clean up, expand, and make a prefab of all our GUIElements to clean up our Hierarchy, and make the elements more easily accessible and reusable.

Step 44: Create a new GUITexture (GameObject>Create Other>GUI Texture). Name it InventoryPrompt. Use ButtonInventory-Tab-Horizontal (from the Project panel's 2D Assets) for the Texture. Change the Transform X = 0 and Transform Y = 1. Change the Pixel Inset to X = 0, Y = -32, Width = 256, Height = 32.

Why?

This GUITexture will serve as the prompt to remind the player how to access the inventory.

Step 45: Make InventoryButton_EMP, InventoryButton_Flashlight, and Inventory_Button_Pistol children of InventoryButton_Tab (in the Hierarchy, select these three GUITextures and drag them atop InventoryButton_Tab).

Why?

We are going to use iTween's MoveTo to move all the buttons on and off en masse. By making the buttons a child of one element (the InventoryButton_Tab), we can animate just the tab, and all the buttons will go with it.

Step 46: Create a new GUITexture, name it Crosshairs. Use the Crosshairs texture from the project panel as the texture for the GUITexture. Leave the Transform values as is, but change the Pixel Inset values to X = -16, Y = -16, Width = 32, Height = 32.

Why?

Yeah, you're right. We made one of these back in the Hallway. We're going to delete that one eventually. The idea is that now that we've determined the GUI elements for the game, we'll assemble them all there and be able to use them again and again as a prefab.

Warnings and Pitfalls
It's VERY important that the Transform values for Position and Rotation are 0. If they are not, when they become the parents of the GUI elements, all sorts of things will go awry as the children will need to change their Position and Rotation to account for their parent.

Step 47: Create a new empty GameObject (GameObject>Create Empty). Name it `GUIElements`. Make sure its Transform Position and Rotation values are all `0`.

Step 48: Make Crosshairs, EntryWayTextHints, InventoryButton_Tab (with its children), and InventoryPrompt all children of GUIElements (Figure 16.4).

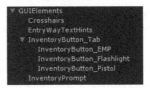

FIGURE 16.4 All the GUIElements grouped under one GameObject, ready to be made a prefab.

Step 49: Rename EntryWayTextHints to just `GUITextHints`.
Step 50: Open the script EntryWayTextTriggerScript.
Step 51: Change the guiTextObject = GameObject.Find line to read:

```
function Awake(){
    guiTextObject = GameObject.Find("GUITextHints");
}
```

Why?

We renamed an object. Since we were finding that object via a GameObject .Find command, we've got to make sure and change the script.

Step 52: Save and return to Unity. Fix any syntax problems.

Create a GUIElements Prefab

Step 53: In the Project panel, choose Create>Prefab. Rename the new prefab `GUIElements`. This can be placed within a folder if you are organizing your prefabs into one place, or just floating within the project.
Step 54: Drag the GUIElements from the Hierarchy to the new GUIElements prefab in the Project panel.

Why?
This populates the prefab we just created and makes the GUIElements in the Hierarchy tied to this new prefab.

Animate the Inventory to Show and Hide

So we've got a great collection of GUIElements that we can reuse again (and will in the Hallway). But we still need to solve the problem of the mouse problems and always having the inventory visible. To fix this, we'll create a new script and get a few scripts to do a bit of talking to each other.

Step 55: Create a new JavaScript. Name it `InventoryToggle`. Open InventoryToggle.

Step 56: Create three new private variables to hold the Inventory Prompt, the Main Camera, and the FPC_AegisChung (the First Person Controller prefab):

```
private var inventoryPrompt : GameObject;
private var mainCamera : GameObject;
private var fpcAegis : GameObject;
```

Why?
The inventoryPrompt will need to be hidden when the buttons are out so we need access to it. The Main Camera and FPC_AegisChung both have attached to them a special script called Mouse Look that makes the character/camera rotate around based upon the mouse moving. We'll need to disable these when working with the inventory so we need access to both.

Step 57: On the game start, have Unity populate these variables:

```
function Start(){
    inventoryPrompt = GameObject.Find("InventoryPrompt");
    mainCamera = GameObject.Find("Main Camera");
    fpcAegis = GameObject.Find("FPC_AegisChung");
}
```

Why?
Assuming we don't rename these elements, this is a quick way to make sure Unity has access to the elements it needs.

Step 58: Establish a Boolean that defines whether or not the inventory is visible. Add the following line to the variable declarations:

```
private var inventoryPrompt : GameObject;
private var mainCamera : GameObject;
private var fpcAegis : GameObject;
private var inventoryVisible : boolean;
```

Warnings and Pitfalls
If, for some reason an extra GUIElement appears in the Hierarchy when doing this step, be sure to delete one. This happened to me while writing this step, but I was unable to get it to repeat. In either case, we only need one copy of it.

459

Why?

If the inventory is visible, and the user presses I on the keyboard, we need to do one thing (hide the buttons), but if it is not when the user presses I, we need to do something else (show the buttons). We need Unity to keep track of whether the inventory is or is not visible.

Step 59: Tell Unity on start that the inventory is indeed not visible:

```
function Start(){
    inventoryPrompt = GameObject.Find("InventoryPrompt");
    mainCamera = GameObject.Find("Main Camera");
    fpcAegis = GameObject.Find("FPC_AegisChung");
    inventoryVisible = false;
}
```

Step 60: Set up the scene to make sure the inventory is indeed not visible. To do this, back in Unity, select InventoryButton_Tab and change the Transform Position X value to -0.5. This will slide the buttons off the screen leaving just the InventoryPrompt visible (Figure 16.5).

FIGURE 16.5 Sliding the buttons off the screen so just the Inventory Prompt is visible.

Step 61: Lock the cursor. Unity provides a very quick and easy way to lock (and hide) the cursor. Make sure that when the game starts, the cursor is indeed locked.

```
function Start(){
    inventoryPrompt = GameObject.Find("InventoryPrompt");
    mainCamera = GameObject.Find("Main Camera");
    fpcAegis = GameObject.Find("FPC_AegisChung");
    inventoryVisible = false;
    Screen.lockCursor = true;
}
```

Step 62: Tell Unity to listen for the player to press the I button, and if I is pressed, run a function that shows/hides the prompt and the inventory. Do this with a new function Update.

```
function Update(){
    if (Input.GetKeyDown(KeyCode.I)){
        ToggleInventory();
    }
}
```

Why?

So the code is saying, "check every frame (`function Update`) to see if I has been pressed (`if (Input.GetKeyDown (KeyCode.I)`). If it has, run the function ToggleInventory." Of course, at this point this function doesn't exist ... but it will.

Step 63: Write the ToggleInventory function to check if inventoryVisible is true, and if it is, slide the inventoryPrompt on the screen and then slide the buttons off (then lock the cursor and free the camera to look around). If it is not true, have the inventoryPrompt slide off the screen and the buttons on (then unlock the cursor and lock down the camera). Add this function to the bottom of the script:

```
function ToggleInventory(){
    if (inventoryVisible){
        iTween.MoveTo (inventoryPrompt, Vector3 (0, 1,
0), 1);
        iTween.MoveTo (gameObject, Vector3 (-.5, 1,
0), 2);
        inventoryVisible = false;
        Screen.lockCursor = true;
        mainCamera.GetComponent("MouseLook").enabled =
true;
        fpcAegis.GetComponent("MouseLook").enabled =
true;
    } else {
        iTween.MoveTo (inventoryPrompt, Vector3 (0,
1.1, 0), 1);
        iTween.MoveTo (gameObject, Vector3 (0,1,0), 2);
        inventoryVisible = true;
        Screen.lockCursor = false;
        mainCamera.GetComponent("MouseLook").enabled =
false;
        fpcAegis.GetComponent("MouseLook").enabled =
false;
    }
}
```

Why?

The iTween.MoveTo should look familiar. After checking to see if inventoryVisible is true, the iTween line is saying, "take the inventoryPrompt GameObject, and move it to the coordinates (0,1,0), and do it over 1 second." Also take the gameObject this script is attached to and move it to the coordinates (–.5,1,0). If inventoryVisible is not true then slide inventoryPrompt to coordinate (0,1.1, 0). Then, take the gameObject this script is attached to and move it to (0,1,0). Remember that 0,1,0 for a GUITexture means that it is aligned in the top-left corner of the interface (visible in this case), but that at 0,1.1,0 the GUITexture is slid off the top left of the screen and at (–.5,1,0), the GUITexture is slid off the left of the screen. So what's happening here is the prompt slides up as the buttons slide in to make inventoryVisible true, and the other way around to make inventoryVisible false.

In each block, notice that after the animations are called, we then define whether inventoryVisible is true or not (`inventoryVisible = false;`), then we lock or free the cursor (`Screen.lockCursor = true;`) and finally turn on or off the MouseLook scripts attached to both the Main Camera and FPC_AegisChung object (`mainCamera .GetComponent("MouseLook").enabled = false;` and `fpcAegis .GetComponent("MouseLook").enabled = false;`).

Step 64: Save and return to Unity. Check for syntax problems.
Step 65: Apply this new InventoryToggle script to InventoryButton_Tab in the Hierarchy. Apply this addition to the prefab by clicking the Prefab Apply button.
Step 66: Play and test. The inventory system should be all set up and running.
Step 67: Save Scene-EntryWay.
Step 68: Open Scene-Hallway.
Step 69: Delete the existing Crosshairs GUITexture from the Hierarchy.

Why?

Remember that now the Crosshairs are part of the GUIElements prefab we've constructed. And since we don't want or need to, we need to get rid of one before bringing in the GUIElements prefab.

Step 70: Place the GUIElements prefab in the scene. Do this by dragging it from the Project panel to the Hierarchy. Make sure its Transform XYZ are all 0.

Why?

Remember that the GUIElements includes our screen hints mechanism as well as our Crosshairs, and most importantly, our Inventory system. Bringing it in as a prefab makes everything work for us.

Warnings and Pitfalls

There can be a bit of confusion about whether or not the lockCursor is working when dealing with the editor environment. Make sure that when testing something that locks the cursor, that the cursor is indeed in the Game window when the game starts. Then, also realize that as the mouse is moved around within the game, it could be escaping and actually be invisible on some other part of the Unity interface. So when the mouse is clicked, Unity could be thinking you're clicking something in the Hierarchy, or elsewhere. If this happens, just guide the mouse back to the game window and click again to tell Unity, "Yeah, I'm working in this window, and I want the mouse click to register here."

Step 71: Double-check the AC_ToolFunctionalityScript that should be attached to the Main Camera object that is a child of the FPC_AegisChung prefab already within the Hierarchy. Make sure that all the elements needed in this scene (Hallway Baked, Hallway Dark, etc.) are populated. Leave things like Keypad Lock and Keypad Smoke unpopulated as they are specific to the EntryWay.

Step 72: Make sure FPC_AegisChung is placed at the entrance.

Why?

When this level is loaded up, the assumption is that we've just walked in the doors. So he needs to be just inside those doors he just entered through.

Step 73: Make sure AC_Flashlight, Flashlight, and AC_Pistol are all activated for FPC_AegisChung in the Hierarchy.

Why?

Our InventoryButtonScript now goes out and finds these objects (if they are inactive Unity can't find them) and then turns them off on start.

Step 74: Activate the unbaked version (the dark version) of the hallway labeled Hallway_Unbaked if you're using downloaded prefabs, and deactivate Hallway_BakedGroup. Be sure to Activate/Deactivate all the children as well.

Step 75: Play and test.

Conclusion

Some great stuff is happening. At this point, the inventory system works, the player can break into the front door, turn on the lights, and then shoot out cameras. The game is almost done. We still need a few more added features.

First, we created a key that we can highlight (via the raycasting mechanism). But we can't do anything with this key. Nothing happens there (other than the highlight). We'll need to do just a bit of adjustment to make this key work to open a door later. In the last tutorial of this chapter we'll create the mechanism for the key to work.

Then we need to create a mechanism to allow the player to succeed and to fail. Right now, the cameras sound the alarm if they see the player, but there are no consequences to this besides a headache from the never-ending sirens. And, if the player makes it all the way down to the bottom of the stairs and finds the device, we haven't a way to indicate to the player that he has indeed found the device and has beaten the game. In the next chapter we'll create a simple health/success/failure engine to keep track of how successful the player is.

Tutorial 16.2: Keys

Hopefully, this will be a fun tutorial. In the process of this tutorial, we'll make use of the techniques we've covered in the past tutorials. By assembling these skills in a new way, we'll have a new mechanism in the game.

The process will go like this. First we'll need to create a trigger that checks to see if the player has the key when the player enters it. If the player does indeed have the key, the door will open; if the player does not, a text prompt will pop up to alert the player that he needs the key. We'll create a PickUpKey function that fires when the player's ray is cast upon the key and the player clicks it. When the player clicks the key, we'll make the key disappear from the scene, but create a GUI element to indicate that the key is on the player's person. It's going to be fun!

Step 1: Create a new GUITexture to show the key. Create a new GUITexture (GameObject>Create Other>GUITexture) and name it KeyIcon. Use the texture Icon-Key from the 2D Assets folder to define its texture.

Step 2: Place the key in the top-right corner of the screen. Select KeyIcon in the Hierarchy and in the Inspector change the Transform X and Y values to 1. Change the Pixel Inset values to X = -70, Y = -70, Width = 64, Height = 64 (Figure 16.6).

FIGURE 16.6 Placed key icon.

Why?
The image is 64×64. With the GUITexture at 1,1,0, the bottom-left corner of the image is at the top-left corner of the screen, meaning that the image is off the screen. By offsetting the pixels by –70 in both X and Y, we slide the image back onto the screen with a 6-pixel buffer above and to the right.

Step 3: Now that you can see what it will look like when visible, move it off the screen. Select KeyIcon in the Hierarchy and in the Inspector, change the Transform X = 1.1.

Why?

We're just sliding it off the screen, so that when the key is actually acquired, it can slide back on.

Step 4: Make KeyIcon a child of GUIElements. Go ahead and break the prefab. Then once the KeyIcon is a child of GUIElements, be sure to press the Prefab Apply button.

Accessing the State Engine

Step 5: Open AC_ToolFunctionalityScript.

Why?

Our state engine exists in the AC_ToolFunctionalityScript. Remember this is where we're keeping track of flashlightActive, pistolActive, empActive, and empGhostActive. We need to add a new state (a new Boolean): keyAcquired.

Step 6: Make the state engine is aware of a new potential state: keyAcquired. Add the following lineup among the variable declarations:

```
private var flashlightActive : boolean;
private var pistolActive : boolean;
private var empActive : boolean;
private var empGhostActive : boolean;
private var keyAcquired : boolean;
```

Why?

We could technically store this Boolean in other places, but keeping all the Booleans in one place really helps when it comes time for bug squashing. If all the states are being stored in one place, we know exactly what place to look if the state isn't working as desired.

Building upon the Raycasting Mechanism

Remember that earlier we set up this AC_ToolFunctionalityScript with a raycasting mechanism. Look up in the function Update section and see that the following block of code exists:

```
if (hitObj.name == "Hallway_Key"){
    AddHighlight(hitObj);
}
```

This exists within the raycasting mechanism and says, "if the object we raycast against is named 'Hallway_Key' fire the AddHighlight function." This really is just a placeholder for what's really going to happen here.

In reality, if the object that is being raycast against is named Hallway_Key, we need to highlight it, and then if the user clicks the mouse we need to fire a new function called PickUpKey.

Step 7: Rework this section to read as follows:

```
if (hitObj.name == "Hallway_Key"){
      AddHighlight(hitObj);
      if (Input.GetMouseButtonDown(0)){
          PickUpKey();
    }
}
```

Why?

So what we're saying here is "if the object raycast against is named Hallway_Key, then highlight it, and then (if the object being raycast against is still Hallway_Key) if the user clicks the mouse button, fire the function PickUpKey."

Fleshing Out PickUpKey

Now we can do all the action involved in actually picking up the key.

Step 8: Scroll and create a new function called PickUpKey. Flesh the function out like this:

```
function PickUpKey(){
    var keyIcon : GameObject=GameObject.Find("KeyIcon");
    iTween.MoveTo (keyIcon, Vector3 (1,1,0), 1);
    var keyGeometry : GameObject = GameObject.Find
    ("Hallway_Key");
    keyGeometry.active = false;
    keyAcquired = true;
}
```

Why?

This does some interesting things. First, notice that there are two local variables declared (keyIcon and keyGeometry). We will use these only once (the character picks up the key only once), so rather than cluttering up an already crowded block of variable declarations, we'll declare these new variables as we need them.

Immediately after declaring each, and even in the same line, we tell Unity to go out and populate them by finding objects by a particular name. Generally, using GameObject.Find in a function can be dangerous,

especially if the function is fired a lot since we don't want Unity spending a lot of processor cycles just finding stuff. But since this particular function fires only once, it's just as expensive to put it here as it is to further clutter the function Awake or function Start areas of the code.

After we declare the keyIcon variable and populate it, we use iTween's MoveTo to slide it onto the screen. Finally, after we declare and populate keyGeometry, we turn it off. So in the game, if the player mouses over the key it highlights. Then, if the user clicks the key, the keyIcon slides in and the geometry of the key disappears.

Finally—and this is important—we tell Unity to keep track and know that now we have acquired the key and to set the Boolean keyAcquired to true. We'll need Unity to know this later when we want to open a door with the key.

Step 9: Save and return to Unity. Fix any syntax errors.
Step 10: To test, temporarily deactivate Hallway_Unbaked and activate Hallway_BakedGroup (deactivate and activate children when prompted).

Why?
Remember that we're cheating a little bit. The Key and LockBox don't even exist in the unlit version (Hallway_Unbaked), but become extant when the power switch is thrown and the Hallway_BakedGroup comes online.

Step 11: Play and test.

Creating a Smart Trigger

So now Unity is able to identify if the ray coming from the camera strikes the key (if it does, the key highlights). If the user clicks the mouse while the ray is on the key, the geometry of the key disappears and the key icon appears on the screen. Importantly, Unity also knows that the player has acquired the key. Now we need to make the door that this key opens have a trigger that checks to see if the character has indeed acquired the key.

Step 12: For the locked door, we need the baked version of the level. Deactivate Hallway_Unbaked and reactivate Hallway_BakedGroup (and their children).
Step 13: Find Hallway_Door_Bulkhead_Group 1. This should be in the large room with the rust-colored walls if you're using the assets provided (Figure 16.7).

FIGURE 16.7 The door that will be locked.

Step 14: Rotate the group so that the door is shut. The Rotation XYZ should all be 0.

Step 15: Make sure the group (and its children) is set to non-Static. Do this in the Inspector by checking off the Static option.

Why?

The group was probably originally set to Static since it needs to be to be included in the bake. However, if it remains marked as Static we can't animate it with iTween (or any other script-driven method for that matter).

Step 16: Create a trigger called Trigger-LockedDoor. As a refresher, remember this can be done by creating a Cube (GameObject>Create Other Cube). Click off its Mesh Renderer in the Inspector. Turn on its Is Trigger option within the Box Collider and resize and place it as seen in Figure 16.8.

FIGURE 16.8 Trigger-LockedDoor.

Step 17: Create an AudioSource that contains the sound of a squeaky door opening. Make sure Play on Awake is turned off. Place the AudioSource right by the door and name it Sound-DoorLocked.

Step 18: Create a new JavaScript. Name it
`HallwayDoorsLockedTriggerScript`. Open the script in your script editor.

Why?

I can hear you hard-core scripters screaming from here, "Just use the HallwayDoorsTriggerScript and alter it to be able to check for a Boolean state." And you'd be absolutely right. A much more efficient method would be to create one door-opening script that is useful in almost all situations; however, we're going to build another to review how triggers function, and to keep the script easy to read within the book.

Step 19: Define variables for the door, the bulkheadHandle, a doorOpenSound, the mainCamera, and the guiTextHints:

```
var door : GameObject;
var bulkheadHandle : GameObject;
var doorOpenSound : GameObject;
private var mainCamera : GameObject;
private var guiTextHints : GameObject;
```

Why?

The door is the object that opens. The bulkheadHandle is the wheel that turns. The doorOpenSound is a sound that plays when this big ol' door opens. The next two private variables allow us to go track down where our state engine lives (attached to Main Camera), and drive a screen hint if the player has not gotten the key yet.

Step 20: On Start, have the script populate mainCamera and guiTextHints:

```
function Start(){
    mainCamera = GameObject.Find("Main Camera");
    guiTextHints = GameObject.Find("GUITextHints");
}
```

Why?

So why make mainCamera and guiTextHints private variables and populate them in script and not do this for the others? Good question; the answer is that this will make the script applicable in other locked-door situations. In most all situations where the door is locked (and we want to be able to open it), the state engine will be accessed, and the screen hints will be shown. Since these two objects won't change, hard coding them saves populating in Unity. But since the door may indeed change if this script is used elsewhere, keeping it a public variable (along with the door handle and sound the door plays) will allow this script more uses.

Step 21: Have the script check to see if keyAcquired is true and if it is, open the door.

```
function OnTriggerEnter (other:Collider){
    if (mainCamera.GetComponent("AC_
ToolFunctionalityScript").keyAcquired){
        iTween.RotateTo(door, Vector3(0,-110,0), 5.0);
        iTween.RotateBy(bulkheadHandle, Vector3(3,0,0), 5);
        doorOpenSound.audio.Play();
        yield WaitForSeconds (doorOpenSound.audio.clip.
length);
        Destroy (doorOpenSound);
        Destroy (gameObject);
    } else {
      guiTextHints.guiText.text = "You need a key to open
this door.\nCheck the lock box near the entrance.";
        iTween.MoveTo (guiTextHints, Vector3(.5,0,0), .5);
        yield WaitForSeconds (3);
        iTween.MoveTo (guiTextHints, Vector3(.5, -.1,0), 1);
    }
}
```

Why?

So in plainspeak, the code says, "if the component 'AC_ ToolFunctionalityScript' that is attached to mainCamera says that keyAcquired is true (`if(mainCamera.GetComponent('AC_ ToolFunctionalityScript').keyAcquired){`), then take the door object and use iTween's RotateTo class and rotate it to Y = –110 (`iTween.RotateTo(door, Vector3(0,-110,0), 5.0);`). Then spin the bulkheadHandle with iTween's RotateTo (`iTween. RotateBy(bulkheadHandle, Vector3(3,0,0), 5);`). Play the audio attached to doorOpenSound (`doorOpenSound.audio.Play();`). Wait for the length of the doorOpenSound audio, and then destroy the sound and the gameObject this script is attached to (`Destroy (doorOpenSound);` and `Destroy (gameObject))`."

But if keyAcquired is not true (`else {`), then change the text on the guiText component of the guiTextHints GameObject to read, "You need a key to open this door (and then on a second line). Check the lock box near the entrance." Then move the guiTextHints object up with iTweens MoveTo, wait for 3 seconds and then move it back down.

Warnings and Pitfalls

If the door isn't opening, double-check to make sure that it isn't still marked as Static (left over from the baking process). This always trips me up because I want to make sure doors are included in the baking, but I want to be able to control them later on in the process via script. Gotta make sure and get Static turned off for items that won't be, well ... static.

Tips and Tricks

Note that the \n is not a typo. Without spaces, this tells Unity to split the string we've used to define the guiText's text into two lines.

Step 22: Save and return to Unity. Fix syntax problems.

Step 23: Apply this script to the Trigger-LockedDoor trigger.

Step 24: Populate the script in the Inspector. Use Hallway_Door_Bulkhead_Group 1 as the Door. Use Hallway_Door_BulkheadWheel 1 as the Bulkhead Handle. Use the Sound-DoorLocked as the Door Open Sound.

Step 25: Test and play. First go walk up to the trigger without picking up the key (Figure 16.9) and the text should provide some guidance. Then go back for the key (which should highlight; Figure 16.10), and then disappear when it is clicked (which should also pull up the key icon in the top-right corner). Finally, go back to the locked door, which should yield before your mighty gaming prowess (Figure 16.11).

Step 26: Make Trigger-LockedDoor a child of Hallway_BakedGroup.

Why?

We don't want the character getting tied up looking for the key before he's turned the lights on. For one thing, the keybox doesn't exist yet. By making the Trigger-LockedDoor a child of Hallway_BakedGroup, we

FIGURE 16.9 Walking up to the locked door, providing help on how to get through the door.

FIGURE 16.10 Raycasting against the key, which disappears when clicked.

FIGURE 16.11 Once the key is acquired, the door opens before the player.

ensure that this trigger isn't functioning until the parent is set active when the lights are turned on.

Step 27: Reactivate Hallway_Unbaked and deactivate Hallway_BakedGroup.

Conclusion

And there it is. Other than the fact that there is no winning or losing the game, the game is done. All the obstacles have been presented to the player, and all of them can be overcome. The scripting mechanisms are in place to handle all of it.

Still, playing the game is pretty unfulfilling when the player can't lose and can't win. In the next chapter we'll set up this engine.

Homework and Challenges

Challenge 1: The inventory system works well; but currently, when a tool is picked, the player is still locked in the inventory system. Wouldn't it be nice if when the player picks a tool, it automatically returns him to the game? Make this happen.
Challenge 2: The inventory system is useless without the player knowing how to use it. Create a trigger so that as the player walks across the dock, a screen hint appears that shows the inventory and provides a bit of instruction on how to use it.
Challenge 3: When the player first enters the hallway, it's awfully dark. How can the player be prompted to activate his flashlight?
Challenge 4: After flipping on the main switch, create a prompt that allows the player to know to watch out for cameras and to shoot them if he finds them.

Health Systems, Winning, and Losing the Game

The game is playable. But the player is in that strange limbo of being unable to win and unable to lose. In this chapter we will look at enabling the player to do both.

Winning will actually be very simple—if the player gets to the end of the level (at the bottom of the stairs) alive, he wins. This means that if we have a trigger down there, when the player passes through it, we can launch the "Congratulations! You Win!" level. We'll further flesh out that tutorial with script to allow for the game to be quit or restarted.

Losing is actually a bit tougher, but allows us opportunities to explore new ideas. To allow the player to lose we need to allow him to have a health system that keeps track of what sort of damage he has taken. We'll throw some escaping steam into the level that hurts the player if he isn't careful about where he walks, and make sure that the frigid water we warn him about does indeed do him in.

First, let's set up the winning mechanism.

Tutorial 17.1: Winning

The process we're going to follow is to first create the congratulations level—the level the game goes to if the player indeed gets to the end and wins. Within this level we'll build the scripting mechanism to allow the game to quit and to restart the game. Then, in the Hallway scene we'll create the trigger that will signal that the player has reached the end.

Step 1: Duplicate Scene-Opening in the Project panel. Just select Scene-Opening and choose Edit>Duplicate. Rename the duplicate `Scene-Closing`.

Why?

This congratulations level could be a lot of things, and if you'd like it to be something besides the spinning version of Aegis, go ahead and create that. This closing level can have anything as the visual candy—the important thing will be the buttons.

Step 2: Open Scene-Closing by double-clicking it in the Project panel.
Step 3: In the Hierarchy delete the data panels and buttons. Left behind should just be Aegis (Figure 17.1).

FIGURE 17.1 Beginnings of closing level.

Step 4: Create three GUITexture objects. Populate them with DataPanel_Congratulations, Button_Exit, and Button_PlayAgain. Resize and place them to approximate Figure 17.2 or to taste. Rename them `Congratulations`, `Button-Exit` and `Button-PlayAgain`.

Tips and Tricks

Remember this is done with combinations of the Transform X and Y values and using the Pixel Inset settings.

Step 5: In the Project panel, duplicate OpenSceneButtonsScript. Rename the duplicate `CloseSceneButtonScript` and open it.

FIGURE 17.2 Placed closing GUI elements.

Why?

Really, the additional functionality for these two buttons could be appended to the OpenSceneButtonScript, and generally, in my own projects in the name of fewer scripts, this is how I would do it (and rename the script GUIButtonsScript). However, in the format of a book, this starts to again become a really long script and can sometimes be difficult to see how it all works with the extra script. So for clarity's sake, we'll make a new script.

Step 6: Get rid of the variables and Awake function (neither are needed here) and adjust the OnMouseDown function to check for the name of the buttons being clicked. If the Button-Exit is clicked, quit the game. If Button-PlayAgain is chosen, load the level Scene-Opening. Finally, make sure that the mouse is free when the level starts (we'll be entering the CloseScenes after playing other levels that may be locking the cursor):

```
function Start(){
    Screen.lockCursor = false;
}

function OnMouseEnter () {
    guiTexture.color = Color (1,1,1);
}

function OnMouseExit (){
    guiTexture.color = Color (.2,.2,.2);
}

function OnMouseDown(){
    if (name == "Button-Exit"){
        Application.Quit();
    }
```

```
if (name == "Button-PlayAgain"){
    Application.LoadLevel("Scene-Opening");
}
```
}

Step 7: Save and return to Unity. Fix syntax problems.

Step 8: Apply CloseSceneButtonScript to Button-Exit and Button-PlayAgain in the Hierarchy.

Step 9: Change the color value of Button-Exit and Button-PlayAgain to RGB=50. Remember to do this, select each button in the Hierarchy; then in the GUITexture component, click the color swatch to change the values.

Step 10: Play and test. When the Exit button is clicked nothing will happen (it'll work when the game is built though). When the Play Again button is clicked, we should be back in Scene-Opening.

Step 11: Save Scene-Closing.

The Endgame Trigger

Step 12: Open Scene-Hallway.

Step 13: Create a trigger that sits right in front of the closet where the device resides (at the bottom of the stairs (Figure 17.3). Name it Trigger-Endgame.

FIGURE 17.3 Trigger location for final trigger.

Tips and Tricks

Note that Figure 17.3 shows the positioning of the trigger with Unbaked hidden, and Baked visible (although it could also be placed by disabling the lighting in the Scene view).

Step 14: Create a new JavaScript and name it `EndgameTriggerScript`. Open it.

Step 15: This script will be easy. When we run into this trigger, load the level Scene-Closing:

```
function OnTriggerEnter (other:Collider){
        Application.LoadLevel("Scene-Closing");
}
```

Why?

It's pretty straightforward here. If the player makes it to the end and runs into the collider, the Scene-Closing scene fires.

Step 16: Save and return to Unity. Fix any syntax problems.

Step 17: Deactivate Hallway_Unbaked and activate Hallway_Baked.

Step 18: Move the FPC_AegisChung toward the end of the map (so that when we test in a minute, the player doesn't have to run through the entire level).

Step 19: Add Scene-Closing to the Build Settings. Remember, to do this, choose File>Build Settings and then drag Scene-Closing from the Project panel into the Scenes in Build section of the Build Settings window (Figure 17.4).

Step 20: Apply EndgameTriggerScript to the Trigger-Endgame trigger. Test and play.

Step 21: When satisfied that everything works, place FPC_AegisChung back at the beginning of the level.

Step 22: Make Trigger_Endgame a child of Hallway_BakedGroup.

Why?

Not that the character could actually get to the end of the level when the game was all dark (the Unbaked version being visible), but just in case, having the trigger not active until the Baked version is turned on will help ensure the game proceeds as planned.

Step 23: Deactivate Hallway_BakedGroup and activate Hallway_Unbaked.

Step 24: Save Scene-Hallway.

Conclusion

Great! He can win. Winning can be fun—but only when there's the possibility that you can't. Let's create a health system so the player can lose.

FIGURE 17.4 Making sure that the Scene-Closing is part of the scenes that Unity knows to play.

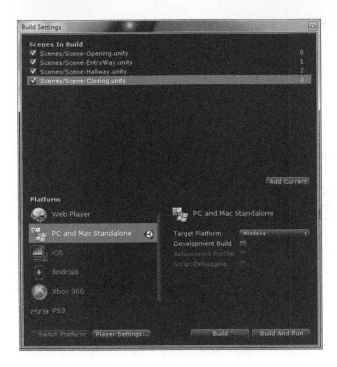

Tutorial 17.2: Health Systems

As usual in Unity, there are several ways to approach a health system. We're going to approach it in the most common way and create a health engine that is attached to FPC_AegisChung. This health engine is really just a counter. It will start knowing that the health of the character is 100 (or whatever). Then, as the character comes in contact with certain situations (gets hit by a bullet, has a rock dropped on him, steam hits him, falls too far—use your twisted imagination here), a message will be sent to this health engine to subtract from whatever the health value is. When the health equals 0, fire a die function to alert the player that he's kicked the bucket and lost the game.

So to begin, we'll need to create the health script.

> **Step 1:** Create a new JavaScript. Name it `HealthEngineScript` and open it.
>
> **Step 2:** Define a couple of variables. One (an integer) will hold the actual value of the health. The second (a GameObject) will hold the GUIText GameObject that displays the health level:
>
> ```
> var health : int;
> private var healthLevel : GameObject;
> ```
>
> **Step 3:** For now, we want to tell Unity that when the game starts, set the health to 100 and then display that value:
>
> ```
> var health : int;
> private var healthLevel : GameObject;
> ```

```
function Awake (){
      healthLevel = GameObject.Find("HealthLevel");
}

function Start(){
      health = 100;
      healthLevel.guiText.text = health.ToString();
}
```

Why?

The first command of the Start function simply defines the value of health. Later we will want to pass this value between levels so that if Aegis gets into trouble in the EntryWay, that his reduced health is the same when he's in the Hallway. But for now, let's just have it set to 100 when the game starts.

The second command defines what should be in the text of the guiText component of the GameObject healthLevel. Notice that this makes use of the fancy ToString function. This is a built in function in Unity that converts (in this case) an integer (which a guiText can't display) to a string (which a guiText can display). So it just takes the value of health, converts it to string (a collection of text), and displays that. Seems a little laborious but it's typical of how many scripting languages work.

Now we haven't created the guiText GameObjects yet. We'll get to that in a bit.

Step 4: Save and return to Unity. Fix syntax.

Creating Health Display

Step 5: Open Scene-EntryWay.
Step 6: Create a new GUITexture (GameObject>Create Other>GUI Texture). Label it `HealthLabel` and populate its Texture with the HealthBG texture from the 2D Assets folder. Position it with the settings shown in Figure 17.5. Make sure Transform X = .5, Y = 1. Then be sure the Pixel Inset values are set to X = -32, Y = -64, Width = 64, Height=64.

Why?

The image is 64×64 (thus the width and height settings). By setting the Transform values at 0.5, 1 we're putting the bottom-left corner of the image at the center of the top of the screen. Offsetting the image by X = −32 slides the middle of the image to the middle of the screen, and then offsetting the image by Y = −64, slides it down so the top of the image is at the top of the screen.

FIGURE 17.5 Settings for HealthLabel.

Step 7: Create a GUIText object (GameObject>Create Other>GUI Text). Label it HealthLevel. Set the Transform Position to X = 0.5, Y = 1, and Z = 2. Set the text to read 0. Change the Anchor to "upper center." Change the Alignment to "center." Change the Pixel Offset Y = -30 and assign a font you like (Figure 17.6).

FIGURE 17.6 Settings for HealthLevel GUIText.

Why?

So this GUIText is set at the top center of the screen (Transform Position (0.5, 1, 2)) and is aligning the text center and using as its anchor the upper center. Then we're sliding it down 30 pixels off the top of the screen. Note that the Z = 2 makes sure that the text is drawn on top of the HealthBG.

Step 8: Make both of these children of the GUIElements prefab in the Hierarchy.

Step 9: Select GUIElements and press Prefab Apply.

Step 10: Apply HealthEngineScript to FPC_AegisChung. Go ahead and break the Prefab connection when prompted, then reattach to prefab via the Prefab Apply button. Test and play. The HealthLevel that should be displayed at the top of the screen should swap from 0 to 100.

Why?

We'll want this health system in all the places we're showing the GUIElements. Make it once here, reap the benefits everywhere.

Back to Script

Step 11: Reopen HealthEngineScript.

Step 12: Create the function that deducts from the health level when damage is done:

```
var health : int;
private var healthLevel : GameObject;

function Awake (){
      healthLevel = GameObject.Find("HealthLevel");
}

function Start(){
      health = 100;
      healthLevel.guiText.text = health.ToString();
}

function ApplyDamage (damage : int){
      health -= damage;
      healthLevel.guiText.text = health.ToString();
      if (health <=0){
            KillPlayer ();
      }
}
```

Why?

The first line is defining the name of the function (ApplyDamage declares a local variable "damage" that is an integer). This local variable declared here will mean we can easily pass values to the function.

Then, the first command is a bit of programming shorthand. `health-=damage` means, "subtract damage from health, and that's the new health value." It's a little unintuitive at first glance, but saves loads of time when doing counting sorts of things.

The next command just says (as before), write the string version of the health value to the text of the guiText component attached to healthLevel.

Finally, it checks to see if the health level is equal to or has dropped beneath 0, and if it has, fire the function KillPlayer (which we haven't written yet).

Step 13: Build a simple KillPlayer function:

```
var health : int;
private var healthLevel : GameObject;

function Awake (){
      healthLevel = GameObject.Find("HealthLevel");
}

function Start(){
      health = 100;
      healthLevel.guiText.text = health.ToString();
}

function ApplyDamage (damage : int){
      health -= damage;
      healthLevel.guiText.text = health.ToString();

      if (health <=0){
            KillPlayer ();
      }
}

function KillPlayer(){
      Application.LoadLevel("Scene-ClosingFail");
}
```

Why?
We haven't built Scene-ClosingFail yet, but the KillPlayer function loads it.

Things That Hurt

What we've built so far is an engine that keeps track of what the health level is for the player. But we need to now create things that will hurt the player. We're going to create a couple of things that do this. The first will be a trigger that we place where the player shouldn't be (like where the water is or in the empty space in the tall hall of stairs). Then, if the character collides with these triggers, the trigger will send a message to the object that has collided with it (the FPC_AegisChung) that the player has sustained damage, and how much damage he's taken. For this mechanism we'll even build in a timer so that if the player remains in the trigger (like in the icy water), the damage amount increases.

The second mechanism we'll build is using particles. There are lots of pipes in the hallways; we'll have some steam leaks pop out, and if the player walks too close to the steam, he'll incur damage.

Creating the Damage Triggers

Step 14: Create a new trigger that encompasses all the areas where the player may come in contact with the water (Figure 17.7). Note that it goes off the front of the dock, but also includes the channel. Make sure

that it's lower than the dock (of course) since it should register a collision only when the player steps off the dock. Name it `Trigger-WaterKiller`.

FIGURE 17.7 Our water collider.

Step 15: Create a new JavaScript. Name it `DamagePlayerScript` and open it.

Step 16: Create two variables—one to store the amount of damage the trigger will do, and a second to keep track of whether the player is still in the trigger or not:

```
var damageAmount : int;
private var inTrigger : boolean;
```

Why?

By leaving damageAmount as a public variable, we can reuse this script again and again. So for the water, the script can be set to do a little bit of damage (and then repeat the damage if the player remains in the water), but if the player jumps off a cliff, it can do 100 damage and kill them right away.

Step 17: Create the mechanism that checks to see if something has entered the trigger. Have it check to see if the object's tag is "Player" and if it is, set the Boolean inTrigger to true, and fire a function that does damage:

```
var damageAmount : int;
private var inTrigger : boolean;

function OnTriggerEnter (other:Collider){
    if (other.gameObject.tag == "Player"){
        inTrigger = true;
        DoDamage (other.gameObject);
    }
}
```

Why?

Of course we haven't made the function that actually does the damage yet (DoDamage), but we'll create that in a minute. Do notice, however, that in the last command in that block of code we're telling Unity to go fire DoDamage, but take with it the gameObject attached to other (which is the collider that entered the trigger).

Step 18: Add a function to set inTrigger to false when the player exits the trigger:

```
var damageAmount : int;
private var inTrigger : boolean;

function OnTriggerEnter (other:Collider){
        if (other.gameObject.tag == "Player"){
                inTrigger = true;
                DoDamage (other.gameObject);
        }
}

function OnTriggerExit (other:Collider){
        inTrigger = false;
}
```

Why?

For some of the triggers this will be used on, the player will never leave it alive. But, the player could enter the water trigger, and then climb out via the terrain. So we need Unity to keep track of whether the player has emerged alive or not.

Broadcast Message

Warnings and Pitfalls
There are some very specific designed restrictions to Broadcast Message that have to do with where objects are within Hierarchy and who hears a message. So if you plan to use this extensively in a project be sure to read the documentation on these sorts of issues.

We've looked at a few ways to communicate between objects and scripts. There's one final method we'll look at in this book—a powerful method called Broadcast Message. What Broadcast Message does is shout a message out and objects that are listening for it hear it and obey. In this game we're using Broadcast Message in a fairly targeted fashion, but consider a situation in which lots of objects in a scene need to do something (say enemies needing to reset their target); using Broadcast Message, a weapon could "shout" to all of them at once, "oy! Now go chase this little distraction robot I've launched!" Using the past methods of finding an object, then accessing a specific script on that object, and then accessing a specific function, would be problematic if there were 100 enemies on screen. But with Broadcast Message, the enemies would hear the command, and all fire their respective function to realign target.

In this case, we are going to use Broadcast Message to yell specifically to the object that has entered the collider. However, this still carries some benefits since we just shout the message, and the object figures out which script needs to hear it.

Step 19: Create the DoDamage function. Include a sort of timer in this function so that if inTrigger is active, it continues to damage the player.

```
var damageAmount : int;
private var inTrigger : boolean;

function OnTriggerEnter (other:Collider){
        if (other.gameObject.tag == "Player"){
                inTrigger = true;
                DoDamage (other.gameObject);
        }
}

function OnTriggerExit (other:Collider){
        inTrigger = false;
}

function DoDamage (target : GameObject){
        while (inTrigger){
                target.BroadcastMessage("ApplyDamage",
damageAmount);
                yield WaitForSeconds (2);
        }
}
```

Why?

We're using our old trick of a while statement so that as long as the inTrigger is true (which is set earlier by setting it to true when an object with tag "Player" enters the trigger), every 2 seconds Unity fires the command that says "get target (which is the object that collided with the trigger) and broadcast the message "ApplyDamage" along with the parameter of how much damage to subtract (damageAmount).

In this case "target" will always be FPC_AegisChung, which also has attached to it the HealthEngineScript. Remember that within this script is a function called ApplyDamage that has a parameter of damage:int. When target "hears" this broadcast message and the parameter of the damageAmount, it will subtract the damage amount from the current health value (check out the HealthEngineScript for review).

The cool thing here is that we didn't have to tell the object what script to use. The object itself received the message and then passed it along to its components. If a component couldn't do anything with it, it ignores it. But when a component recognizes the message (like HealthEngineScript), it obeys.

Step 20: Save and return to Unity. Fix syntax.

Step 21: Attach this new DamagePlayerScript to the Trigger-WaterKiller GameObject in the Hierarchy.

Step 22: Select Trigger-WaterKiller and in the Inspector under the Damage Player Script component, define the Damage Amount as 10.

Step 23: Test and play. Jump in the water and stay there. Watch the Health meter at the top and see how it drops by 10 every 2 seconds. Eventually, the Console will throw an error because you'll be dead, but Unity won't know of any Scene-ClosingFail scene.

Step 24: Save Scene-EntryWay.

Step 25: Open Scene-Hallway.

Step 26: Deactivate Hallway_Unbaked and activate Hallway_BakedGroup.

Why?

I know, you're probably sick of turning these off and on, and it would have been great if the tutorials were set up so we never had to do that but alas, with the concepts we're exploring this little annoyance is necessary to allow ideas to build upon each other.

Step 27: Create a new trigger that fits into the area between all the stairs (Figure 17.8). This needs to be very accurate because if it's too big the player will hit it running down the stairs and die, but if it's too small, he might be able to fall all the way to the ground without hitting the trigger. Name the trigger `Trigger-FallDeath`.

FIGURE 17.8 Trigger-FallDeath.

Why?

There are different ways to handle a character falling to his death. Some are more interesting than this one and can include timing how long a character is not grounded and is falling. Others simply measure how far a

character has fallen to determine how much damage a fall does. However, for this one, we'll kill with very broad strokes and say that if the character jumps off any of the stairs very far up, he doesn't survive the fall.

Step 28: Apply DamagePlayerScript to Trigger-FallDeath. Set the Damage Mount for the script (in the Inspector) to 100.

Step 29: Test and play. Try jumping over the rail—an error will pop up in the Console (which is just what we want to see) that says it can't find Scene-ClosingFail. It means the script is working like it should and is trying to launch the level that tells the player he failed.

Particles Doing Damage (Steam)

To add extra peril to the game, we'll make some of the pipes in the facility spew steam. Of course, if the player walks through that steam he'll get hurt and his health level should decrease. The steam of course will be constructed with a particle emitter system (there is already one in the scene if you've brought in the Scene-Hallway), or it can be brought in as a Unity Package (Steam.unitypackage) from the supporting web site (http://www.Creating3dGames.com). But how to make the HealthEngine know that the player has been hit by the steam can be accomplished in a myriad of ways.

Unity includes a function for OnParticleCollision that can allow an object to know when a particle has hit it and then perform actions. So, we could add a script (or append a script) that was attached to FPC_AegisChung that watched for particles, checked to see if the particles came from Steam, and then hit the HealthEngineScript. But this means adding the script that does the hurting to the player, which would really shift us away from the current system of the player containing the health information and the objects doing the hurt containing the script that communicates the hurting.

Or, the GameObject that contains the steam could be set up with a raycasting mechanism so that when the player is struck by the ray, the message to hurt him is sent. But this means that the area of pain is quite small (within a ray), and sends the message only when the player is directly in front of the steam.

Or, and this is the method we'll use, we can reuse the idea of a trigger. With a trigger we can set up a broader area of influence for the steam, and then as the character comes in contact with this influence (collides with the trigger), the steam can tell the player's HealthEngineScript to DoDamage. With the current mechanism, we already have things set up to take care of duration of time within the steam.

If you wish to build your own steam package, feel free to do so. It's simply a modified version of the Smoke particle system included with Unity's Particle Unity Package (and renamed Steam). Under the Ellipsoid Particle Emitter

component Emit is turned off (a script activates it). This script is called SteamEmitters and it simply turns the emitters on and off based upon the distance the emitters are from the player:

```
private var fpcAegis : GameObject;

function Start (){
        fpcAegis = GameObject.Find("FPC_AegisChung");
}

function Update () {
        var dist = Vector3.Distance (fpcAegis.transform
.position, transform.position);
        if (dist <=25){
                particleEmitter.emit = true;
        } else {
                particleEmitter.emit = false;
        }
}
```

This is so that when walking through the dark version of the model, the steam for the entire level isn't visible (the shaders for particles are light independent). So as the player gets closer, the emitter emits.

The version of steam included in the Steam Unity package also includes an Audio Source component (Component>Audio>Audio Source) with a looping steam sound. Importantly, it contains a Box Collider component (Component>Physics>Box Collider) that is set to be a trigger. Finally, the Steam GameObject has attached to it the DamagePlayerScript with a Damage Amount set to 2 (Figure 17.9).

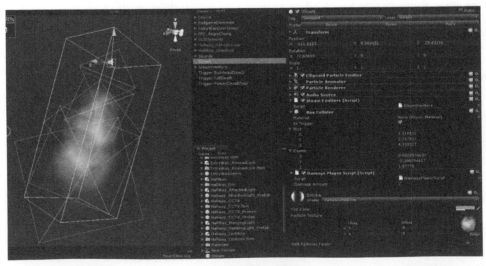

FIGURE 17.9 Steam prefab.

If you understand how this was all put together, don't worry about assembling your own; just use the provided prefab.

Step 30: Either create your own steam prefab with these directions or import Steam.unitypackage from the supporting web site (http://www .Creating3dGames.com).

Step 31: Place a bunch of Steam prefabs into the scene. Stick them inside the pipes that run through the hallways. Be sure to vary the rotations (some pointing straight down, some at an angle), so they don't all appear quite as much like copies of themselves (Figure 17.10).

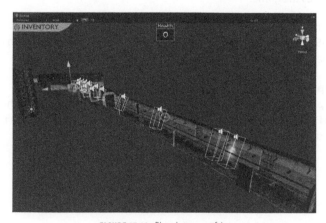

FIGURE 17.10 Placed steam prefabs.

Step 32: Group the Steam objects by creating an empty GameObject, labeling it `SteamEmitters` and placing all the Steam objects as children of it.

Step 33: Play and test (Figure 17.11). As the player hangs out in the steam, their Health should decrease by 2 units every 2 seconds.

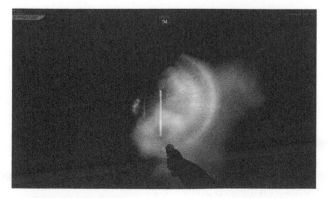

FIGURE 17.11 Working steam and damage being done as we hang out in it.

Step 34: Save Scene-Hallway.

Timers on Cameras

Getting closer. We now have all sorts of ways to die. In a few pages, we will keep track of health from level to level (right now he miraculously is healed when he moves from the EntryWay to the Hallway). We just need to do a little bit of cleaning up.

Currently, if the CCTV cameras see you they throw up an awful racket, but there are no consequences. We need to add a mechanism to the cameras so that once they see the player, a countdown begins where if it reaches 0, the player loses the game.

Luckily, much of the mechanism already exists within the CCTV-CameraSearchingScript. We simply need to add a CountDown function that ends the game if the player doesn't destroy the camera.

Step 35: Open CCTV-CameraSearchingScript.

Step 36: Tell the script that when the raycast hits the object with the tag Player, to not only fire the PulseLight function, but to also fire a new function called CountDown:

```
var seenSomething : boolean;

function Update () {
        var hit : RaycastHit;
        if (Physics.Raycast (transform.position, transform
.forward, hit, 100)){
                Debug.DrawLine (transform.position, hit
.point, Color.yellow);
                if (hit.collider.gameObject.tag == "Player"){
                        seenSomething=true;
                        PulseLight();
                        CountDown();
                }
        }
}

function PulseLight(){
        audio.enabled = true;
        while (seenSomething){
                var textureColor : Color;
                textureColor.r = Mathf.Sin (Time.time * 10.0);
                renderer.material.color = textureColor;
                yield;
        }
}
```

Step 37: Create a simple function that tells Unity to wait for 10 seconds, and then launch the level Scene-ClosingFail:

```
var seenSomething : boolean;

function Update () {
        var hit : RaycastHit;
```

```
        if (Physics.Raycast (transform.position, transform
.forward, hit, 100)){
              Debug.DrawLine (transform.position, hit
.point, Color.yellow);
              if (hit.collider.gameObject.tag == "Player"){
                    seenSomething=true;
                    PulseLight();
                    CountDown();
              }
        }
}

function PulseLight(){
      audio.enabled = true;
      while (seenSomething){
            var textureColor : Color;
            textureColor.r = Mathf.Sin (Time.time *
      10.0);
            renderer.material.color = textureColor;
            yield;
      }
}

function CountDown(){
      yield WaitForSeconds (10);
      Application.LoadLevel("Scene-ClosingFail");
}
```

Why?

Remember that this script is attached to the camera itself, and when the camera is shot it's destroyed and the broken version is instantiated in its place. Because the camera itself gets destroyed, the scripts attached to it destroy as well. So, if the player does indeed find the alerting camera and shoots it, this function (CountDown) never gets to its 10 seconds and therefore never launches Scene-ClosingFail.

Step 38: Save and return to Unity. Fix syntax problems.

Scene-ClosingFail

Step 39: Duplicate Scene-Closing (select it in the Project panel and choose Edit>Duplicate). Rename the duplicate `Scene-ClosingFail`. Open this new Scene-ClosingFail.
Step 40: Rename the Congratulations GUITexture to `Fail` and replace its texture with the DataPanel-Failed texture from the Project panel's 2D Assets.
Step 41: Adjust lighting or other visual elements to give this version a darker feeling of failure. The image shown in Figure 17.12 simply turns the color balance of all the lights toward red.
Step 42: Save Scene-ClosingFail.
Step 43: Add Scene-ClosingFail to the Build Settings' (File>Build Settings) Scenes in Build.

FIGURE 17.12 Scene-ClosingFail.

Global Variables

We've created all sorts of variables at this point. We've created public variables (var nameOfVariable) that create a variable that can be populated within Unity's editor. We've created private variables (private var nameOfVariable) that store data, but usually are controlled and populated within the script. We've created local variables whose scope is limited to just a particular function.

The last type of variable we're going to cover is called a **global variable**. Global variables actually do just what the name implies—they are variables that are accessible globally. Importantly, a global variable remains constant between scenes. This becomes ideal for something like health.

Step 44: Open the script HealthEngineScript.

Step 45: Convert the variable "health" from a private to global variable and give it an initial value. Because we're defining an initial value in the declaration, remove the line health = 100; from the Start function:

```
static var health : int = 100;
private var healthLevel : GameObject;

function Awake (){
      healthLevel = GameObject.Find("HealthLevel");
}

function Start(){
      healthLevel.guiText.text = health.ToString();
}

function ApplyDamage (damage : int){
      health -= damage;
      healthLevel.guiText.text = health.ToString();
      if (health <=0){
            KillPlayer ();
      }
```

```
}
function KillPlayer(){
     Application.LoadLevel("Scene-ClosingFail");
}
```

Why?

In the very first line we're declaring a variable that any script can access via HealthEngineScript.health. There is a lot of functionality there that could be exploited that we haven't discussed in this book (and unfortunately won't be able to as our journey together draws to an end). However, the power that is going to be important to us is that the value of health—since it is a global variable—will now transfer between levels.

So if the player goes for a little icy swim in Scene-EntryWay and loses 20 health points, after he enters the doors and Scene-Hallway is loaded, he isn't miraculously healed. His health remains at 80.

Step 46: Save and return to Unity.
Step 47: Make sure to reset the Health to 100 if the player chooses to play again. Do this in the CloseSceneButtonScript. Add the following line:

```
function Start(){
     Screen.lockCursor=false;
}

function OnMouseEnter () {
     guiTexture.color = Color (1,1,1);
}

function OnMouseExit (){
     guiTexture.color = Color (.2,.2,.2);
}

function OnMouseDown(){
     if (name == "Button-Exit"){
          Application.Quit();
     }
     if (name == "Button-PlayAgain"){
          HealthEngineScript.health = 100;
          Application.LoadLevel("Scene-Opening");
     }
}
```

Why?

Remember that health is a static variable and thus accessible at any time through any scripts in the project. By entering this line we simply say, "when someone presses the Button-PlayAgain GUITexture, set the player's health back to 100 (the health that's stored over in the HealthEngineScript script), and then launch the Scene-Opening level."

Step 48: Save and return to Unity. Correct syntax problems.

Final Test

Step 49: Make sure the Scene-Hallway is set up appropriately (Hallway_BakedGroup deactivated, Hallway_Unbaked activated, etc.).
Step 50: Open Scene-Opening.
Step 51: Play the game. Be sure to die and see if Scene-ClosingFail indeed pops up. Also, get a bit damaged and make sure that the health state transfers from level to level.
Step 52: Celebrate! The game is done; or at least started.

Conclusion

So there's the game. There is still one vital step before we can share it—we need to "build" it, or more accurately, "create a build." This will produce the actual product that others can launch. Additionally, we'll need to create a build to make sure that the game does indeed quit. In the next chapter we'll wrap up with a brief discussion of builds.

But the basic functionality is complete. This, of course is just the beginning. Be sure to be thinking about how the game might be expanded, and while these assets are still familiar to you, add new challenges to it. There are lots of doors unopened, and lots of mini-games that could still be implemented.

Homework and Challenges

Challenge 1: The EndgameTriggerScript gets the job done, but can this be polished some more? Maybe a fade (Hint: Consider a GUITexture (all black) with an animated iTween.FadeTo attached to it)? Or an additional camera with some animation to ease us out of the scene? How could these be integrated into the EndgameTriggerScript? Can this be expanded to allow for smoother transitions into Scene-Closing?
Challenge 2: The camera countdown works, but it could let the player know better the consequences of not taking out the cameras. Create a mechanism that alerts the player that if he doesn't destroy the camera that's seen him, the authorities will descend and catch him.
Challenge 3: At this point the game can be ended by losing (either by the cameras catching you or by the health hitting 0). However, what if the player wants to quit? On a Mac, Command-Q will stop the game, and on a PC, Alt-F4 will do the same thing, but this isn't something that most PC users instinctively know. Their first impulse is to press the Esc key. Create a new script that listens for the key input of the Esc key (Hint: Keycode.Escape), and then quits the application (Application.Quit). Where should this script be housed?
Challenge 4: The steam emitter uses a tool that constantly checks for the distance between fpcAegis and the emitter (and turns the steam emitter on if he is within a certain range). Unfortunately, this is very expensive to have a bunch of objects checking every single frame what their distance is to another object. How could this be instigated in a more efficient way (hint: think collider triggers....).

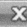

cursion Configuration

Incursion

GET IN. GET OUT. DON'T GET CAUGHT.

an Adam Watkins game produced
in association with the
Los Alamos National Laboratory

Graphics | Input

Unity Debugging, Optimization, and Builds

Finding the Bugs

The game is playable. We don't know whether some things work yet (like anything that uses Application.Quit), but more importantly we need to get this game in the hands of someone else. Quality assurance is always a tough thing for indies to handle since it requires other people to play the game. As the designer, you know where to look and what to do, but you don't count. The game needs to make sense to the uninitiated. Can someone just playing the game figure out what they're supposed to do? What's the goal? Where are they supposed to go? Beyond that are the important issues of how bullet-proof the game is. When the uninitiated play the game, do they use the Inventory as anticipated? As they are using it, are there new bugs that pop up because they push buttons too quickly? Do they use the tools in unexpected ways that result in unexpected and undesired results?

All of this can happen only when someone else plays the game. Get your game at various states into the hands of others, and sit back with a notebook with your mouth shut and just watch how they interact and what they do. Very often the results are quite surprising.

Luckily because of the Console and Unity's functionality, which allows you to play the game within their Editor environment, most big bugs in the code have been taken care of long before you even think of having someone else play your game. However, there are those design bugs—bugs that happen when a tool is used in a way that isn't intended—that also need to be squashed before the game is shipped to the general public.

There are other reasons to get your game in other people's hands, or more specifically, on other people's computers. There really is tremendous variation in machines out there—not only Mac/Windows/Linux, but even within a given platform the hardware on which that platform is running can vary significantly, and how your game looks and plays also can vary significantly. We've had games that looked great on our development machines and then suddenly on the users' machines the trees on the terrains were fluorescent green. In other cases the real-time shadows were suddenly a checkerboard that was equally spread out all over the scene. None of these issues were present on the machines we built the projects on, but the experience was certainly other than intended for the player.

Now to be fair, often these issues were fixed with a driver update (the player hadn't updated the driver on his video card for three years!), and one of the things Unity does really, really well is provide a very constant experience across platforms. The built-in shaders are smart and if the video card drawing them can't do some of the things the game is asking it to, the shaders will send other information so the game doesn't crash or look really terrible. However, there are always potential issues, so the more people and the greater variation of hardware and operating configurations that can test the game, the more troubles can be found and bugs can be squashed.

Optimization

Optimization is really a process that happens all along the game creation process. We've already covered extensively the issues on the art side that can keep games running smoothly (low polygon count, effective textures, texture maps, combined meshes, etc.). Ideally, much of the optimization of a project is done during art production. It can be difficult to go back and reduce polygons in a model, so building efficiently to begin with helps a great deal.

When trying to work out the mechanics of a game, it can be frustrating and not terribly productive to try and do a whole lot of optimizing (although knowing what kind of code is expensive and not using it in the first place can certainly help). But once the game is functional, taking a bit of time to optimize both art assets and script can ensure a smoother experience for playing the game.

Finding What Needs to Be Optimized

There are a several ways that Unity lets you see what's taking a lot of hardware resources. They all take some interpretation but can be very effective.

The Profiler

This is a Pro-only feature; since most people reading this book will not have Unity Pro we won't spend a huge amount of time on it. But it does what its name says it does—it profiles (Figure 18.1).

The Profiler really is a thing of beauty and can let you know as you're running the game what's taking the most processing power. Generally, of course, rendering (drawing the stuff we can see) is what takes the most, but there are also peaks of scripts taking a lot of resources as well.

The Profiler is available at Window>Profiler, and when the game is run it provides a real-time histogram of where your resources are going. This can be very educational to see; for instance, what kind of resources the water takes when it is being drawn on screen. Or how much of a hit the system takes when passing through a trigger. Importantly, as the player moves around in the screen, the Profiler will show which areas are taking the most rendering power; this can begin to show where textures are the largest or the polygon count is the highest, and thus provide a hint on where to start optimizing.

Stats

Even if you don't own Unity Pro, standard Unity offers some good tools to see how hardware resources are being used. In the top-right corner of the Game window is a Stats button (Figure 18.2). Activating this will provide real-time stats on what's happening on that frame of the game. Importantly, it will provide the frame count (in frames per second, fps). Anything below 30 fps will appear jerky to the player—it's better to be up around 60 fps if possible.

Notice that this little panel also provides a plethora of other information. It will show Draw Calls, number of tris and verts, and how much texture memory is being used. All of this can be incredibly valuable as the player walks around. It can show exactly where—or when you're looking at objects, what—the biggest drop in frame rate might be. Once the bottleneck regions are located, much of the art optimization can happen.

FIGURE 18.1 Profiler in action.

FIGURE 18.2 Stats activated.

FIGURE 18.2 Stats activated.

Log Files

The Console shows errors generated when playing a game within Unity's editor. This is the preferred method of bug squashing and optimization since the warnings and errors can be fixed as the game is created. However, there are also **log files** that are created when the stand-alone game is run. These log files can be a laborious but comprehensive form of tracking down what's happening in the game.

Most beginning game designers never have need to access this level of information, but it's worthwhile to point out that these logs exist and where to find them.

For Mac users, the logs are stored at ~/Library/Logs/Unity. For Windows XP logs are usually stored in C:\Documents and Settings*UserName*\Local Settings\Application Data\Unity\Editor. On Windows 7 the logs are stored at C:\Users*UserName*\AppData\Local\Unity\Editor.

It's important to remember though that each time the game is run, the log (Editor.log) is overwritten. So if you need to compare logs, be sure you're moving copies of the log out of that folder or renaming them.

Optimizing with Textures

Keeping an eye on the prize of maximum impact with the smallest texture file size is a nonstop consideration in the creation of textures for a game. However, often a texture is created at a resolution that we think we need and turns out not to be needed at that high a resolution. This is commonly where I find the quickest and most needed optimization to take place.

Remember that when texture files are imported into Unity, by default its max size is set to 1024. This means that if an image comes in at 512×512, it remains at 512×512, but if a 2048×2048 image is brought in, Unity down-samples it to 1024×1024. While putting together the Scene-EntryWay, we looked at how to up-sample this texture information so that Unity is indeed using the 2048×2048 if it's needed.

What often happens is that when creating a scene and closely scrutinizing each object, the tendency is to feel the need to up-sample all sorts of stuff. But when all is said and done, especially when lighting has been

created and baked into a scene, these higher-resolution textures are often indistinguishable from their lower-res versions in game.

As an example, in optimizing the final build included on the web site (http://www.Creating3dGames.com), I went through the objects in Scene-EntryWay, and halved the resolution of nearly every texture—quartered the size of some. This is done by selecting the texture in the Project panel, and then in the Inspector changing the Max Size (Figure 18.3).

This is a nondestructive method. The original file is still at its resolution. This means the Max Size can be turned back up if the texture's visual quality in game degrades too far. But as I went through, halving textures, I watched carefully for its impact on the scene. With all the ambiance of the darker lighting and the fog, usually there was little or no visual difference.

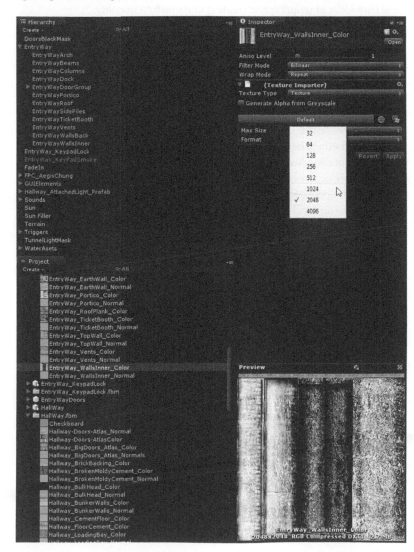

FIGURE 18.3 Changing the Max Size of a texture.

However, after doing this, on my machine, the frames per second went from being about 30 to 33 fps to 45 to 47 fps. This is a significant speedup for just a little bit of detective work. Of course this can be taken too far and suddenly the textures turn to mush, so work with caution, but be aware of the significant benefits of tweaking down textures.

Optimizing with Scripts

Writing fast code is a skill that is highly desired, but too rarely mastered. The code that we have written for this project without a doubt are not the fastest or most efficient solutions, but they are effective. Unfortunately, some of the most efficient code can sometimes be difficult to interpret for the uninitiated. So at the risk of slower code, our approach has been to focus on understanding some core ideas of scripting and creating in-game functionality.

However, there are some general notes to keep in mind that we've largely subscribed to as the scripts were created. Following is a recap of some ideas for faster code.

Be Careful of Where Lookups Occur
Lookups can refer to things like GameObject.Find("name of object") or GetComponent("name of script")—situations in which the script is telling Unity to go find something before the script can complete the task. Placing this sort of thing in a function Awake or a function Start works great—it means they fire once. However, occasionally beginner scripters will include them in something like a function Update. Included in an Update function means the script is telling Unity to go out and find a particular object *every frame of the game*. That's an awful lot of work for something that the script could do once and just remember.

Type the Variables
JavaScript allows for a variable to be simply declared (var myVariable;) without indicating what type of thing will be contained in that variable. In our code for this book, we have been careful to assign types to variables that we declare (GameObject, boolean, int, float, string). But when reading code others have posted online, occasionally you'll see the lazy scripter who simply declares a variable without declaring a type to save that little bit of extra typing it takes to type it. When there is not a type assigned to a variable, Unity has to *infer* what the type is and make some guesses at how to treat it. When you consider how many variables we have declared even in our basic game, you can see how this sort of guesswork can add up quickly for Unity and start to impact performance.

Don't Fire a Function or Activate an AI if You're Not Close Enough to See It
One of the scripts on the steam prefab simply checks the distance between the player and the steam object. If the player is too far away, the steam shuts itself off. In Unity's documentation, they list the example of having an enemy go to sleep when the player can't see him or be close enough to be aware

of him. If the enemy's processor-cycle-using scripts aren't firing, or if the enemy doesn't even exist until the player gets close, the computer has more cycles to use on the immediate experience of the player. Even within this optimization tip, there are smarter ways to do it. For instance, using a function that checks for the distance of the player (via an Update) is less efficient than if there were a trigger with an OnTriggerEnter function. Checking the distance via function Update means that the computer is doing work every frame to check distance, whereas the OnTriggerEnter doesn't do anything until the player walks into the realm of influence.

Making the Build

Once the game is built, and the optimizations have been made, it's time to create a build of the game that is consumable by either the general public or just your nearest friends. Either way, making a build means making an .exe (for Windows), an .app (for Mac), a web player, an Android app, or an iOS app that can be run by players without having Unity installed on their machine.

In this book we have been focusing on developing a PC/Mac/Web application, although with a little modification in the input system, the game could run on iOS or Android platforms—it was designed primarily as a keyboard-and-mouse-driven game. Because of this we'll focus on creating builds for Mac and PC output.

There are a few things we need to do to get ready to create a build, but then making the builds themselves is really quite trivial.

Preparing Player Settings

When Unity refers to Player Settings it is referring to Player as in the vehicle that carries the game, not the player as a person. In the past, we looked at Player Settings to select the default Rendering Path (Figure 18.4). But Player Settings carries oh so much more power.

FIGURE 18.4 The Player Settings window.

FIGURE 18.5 Player Settings allows for the executable icon to be defined.

FIGURE 18.6 Player Settings also allows for definition of the images shown in the game's startup dialog.

Specifically, the Player Settings window can allow us to start to brand the build we are about to output. This can include text branding but also can allow visual elements like what the icon looks like for the executable once the file is built (Figure 18.5) and what the splash image looks like when the user first launches the game (Figure 18.6).

There are two ways to access Player Settings: Edit>Project Settings>Player, or File>Build Settings and then pressing the Player Settings button at the bottom of that dialog box.

The Player Settings window has an interface that can be a little confusing at first glance—the buttons don't always make it easy to see what's happening. There are two main sections of the window, Cross-Platform Settings and Per-Platform Settings.

The Cross-Platform Settings allows for the quick definition of your Company Name and the Product Name. Easy enough.

The Per-Platform Settings actually includes quite a few sections. Resolution and Presentation, Icon, Splash Image, and Other Settings are all expandable sections that expand once you click the word. At the top of the Per-Platform settings are two tools for either PC and Mac Standalone mode (shown in Figure 18.7) or Web Player settings. It can be goofy figuring out which one is actually selected so be sure to just note which is active with the line of text immediately beneath the buttons.

Resolution and Presentation

This area of course allows for how the game is to be presented. It's an interesting area though as in some ways it's simply a "suggest how the game should look" section. All the default settings (Screen Width, Screen Height, Is Full Screen) are simply the suggested settings when the player launches the application. As long as the Display Resolution Dialog drop-down menu (also in this Resolution and Presentation area) is set to Enabled, the player still has the chance to change the resolution up or down.

FIGURE 18.7 Player Settings and the Per-Platform area.

Now this can be an important issue if the project's GUI elements are built in peculiar ways. For instance, if any of the GUI elements you've built are really huge, a small resolution could be a problem. Or, if the GUITextures were not laid out using the Transform methodology (0,0 is lower-left corner) and instead were laid out using the Pixel Offset options exclusively, some resolutions could be a problem. Generally though, if the GUITextures were handles the way we did them in these tutorials, a flexible resolution and Aspect Ratio work great and allow the player to adjust per their machine.

Generally, I tend to be optimistic that the player has a good-sized monitor on which to play my games, and change the default screen width and height to 1600×1200 and leave the rest of the settings the same.

Note that this area also has things for Dashboard Widgets (which seems cool, but why would anyone want to play a 3D game as a widget?). Although if you wanted to author a Dashboard Widget (likely not a game) with Unity, this would be the place to activate this.

Icon
The Icon area just defines the icon that will be used to represent the .exe. It is populated in the Default Icon area in the Cross-Platform settings. This is really just a 2D texture file (the one shown in Figure 18.8 is included in the 2D Assets folder (called BuildIcon)) that works best (without distortion) if it is authored

FIGURE 18.8 Icons for the final build.

as a square image. Be sure to include an Alpha channel in Photoshop if you don't want a frame around the image.

Splash Image

This is the image that shows up in the dialog box that appears when the player first launches the game (shown back in Figure 18.5). The maximum size for this image is a curious 432×163, but there are some specific things that need to be tweaked before this can be used effectively.

In Photoshop, creating a 432×163 image and authoring to that image is the way to start, and is the way to save the image (Figure 18.9). Of course, this image should be saved to the Assets folder of the Unity project file.

FIGURE 18.9 Starting out with a 432×163 image is how to start the Splash Image.

The problem is that Unity now attempts to automatically resize images to power of two textures. The problem is that 432×163 is not a power of two. This means that the image gets stretched (and thus mushy) so that even when it is defined as the Config Dialog Banner (Figure 18.10), it looks really bad in the final build (Figure 18.11).

FIGURE 18.10 Defining an image as the Config Dialog Banner.

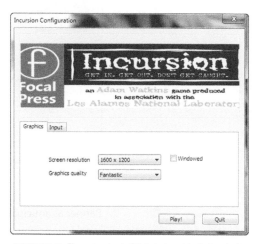

FIGURE 18.11 The poor output of Unity being a bit of a busybody.

The solution to this is simple but surprisingly poorly documented in the Dialog Banner support documents. We just need to make sure that Unity does not resize this particular image to a power of two image. To do this, select the file in the Project panel, and then in the Inspector change the Texture Type to Advanced. Change the nonpower-of-two drop-down menu to None and press the Apply button to reimport the file (Figure 18.12).

FIGURE 18.12 Telling Unity to leave the banner image alone and leave it at its nonpower-of-two settings.

FIGURE 18.13 Banner as anticipated.

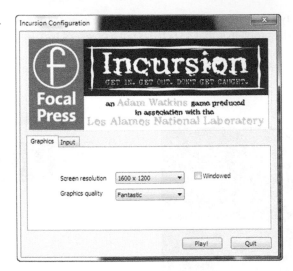

The result will be a cleaner image that actually fills the space of the Dialog Banner as anticipated (Figure 18.13).

Outputting the Final Build

Once the Player Settings have been configured to your taste, to create the build, choose File>Build Settings. Here, double-check that all the Scene files for the game are included in the Scenes In-Build section. If you've been testing the complete game in Unity this will already be populated.

Then, pick the Platform (in this case PC and Mac Standalone) and choose Windows or Mac in the Target Platform drop-down menu (Figure 18.14). Then click the Build button (or Build and Run if you want Unity to automatically open the .exe or .app it creates).

Now, to be honest, there's a bit of marketing going on in this window. The Platform area shows all sorts of target platforms (Web Player, iOS, Android, Xbox 360, PS3, and Wii). With standard Unity and even with Unity Pro, the only builds you can actually create and use are Web Player and PC and Mac Standalone. The rest of those platforms listed is Unity's way of saying, "You could build for these if you were a licensed developer with those platforms, and if you owned the additional licenses we sell to develop on those platforms." So don't let that fool you—just because they are options doesn't mean they can actually be used.

However, having griped about that, after making a Windows build (for instance) simply change the Target Platform to Mac OS X Universal (if you've got people on legacy Macs who might be playing the game) or Mac OS X Intel Only if you're sure all the Mac users will be on reasonably recent hardware, and press the Build button. Just like that you've created a cross-platform application.

FIGURE 18.14 Creating a build.

A Few Notes on the Output Files

When creating a Windows build, do note that there are actually two files. The first is the .exe file—the actual executable that the player launches to play the game. The second is a folder that is called NameOfYourGame_Data. To play the game, both must be present and in the same folder. When distributing the build, I find it helpful to take both files (the executable and the data folder) and zipping them into one archive and sending that off. We have had occasion here where we sent off a project to a client, who then tried to show it to someone else by just sending the .exe—it doesn't work.

On the Mac side, things are a little more elegant for the final user. An .app in Mac OS X looks to the user like a simple icon in their Finder. However, in reality it's really a folder (that OSX calls a Package) that contains a bunch of things. When Unity creates a Mac build, it creates an .app folder. On a PC, this will appear as a folder (which I usually compress into a zip archive before sending it off to someone), but when a Mac user unzips it to his machine, it will appear as a single icon that will contain all the assets he needs. The user just double-clicks to launch it.

Finally, note that when creating a Web Player build, Unity won't ask for a simple location to save the build—it will ask specifically for a Folder. The reason for this is that there are some very closely linked files that Unity will output. One will be the .html file that presents the Unity content (a .unity3d file). The specifics of this .html file can be controlled in a general way via the Player Settings in the Per-Platform Setting section. Specifically, the look of this html file can be altered and customized manually via your favorite HTML editor.

When creating this build, Unity puts an extra layer of compression on assets (LZMA) to try and help the player actually get to play the game faster; so the build can take a little bit longer to output.

Conclusion

And with that we end. By this point, you should have a build that you can pass on to most any of your friends with Windows on Mac machines. It's a functioning game, but just a start.

Through many years of teaching 3D and game design in semester-long formats and one week seminars and writing many books, I've seen a lot of students create a lot of projects. Often these projects are of dazzling complexity, and sometimes they were more the stuff of very solid foundational understanding. But in all cases, the nature of books or classes can yield a kind of dependency on the information deliverer (either the instructor or the book).

What this means is that the learners think they've got it all under control and that they've learned lots—and they have. But usually this new knowledge is right on the edge of their memory, and without immediate further application, it slides out of their memory banks.

So here's my plea. If you have not been doing the Homework and Challenges, go back and hit a few of them to expand on the game we've just built together. And go back and do this soon (as in today or tomorrow). Then, start a new project from scratch within the week. Being able to access skills and techniques and apply them to your unique situation is when a book or class has really been worth the money and time you've invested in them.

We've covered a lot in the pages of this book. Now go make the leap from tutorial follower to game creator and be brilliant!

Index

Note: Page numbers followed by *f* indicate figures.

U

Printed and bound by CPI Group (UK) Ltd, Croydon, CR0 4YY

22/10/2024

01777636-0012